THE ART OF MOVEMENT

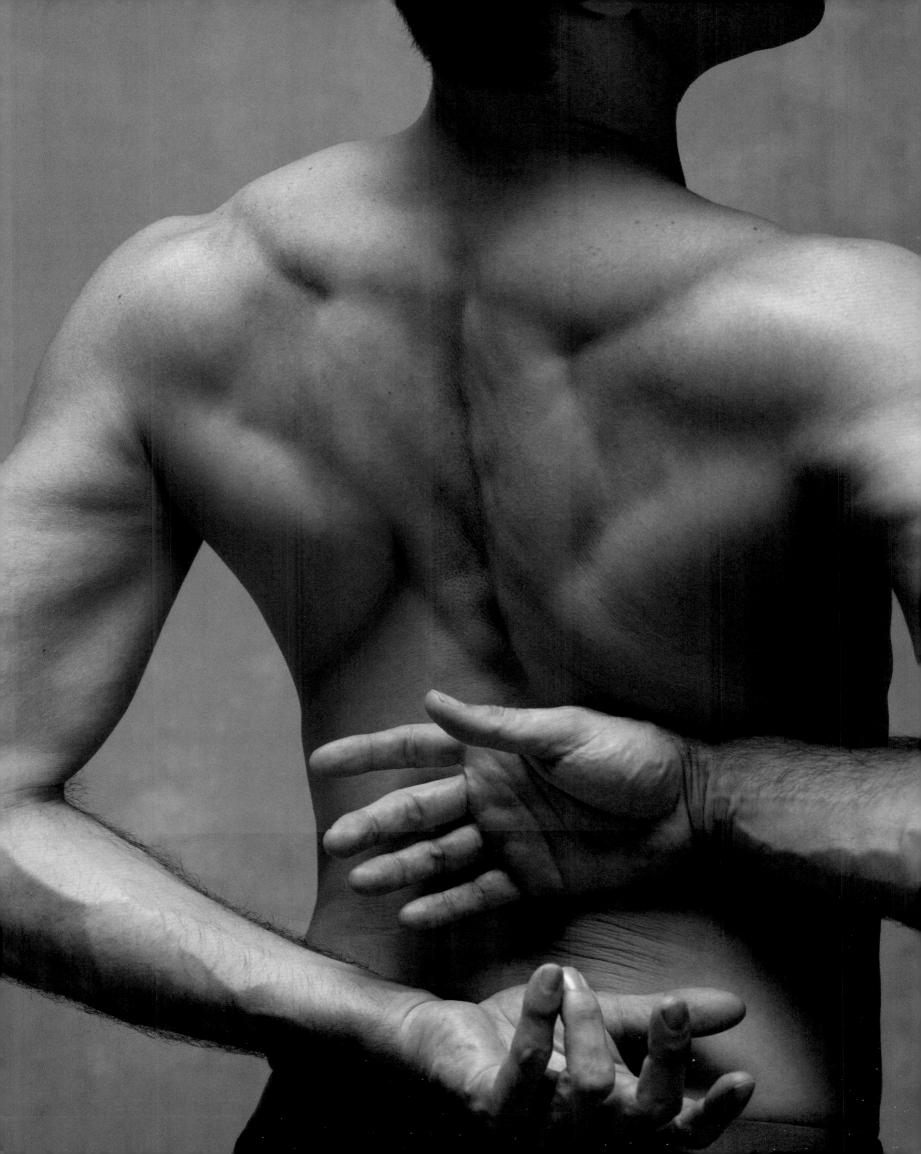

THE ART OF MOVEMENT

Ken Browar and Deborah Ory
NYC Dance Project

BLACK DOG
& LEVENTHAL
PUBLISHERS
NEW YORK

This book is dedicated to
Sarah and Jenna Ory
Elise Weisbach

&

in remembrance of
Jerry Weisbach
Marilyn and Joe Browar

Introduction

As the choreographer Merce Cunningham once put it, "You have to love dancing to stick to it. It gives you nothing back, no manuscripts to store away, no paintings to hang in museums, no poems to be printed and sold, nothing but that fleeting moment when you feel alive."

Ken Browar and Deborah Ory, two photographers devoted to dance, are driven by the notion of making the impossible possible: capturing the art form's ephemerality with a camera. In their desire to give something back, they defy logic. Their approach has little to do with static poses. Instead, their lithe subjects—all different, each an individual—shape and charge the air with their bodies.

Images are imbued with the idea of flight; skirts stream and swirl around legs like parachutes, spines torque yet never freeze, and arms, extended out, trail off to enhance the body's frame. Even the hair is free to dance. How is it that a body can grow, seemingly, in a still picture? It has something to do with energetic effort; we may not be able to see the liftoff or landing of a jump, yet, in each of Ken and Deborah's images, we can absorb the before and after, all the while feeling the rush of that fleeting, life-affirming moment.

Just as the more time you spend with dance, the more you glean from it—nuance, detail, even subtle strains of spirituality—it becomes apparent that dancers are not generic, one-size-fits-all entities but finite beings that walk and stand differently in the world. There's a reason Martha Graham referred to a dancer as "an athlete of God." They descend, grace us with their gifts, and disappear.

To reveal that moment in which dancers move beyond the physical labyrinth of ligaments and muscles to show who they are in their essence is somehow at the heart of Ken and Deborah's explorations. In one image, PeiJu Chien-Pott, an exceptional Martha Graham dancer, is caught in the air. Floating above the ground with pointed feet and taut, stretched legs, her chest and arms—they are open, relaxed, generous—draw us to her serene face. Is she bathed in moonlight? In this contrast of soft and hard, strong and vulnerable, sylph and woman, Ms. Chien-Pott reveals her immaculate strength and more: how years of training allow a dancer to just let go of rigor and simply be.

What do many of the images have in common? The dancers, as if lost in private worlds, collect our gazes, but don't return them. We feel action, momentum, and force, but, rarely, seduction as they pose in profile with their faces tilted angelically toward the light. There's more of a heightened alertness as Miriam Miller, an especially elegant member of New York City Ballet, tilts her eyes upward to expose her delicate neck, as well as the sculptural strength of her shoulders. Her black dress, which encloses her ribs snugly with material that gathers to a point at her throat—it's like an arrow directing us to her face—comes to billowing life when she, in another image, rises in arabesque and its sheer, tiered skirt flutters to the side with emphatic flurry.

Windswept and ravishing, Miller, with raised arms, glances back toward her outstretched leg and, in that instant, you sense the velocity of her body: its breath, its muscular reverberations, its ability to keep growing. Of course, this is where it gets tricky: a photograph can only catch a moment in time, yet Miller, embraced by the space around her, is anything but stationary.

Ken and Deborah work intimately with their subjects, who hail from world-class companies, including American Ballet Theatre, New York City Ballet, the Martha Graham Dance Company, Alvin Ailey American Dance Theater, and the Royal Danish Ballet. In essence, these photographs are collaborations, not only between Ken and Deborah, but between the couple and each dancer. Their subjects' training varies, but the photographers dismiss style or technique in favor of the body's natural flow. On these pages, a dancer is a dancer. And they're relaxed. Because they're playing themselves, a gossamer fragility shines through their natural beauty. This is physical expression realized through practice; you see the work in articulation, in execution, but also in the tranquility.

That, in part, must have something to do with the environment. The majority of the photographs are taken in the couple's loft in Greenpoint, Brooklyn, which is their home as well as their studio, and where their two cats, Lilly and Olivia, occasionally tiptoe into the frame. (It is their living room too, after all.)

The photographers collaborate with the dancers; every detail is discussed from lighting to position to clothing. The dancers examine images of themselves on a monitor to scrutinize their line before getting back into the shot, knowing that they are in safe hands. The agenda is pure: getting the most beautiful shot imaginable. Daniil Simkin, a Principal at American Ballet Theatre, was their first subject; as such, he began a tradition by signing their daughters' bedroom walls. They're now covered. A particular favorite: "I was here. Alessandra Ferri."

A dancer's life is over fast, but with their work, Ken and Deborah are leaving behind traces of motion. They're not dances, they're artifacts—and, yes, you can hang them on the wall.

–Gia Kourlas writes about dance for the *The New York Times* and other publications

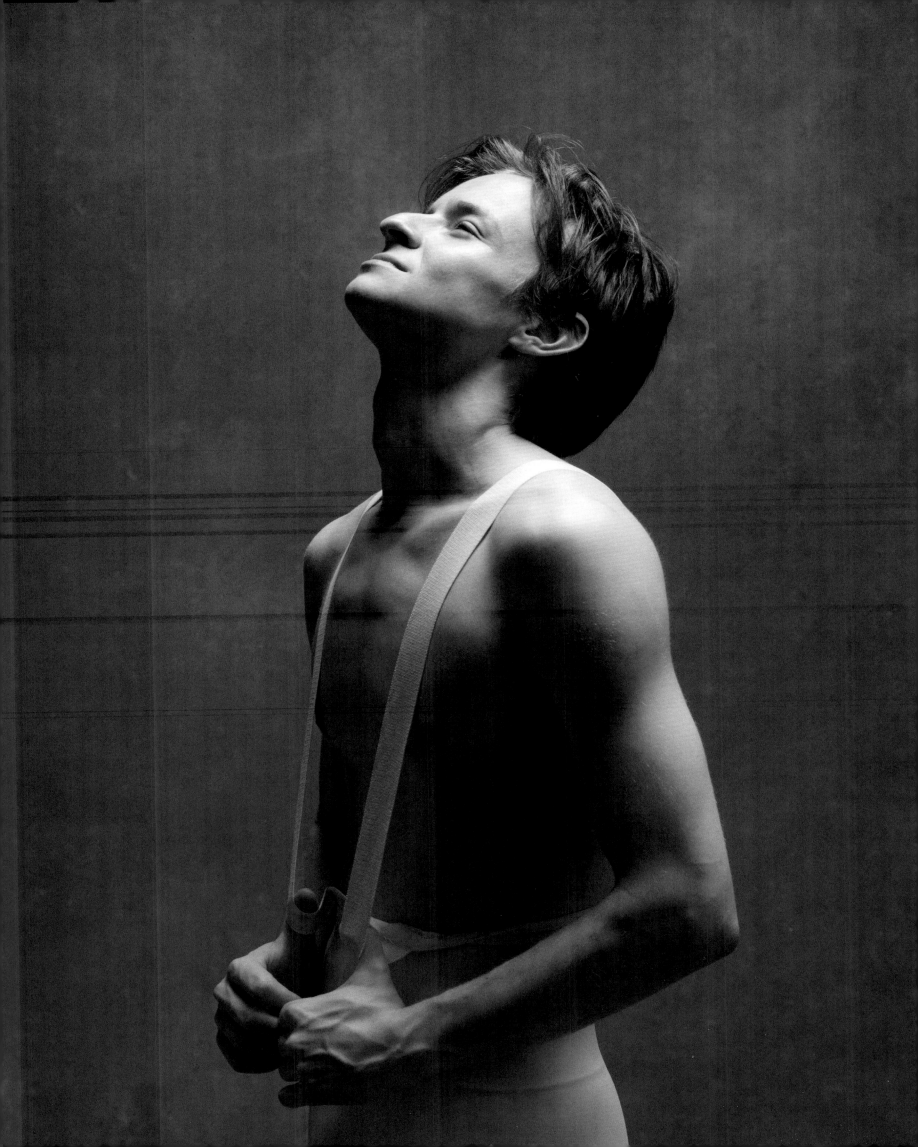

Foreword

Dance as an art form is bittersweet. On one hand, its beauty is instantaneous and visceral, and on the other, it only exists in a very fleeting moment of "now." In one instant, it "lives" onstage in performance, and in the next moment, it vanishes. While every show is unique and contributes to the flow of life, performances of the same show are never the same. That is part of the beauty and sadness of dance.

The constellation of elements felt right when I arrived for the first shoot with Ken and Deborah at their Greenpoint loft and I felt that this project could result in a very important record of our community's moments in time.

What attracts me to photography is the beautiful balance between a passing moment in dance and one frozen in time in a photograph. In photography many elements have to align or be aligned in one particular moment of truth to result in a piece of art—which comes about when the photographer captures that one moment that can live forever. Dance is, of course, comprised of many fleeting moments, but photography can address the evanescence of dance and preserve those moments that would otherwise be just a memory.

As a dancer that has been photographed by Ken and Deborah, I am excited about the opportunity that these photos create to look backwards in time—years from now—and be able to remember these fleeting moments.

–Daniil Simkin

Daniil Simkin | Principal, American Ballet Theatre

"The body is a barometer telling the state of the soul's weather to all who can read it."

–Martha Graham

Martha Graham had a reverence for the human body—not only for its physical beauty, but also for all the human intangibles that the tangible form reveals. The belief that a simple, unadorned gesture could make a visceral, revelatory connection to her audience was the essence of her revolution in dance.

In recent years, the remarkable dance photos of Ken Browar and Deborah Ory have brought home again and again the idea that an instant can evoke a world–a microcosm in a moment. Their photographic talents—combining beauty and fashion with editorial storytelling—have created a fresh and recognizable style of dance photography that has gained global appreciation seemingly overnight.

As we discover each breath-catching, eye-opening photo in these pages, we are moved by both the thrill of the instant and the innate understanding of all that the instant contains.

Of course, Ken and Deborah have the great advantage of photographing some of the most exquisite bodies and greatest silent storytellers in the world. But these photos draw us in and somehow offer a more personal, intimate connection with each dancer. While we sense the years of training, challenges, and sacrifice these artists have faced in order to astound us, we are also stirred by the intangibles—the humor, intelligence, confidence, innocence, and even hopes, wishes, and dreams that come off the page. We feel we know them. We see the state of the soul's weather.

With thanks to Deborah and Ken for allowing each of us to be delighted and moved by these glorious dancers.

–Janet Eilber

Janet Eilber | Artistic Director, Martha Graham Dance Company

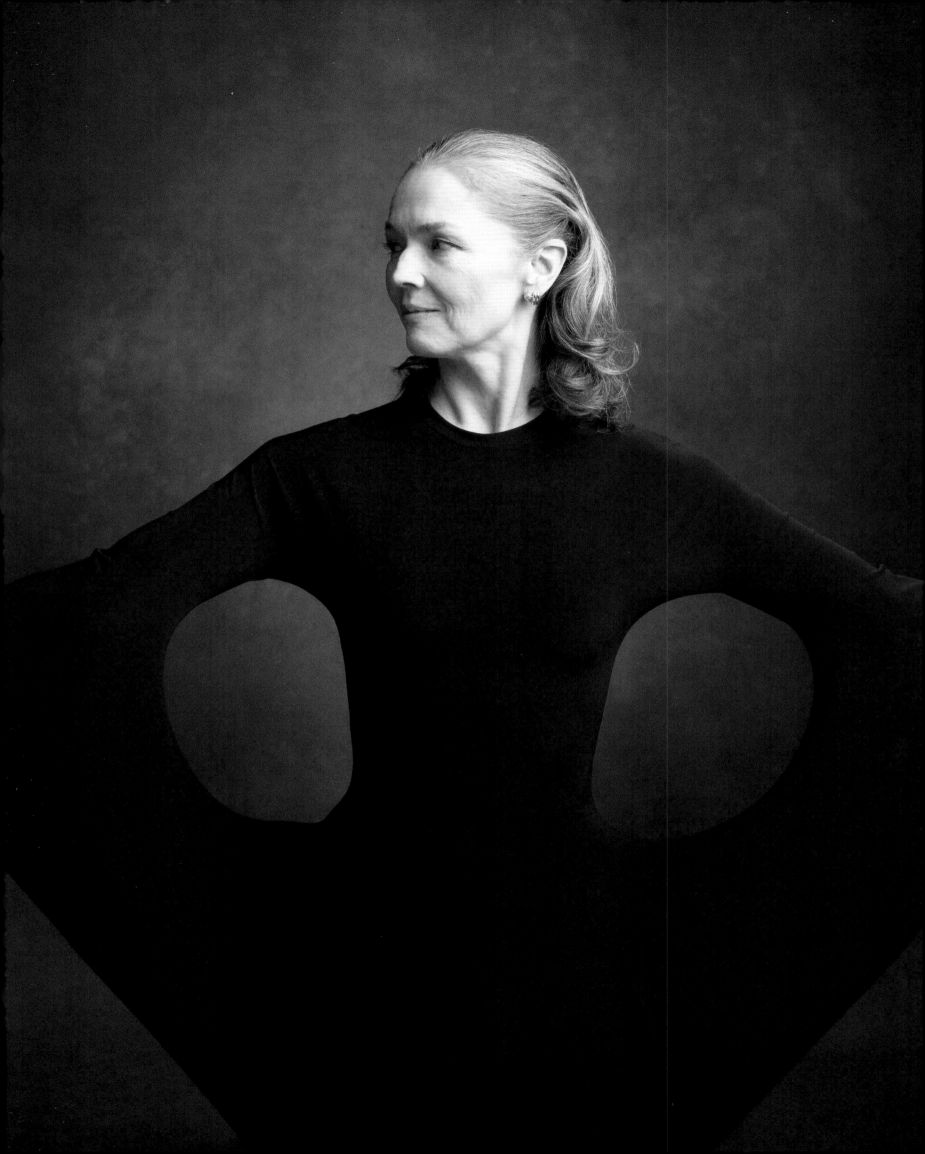

"I wanted to *be* Gene Kelly when I was growing up.
When I was 15 my sister, Megan, told me to go to
The School of American Ballet for a summer course to get my
technique stronger so my jazz dancing would be better.
I went and ended up falling in love with ballet.
I had never seen ballet be so masculine and powerful.
I was hooked."

–Robert Fairchild

Robert Fairchild | Original Broadway star, *An American in Paris* and Principal, New York City Ballet

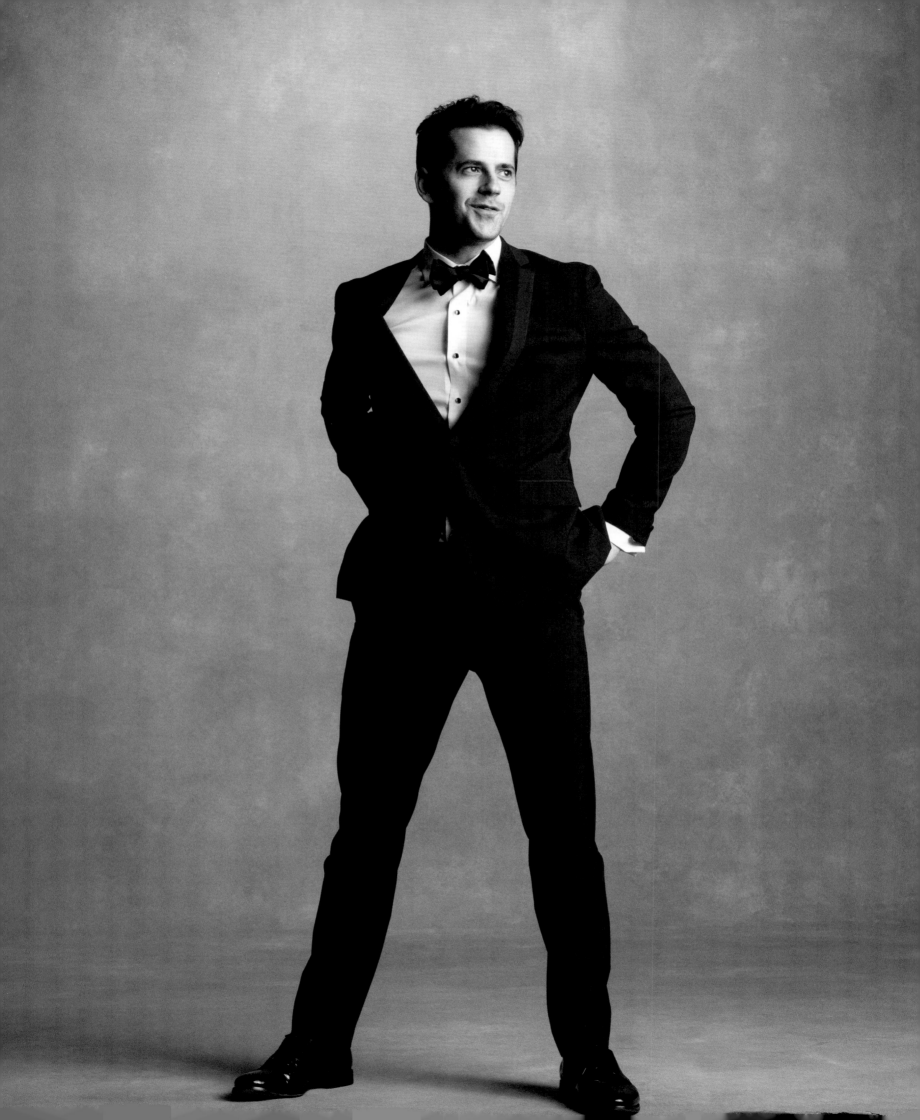

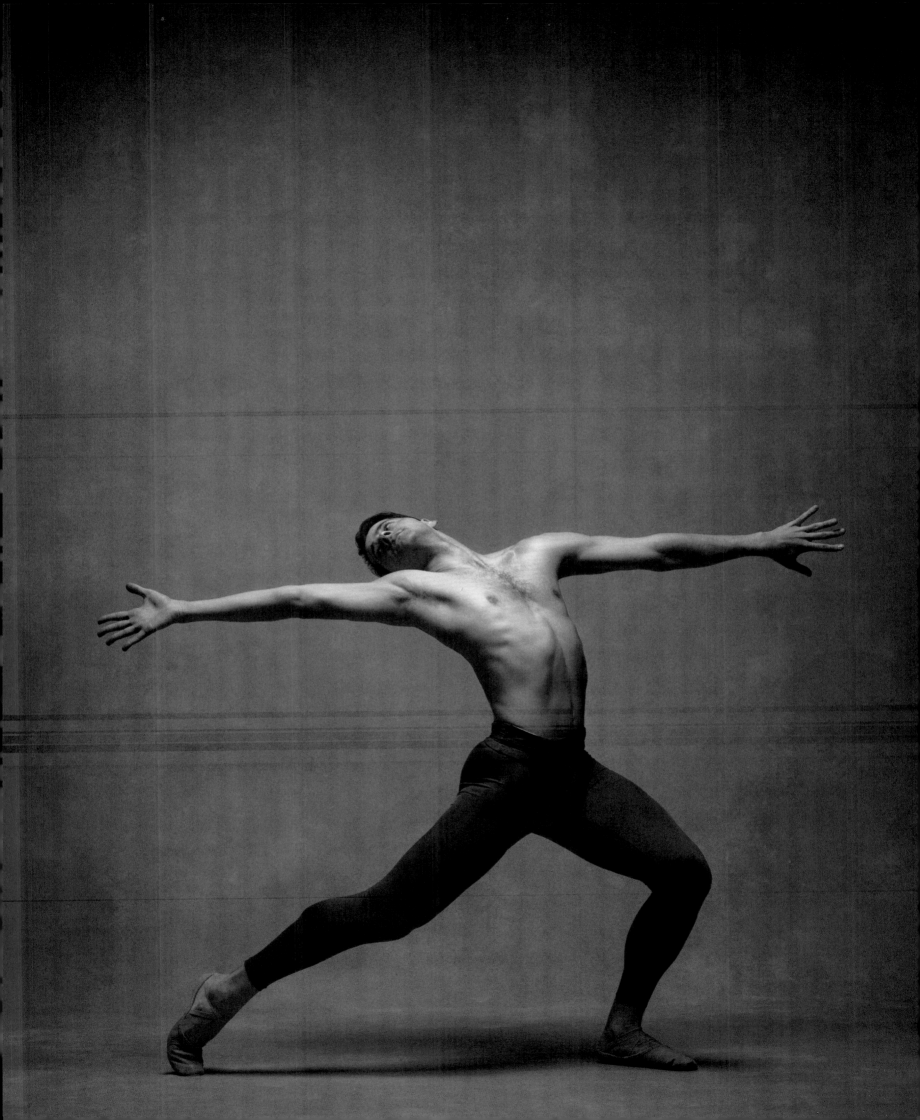

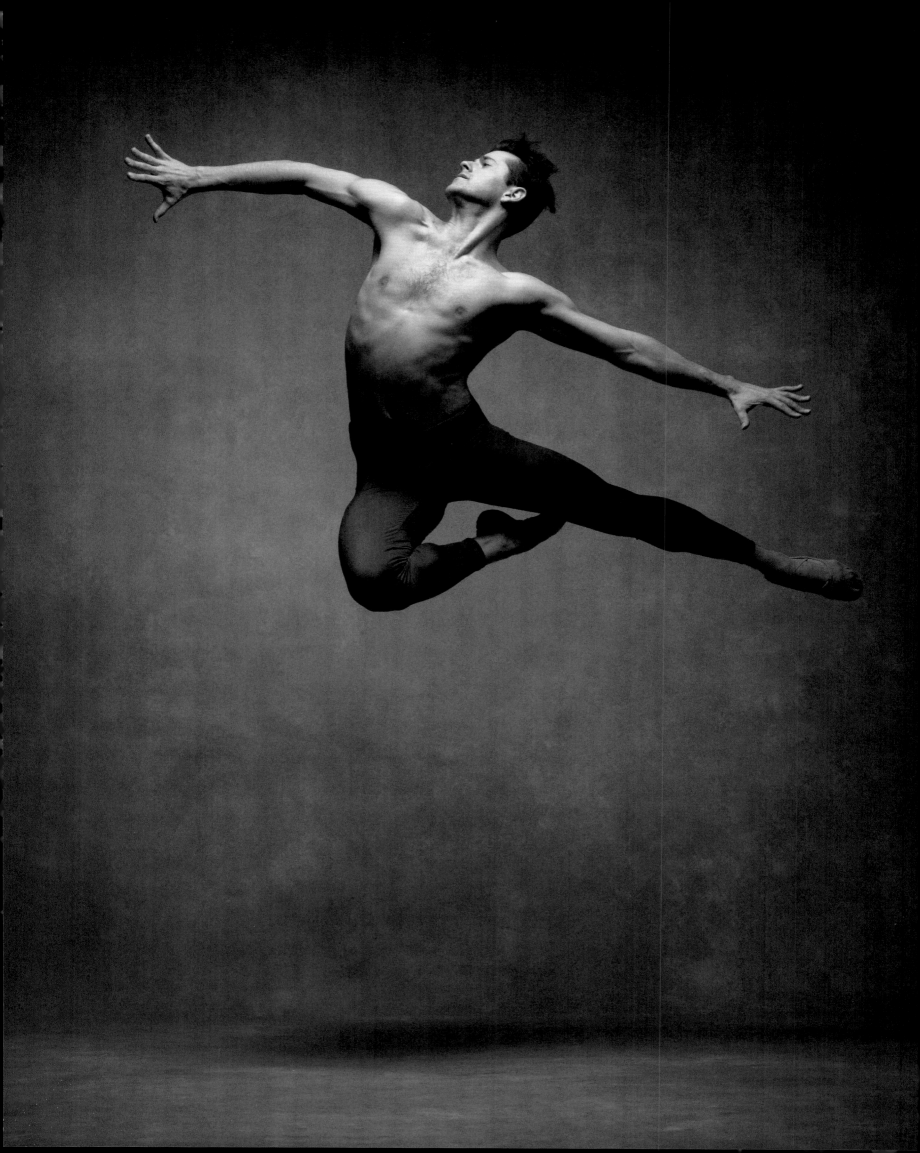

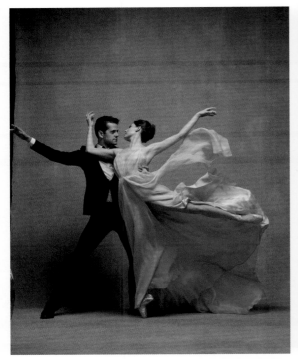 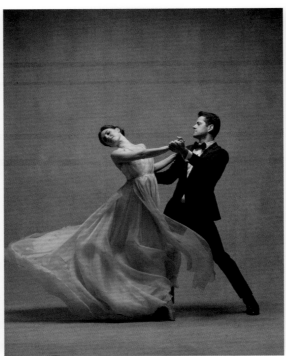 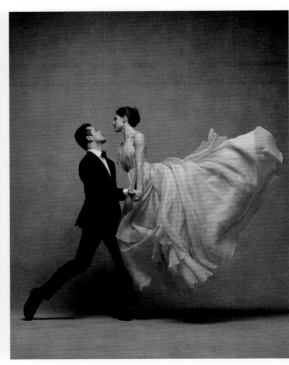

Tiler Peck and Robert Fairchild | Principals, New York City Ballet

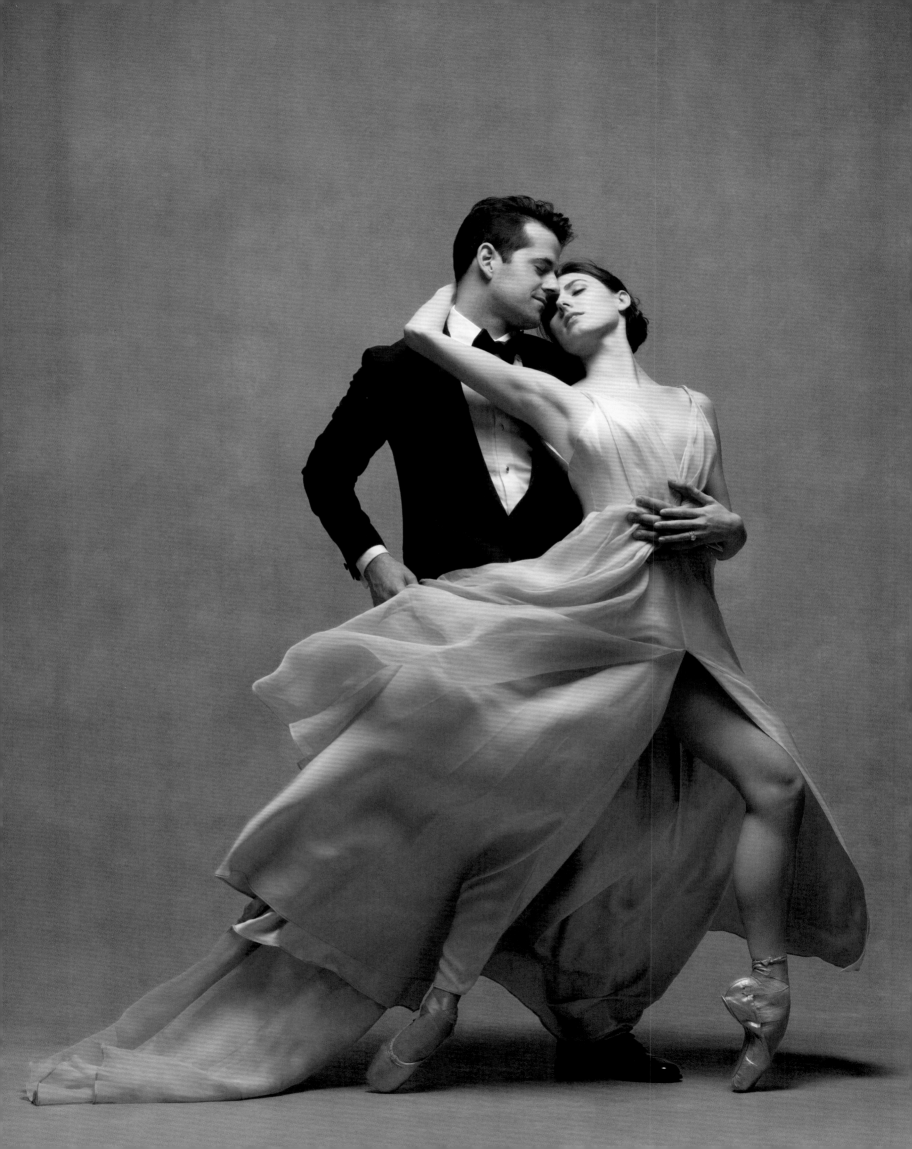

"I wish I had known how to take care of my body
when I started dancing.
Dance is an extremely physically demanding career and
it is really important to be good to your body
because it is your instrument."

–Tiler Peck

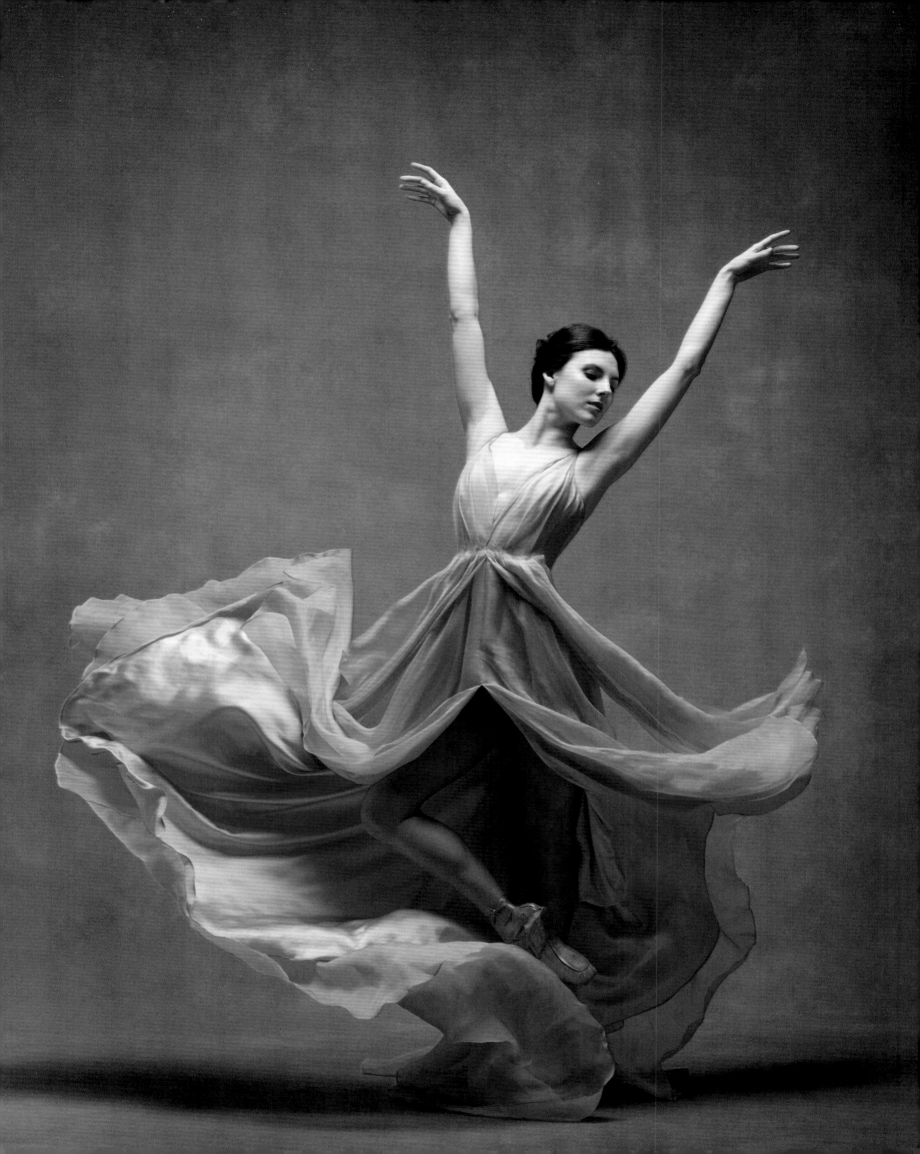

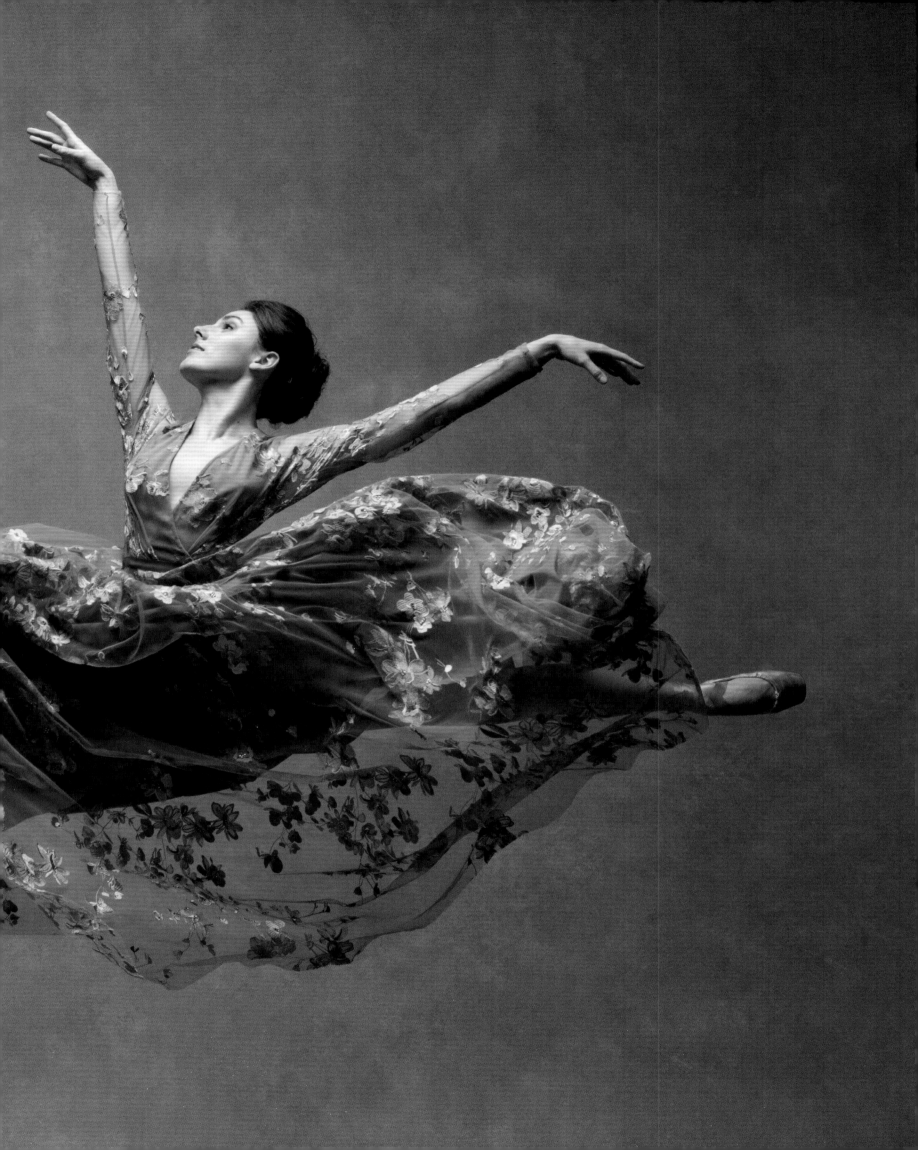

"Ever since I can remember, I always had a passion for dance. As a child I made up my own choreography to songs by Madonna. It was in my DNA to dance. When I was five I watched my sister's musical theatre class and asked to join in."

–Marcelo Gomes

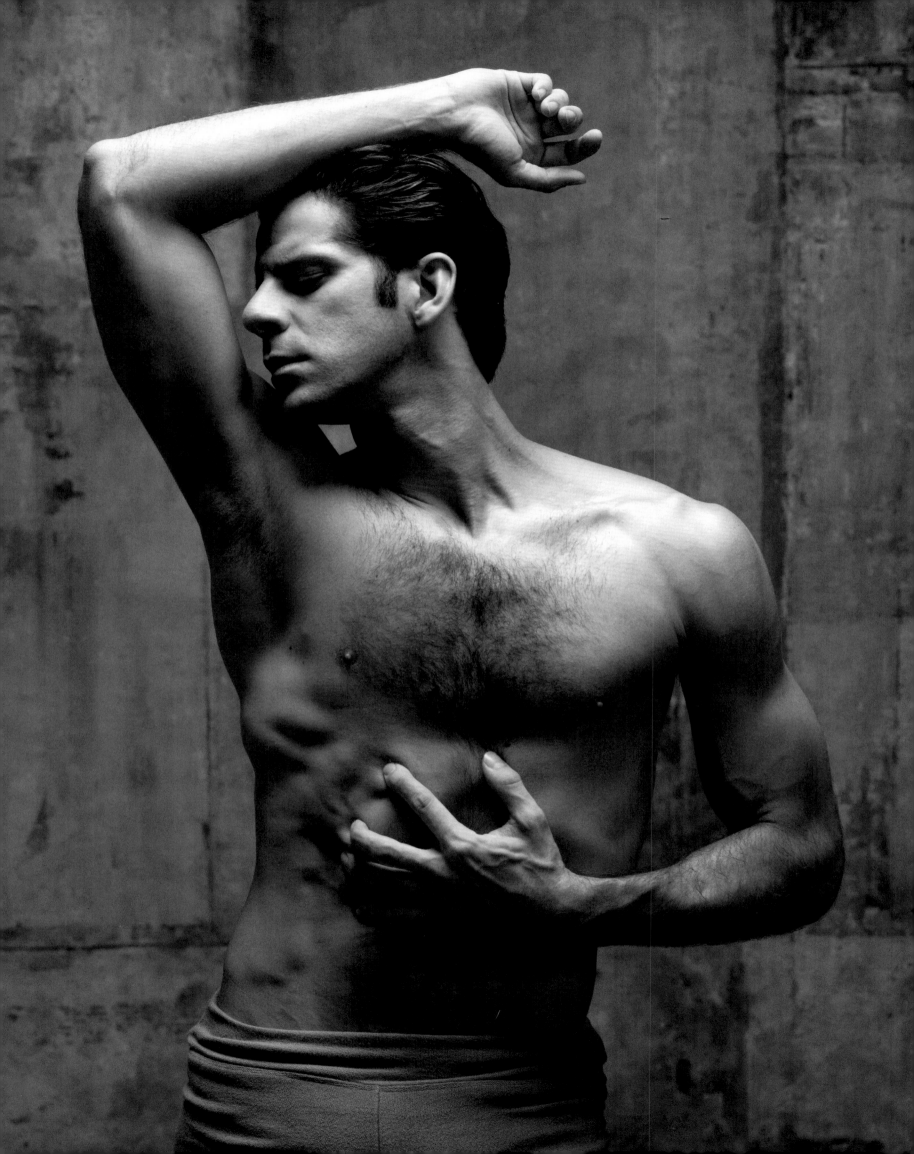

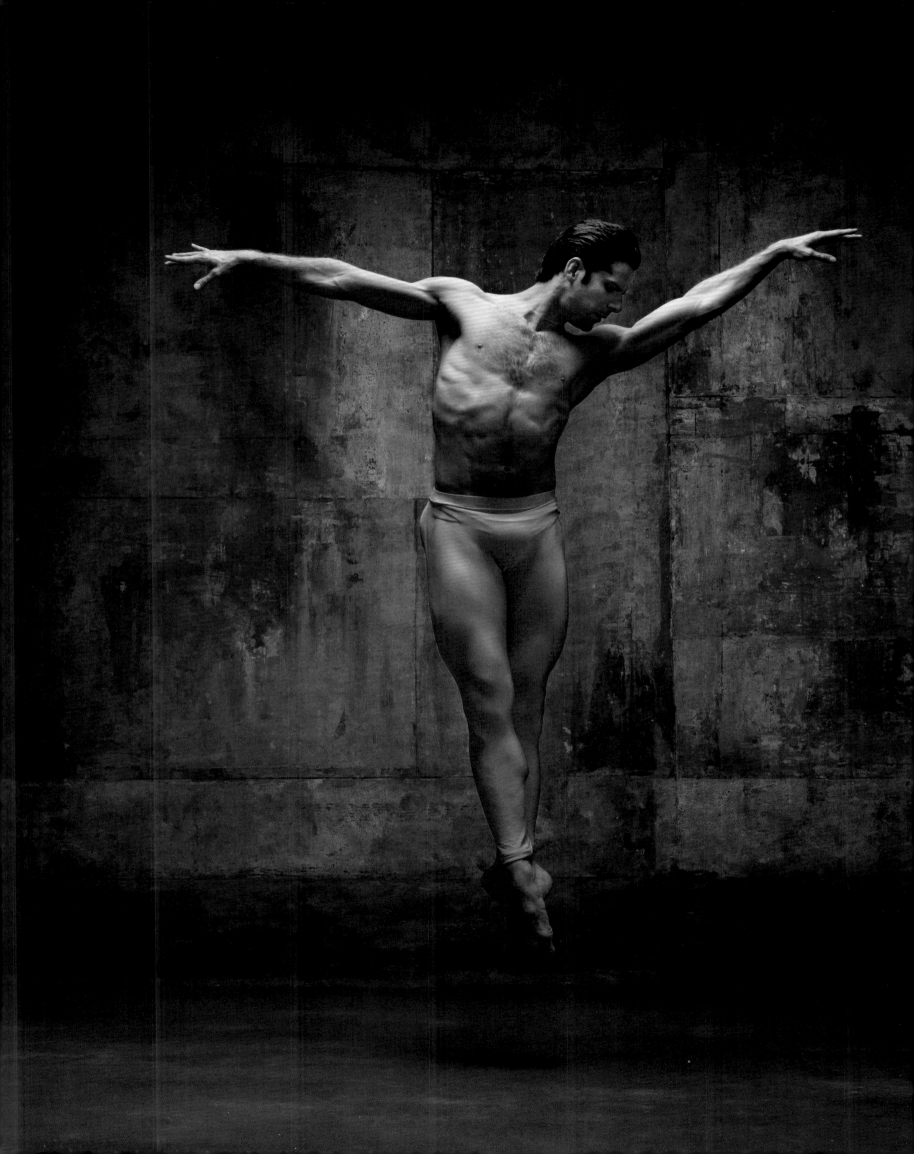

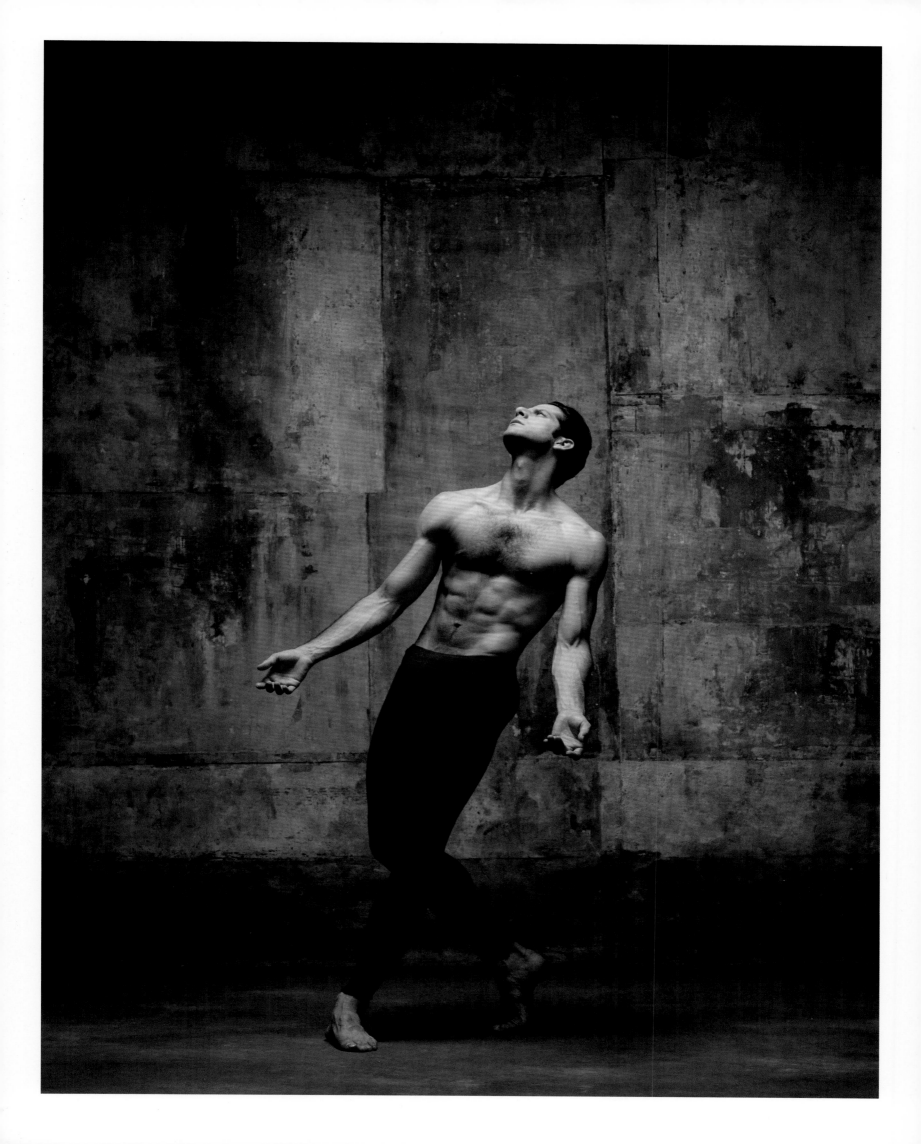

"I wish I'd known how to be patient when I first started dancing. Sometimes we put so much pressure on ourselves to 'get there' that we forget to enjoy the process."

–Sebastian Vinet

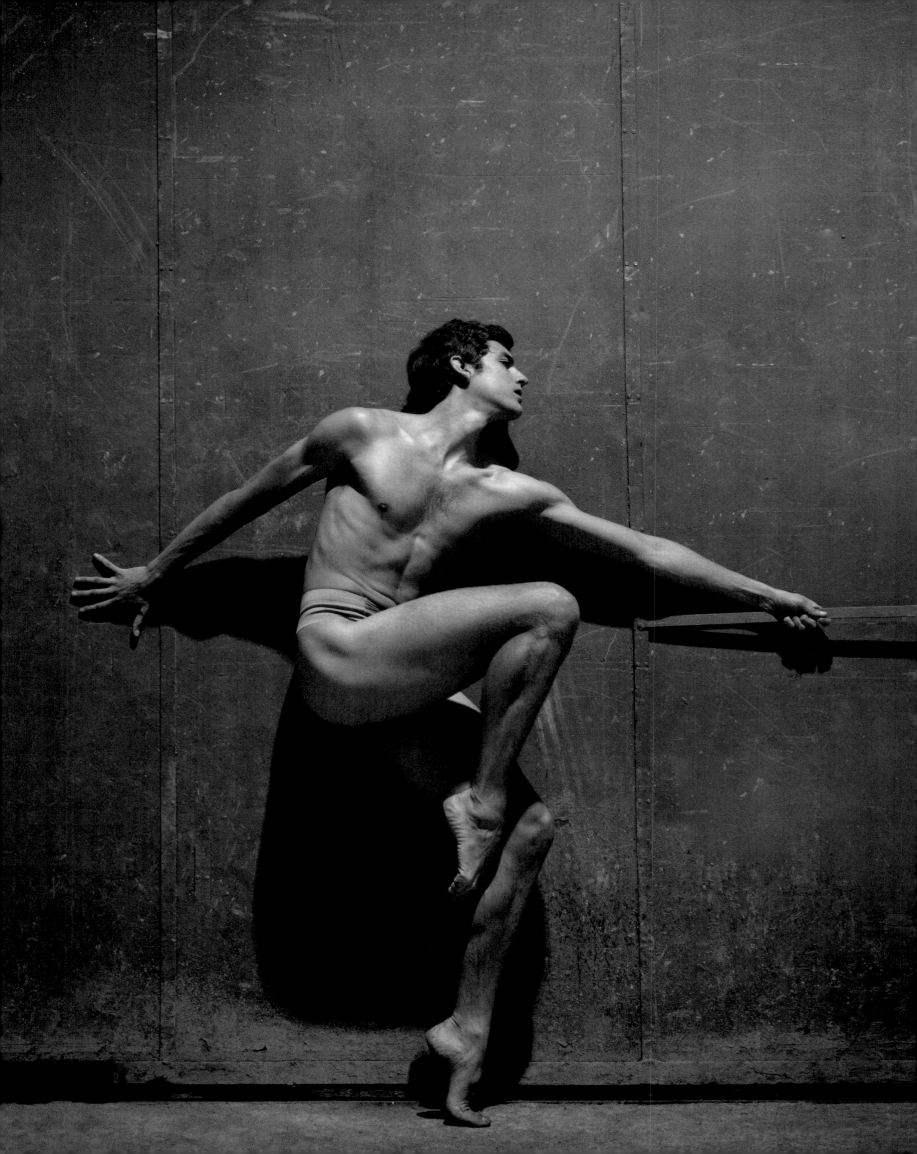

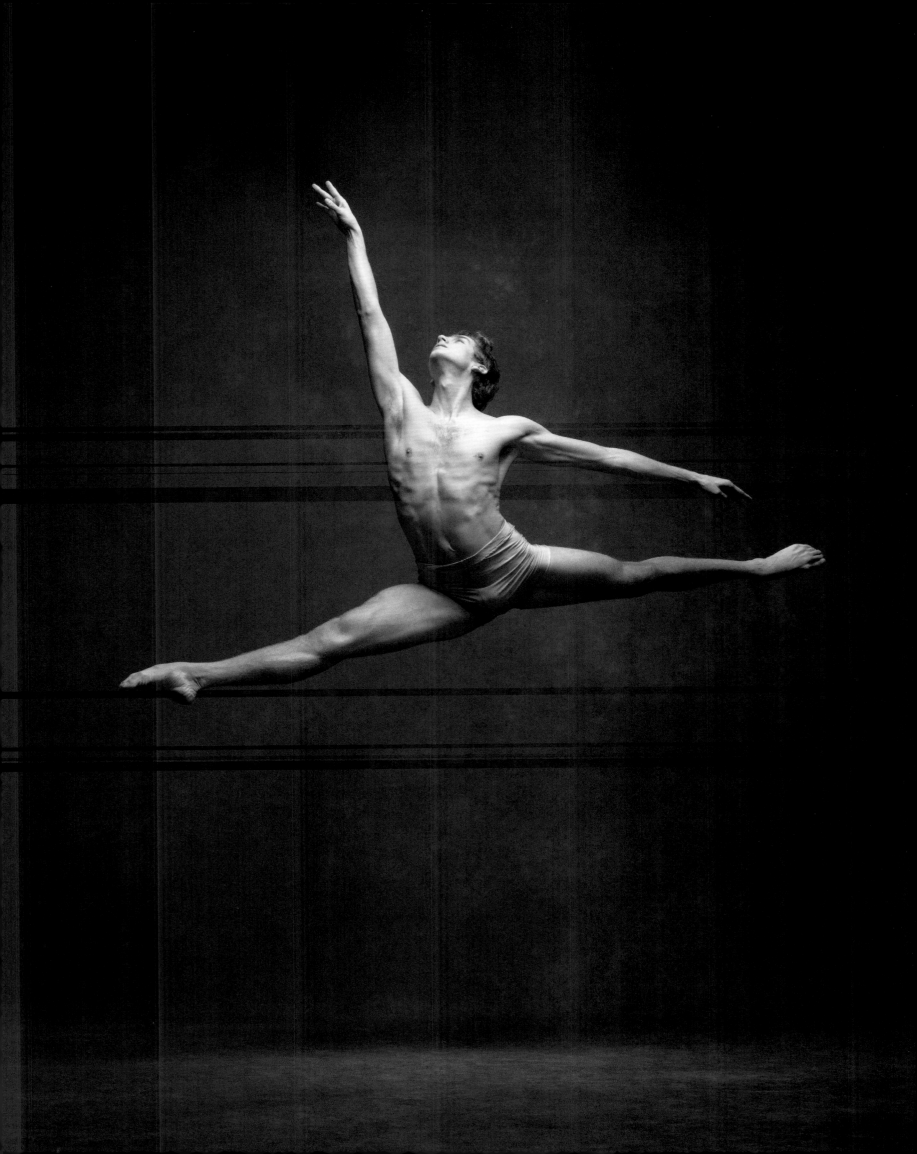

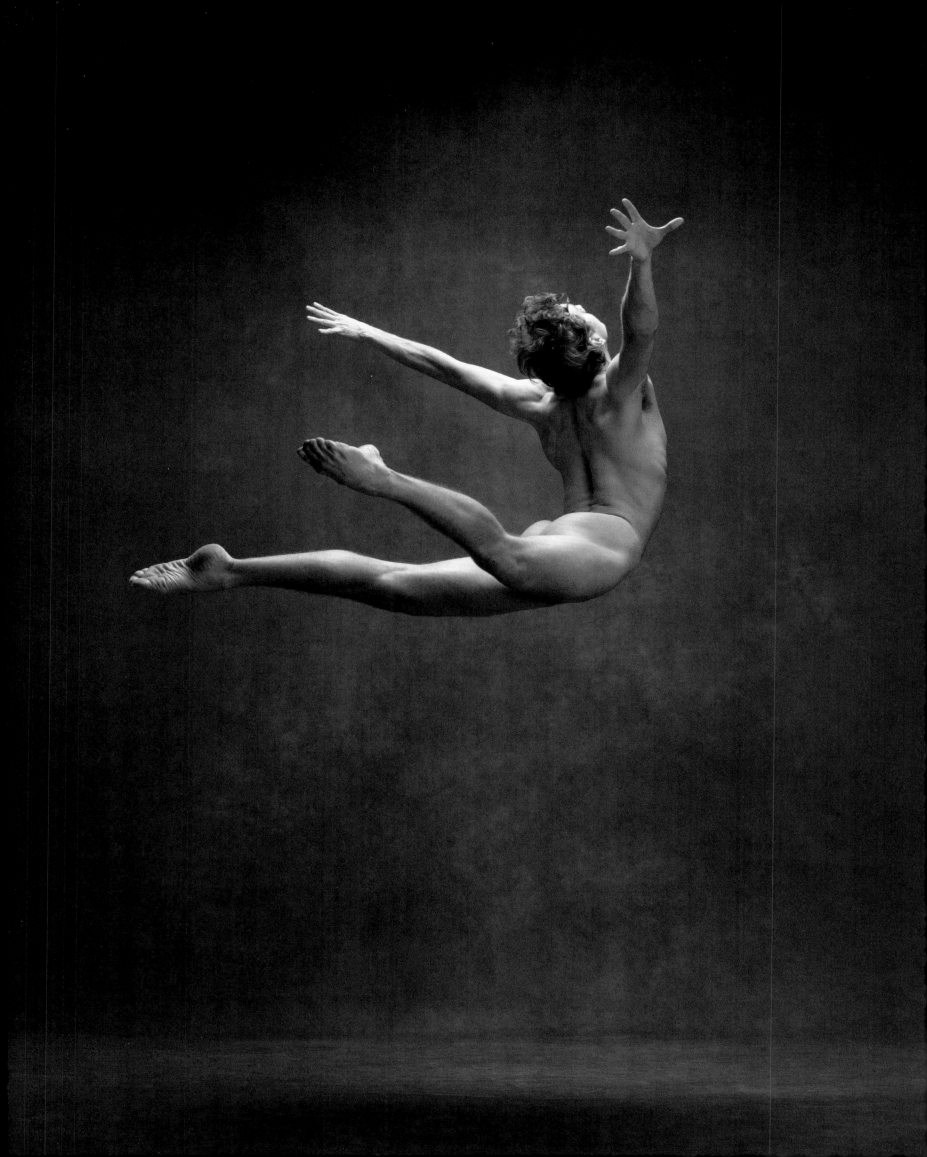

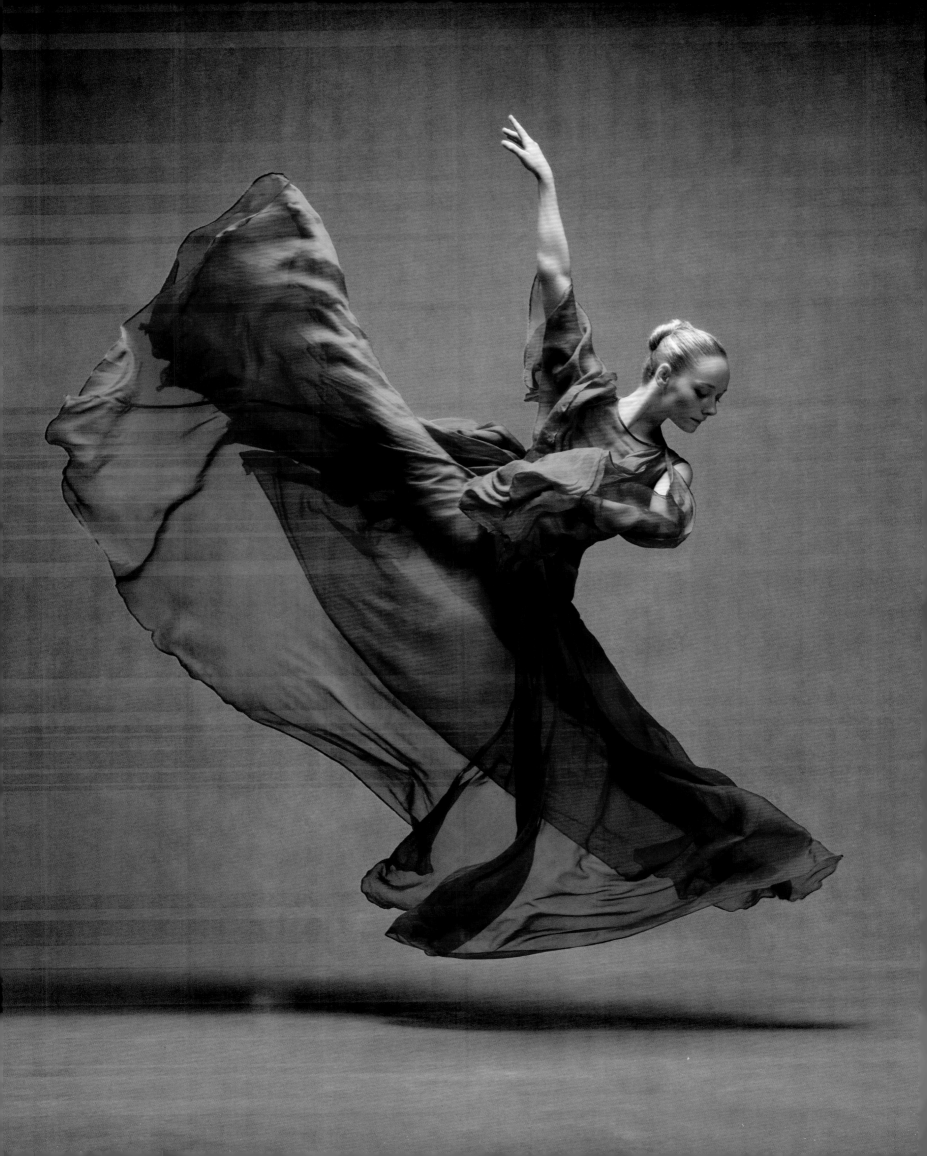

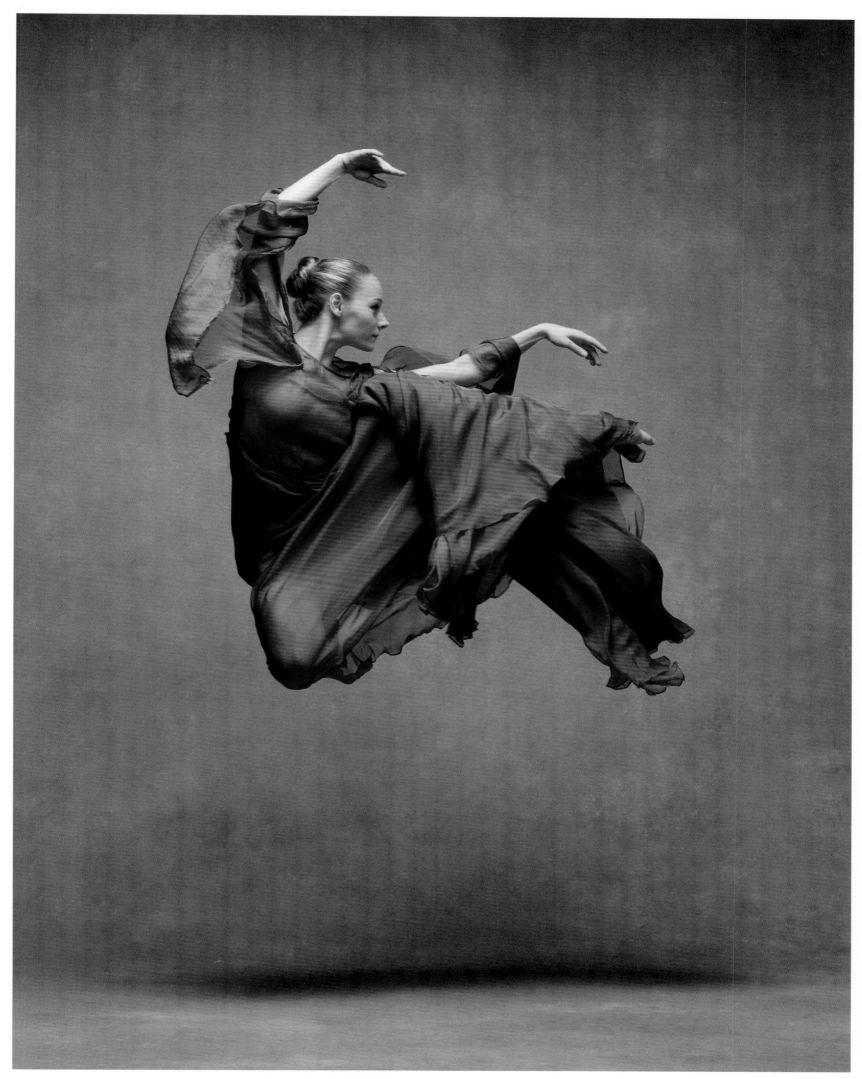

Charlotte Landreau | Soloist, Martha Graham Dance Company

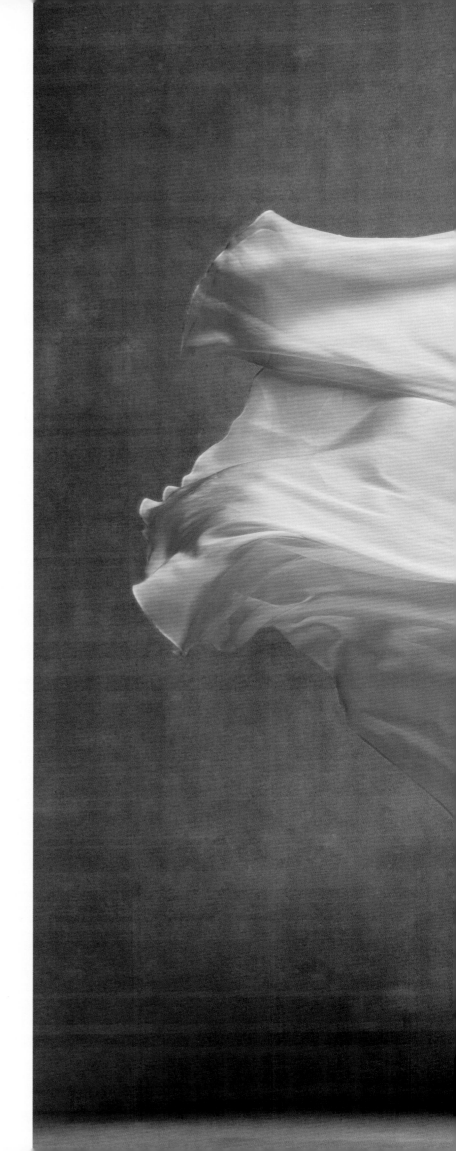

"When you go on stage,
you're giving your emotions to the world,
you can express your inner world,
become a goddess,
die, and then kill, transform yourself
over and over again.
I would say don't be afraid to throw
your soul to your audience,
if you want to be a dancer."

–Charlotte Landreau

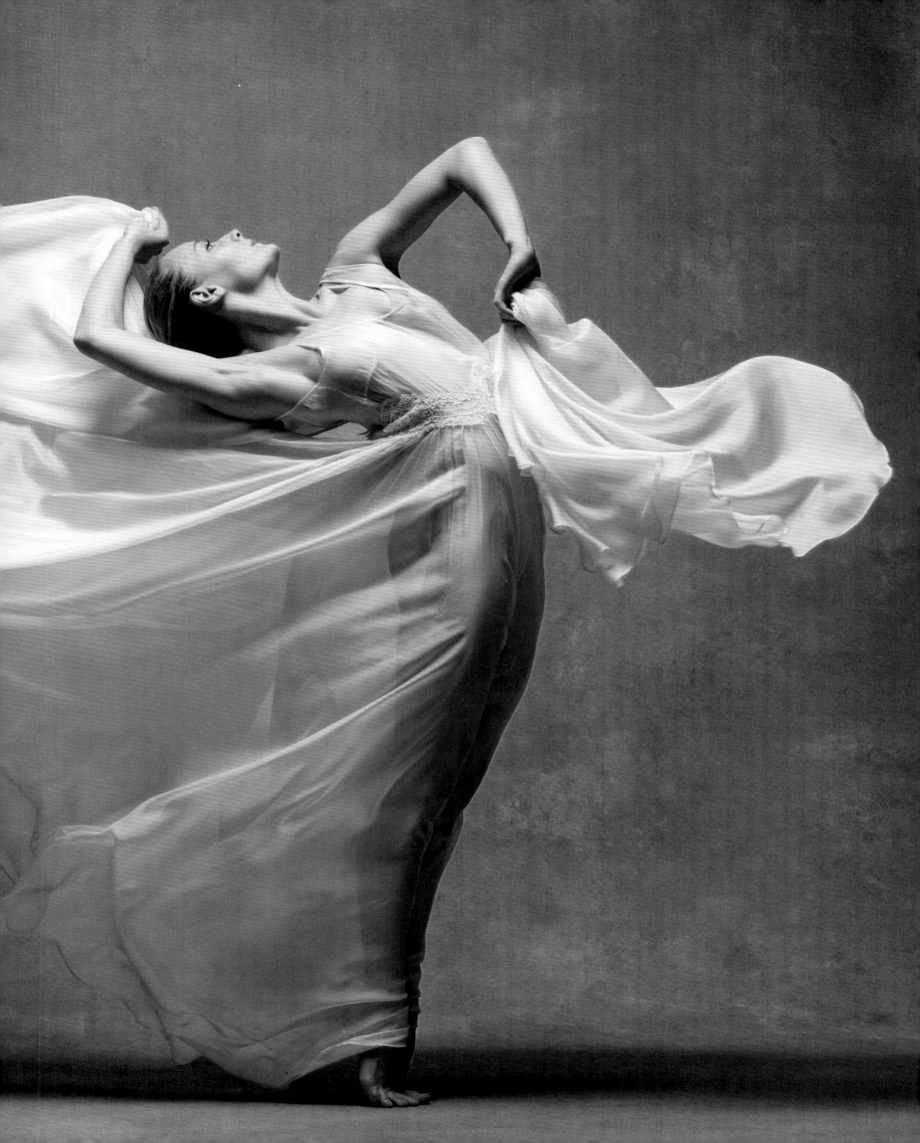

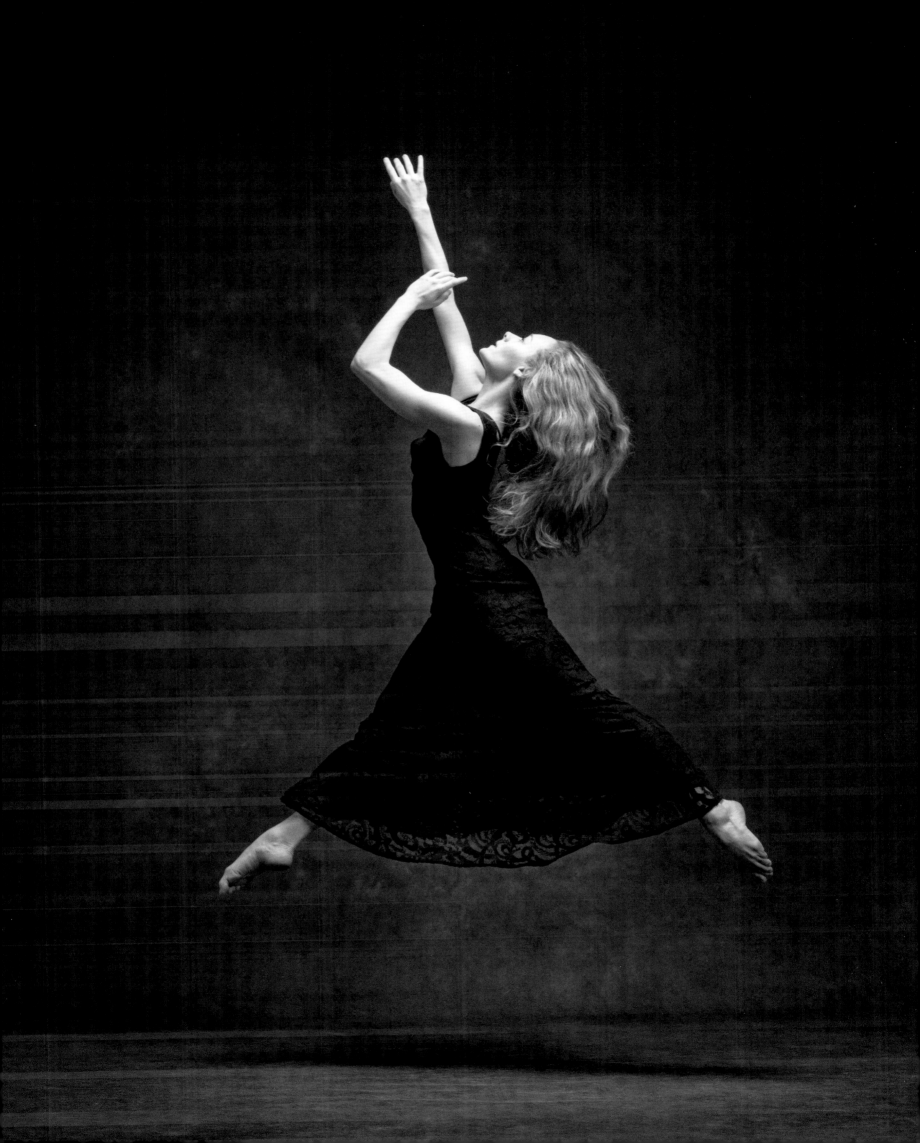

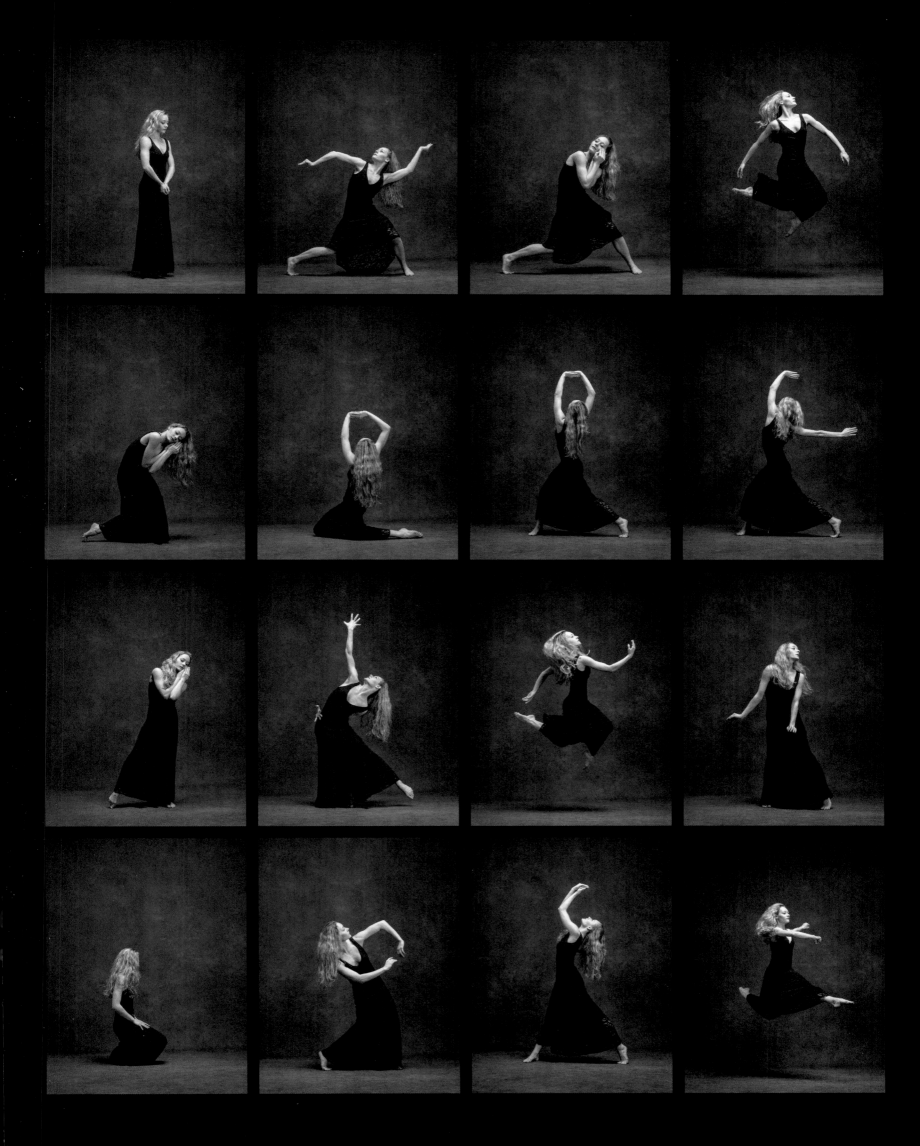

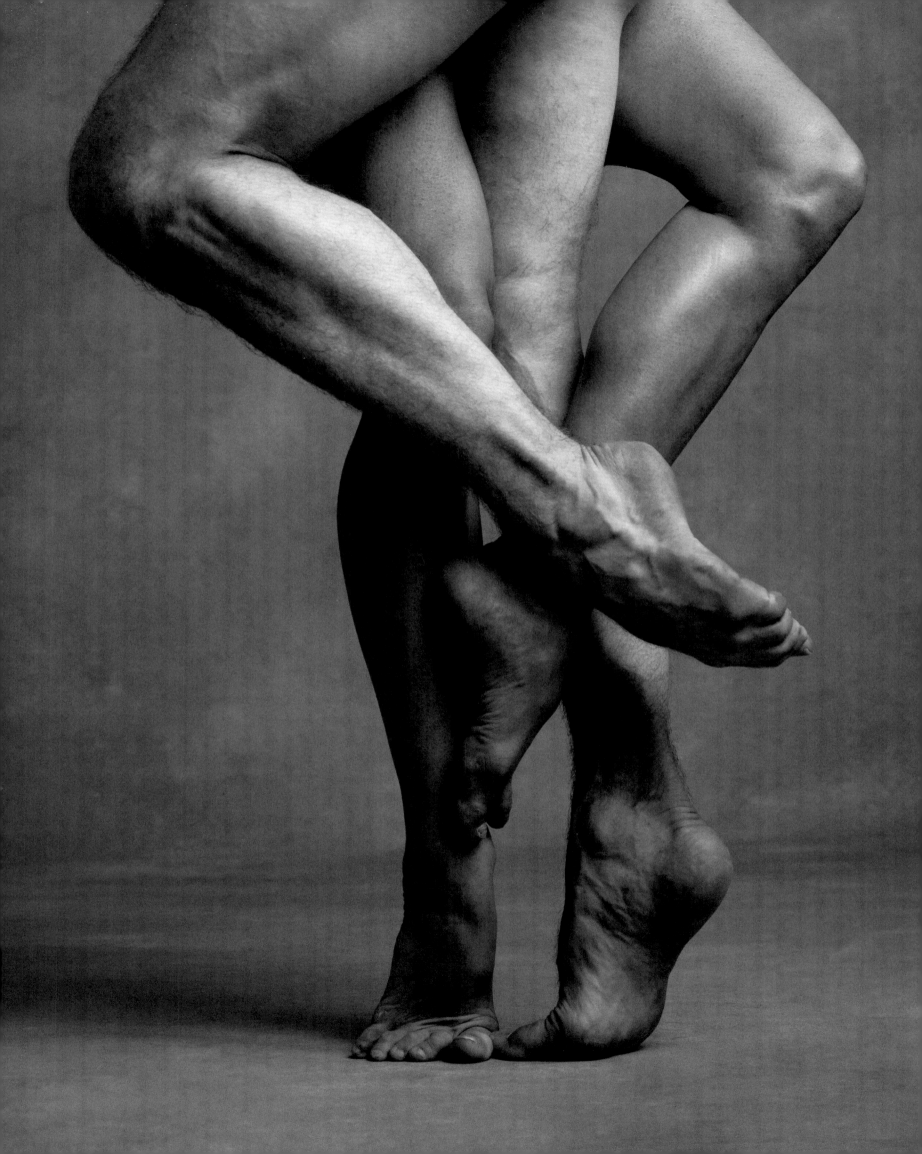

"Everyone sees the beauty in dance, but a lot of the time they do not realize the hard work that goes on behind the scenes."

–Nayara Lopes

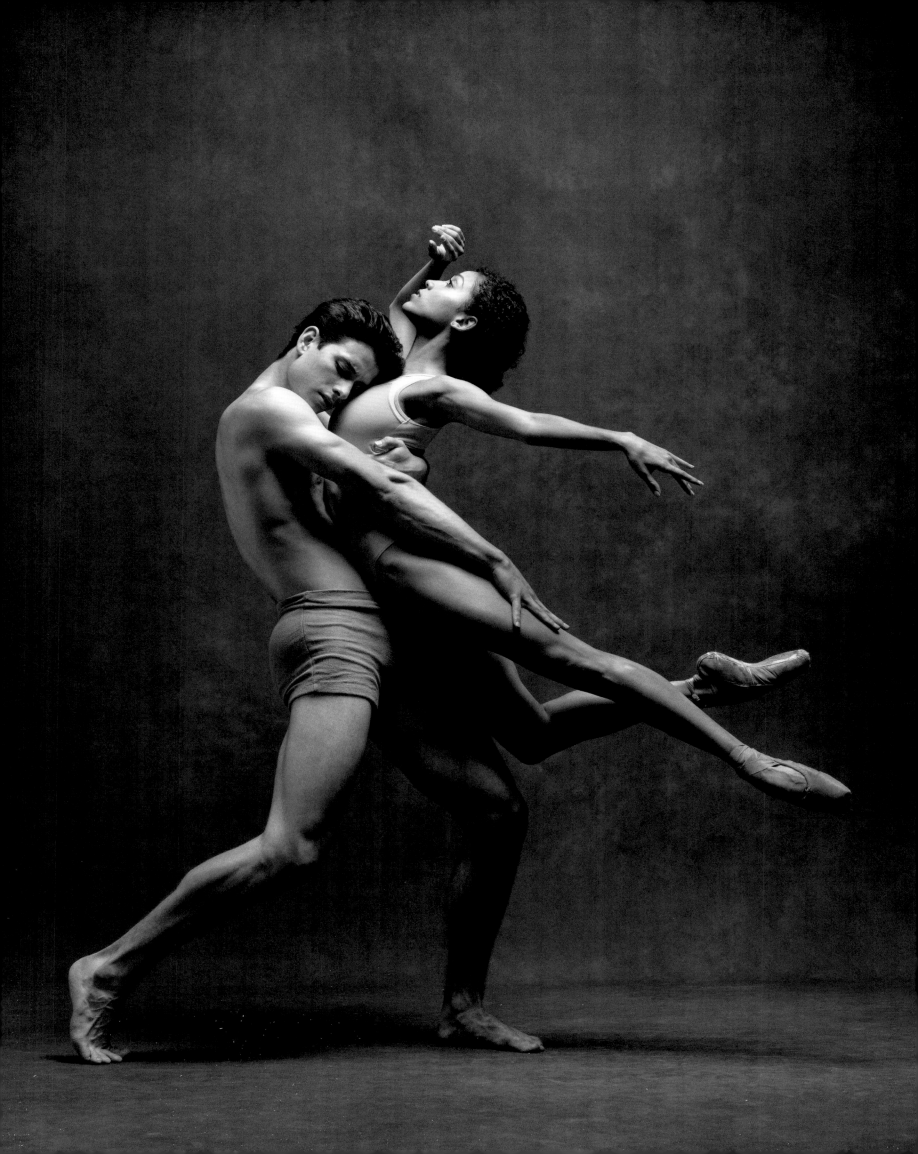

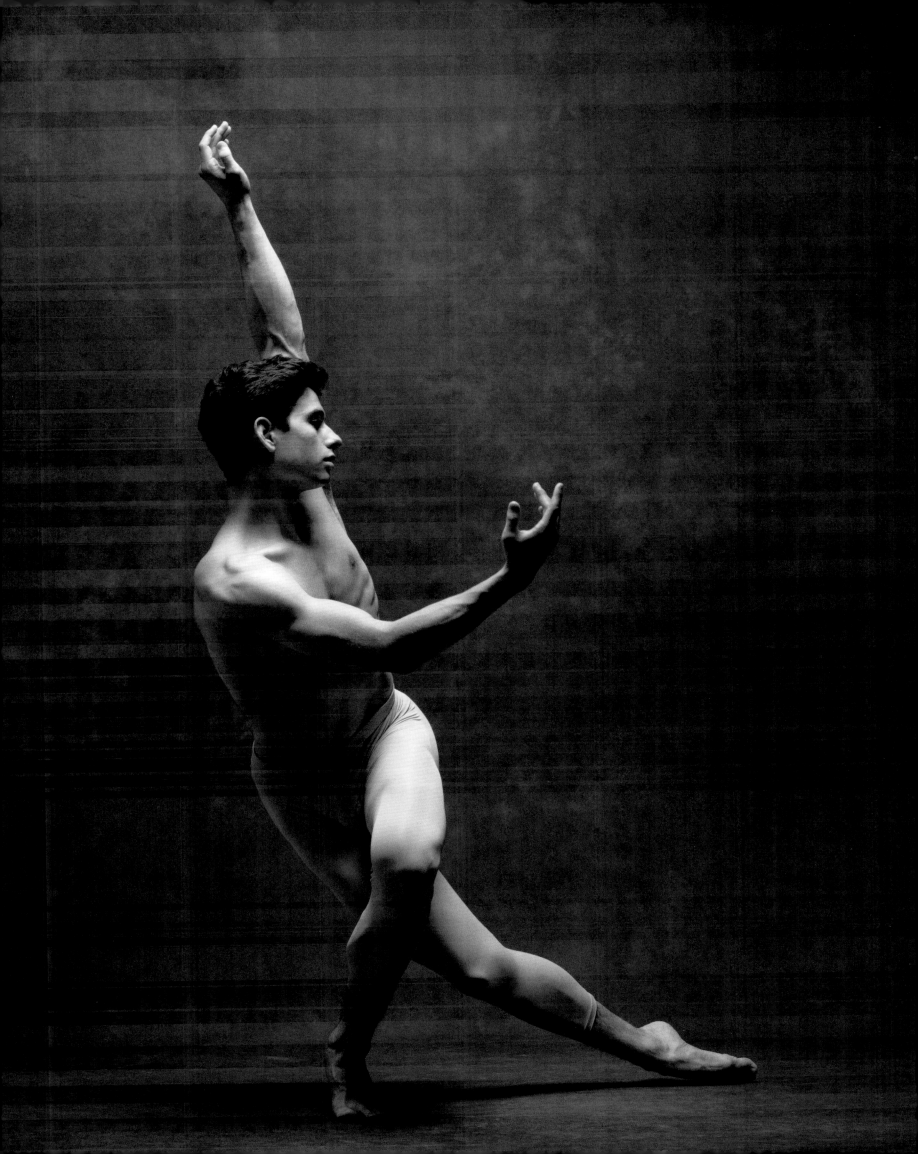

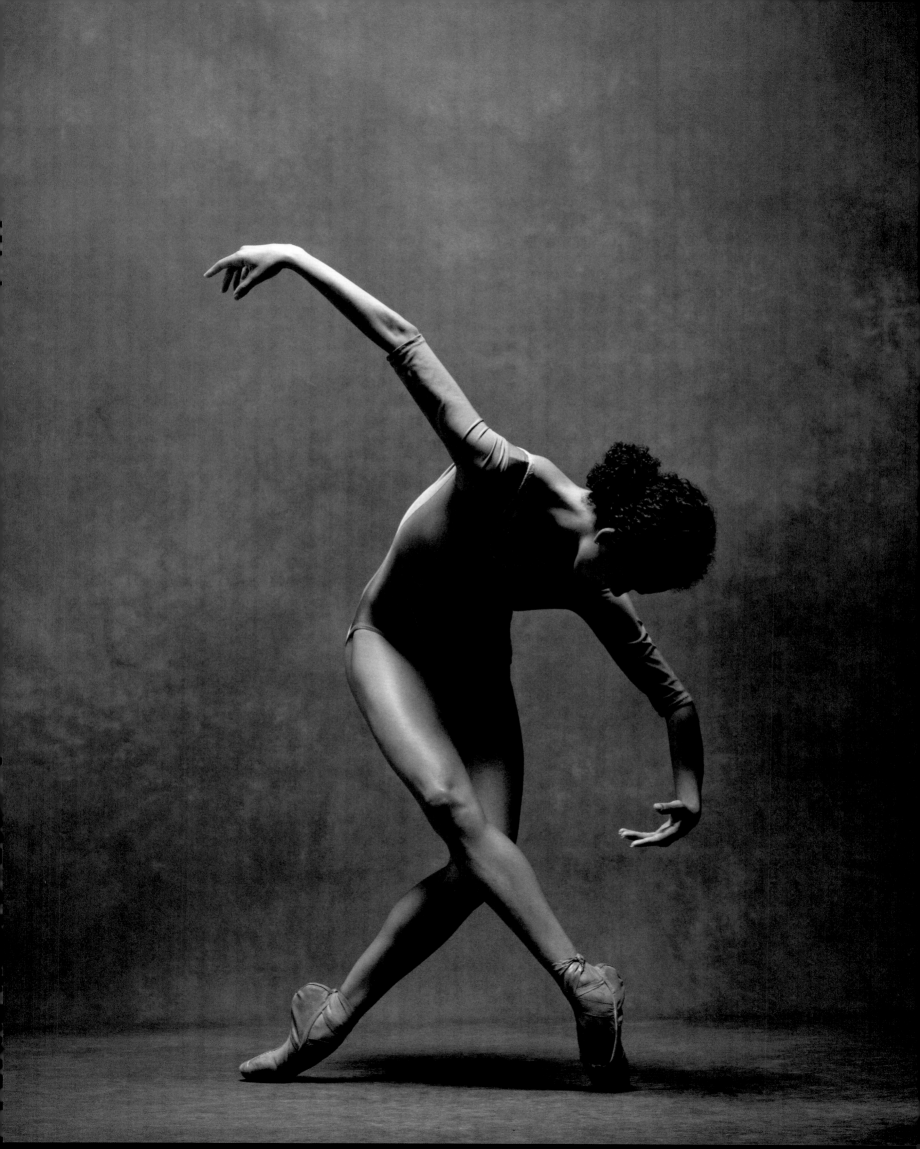

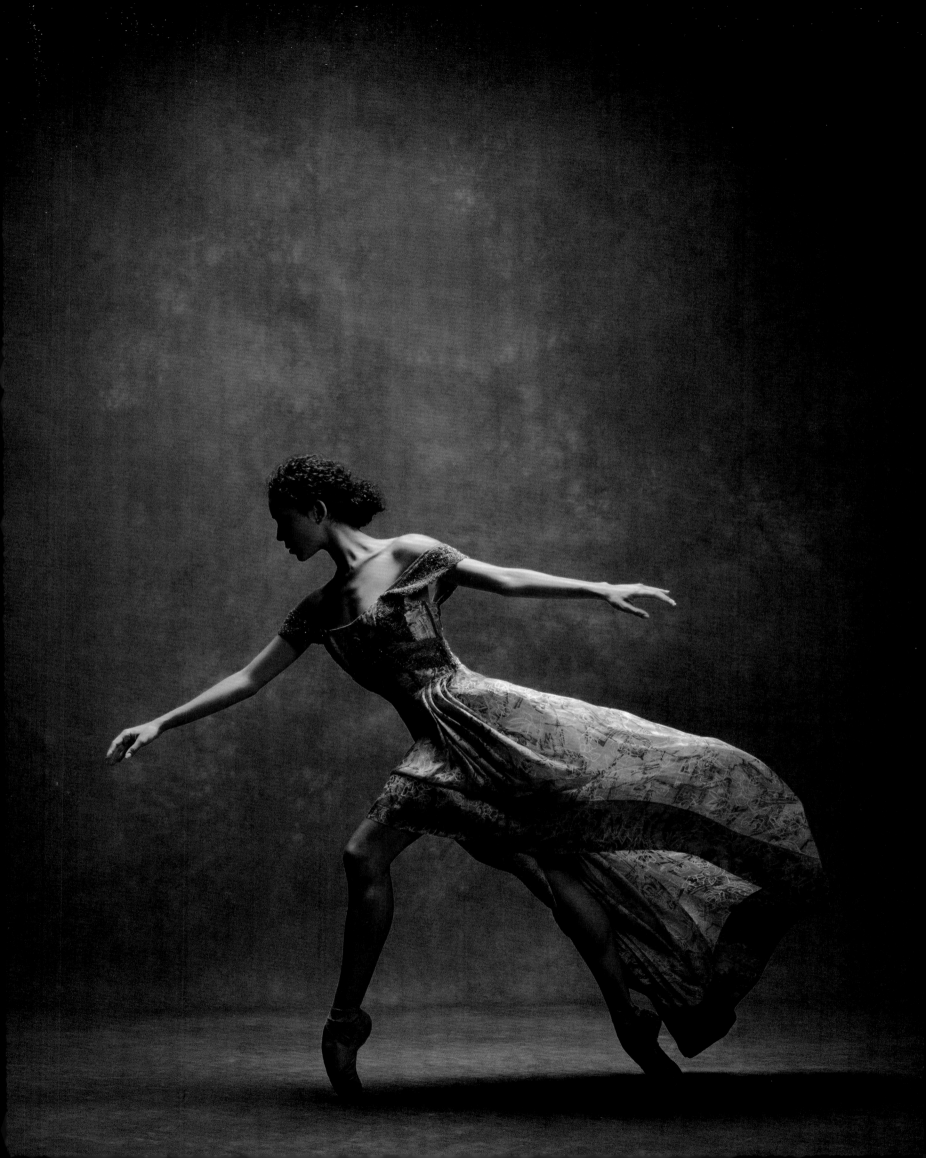

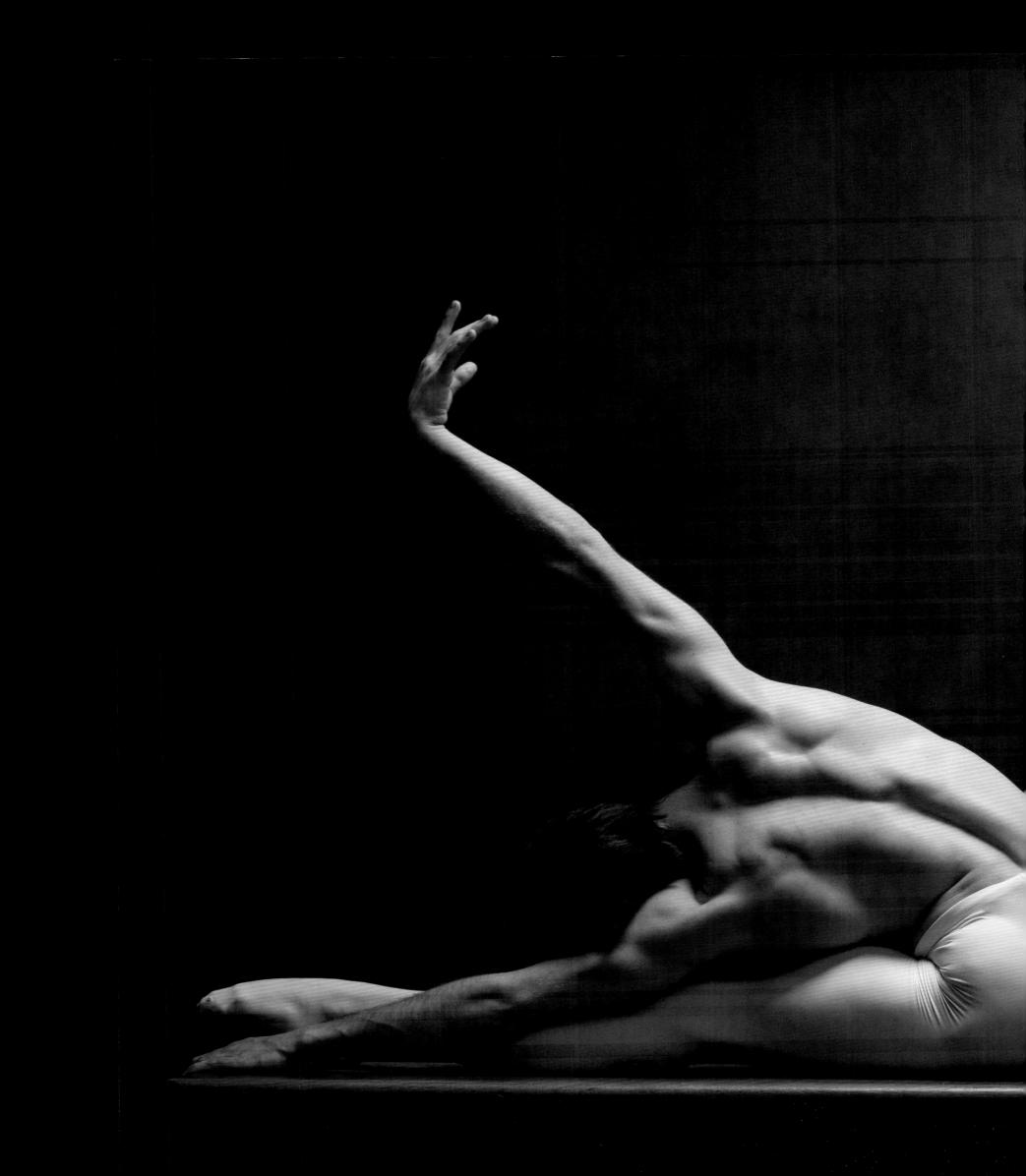

"I believe that art has no national boundaries.
It is important for us on tour to show that we,
the Russian people, have the same sorrows and joys,
that we are capable of the same strong emotions, and art
can reveal the beauty of what we have inside us and
are willing and want to share it with the world."

-Artem Ovcharenko

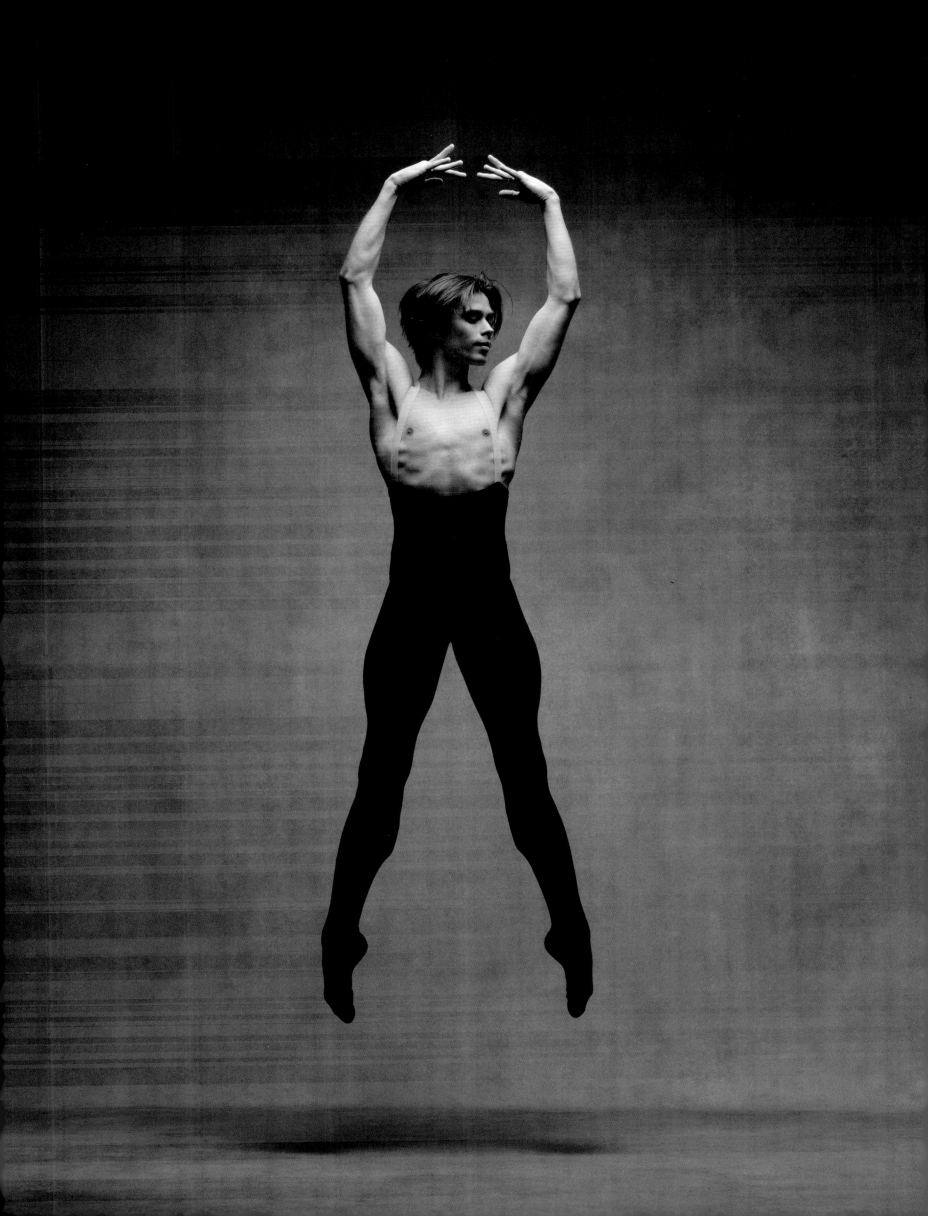

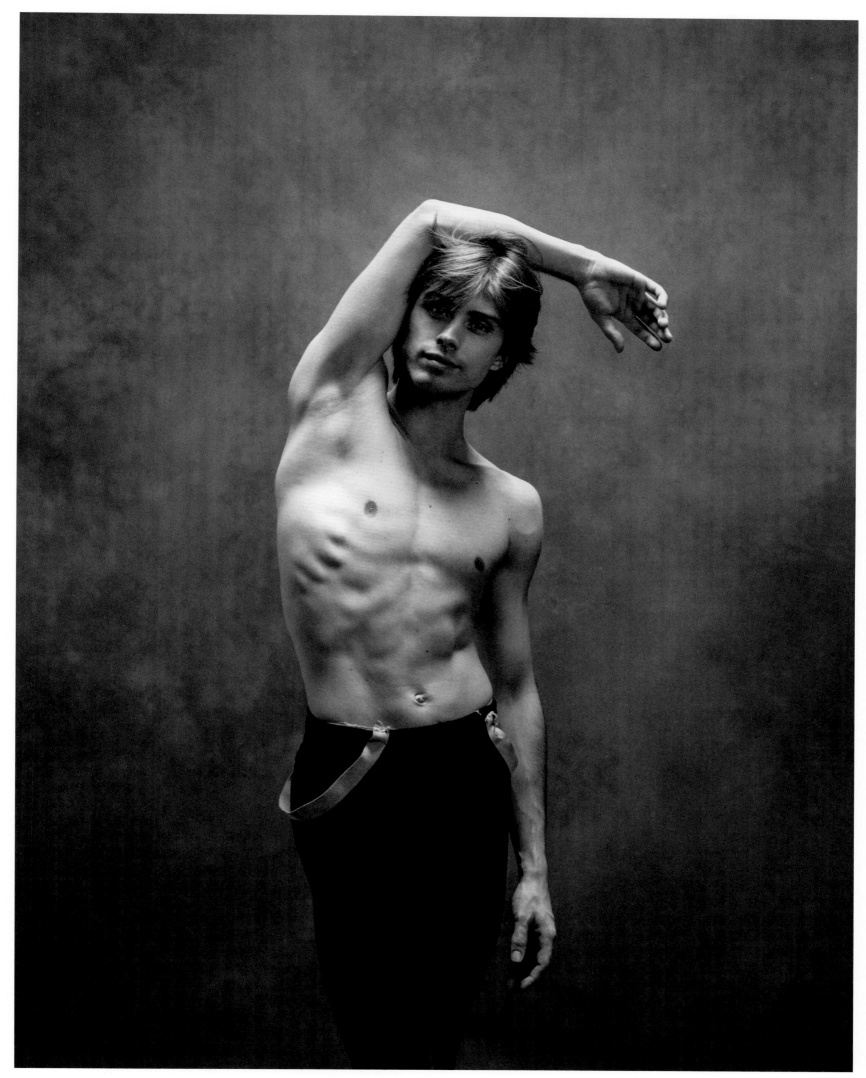

Artem Ovcharenko | Principal, Bolshoi Ballet

Hee Seo | Principal, American Ballet Theatre

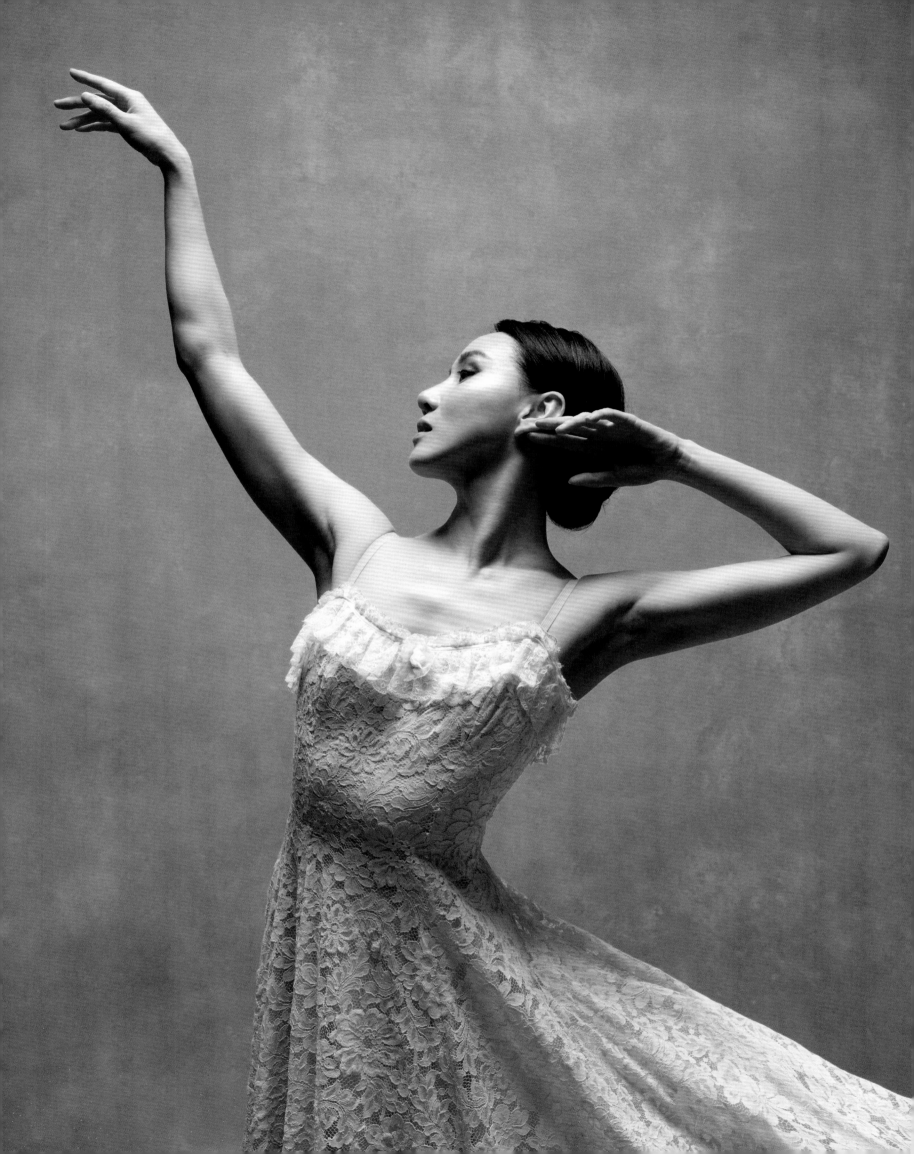

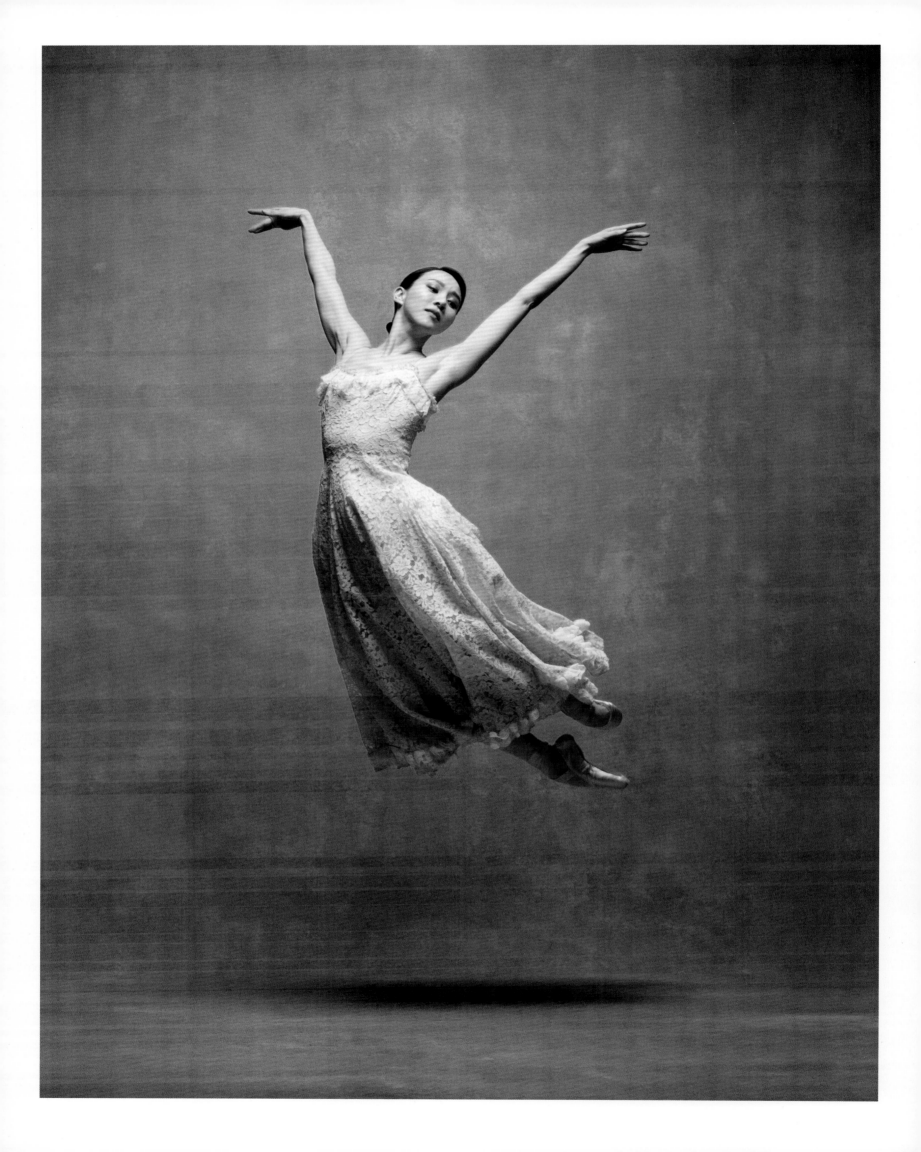

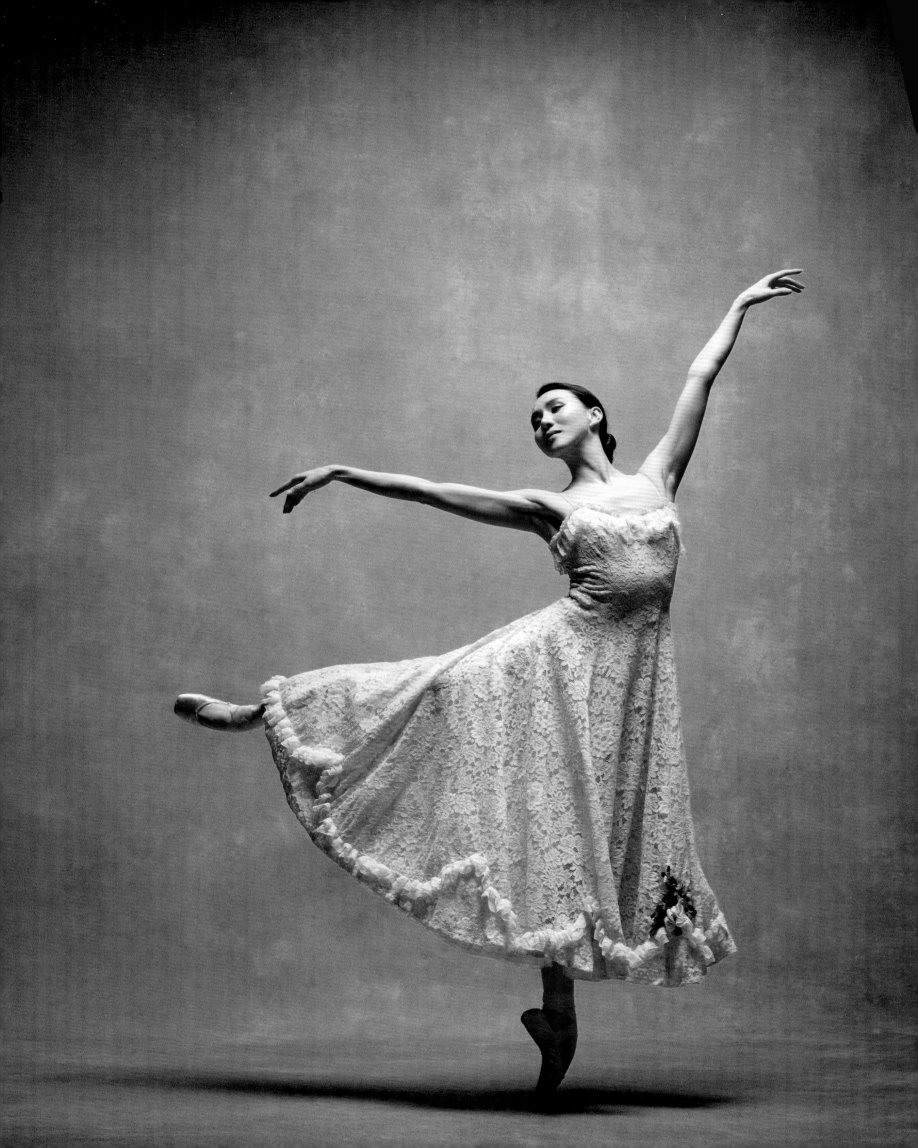

"I wish I had known how to accept myself when I first started dancing professionally. I let my limitations define me, which is something I have worked very hard to shed. They linger on the outskirts, instead of dominating the center."

–James Whiteside

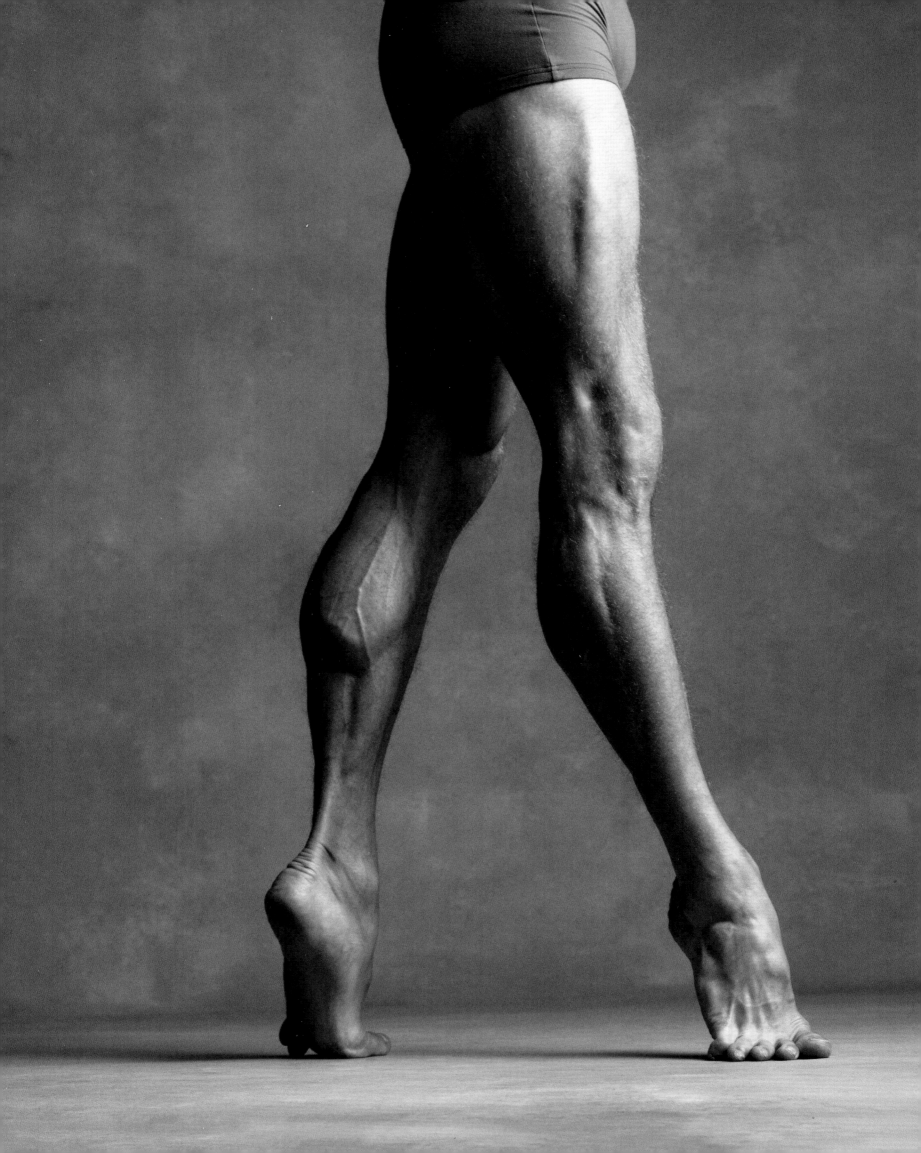

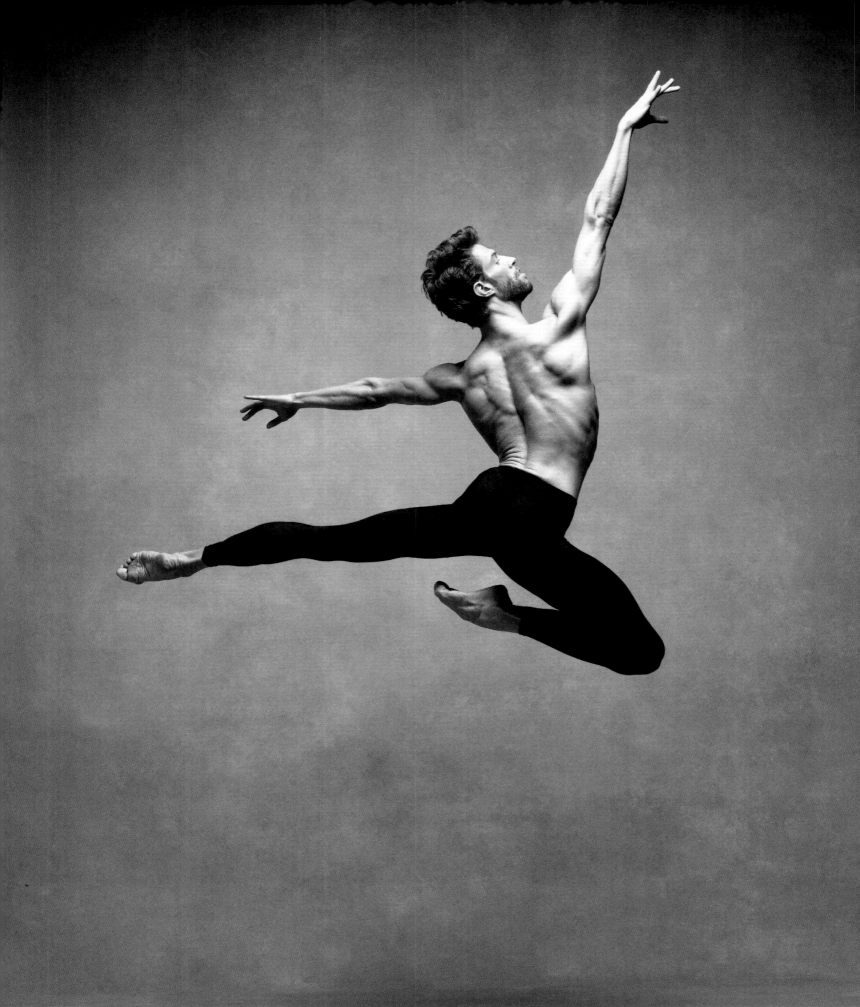

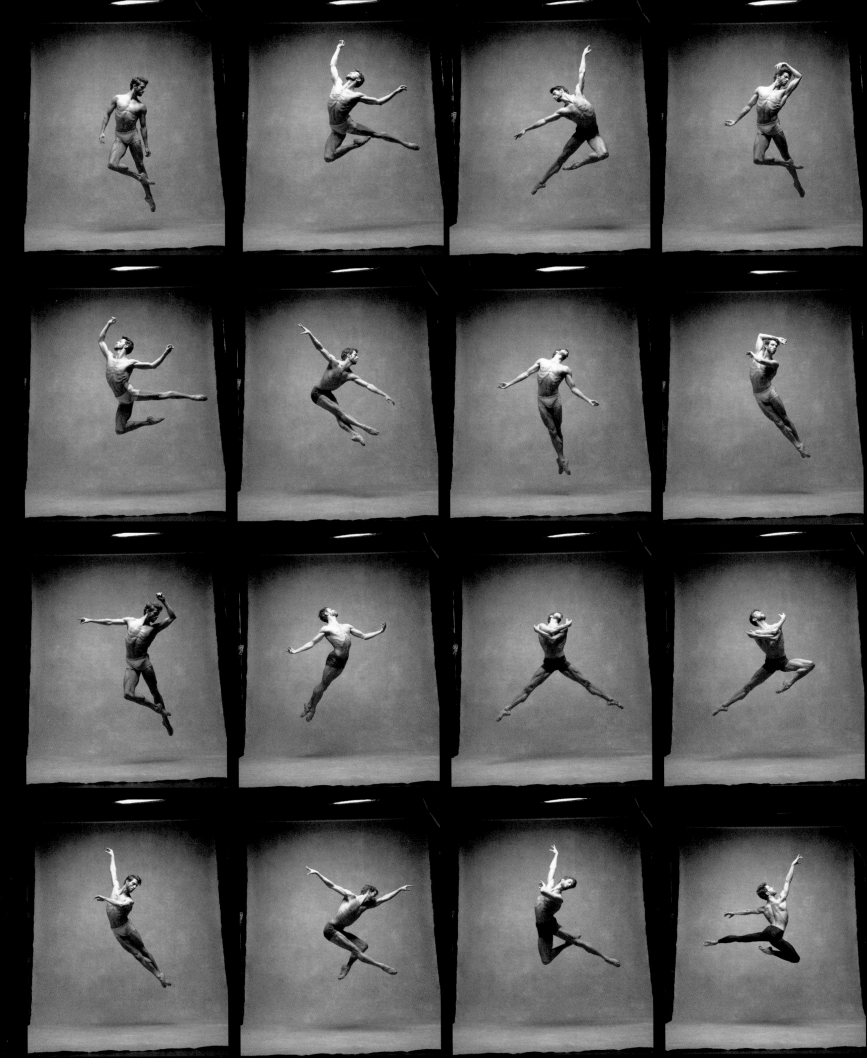

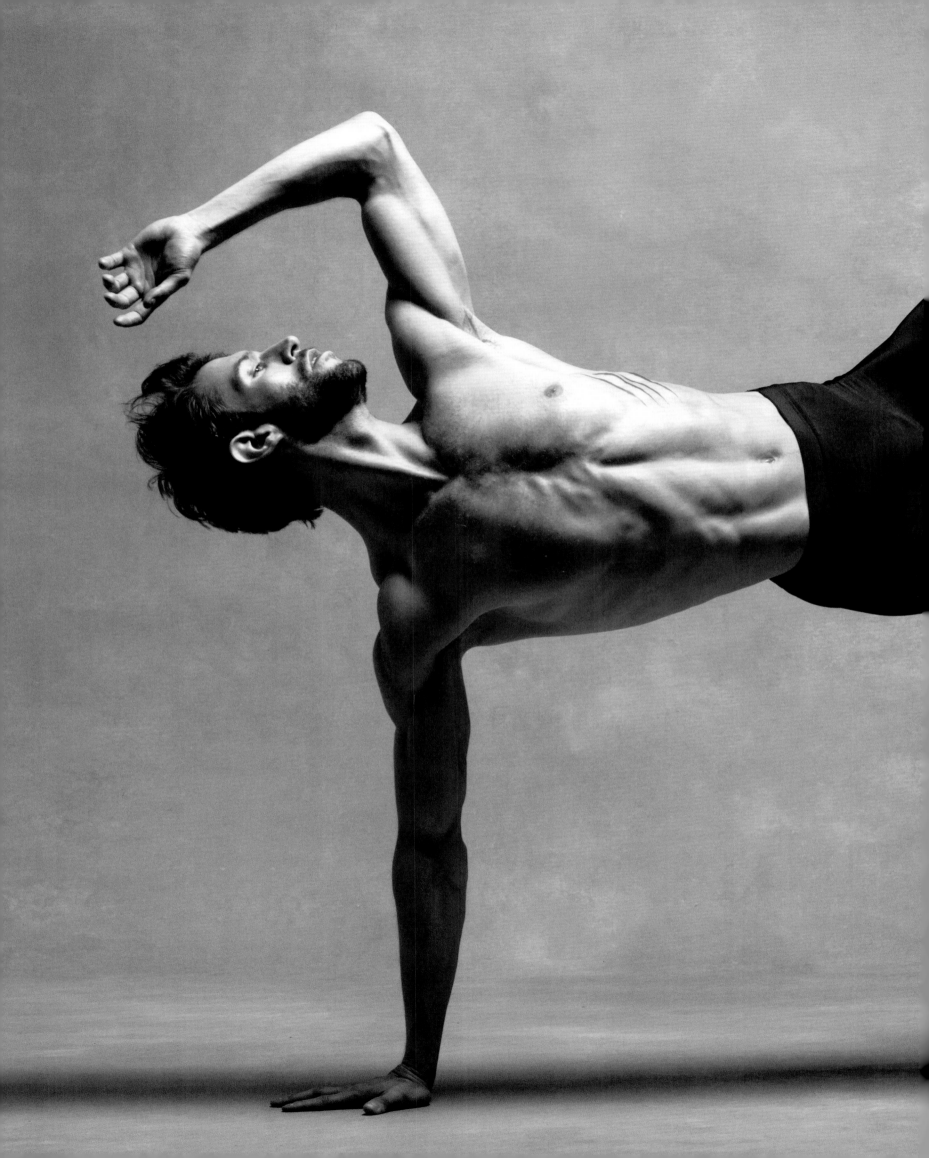

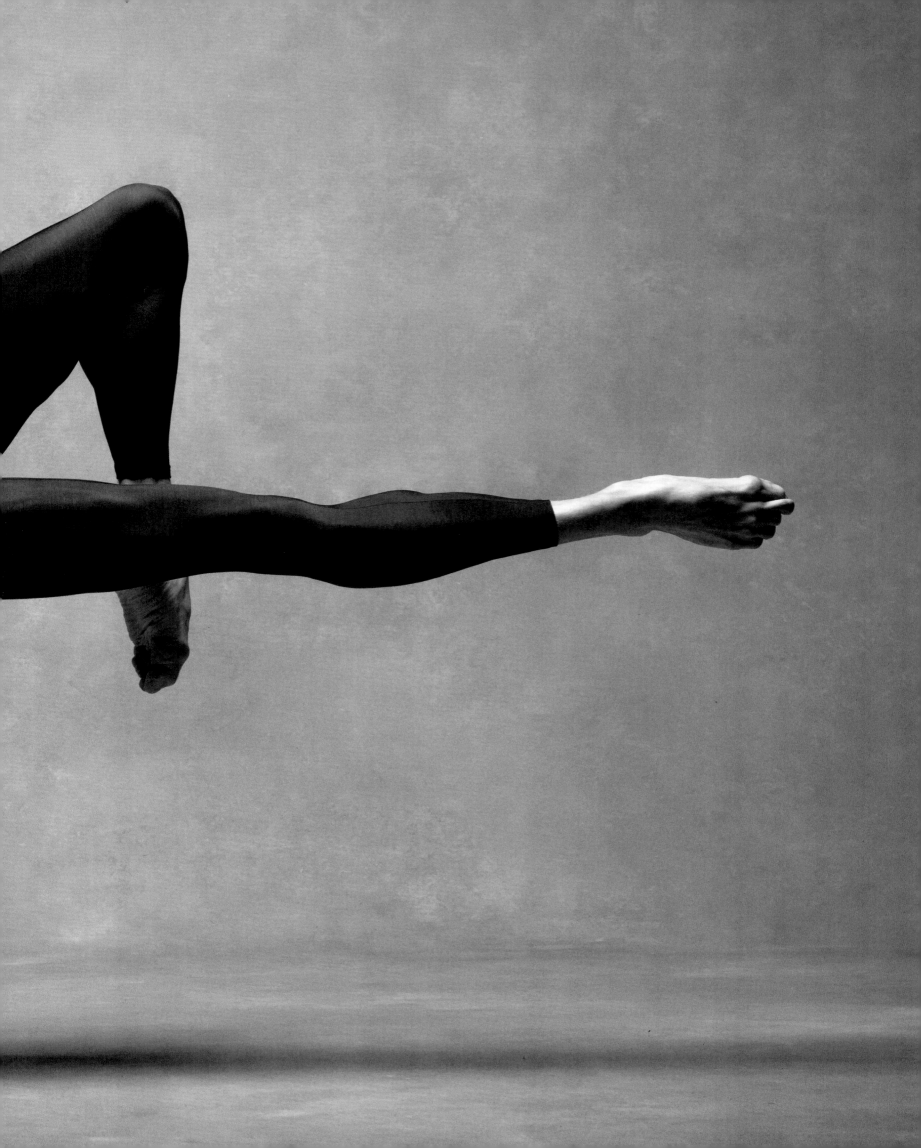

"I wish more people knew what it felt like to actually dance.
I'm not referring to the difficulty of learning a technique
or a combination. I mean the part that comes after
everything clicks. When your most-focused mind,
your most-moldable body, and your truest spirit all
intertwine at their highest level.
That point will look different for everyone, of course,
but I wish everyone could attempt to reach it at least once.
It can literally feel like flying."

–Fana Tesfagioris

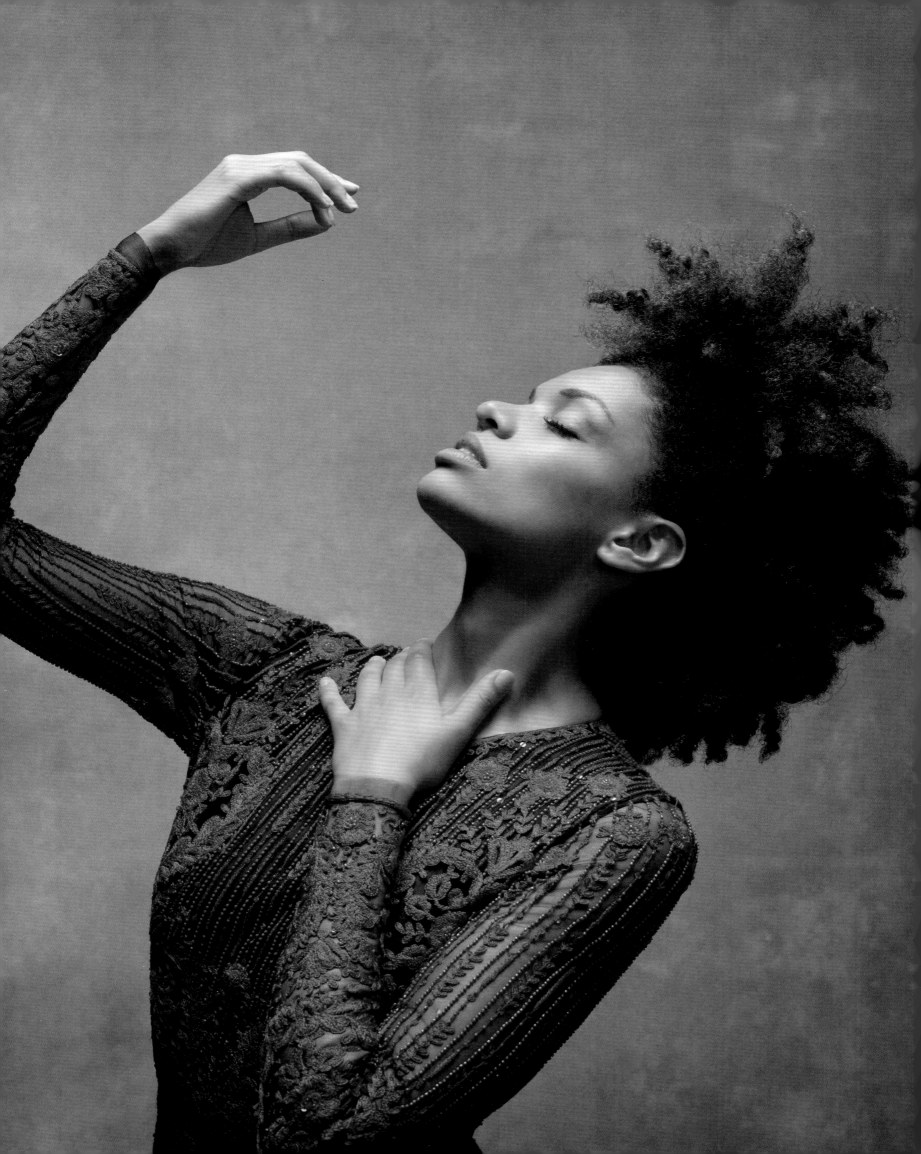

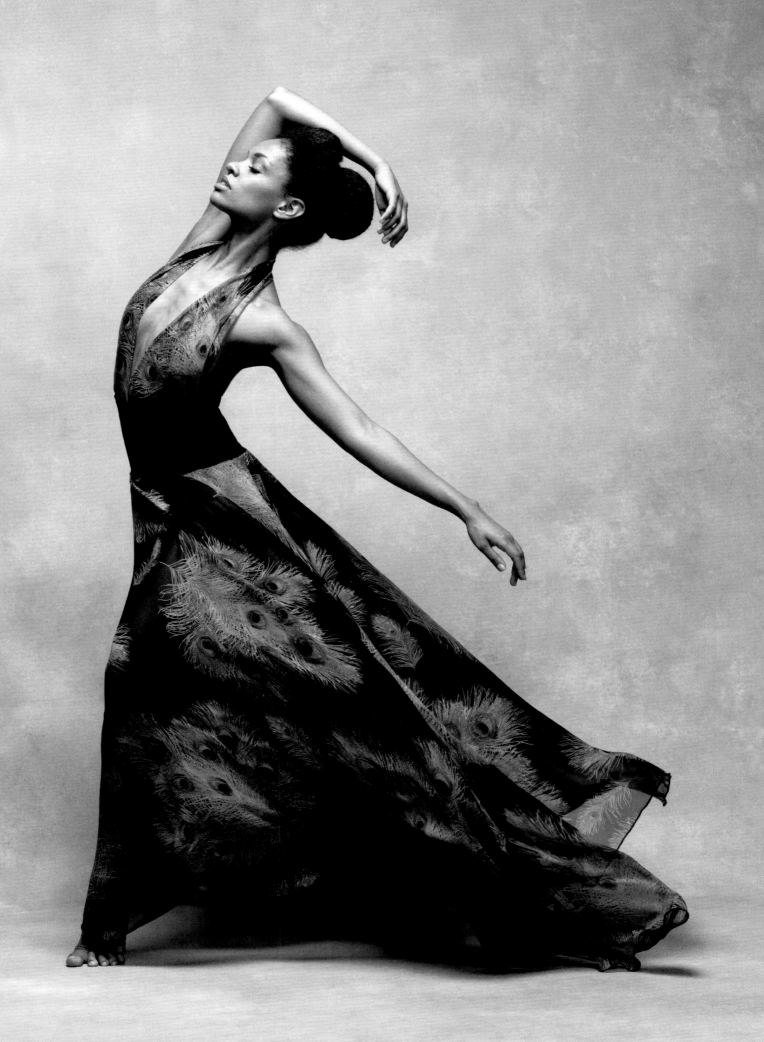

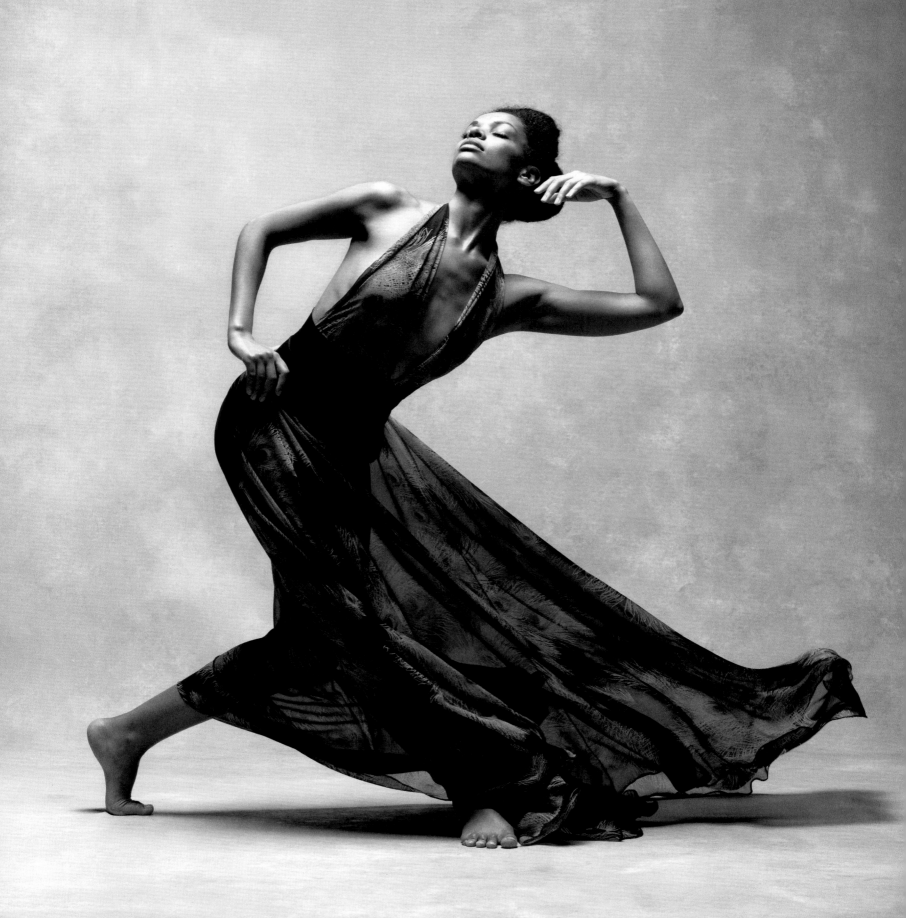

"When I was a child and got made fun of for taking ballet, I'd often say I was in a ballet class with 50 pretty girls in leotards. Versus hairy ugly guys at soccer . . . The argument was quickly over!"

-Joaquin De Luz

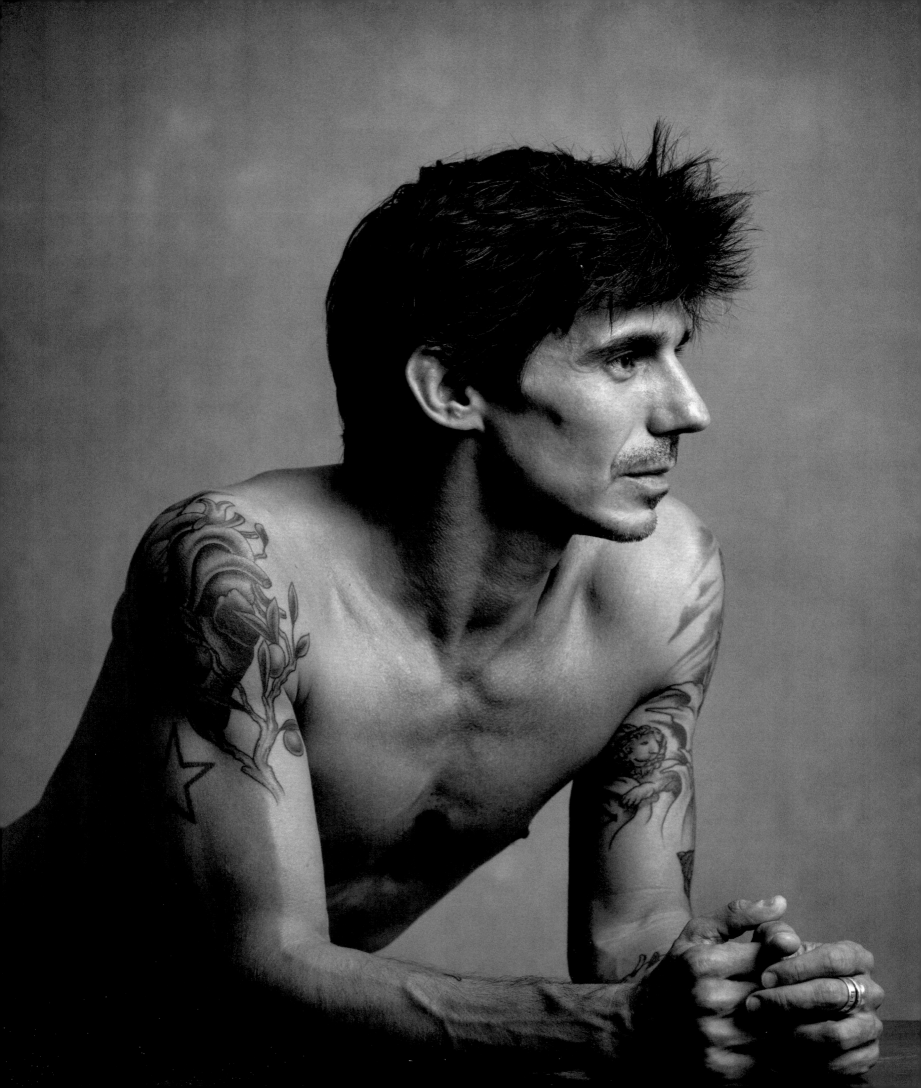

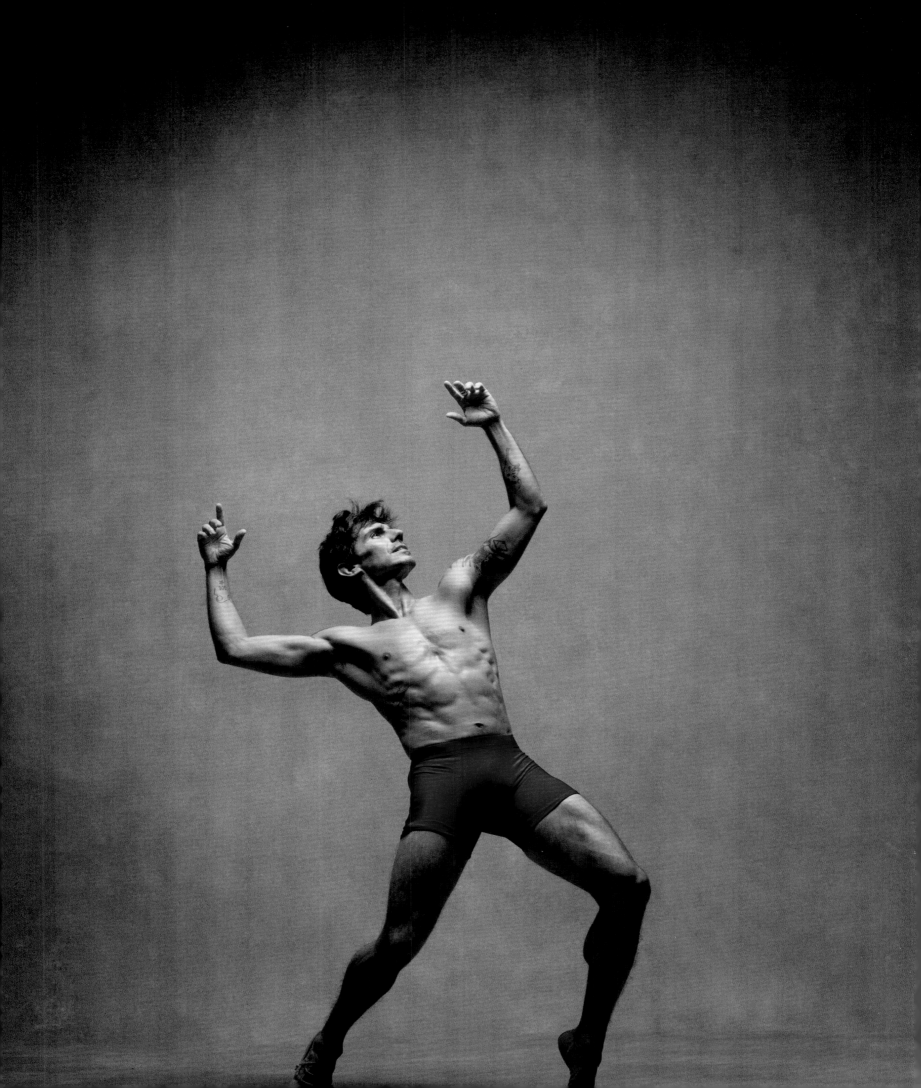

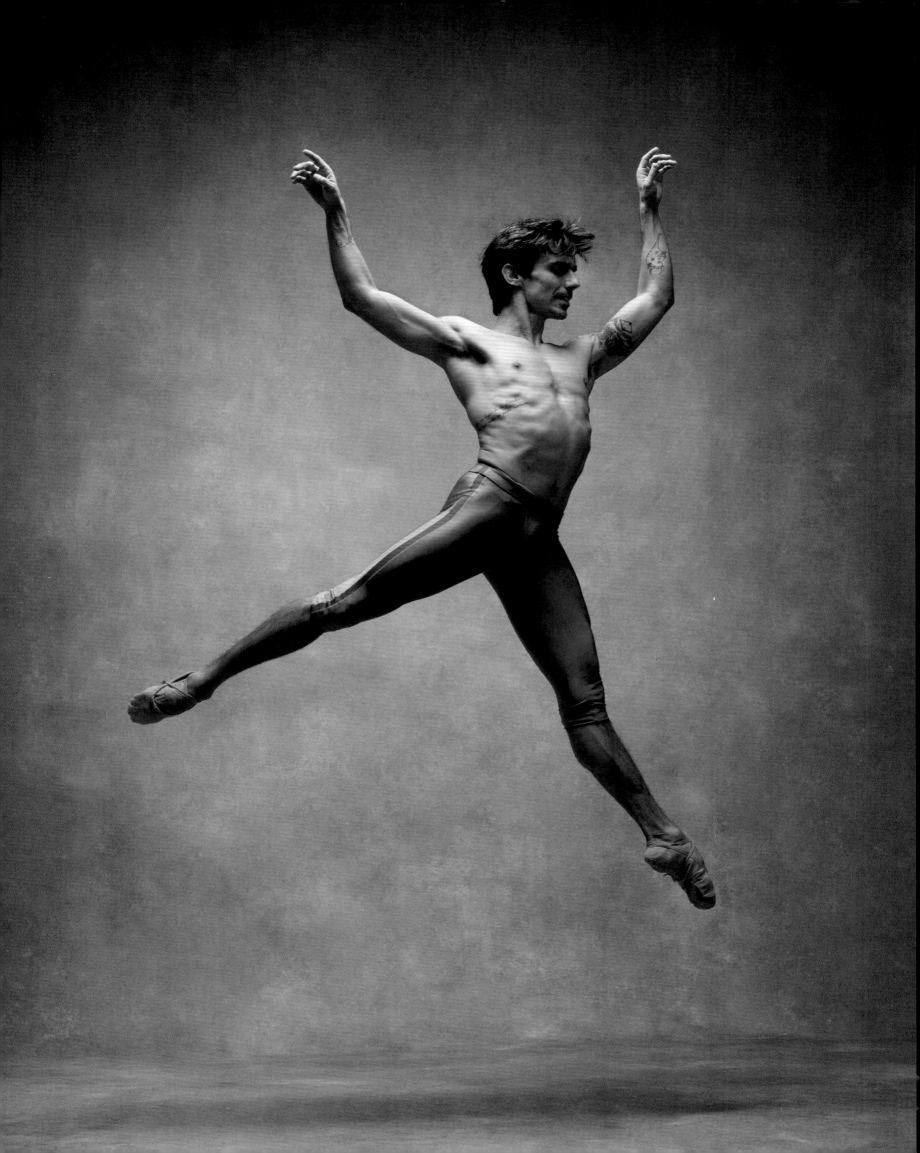

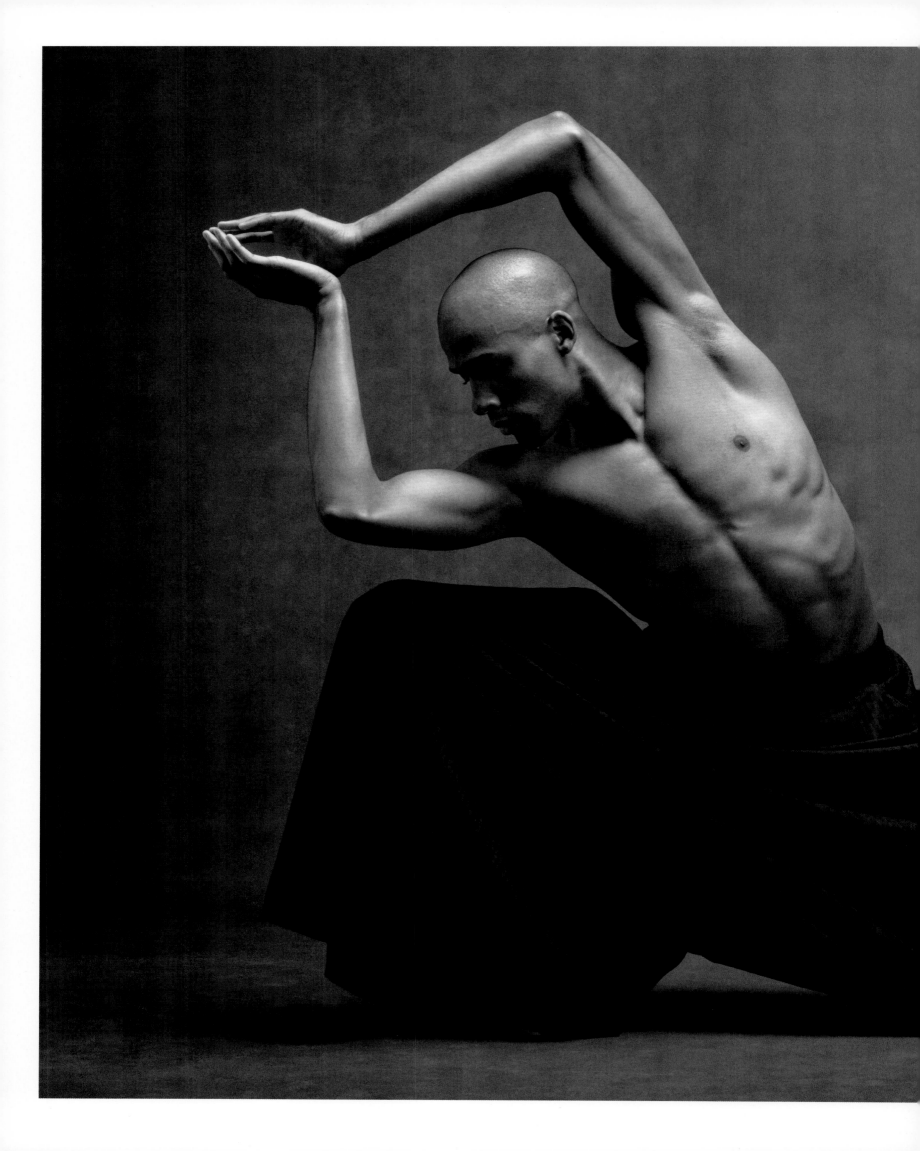

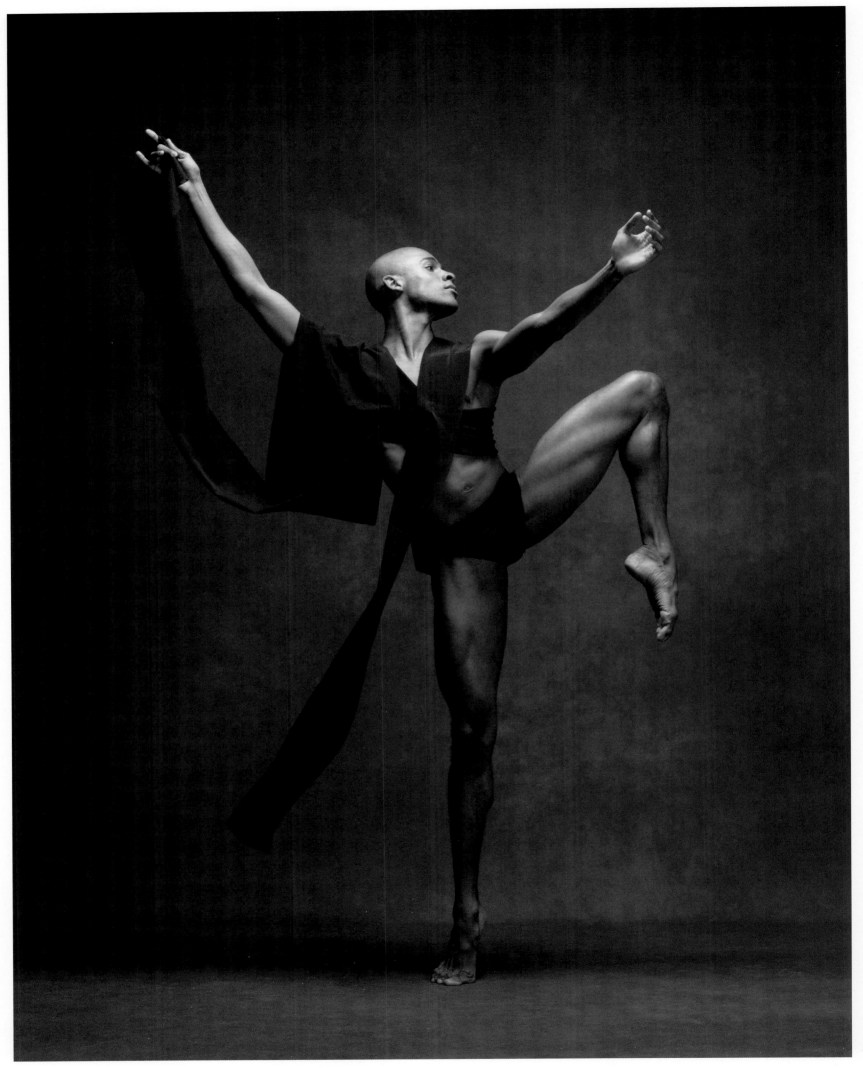

Yannick Lebrun and Jacqueline Green | Alvin Ailey American Dance Theater

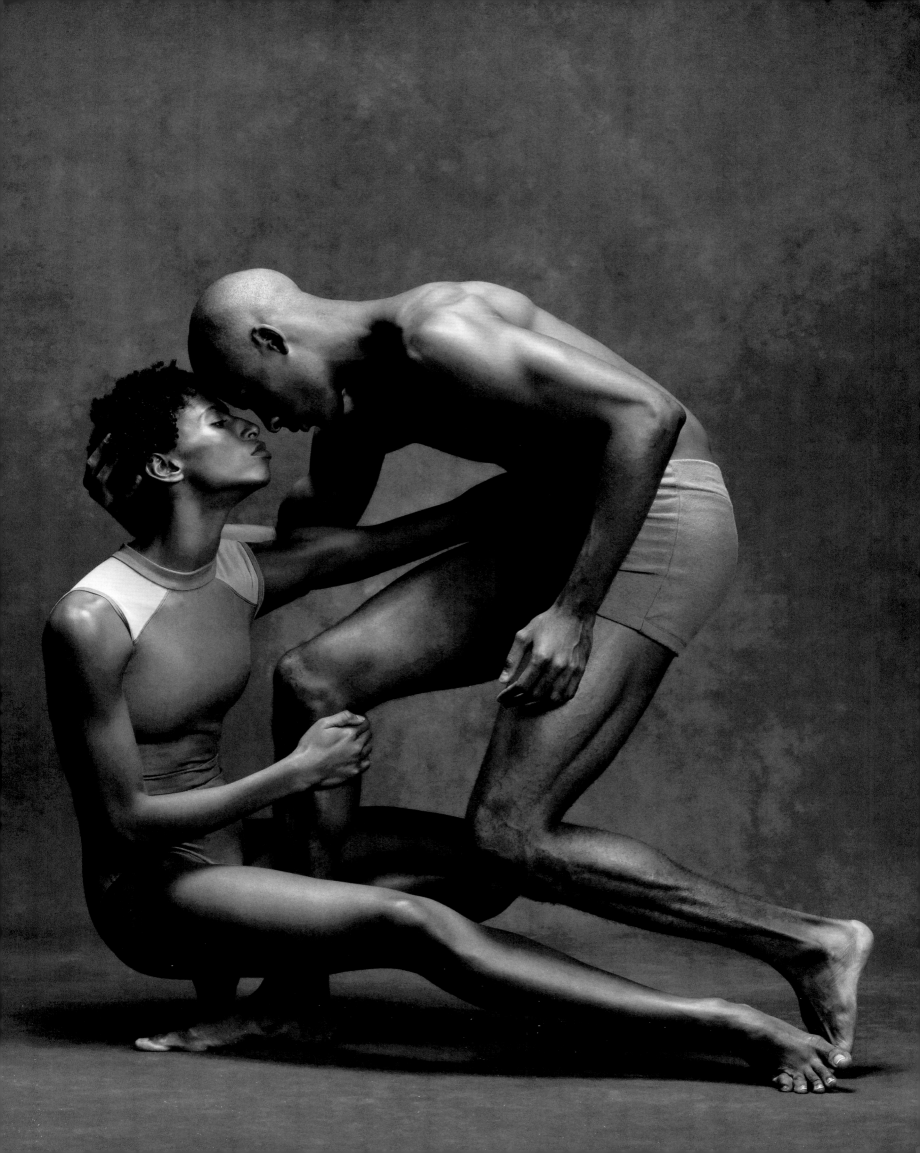

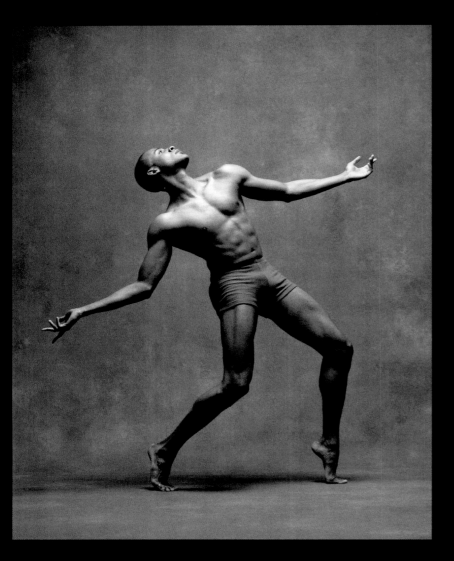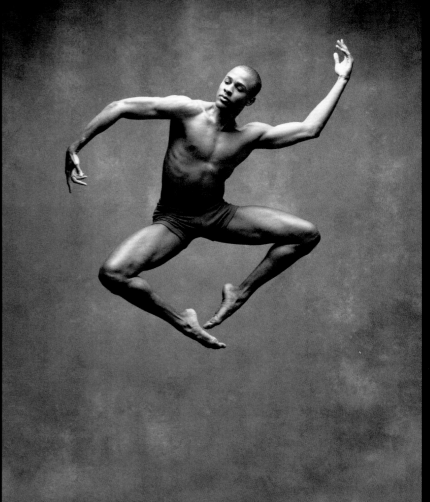

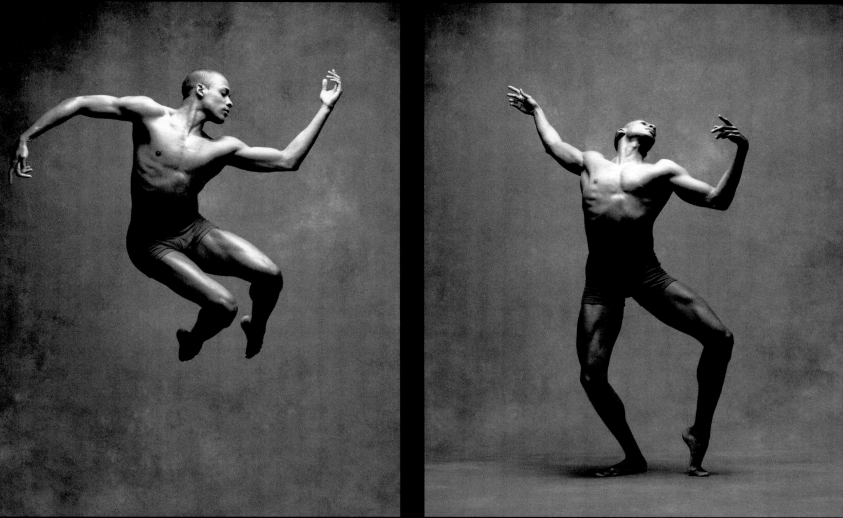

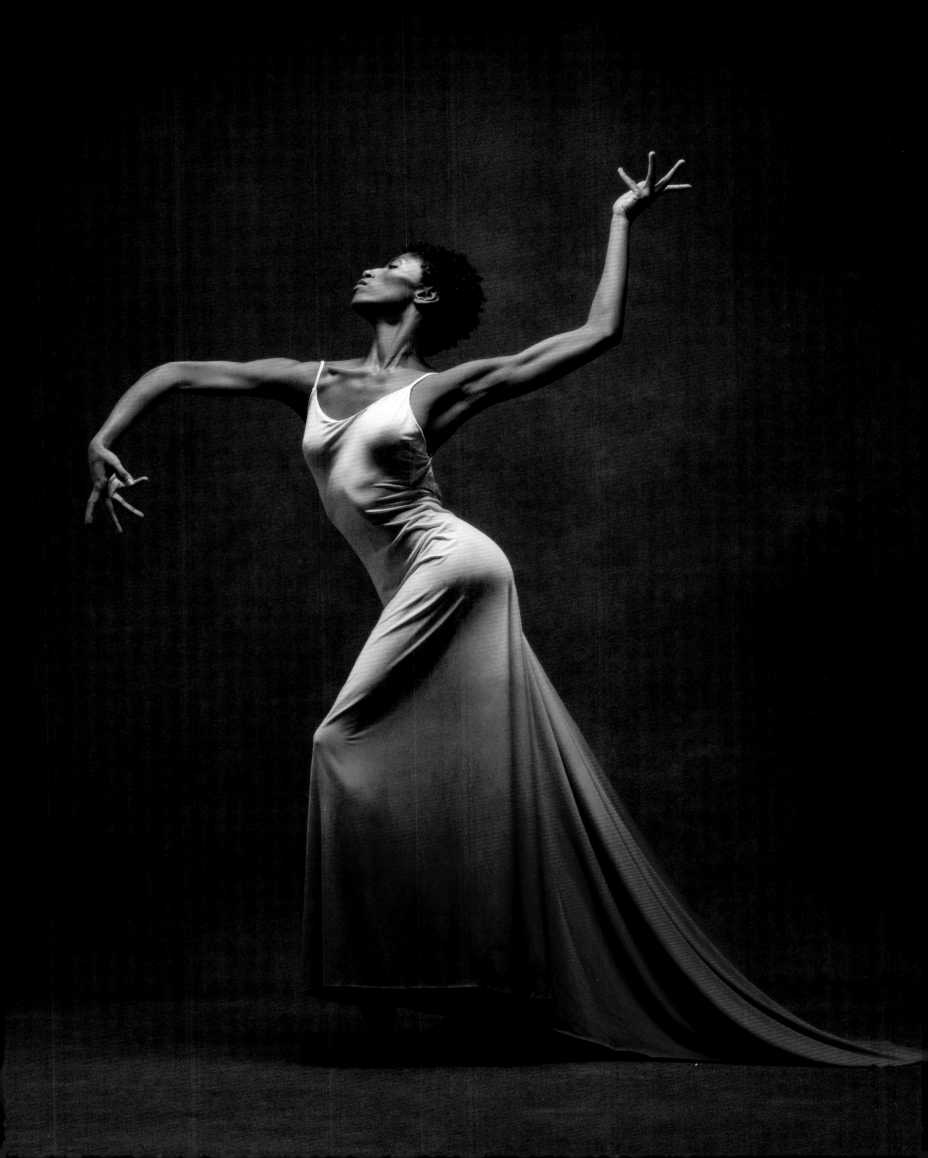

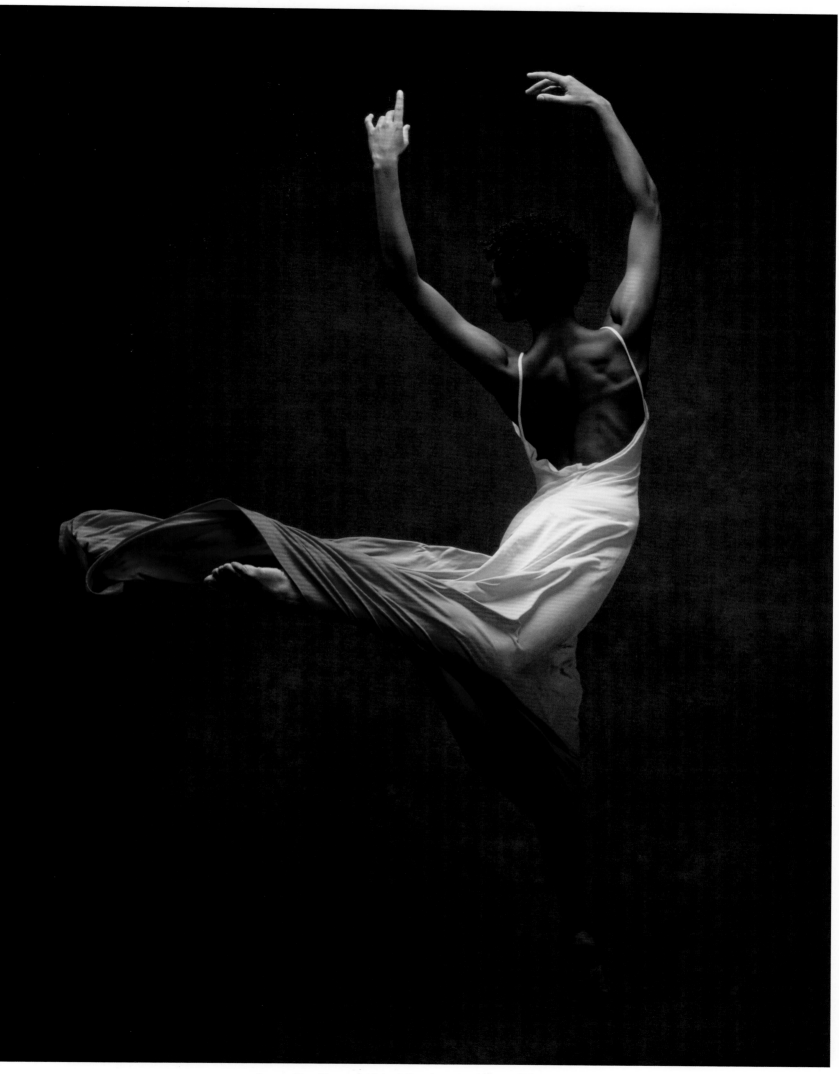

Jacqueline Green | Alvin Ailey American Dance Theater

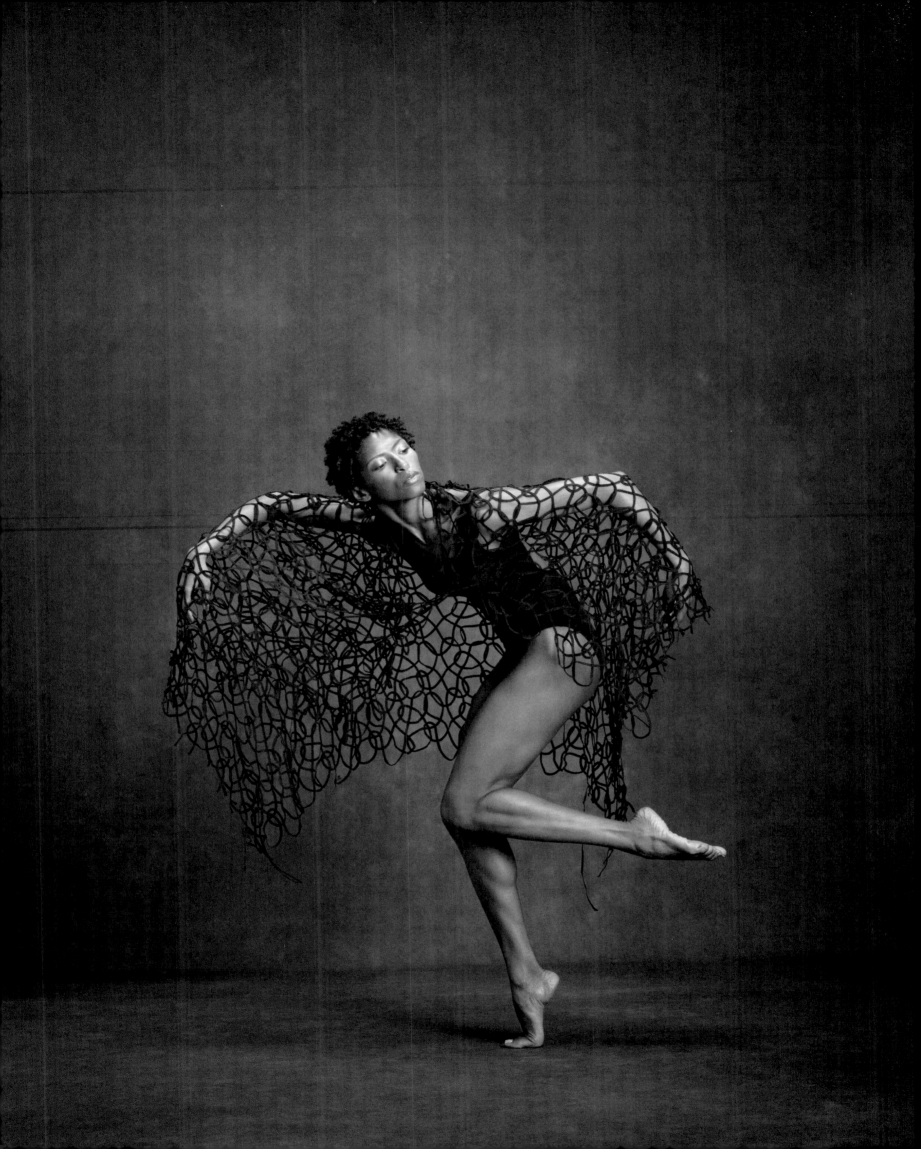

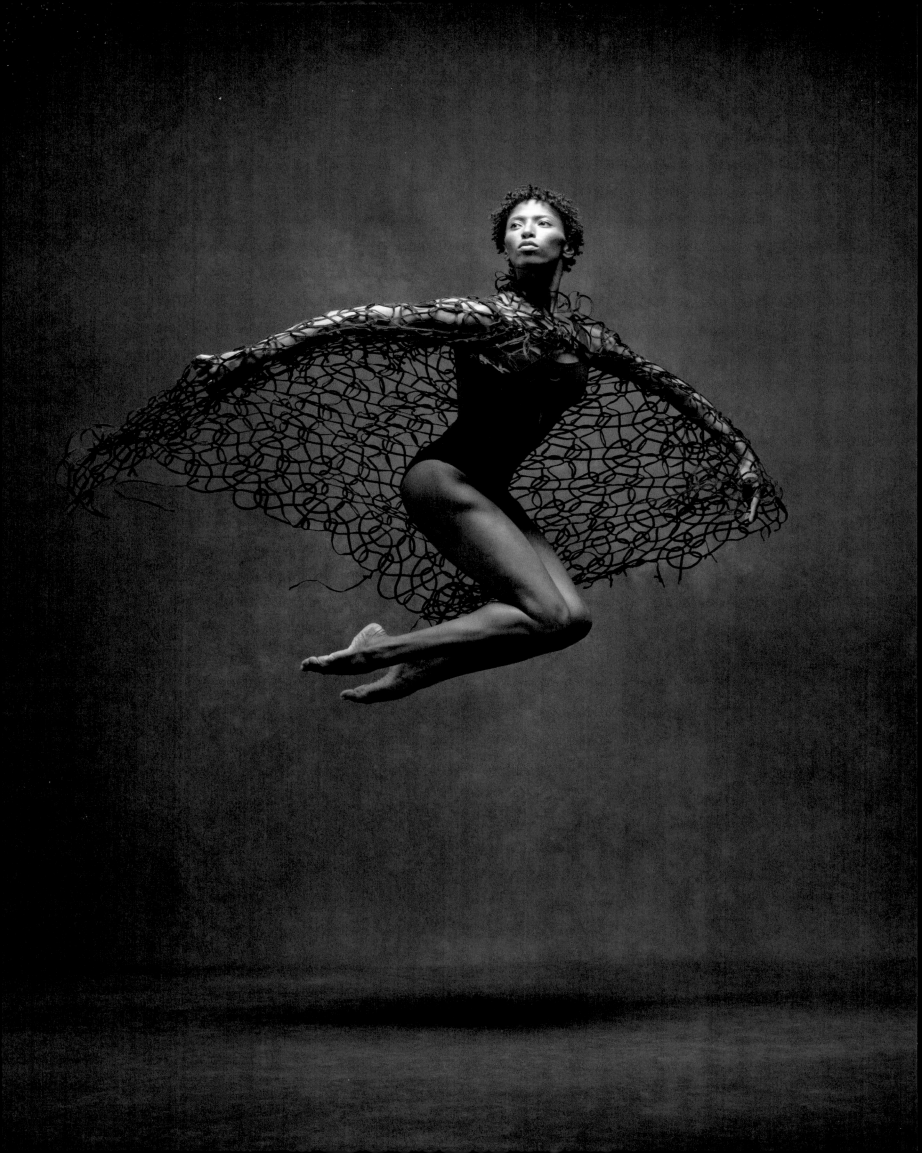

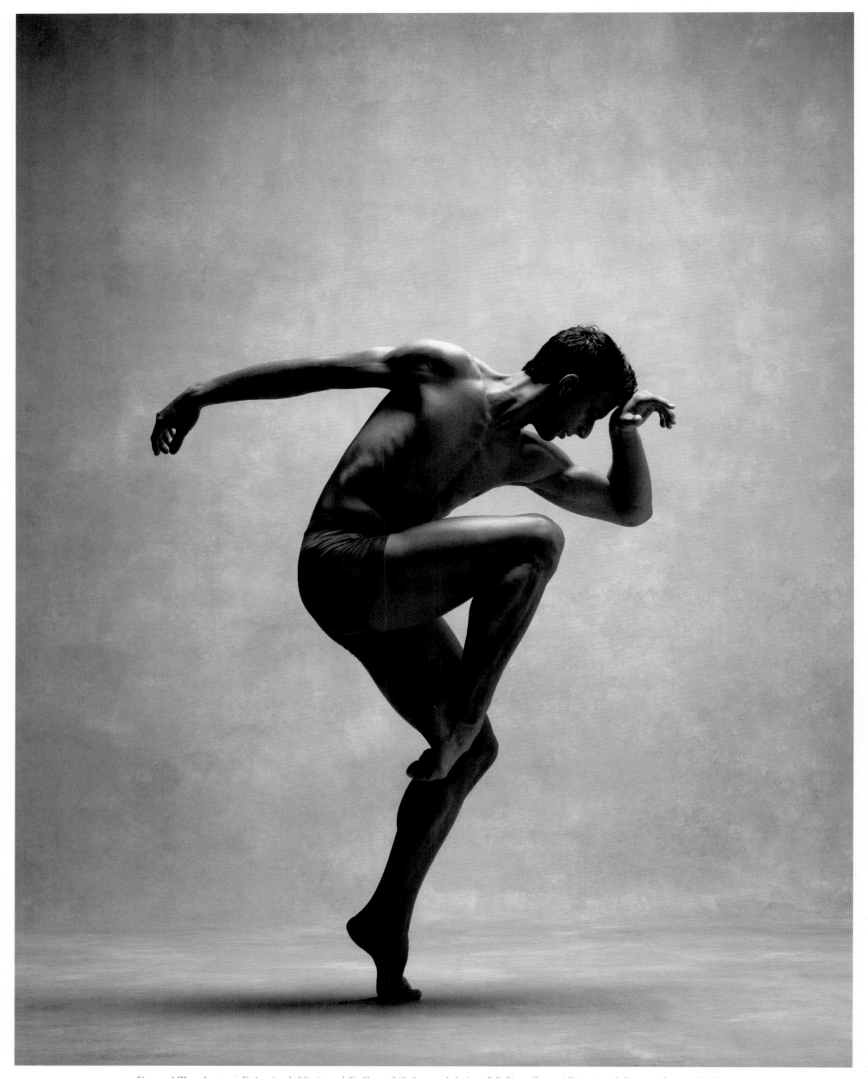

Dayesi Torriente | Principal, National Ballet of Cuba and **Arian Molina Soca** | Principal, Pennsylvania Ballet

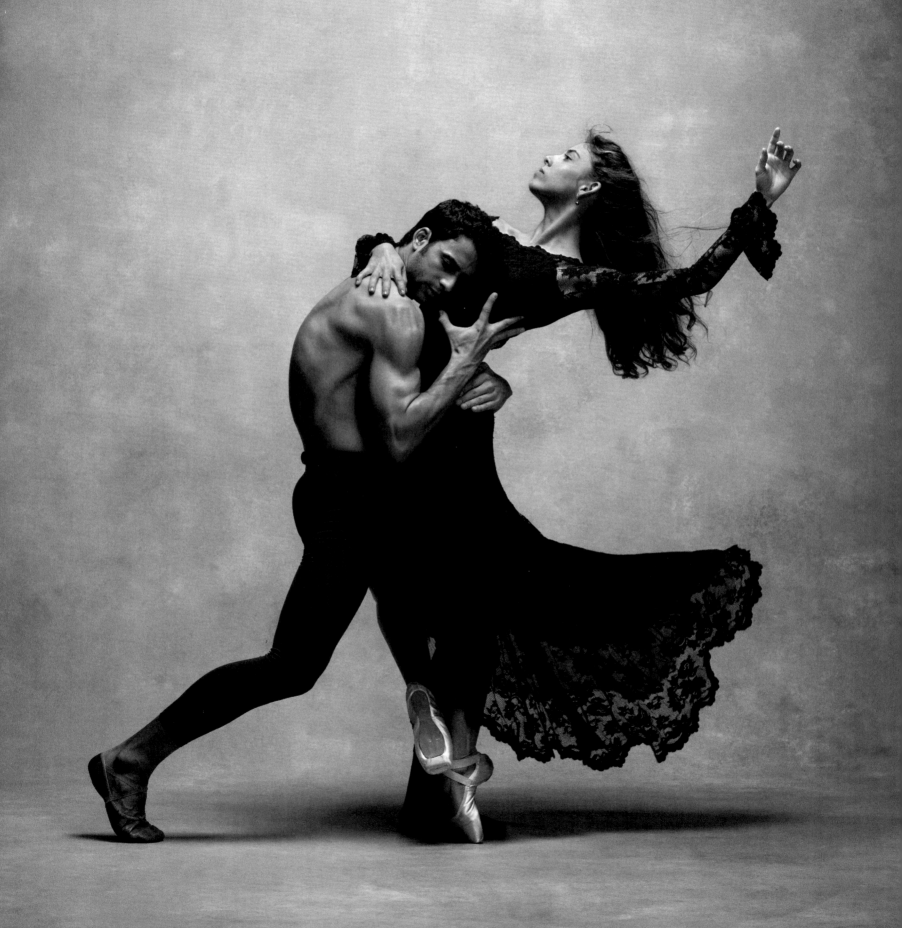

"I started my own company because I wanted to see how I could experience this art, my art form, in different ways, on my own terms."

–Michele Wiles

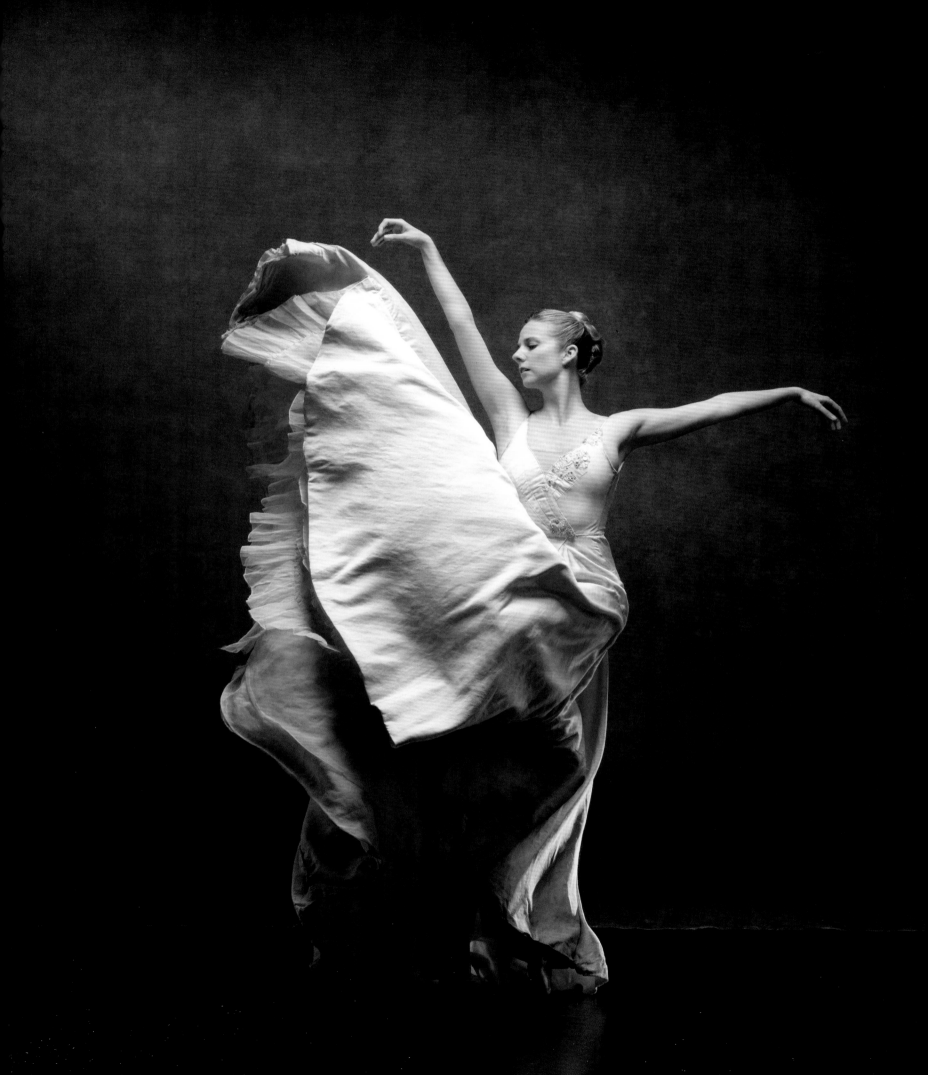

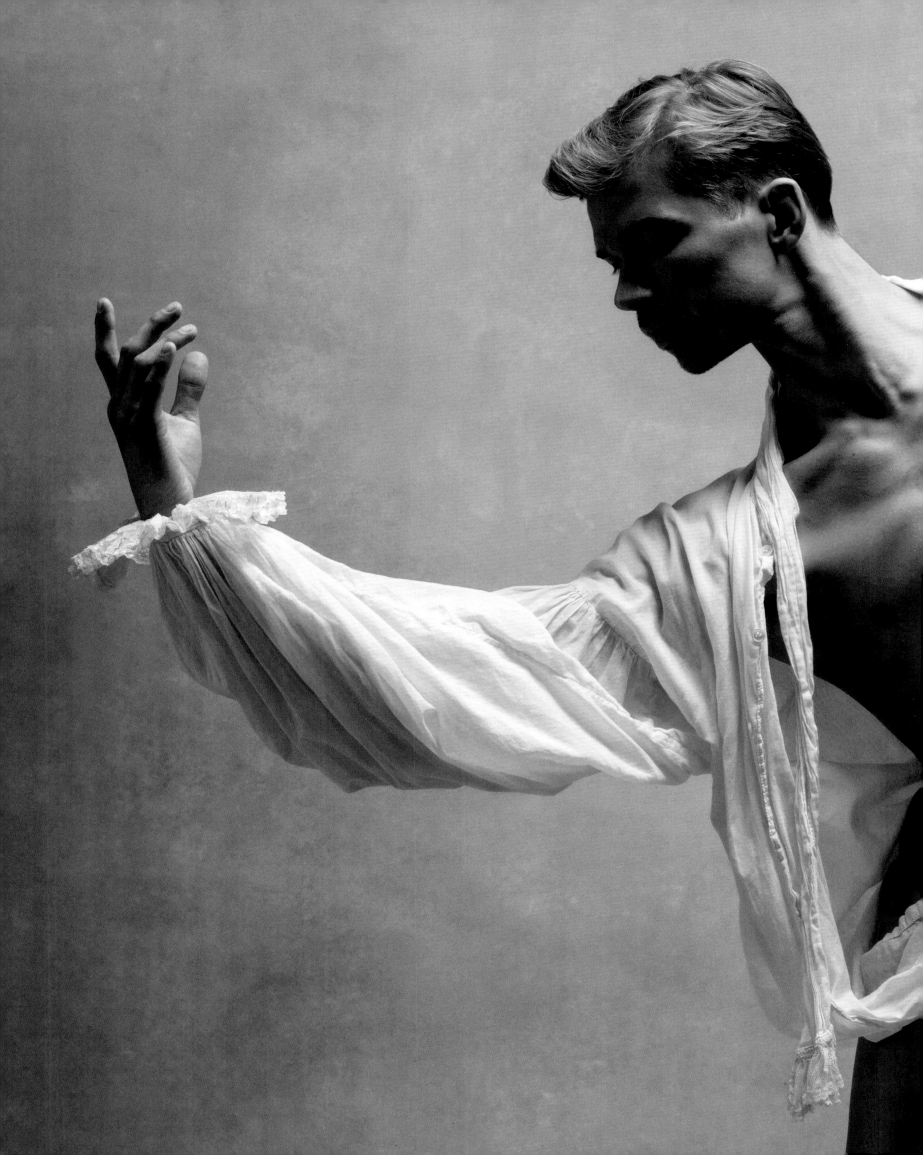

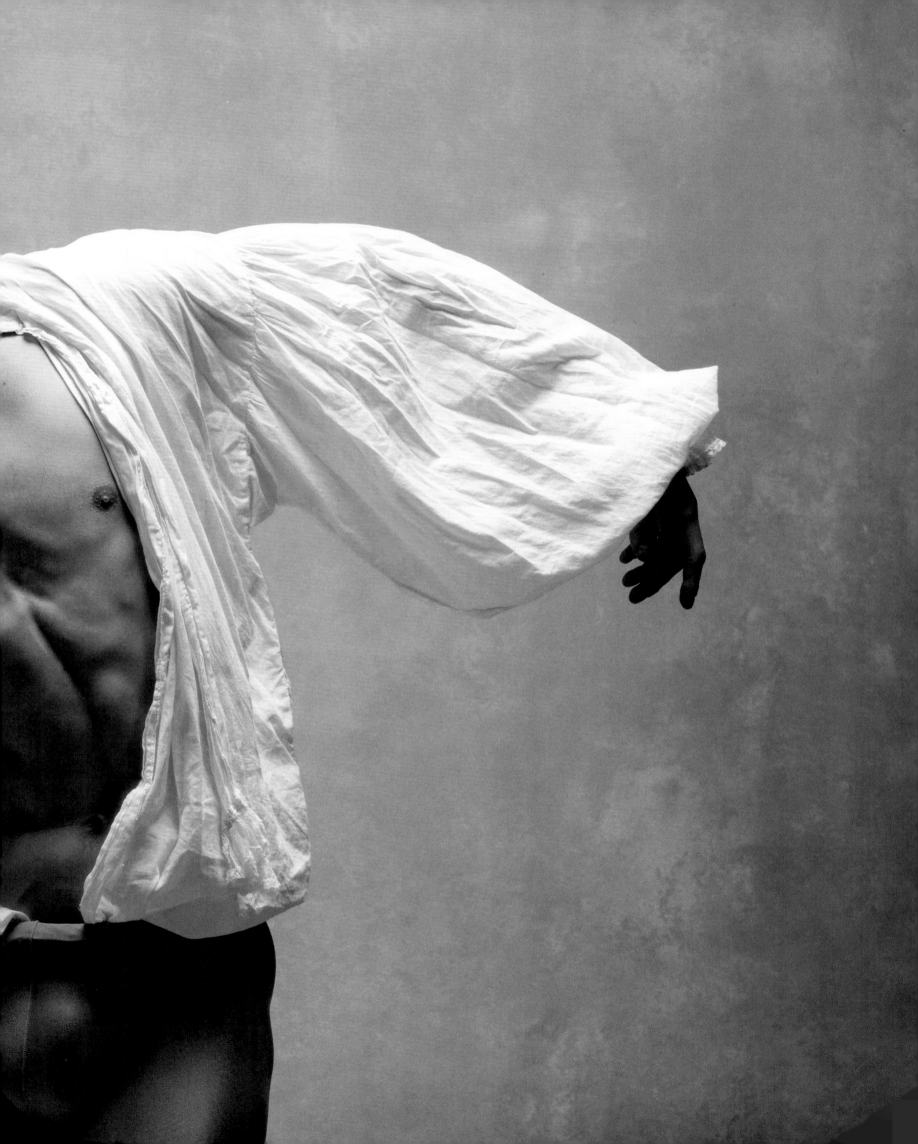

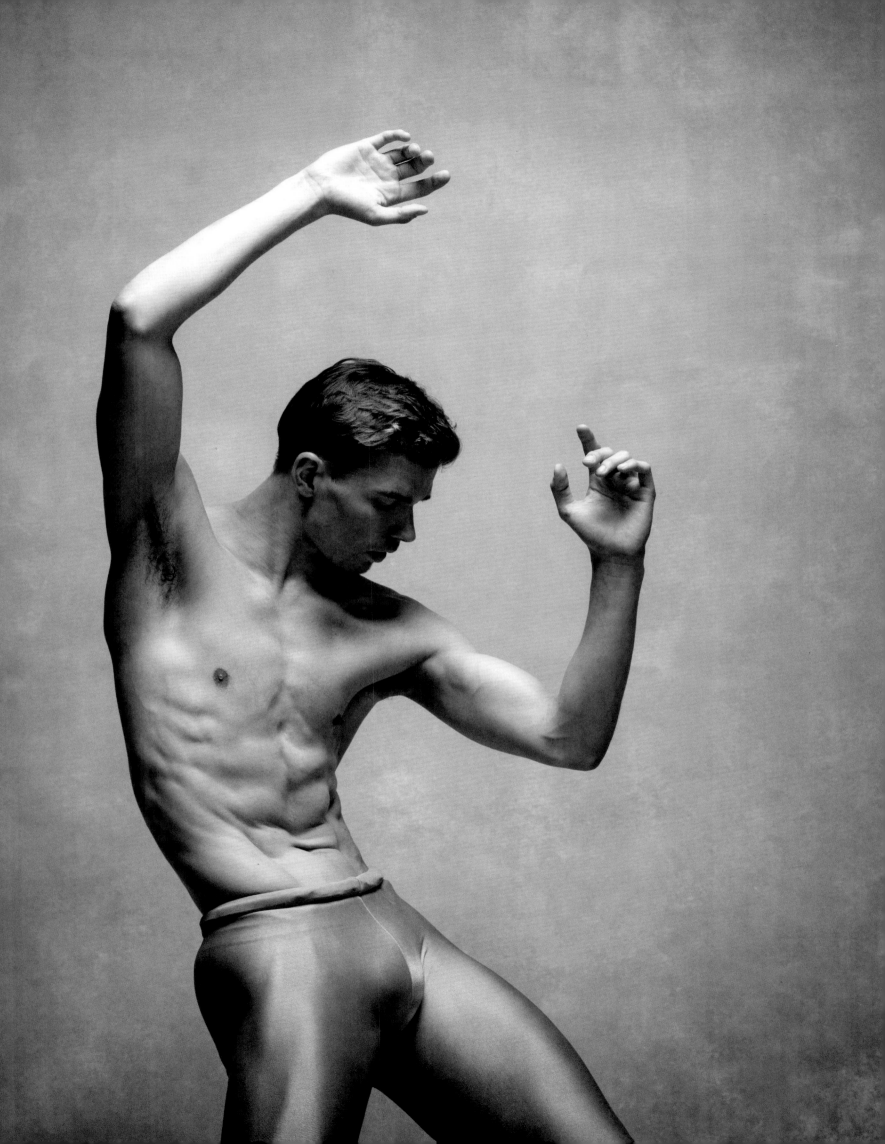

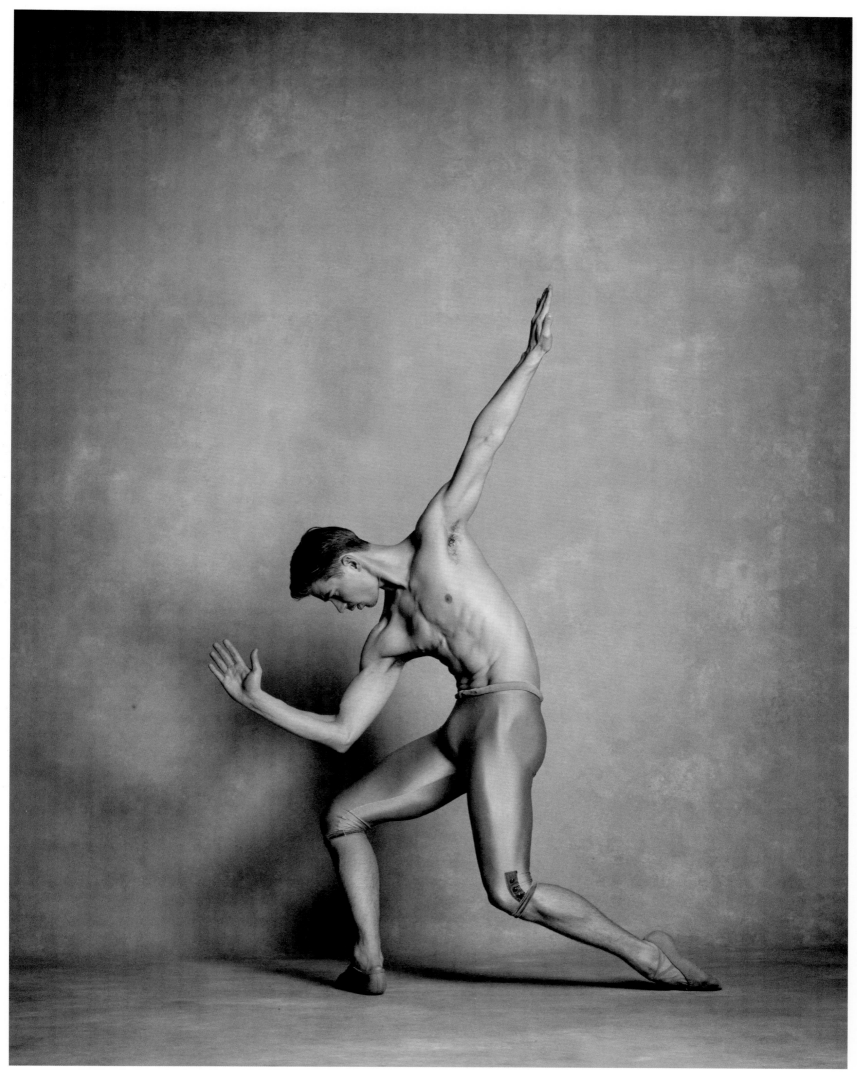

Gregory Dean | Principal, Royal Danish Ballet

"My biggest fear is getting injured and not being able to dance the same way, even though I've had major injuries before. I'm the only dancer in the world who's missing an ACL, which is basically impossible. I remember going to the doctor, and I could hear these residents watching videos of me on YouTube, and they asked, 'How do you do this?' I'm a medical anomaly."

–Ashley Bouder

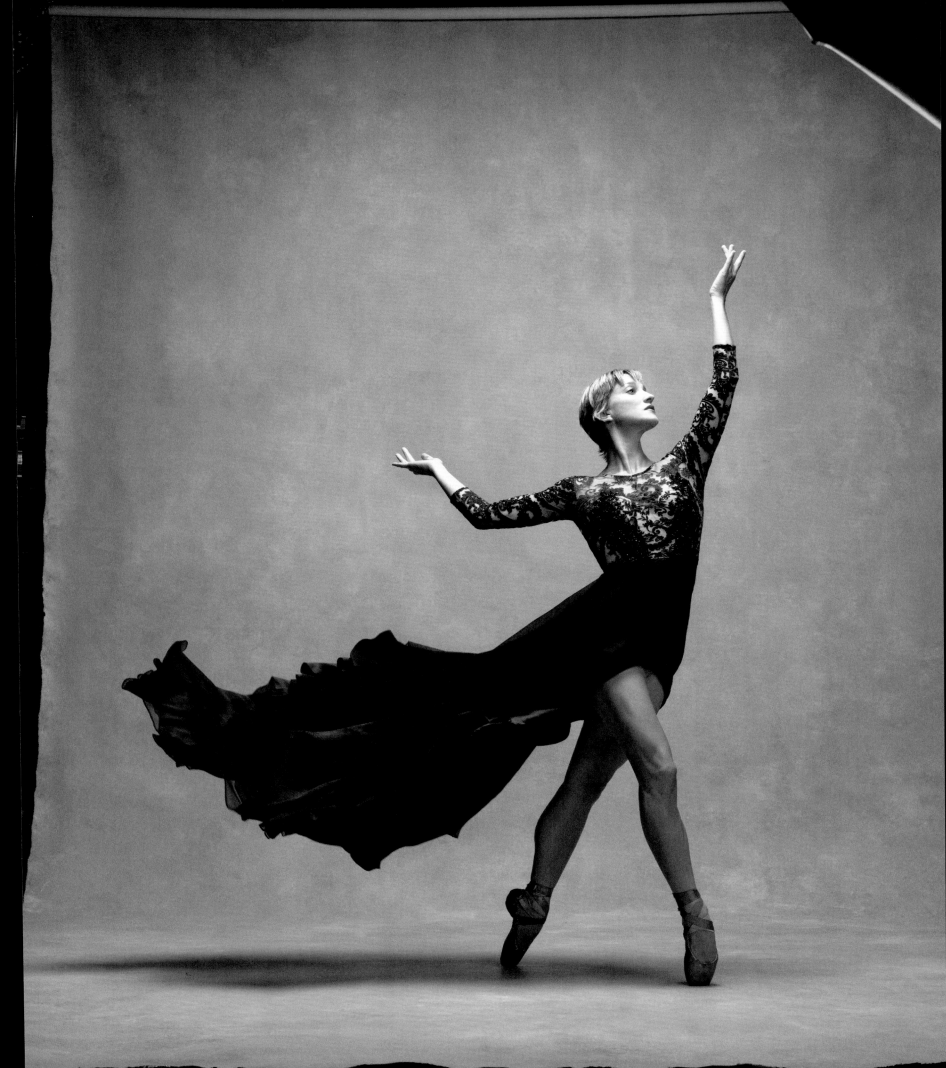

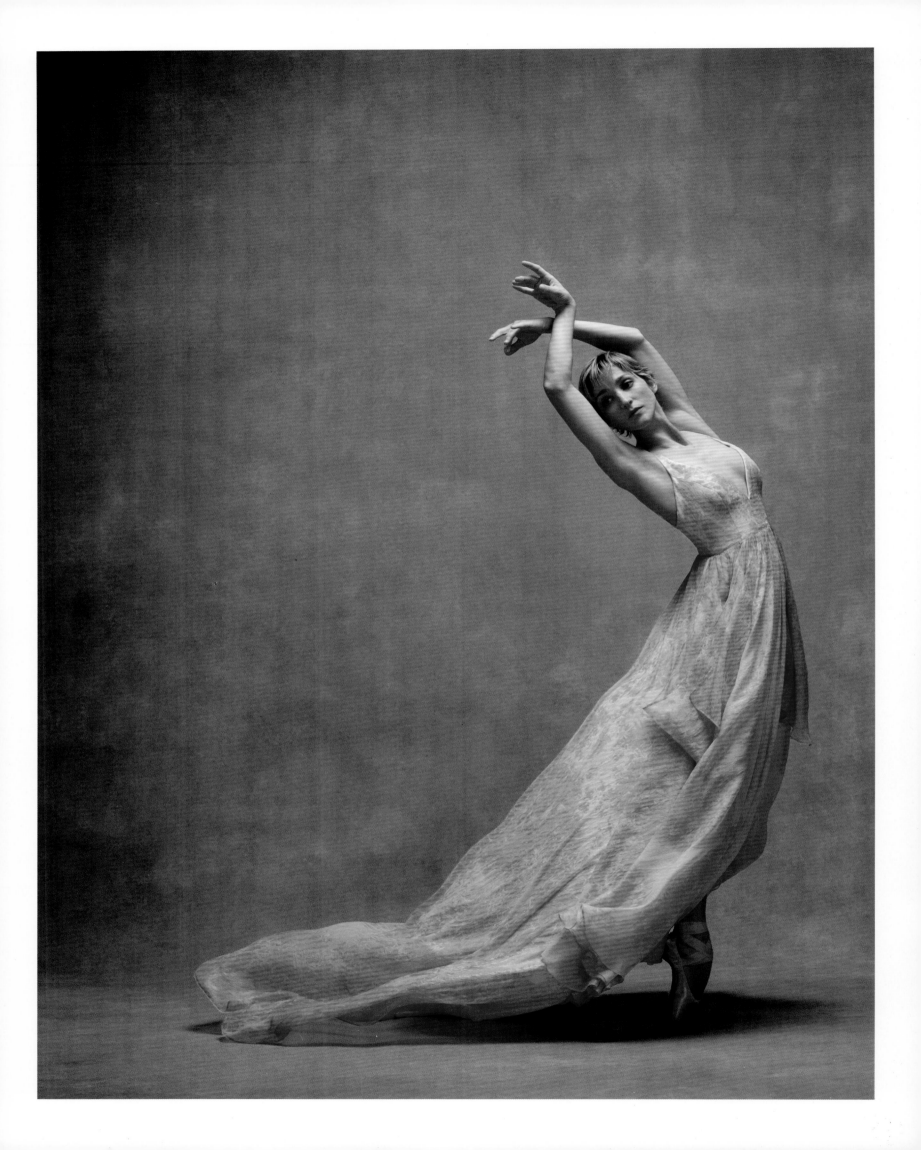

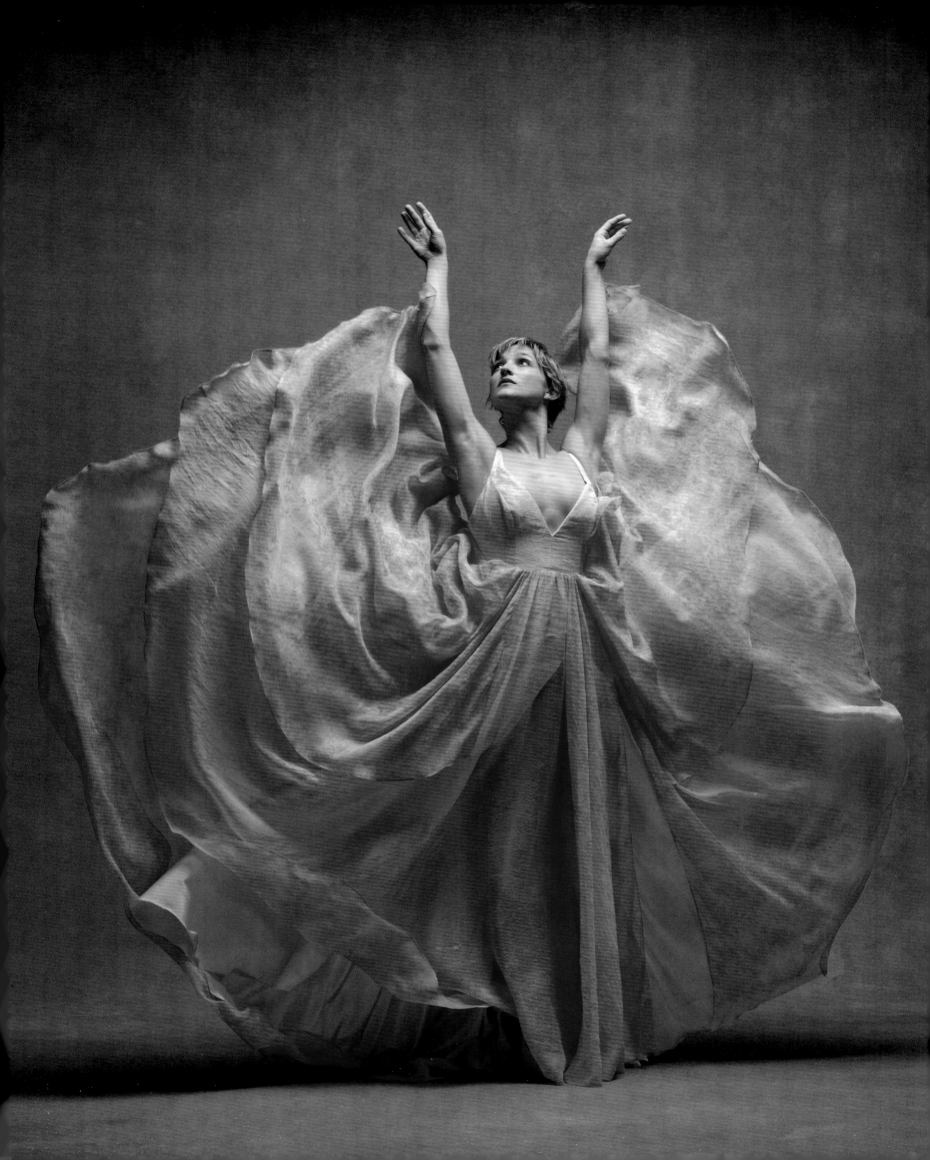

"If string theory is correct, then the universe is made up of
infinitesimally tiny vibrating strands of energy.
Each vibrating strand emits a tone of its own.

As strands are attracted to each other, they combine to
compose every single thing in existence—you, me, this page,
this picture—the more strands that attach to one another,
the greater number of tones that are combined.

If all these tones are vibrating at once, then one might conceive of
every single thing as a unique chord of music. If that's the case,
then the universe is made of music. If the universe is made of music,
I cannot imagine a more appropriate response than dancing."

–Lar Lubovitch

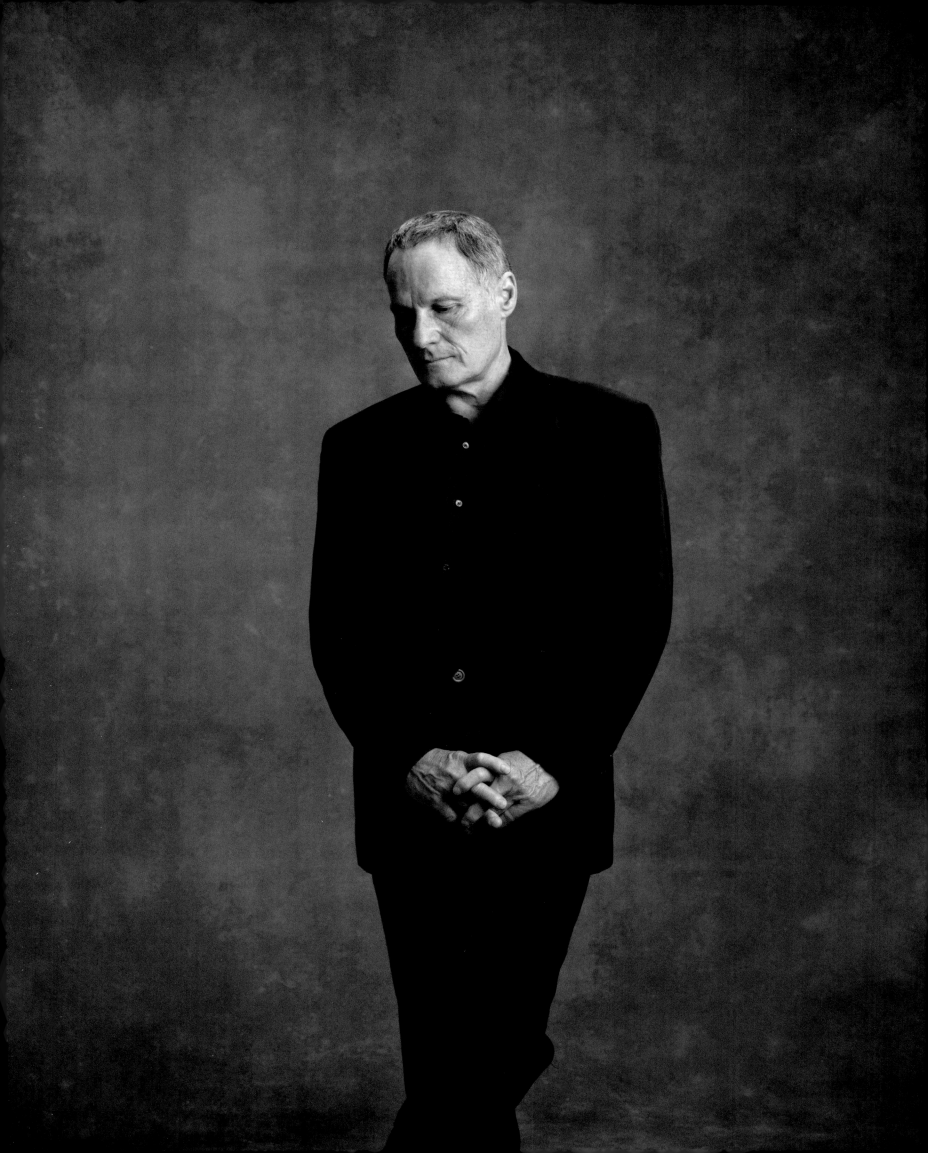

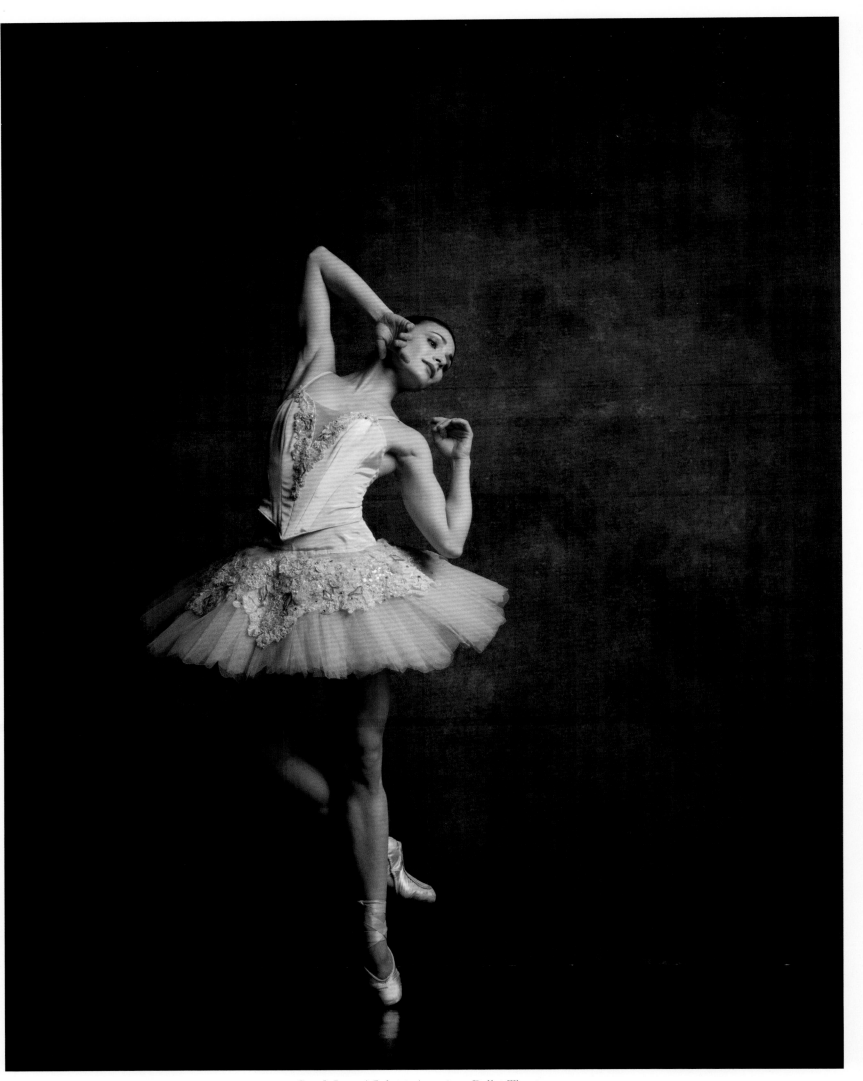

Sarah Lane | Soloist, American Ballet Theatre

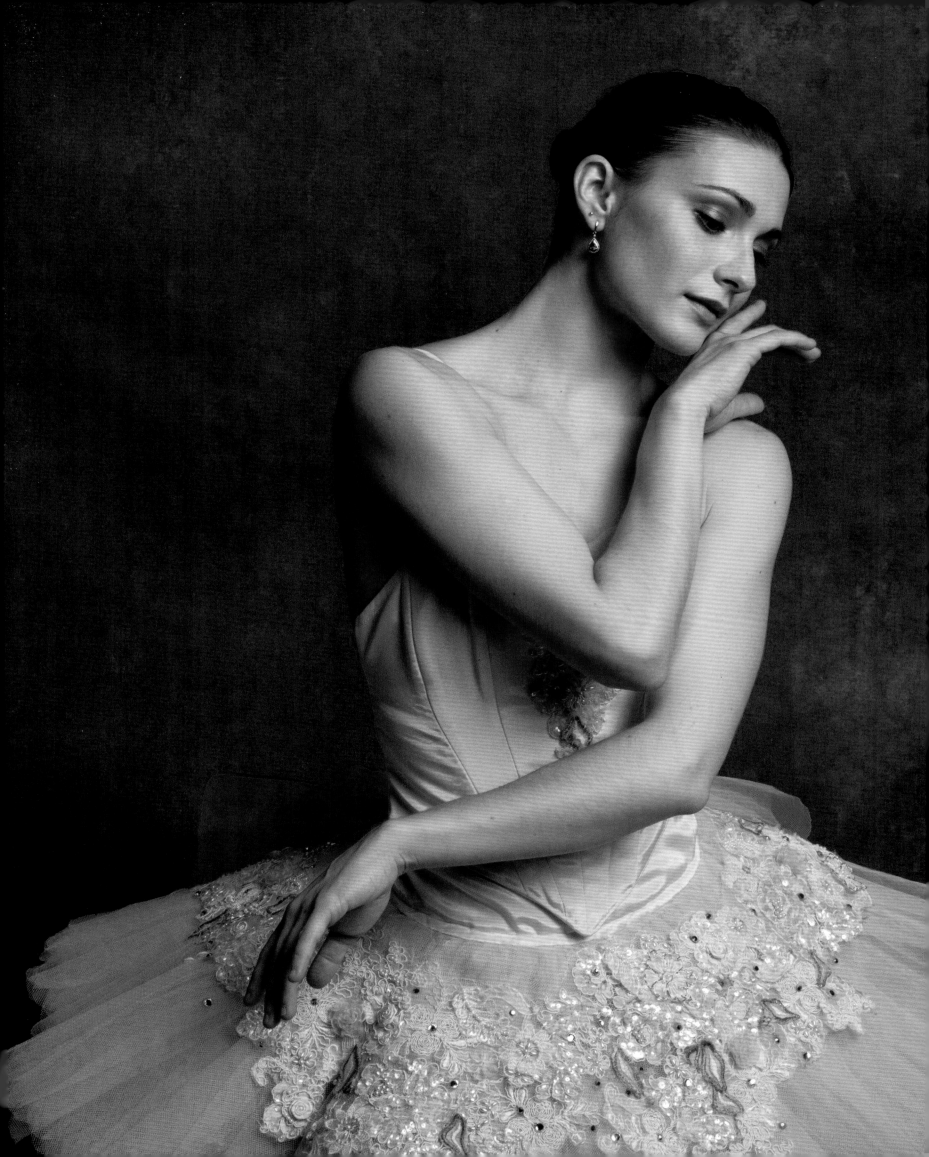

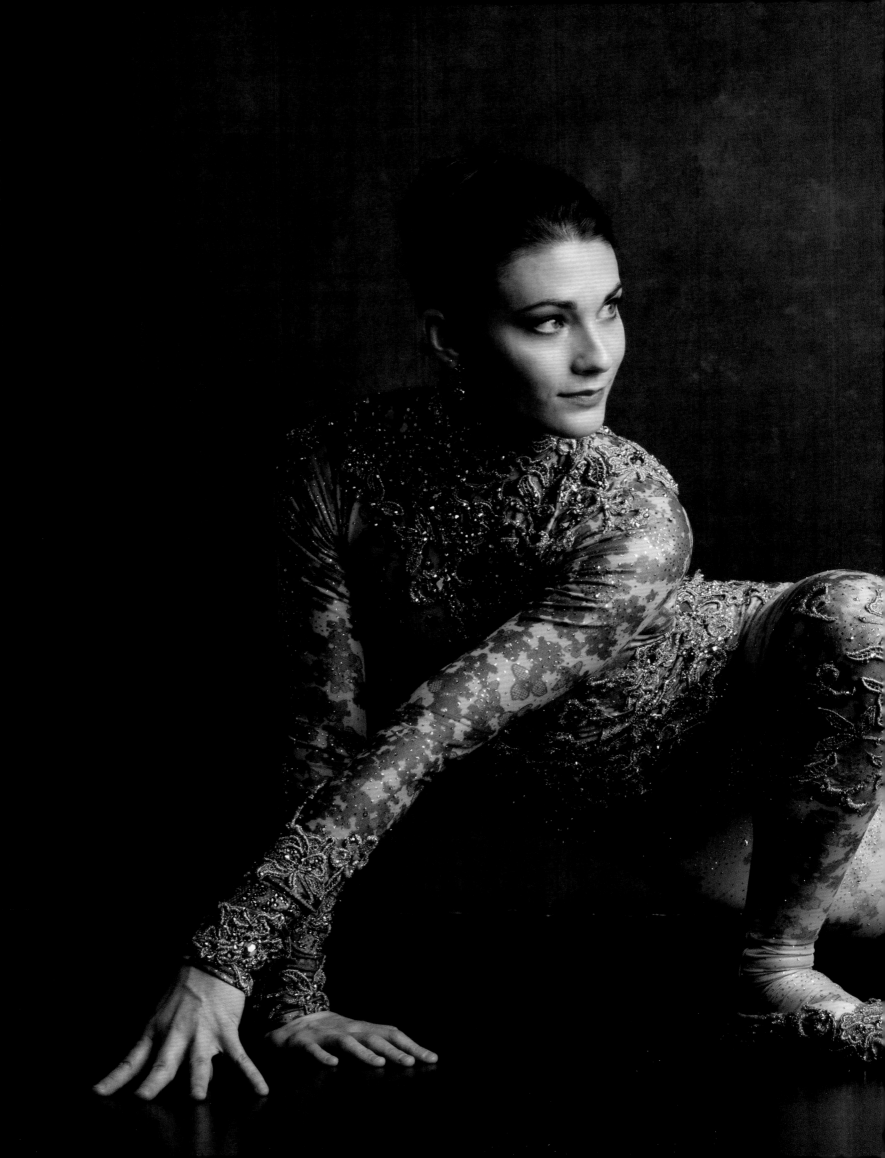

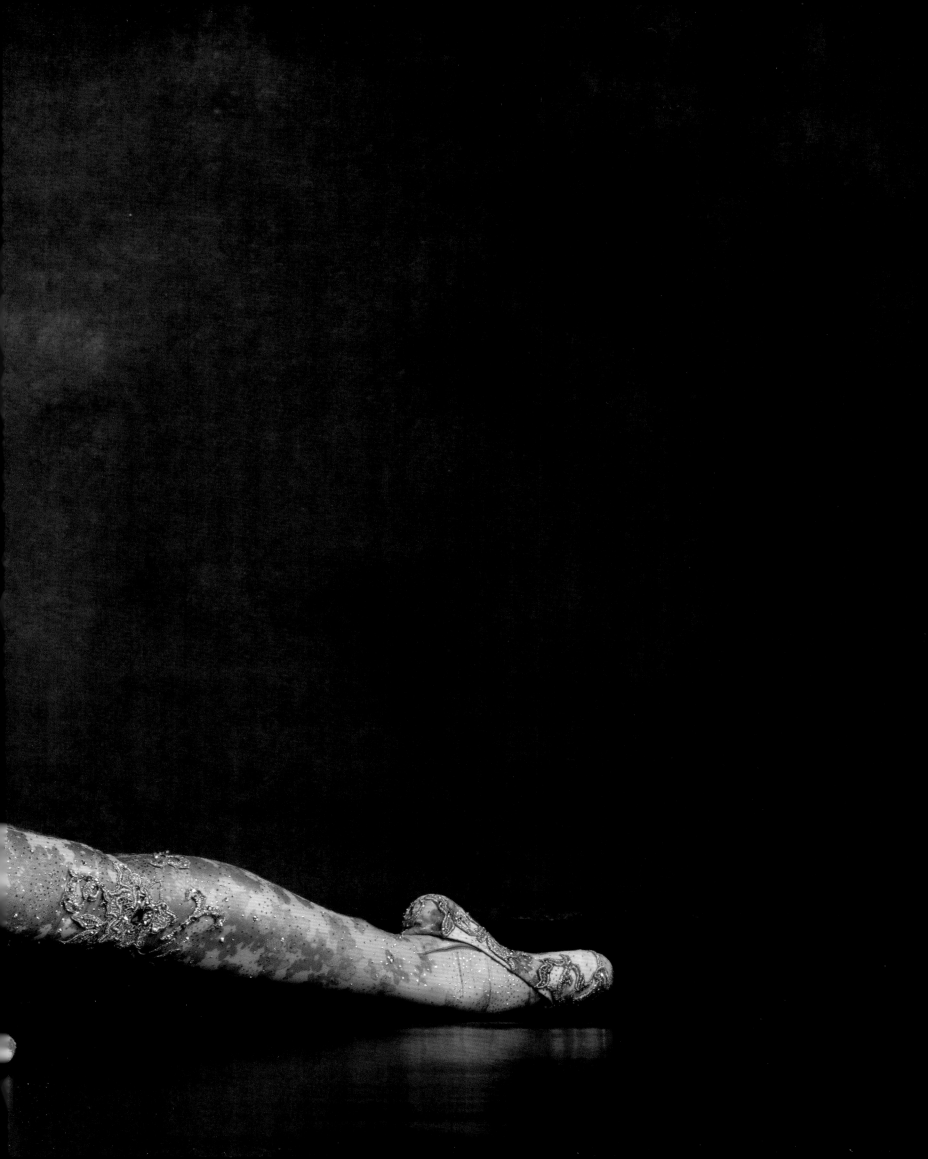

"'Watch and learn. Learn what to do and what not to do.'
I think about those words daily.
I watch rehearsals and performances and am always learning.
Everyday we can learn, and it may be surprising who you
can gain the most knowledge from."

–Meaghan Grace Hinkis

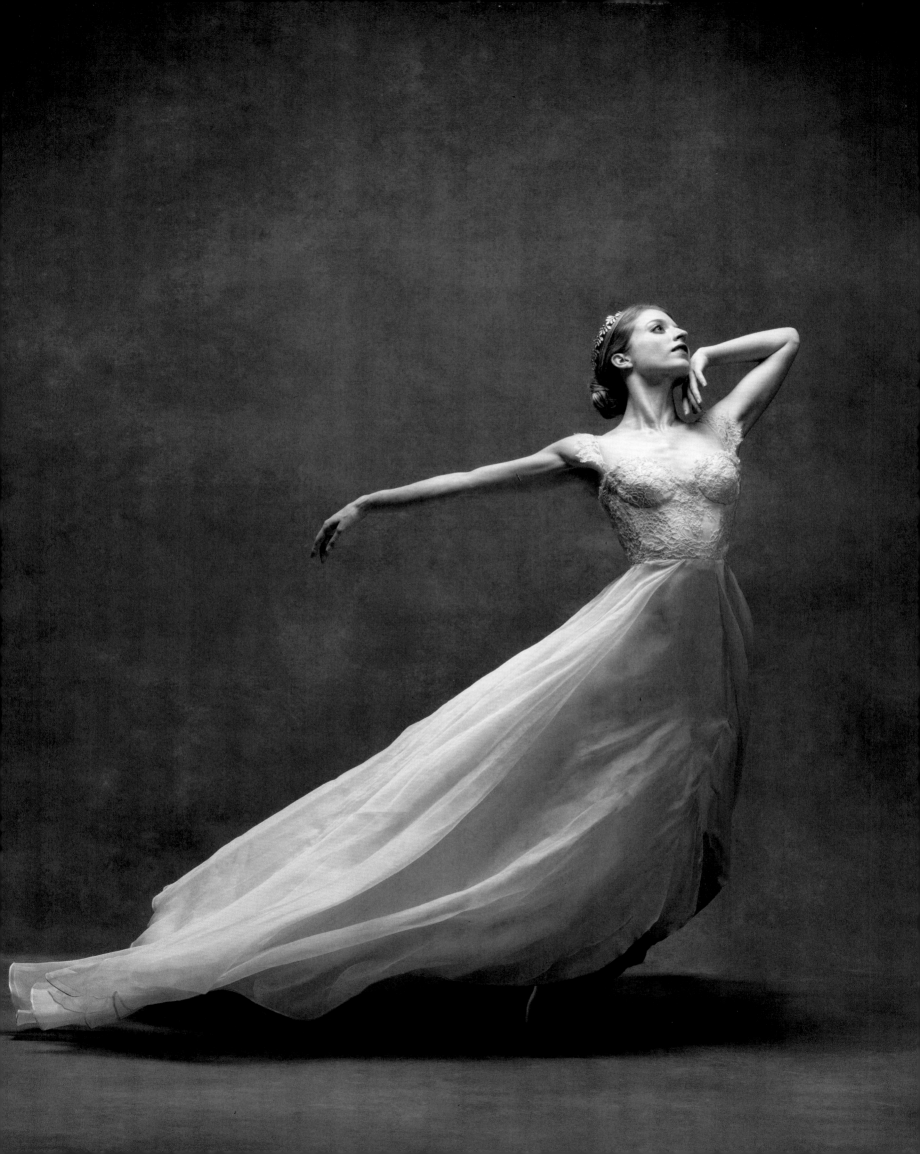

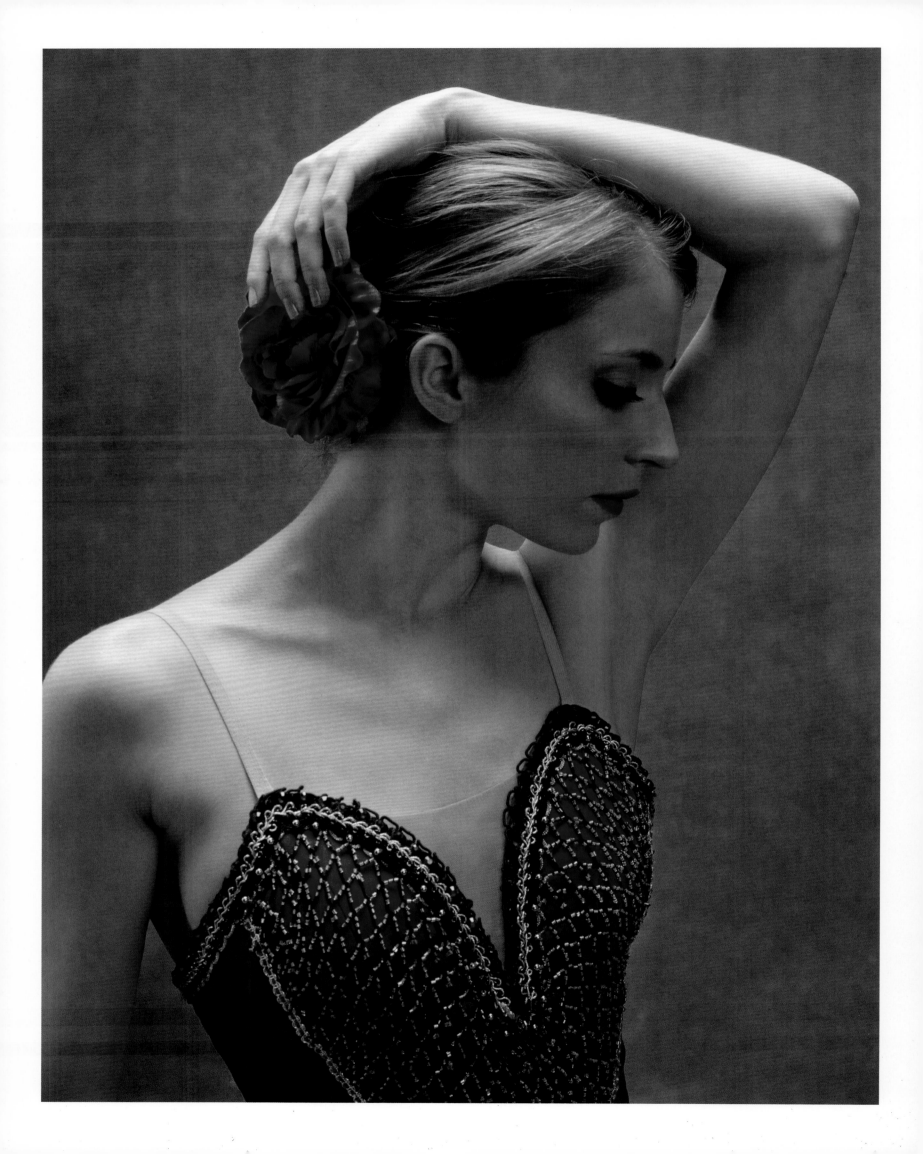

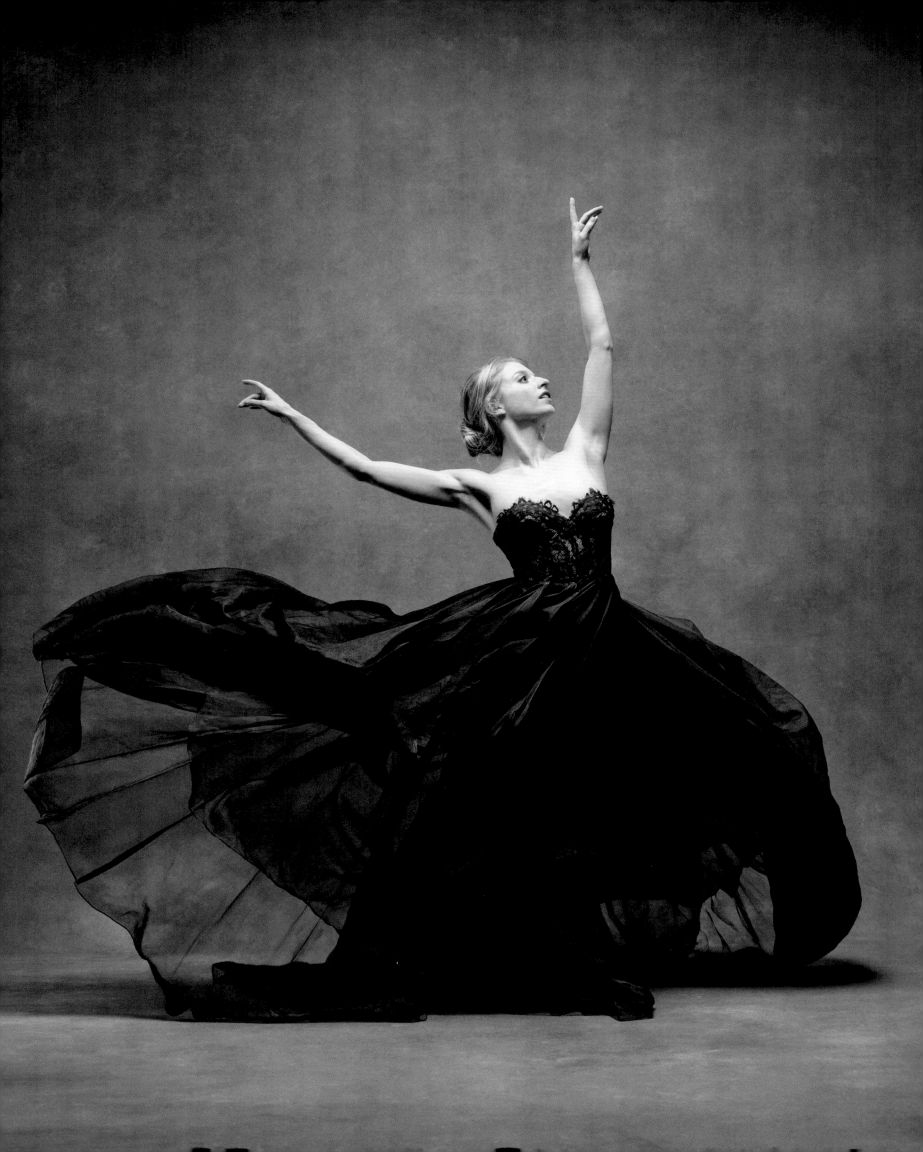

"When you're hungry, eat. When you're tired, sleep. When you hear music, dance."

–Garen Scribner

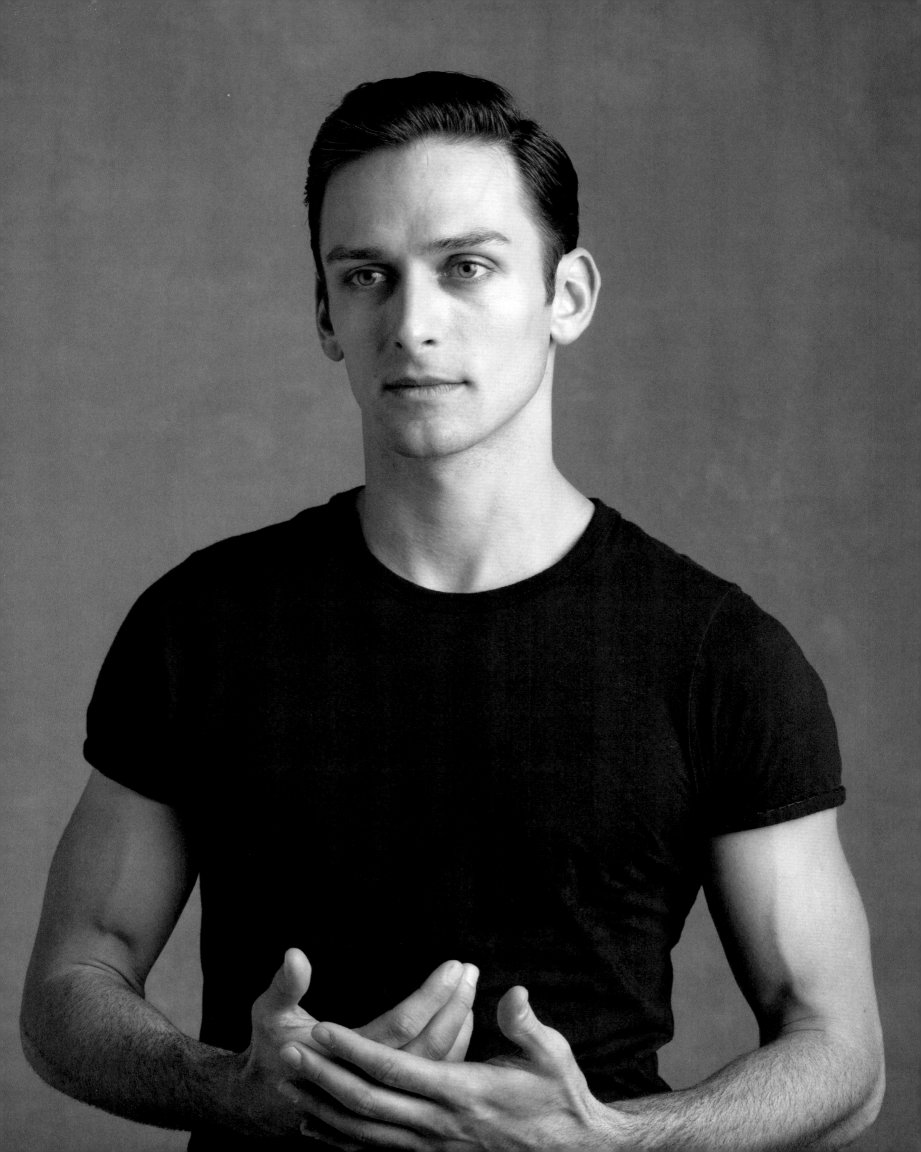

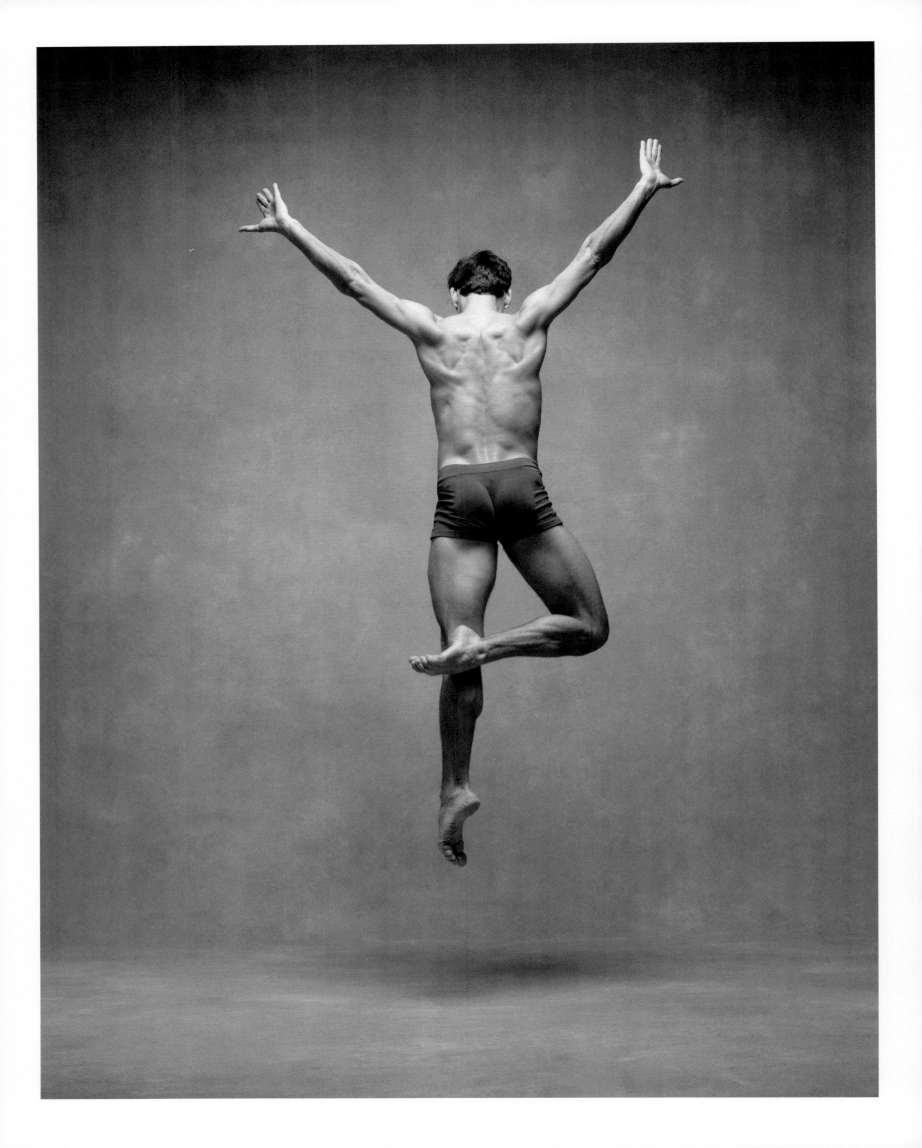

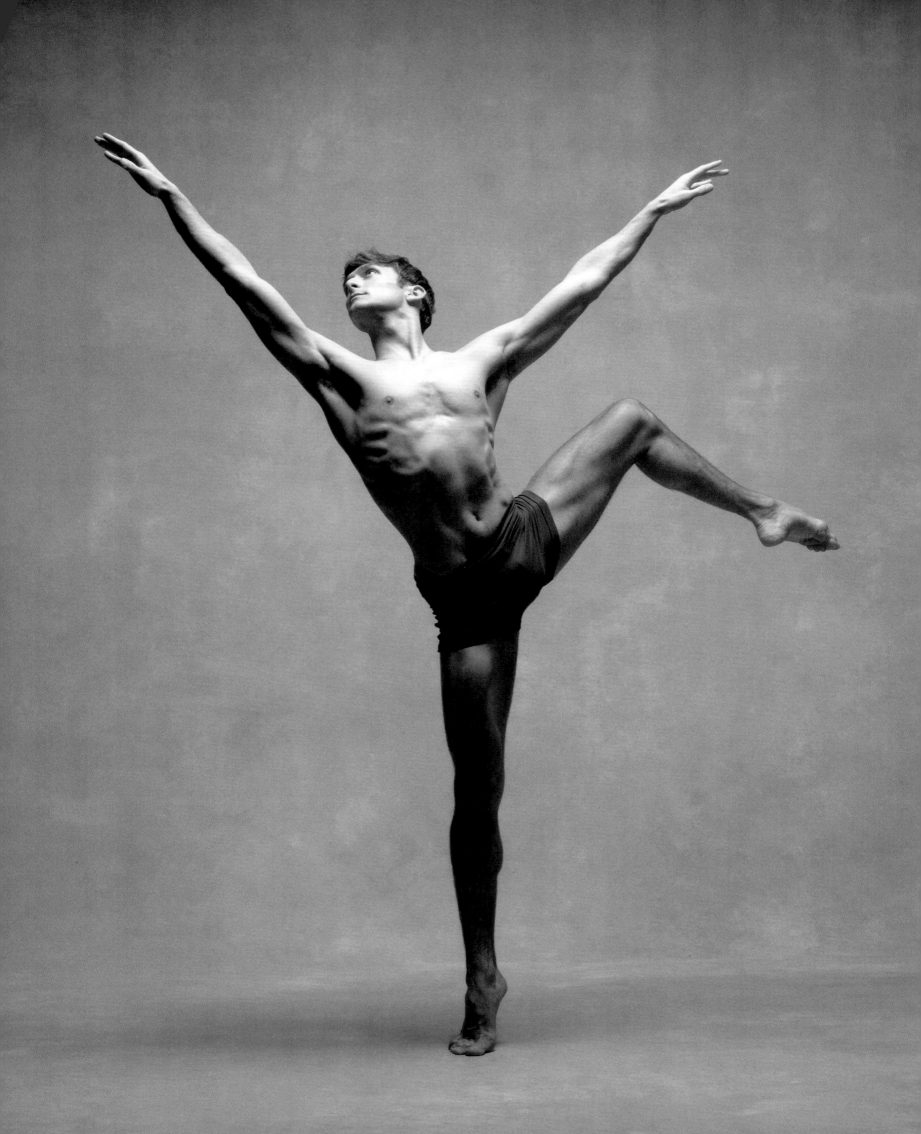

"Having confidence in yourself will help you become
a stronger dancer. It's not about being conceited
or worrying about whether you are good enough,
but feeling focused and confident about your dancing.
This will improve your artistry and presence and help you
stand out more. Also, having confidence allows you
to take more risks and realize your full potential."

–Miriam Miller

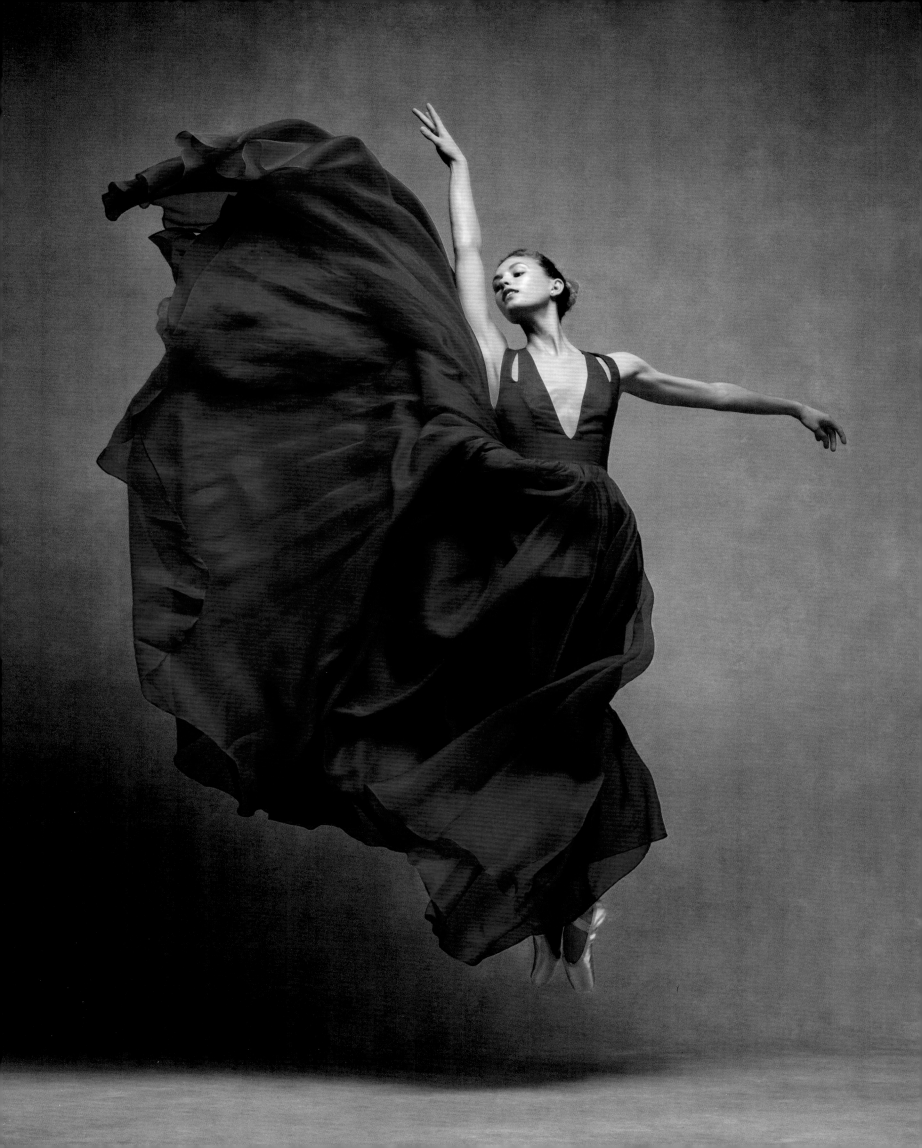

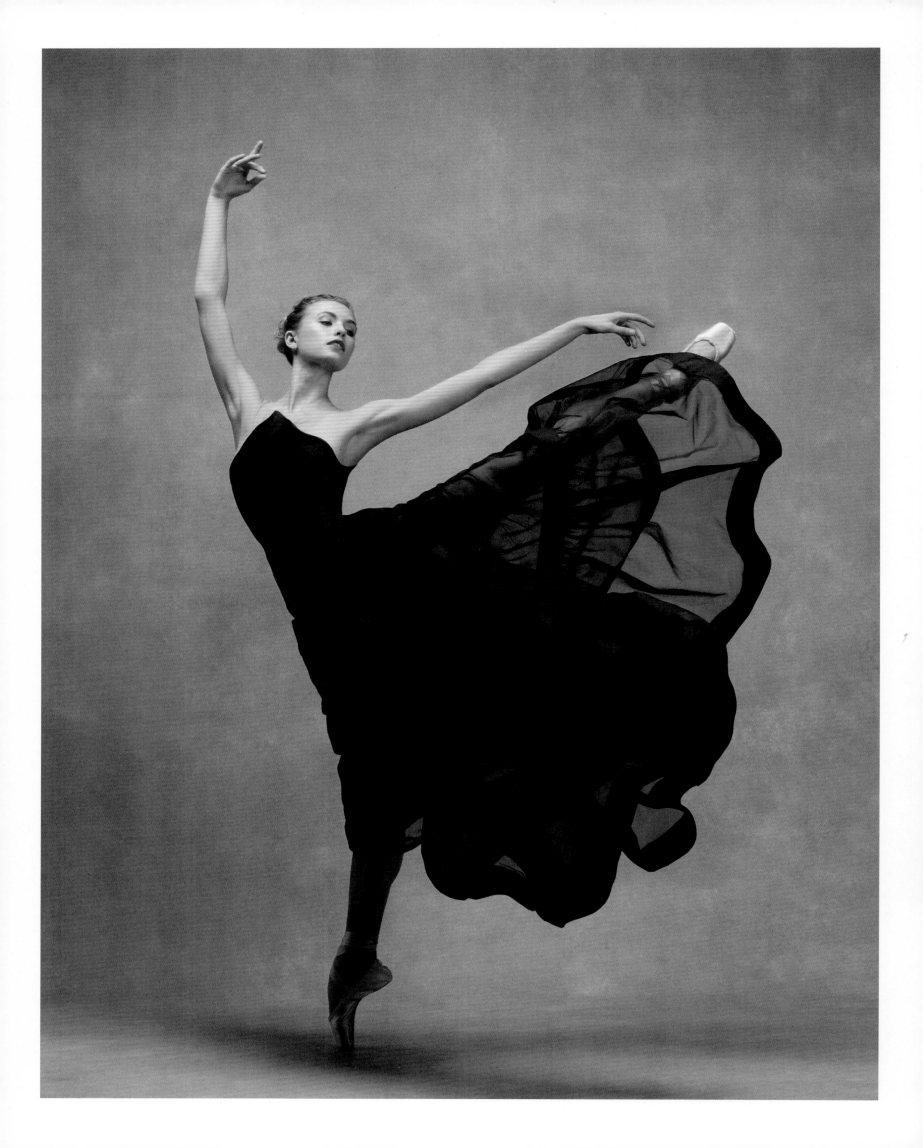

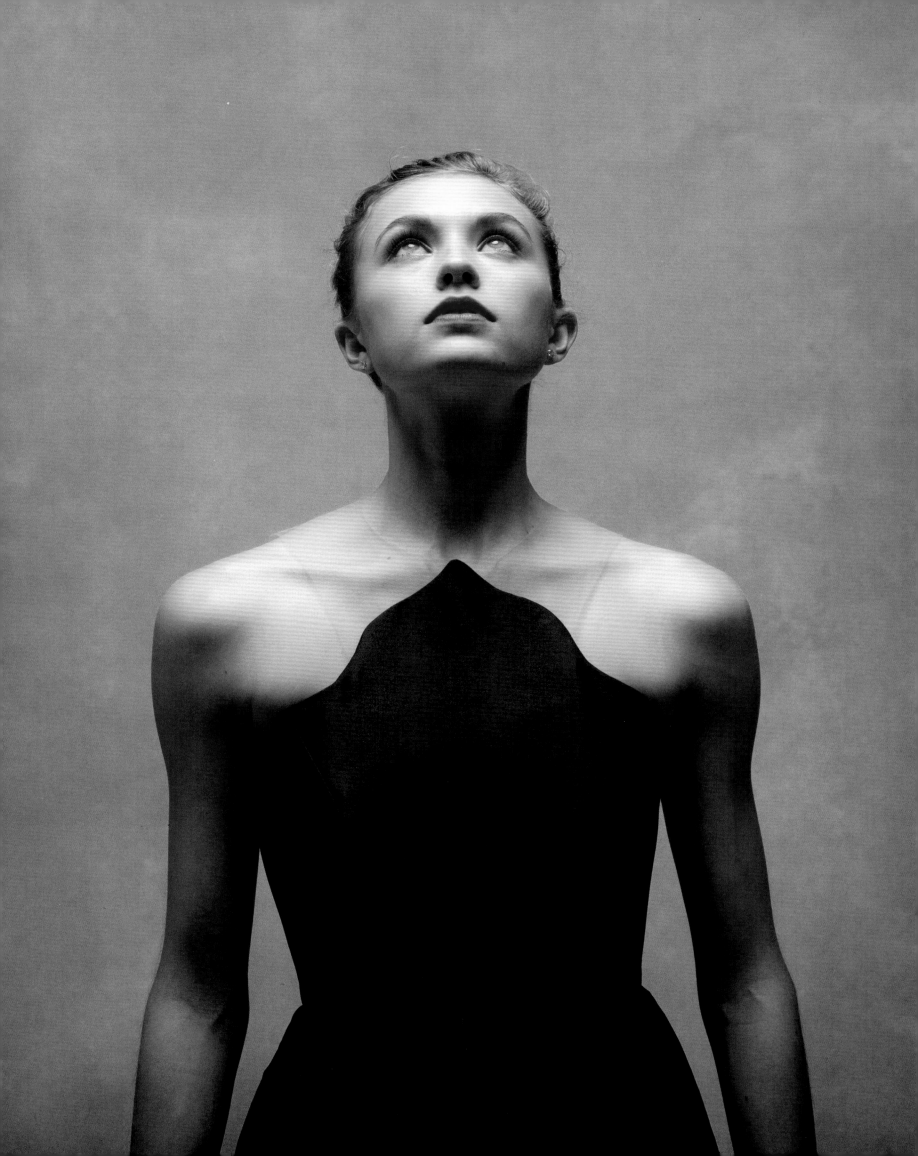

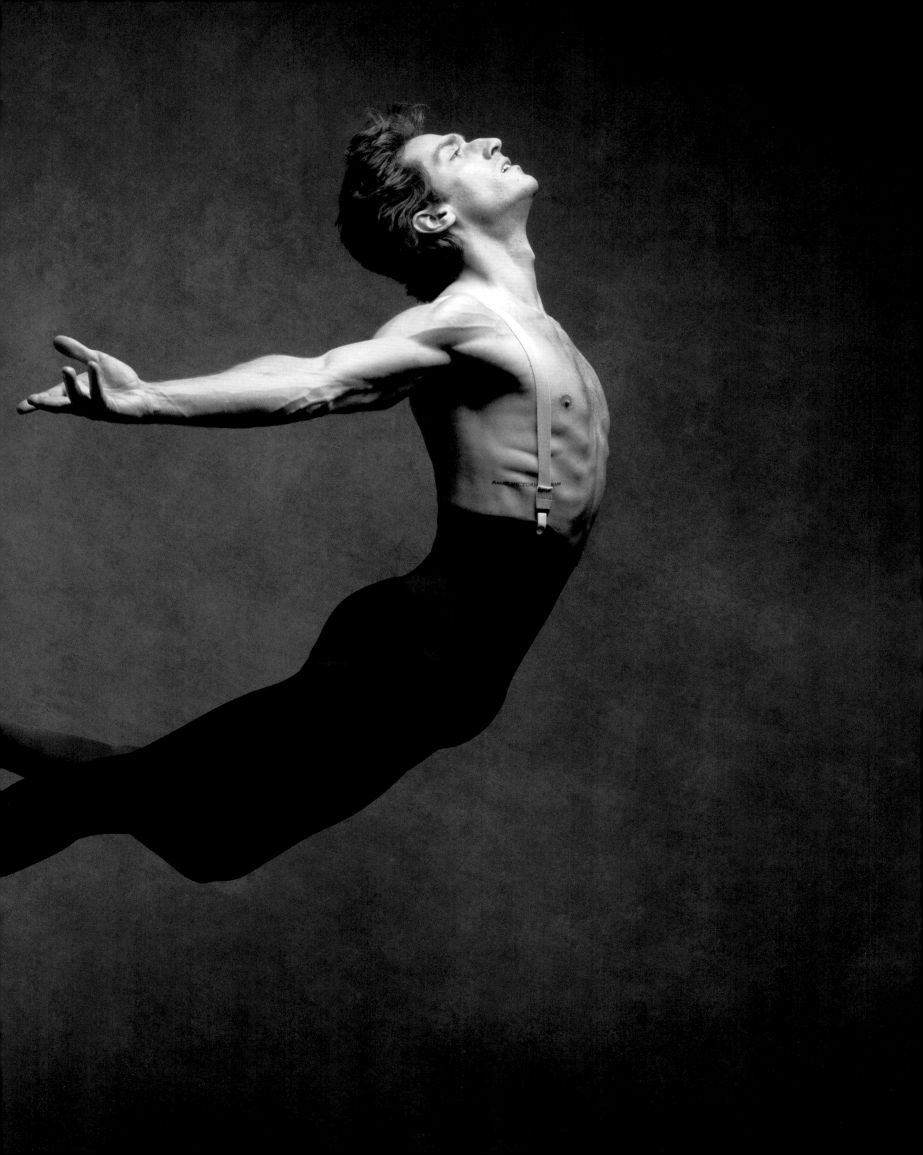

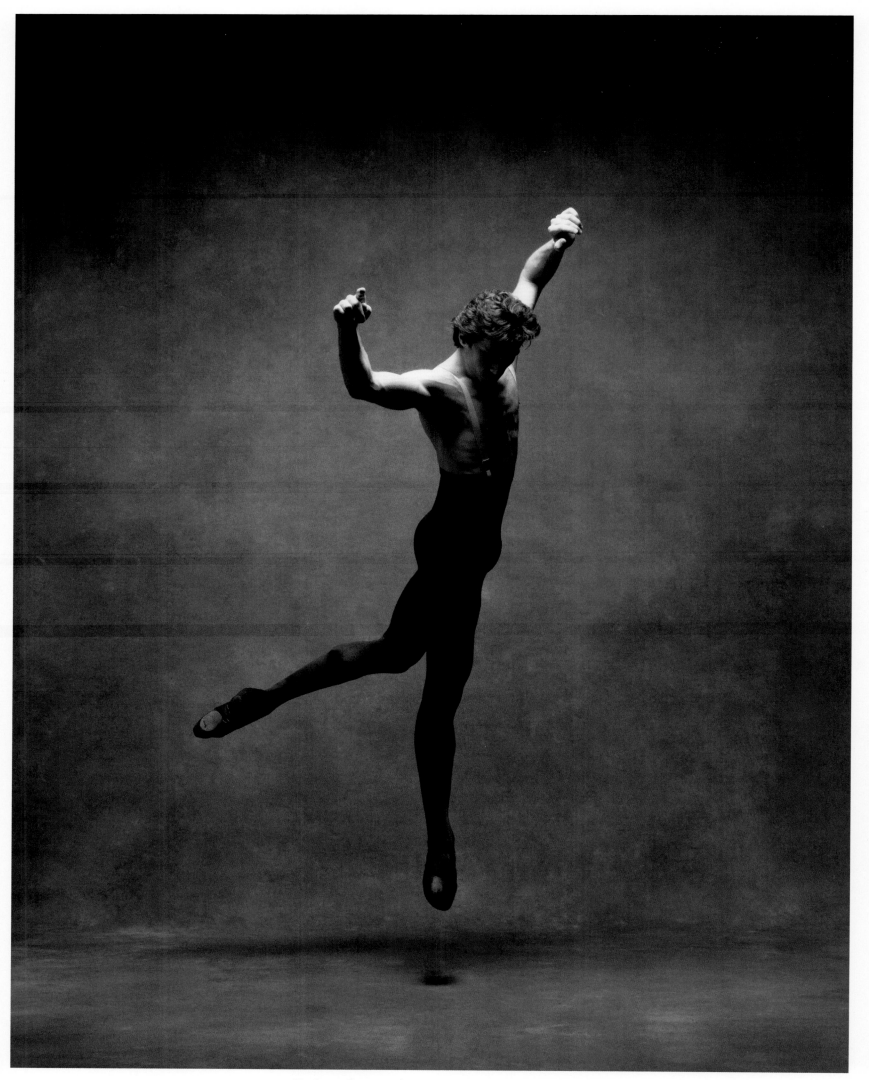

Zachary Catazaro | Soloist, New York City Ballet

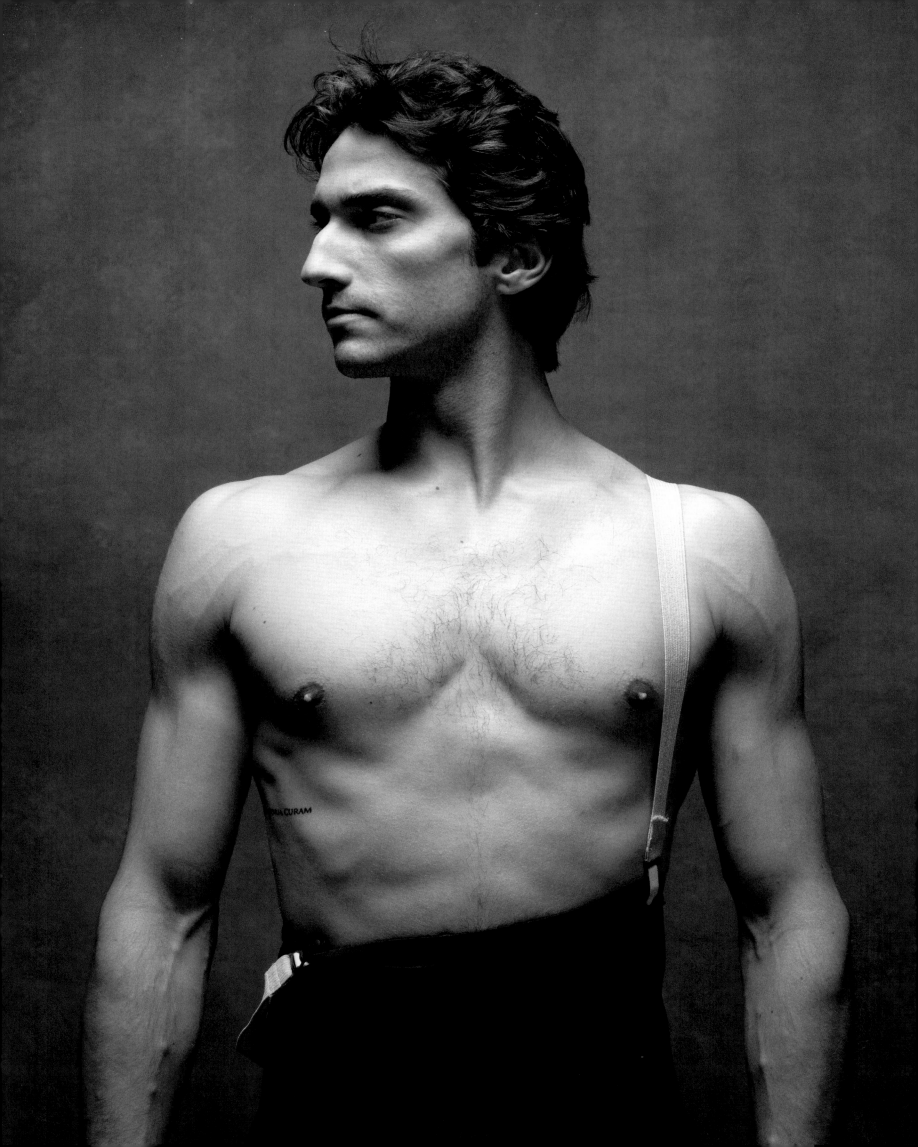

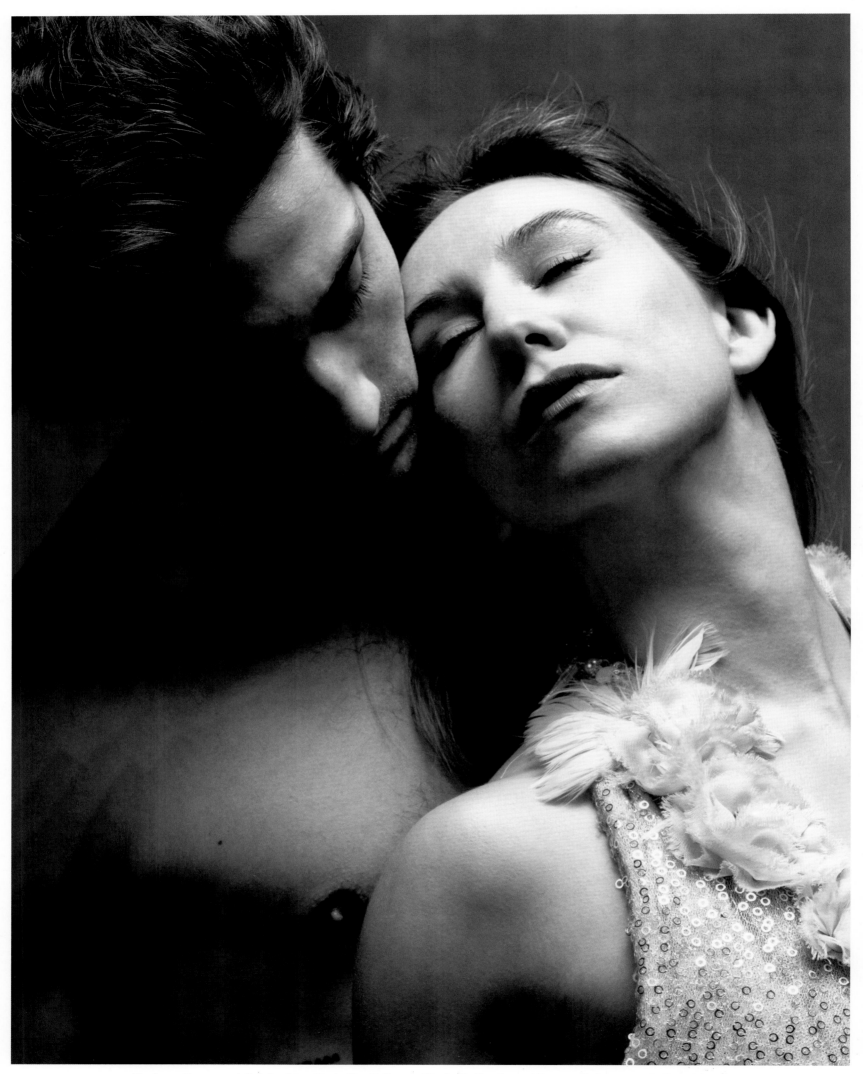

Zachary Catazaro | Soloist, New York City Ballet and **Isabella Boylston** | Principal, American Ballet Theatre

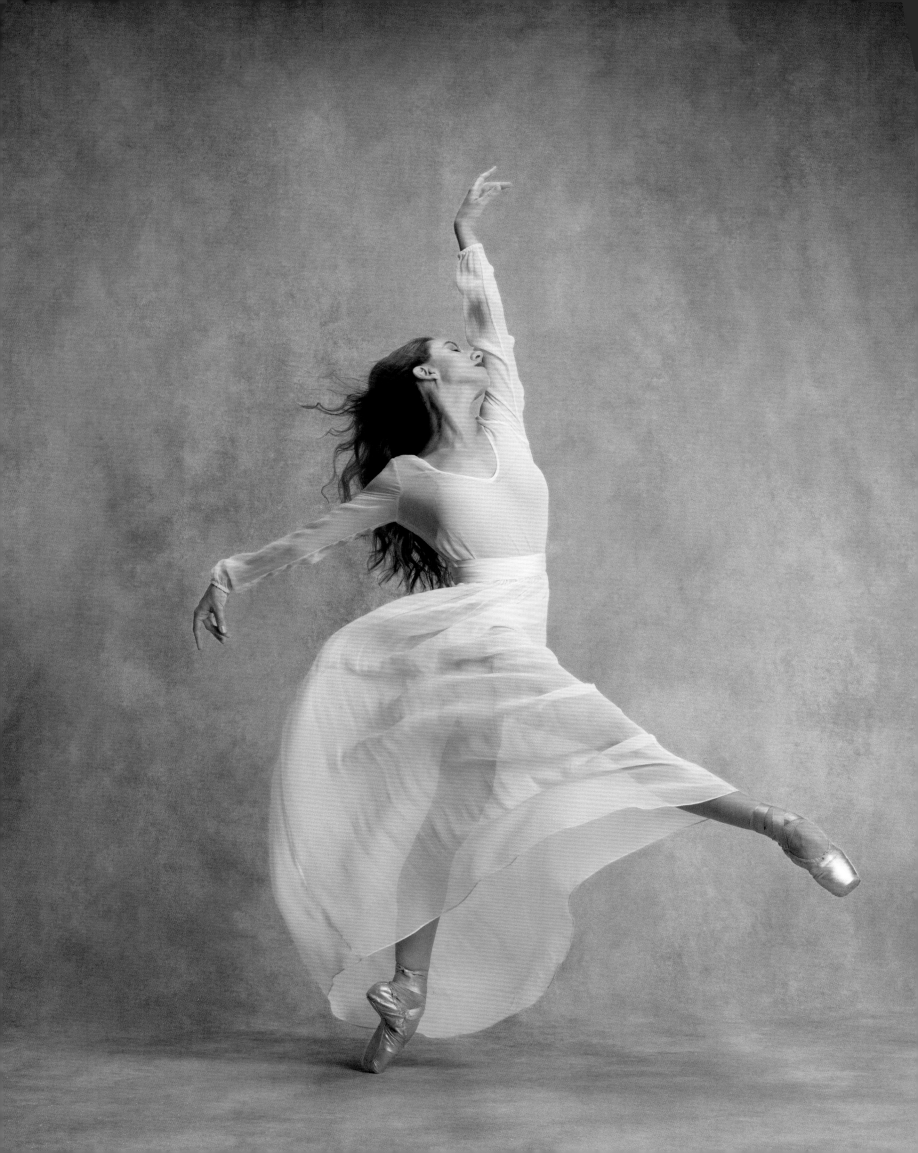

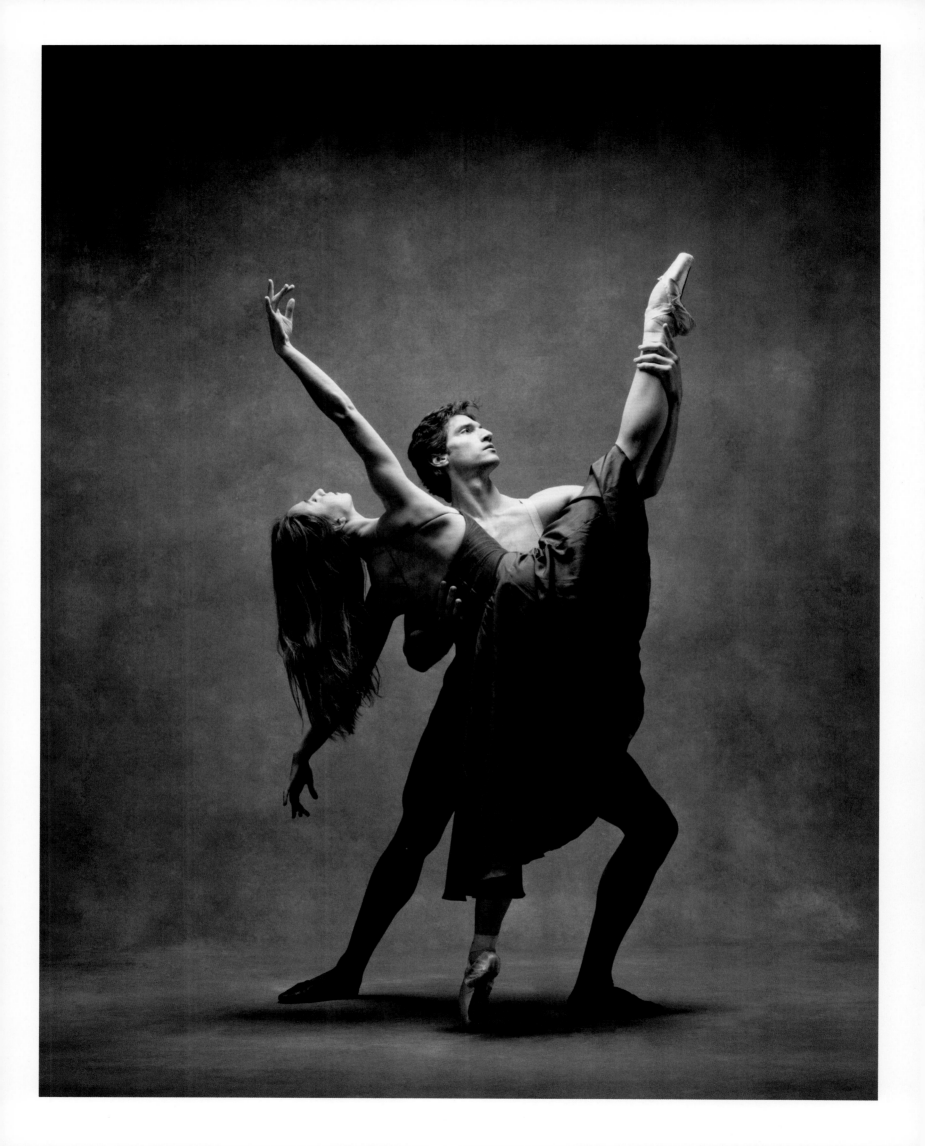

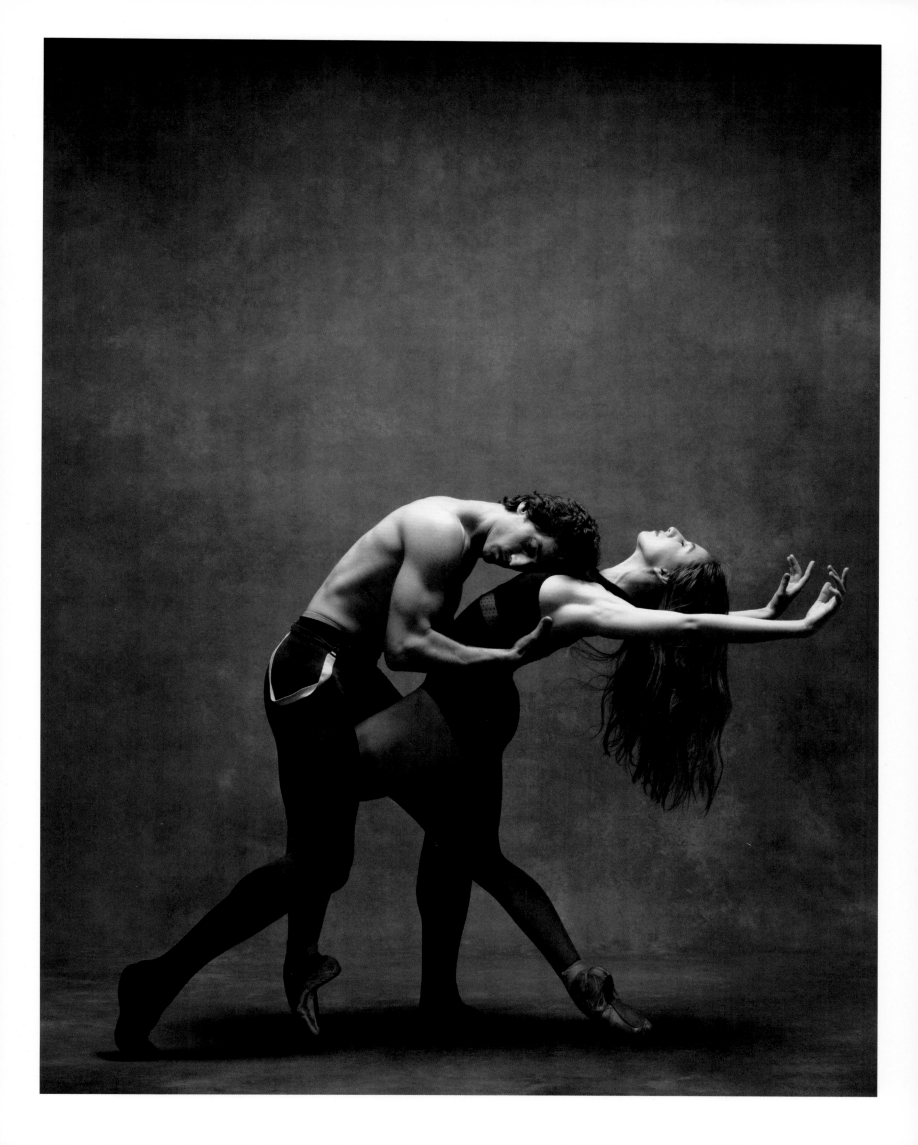

"Doing a show and knowing that I just left everything on stage,
like my guts are on the stage, is literally euphoria.
It's the best feeling ever.
When I am able to be totally in the moment and
free on stage, that's pretty rewarding!"

–Isabella Boylston

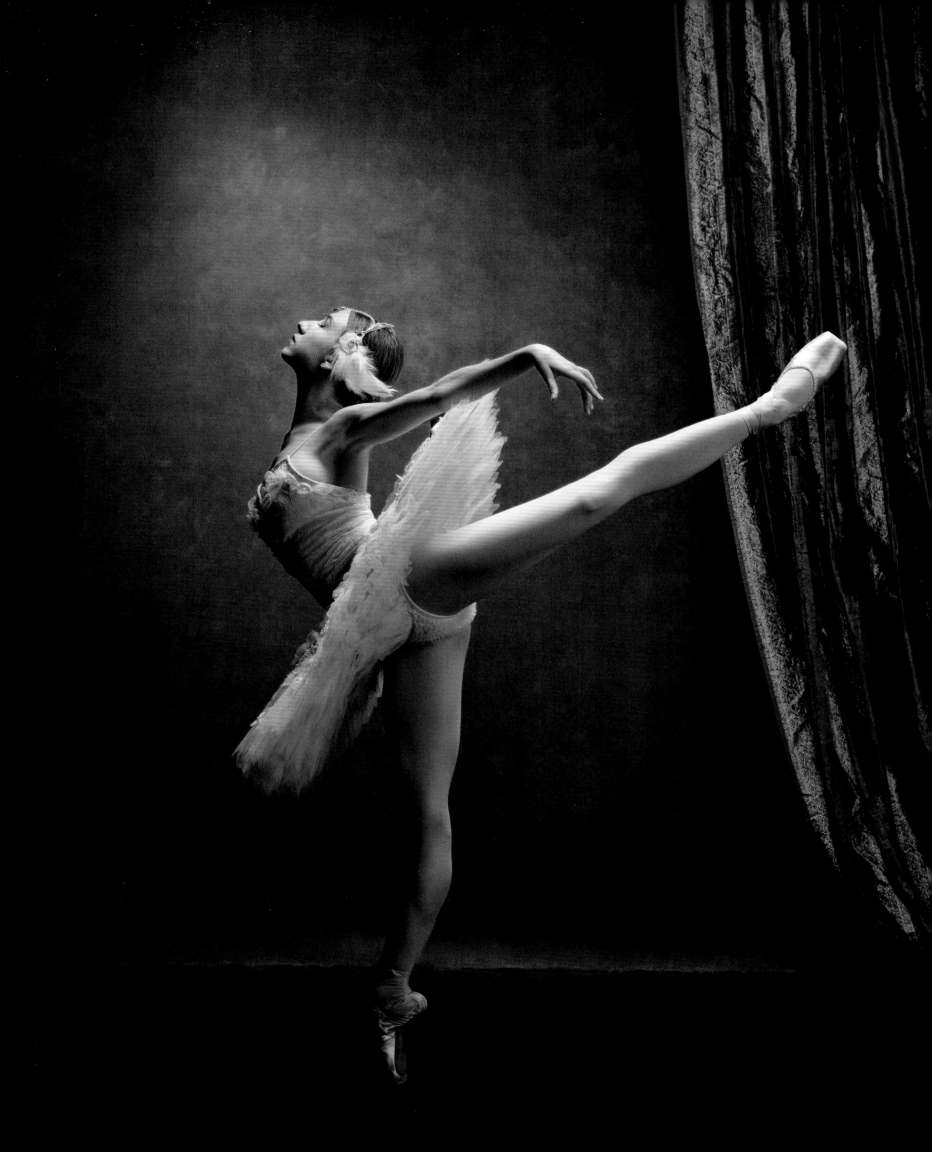

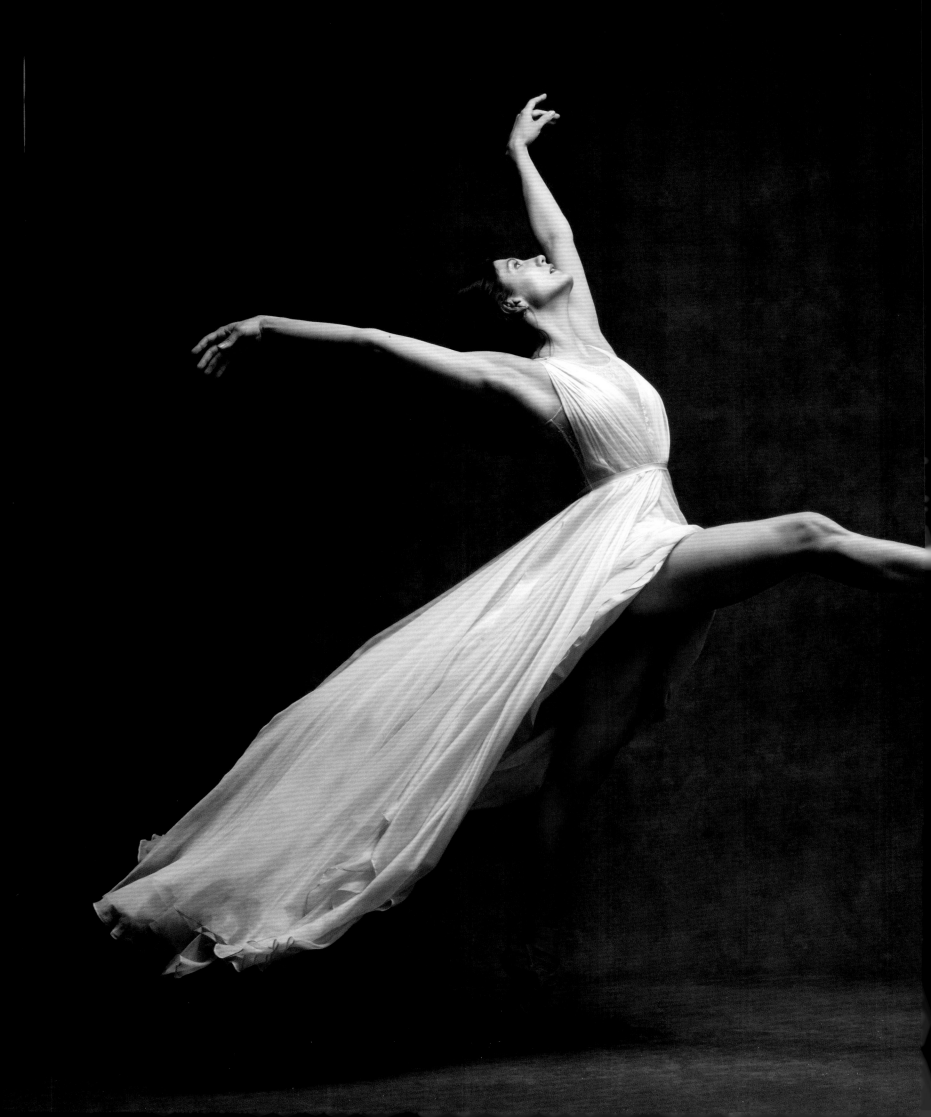

"When I was young, I danced in my room to an old recording of *Swan Lake* and my mother decided she would like it if I grew to be a ballerina."

–Veronika Part

Veronika Part | Principal, American Ballet Theatre

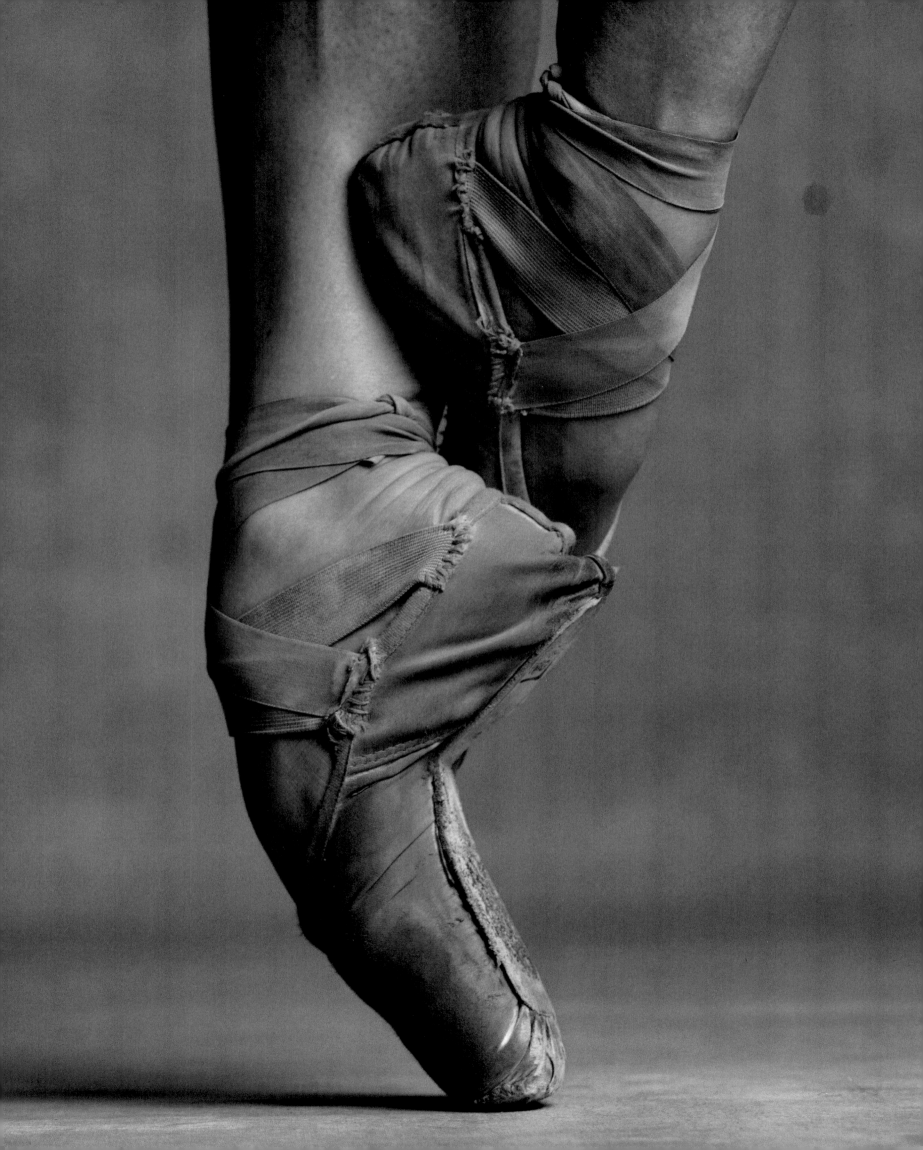

"Dance is a reflection of life;
 there will be many moments of excitement, fear,
 great joy, and great pain,
 but, as in life, each moment brings its own blessings . . .
 so does dance."

–Abdiel Cedric Jacobsen

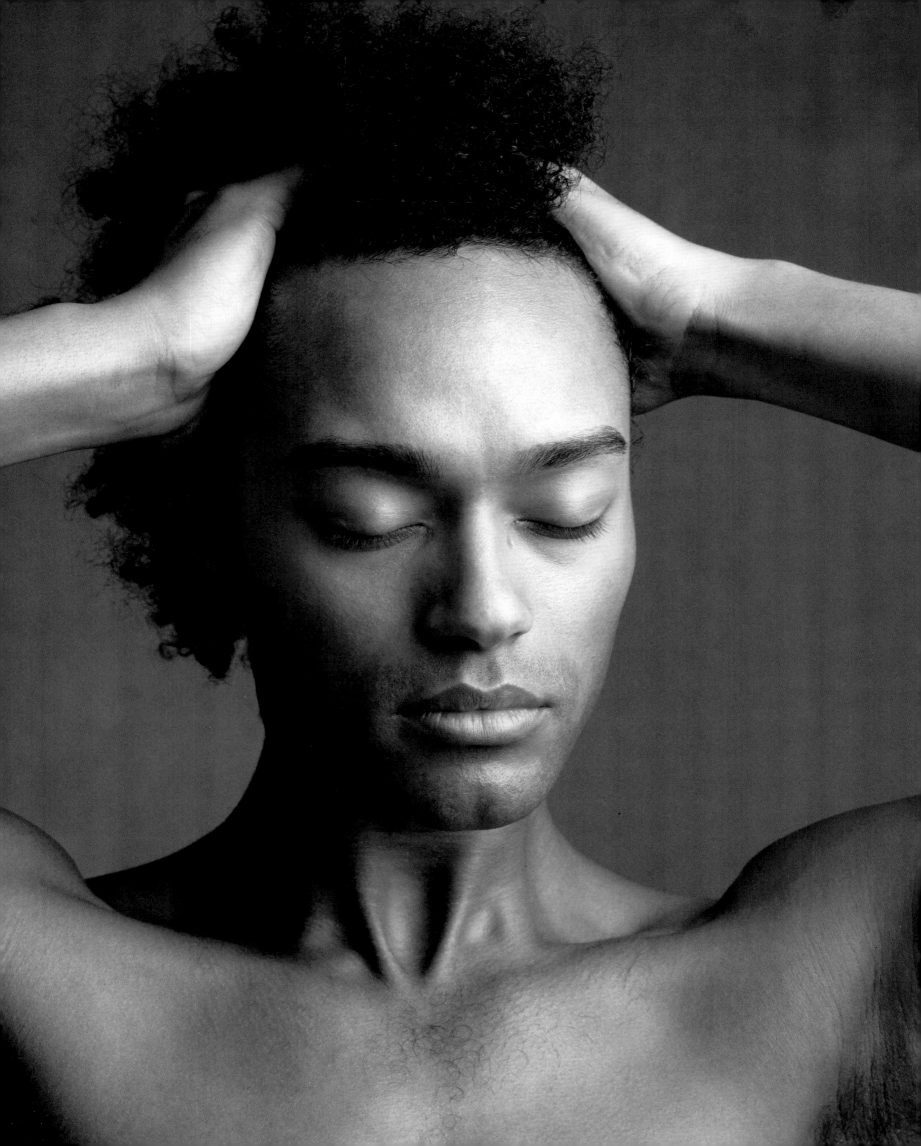

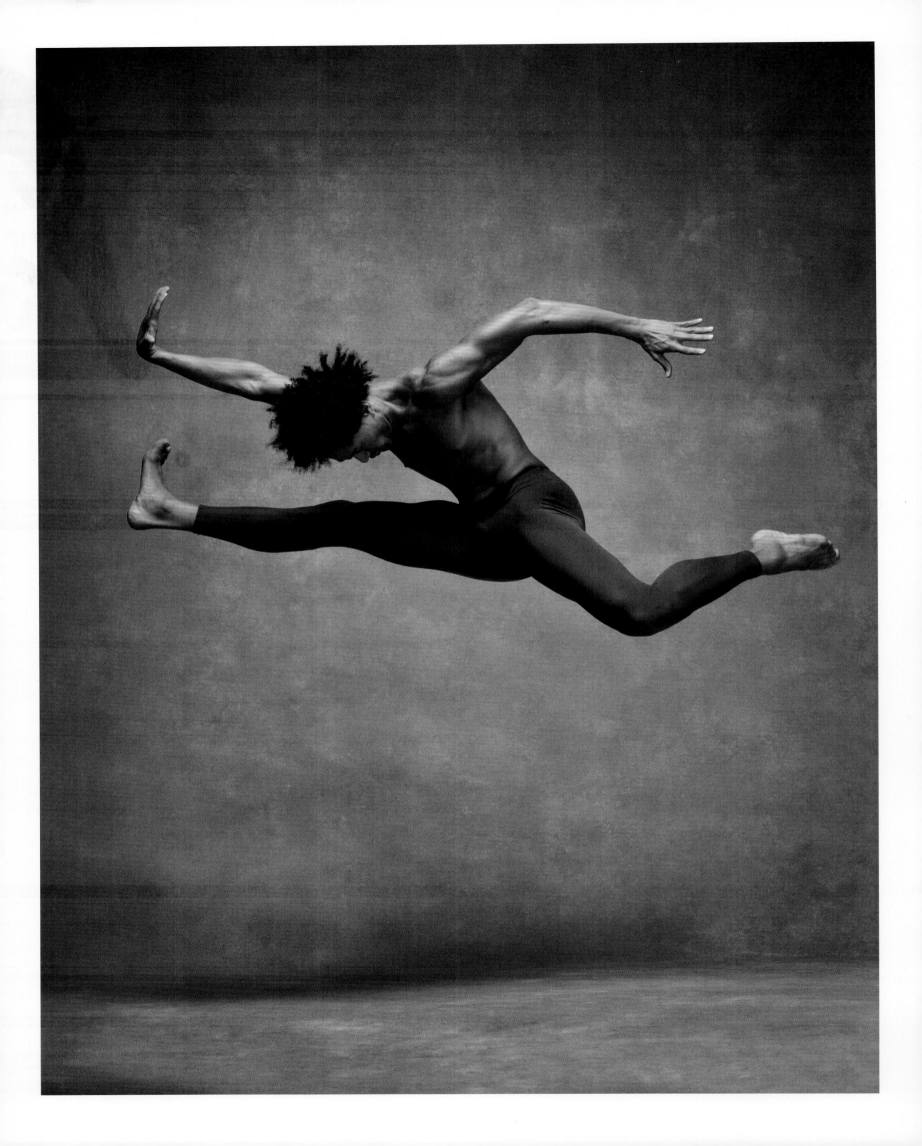

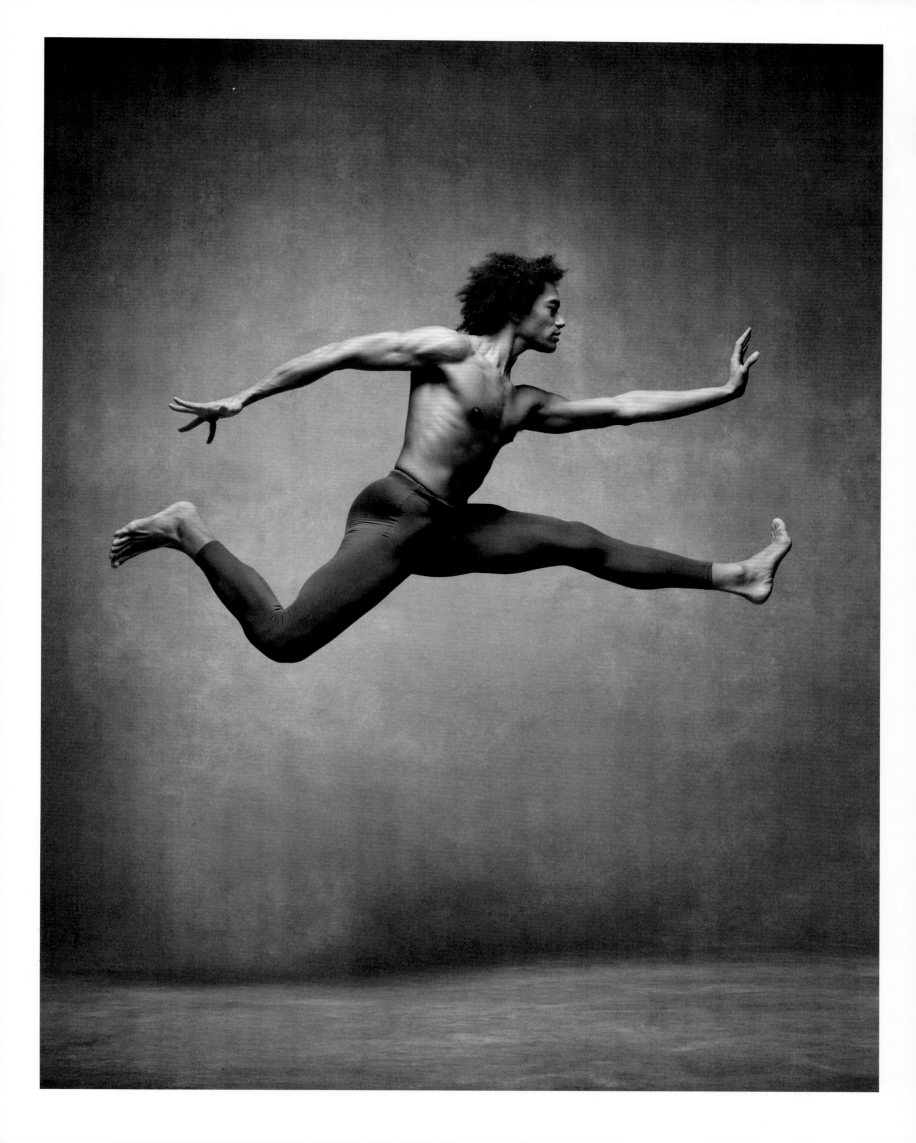

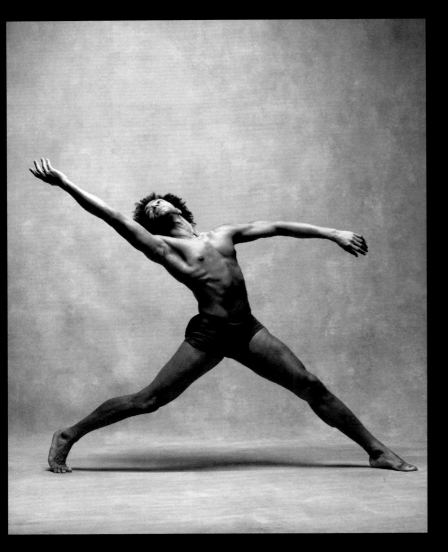
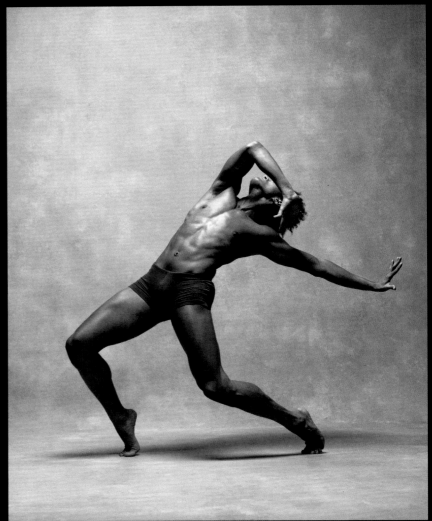

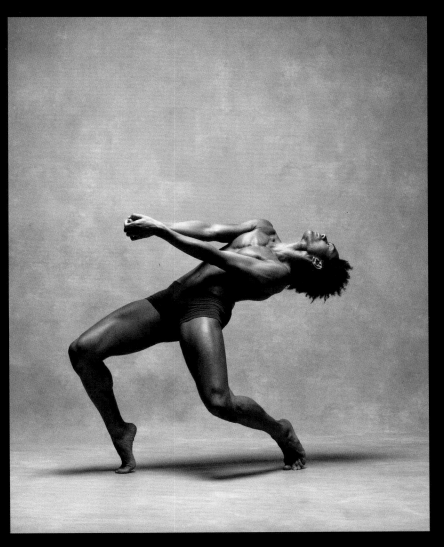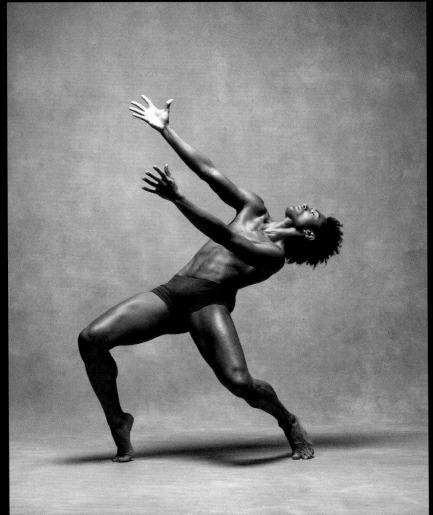

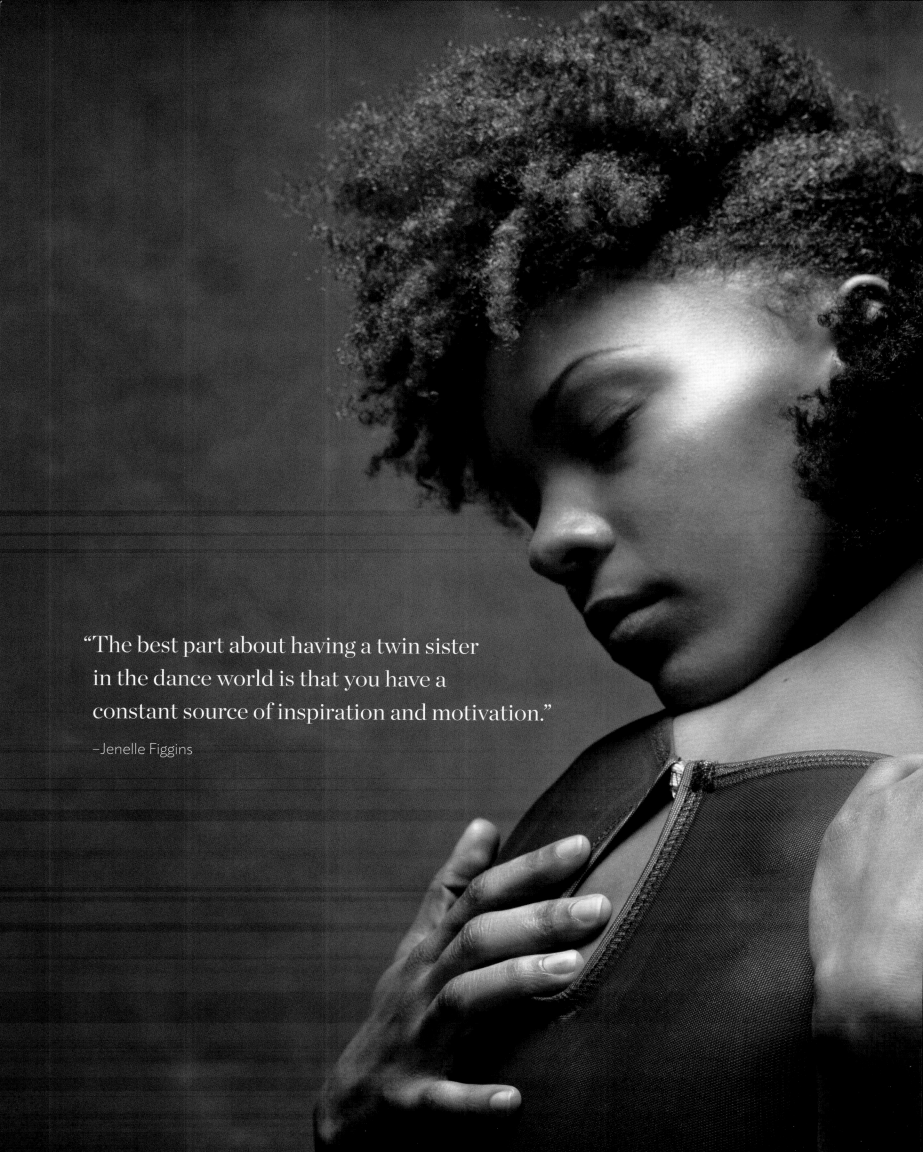

"The best part about having a twin sister in the dance world is that you have a constant source of inspiration and motivation."

–Jenelle Figgins

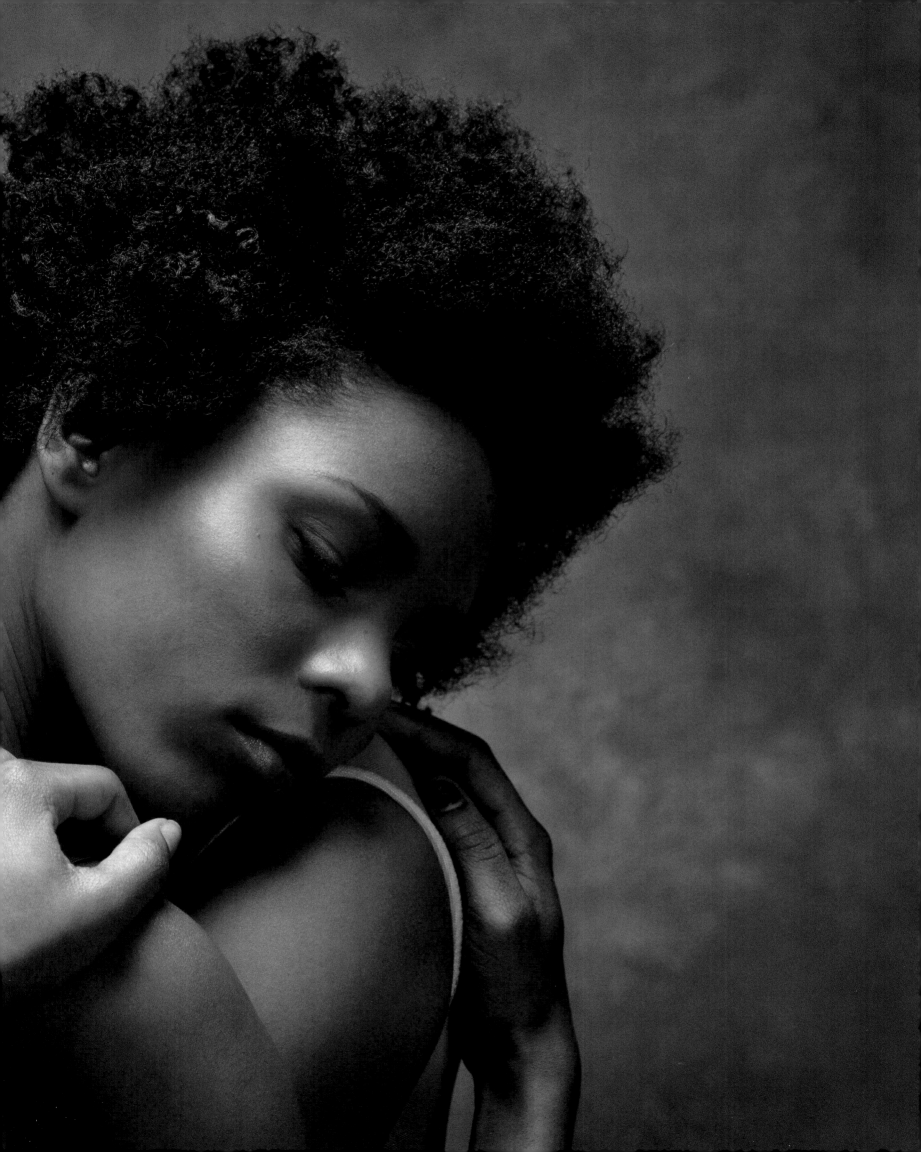

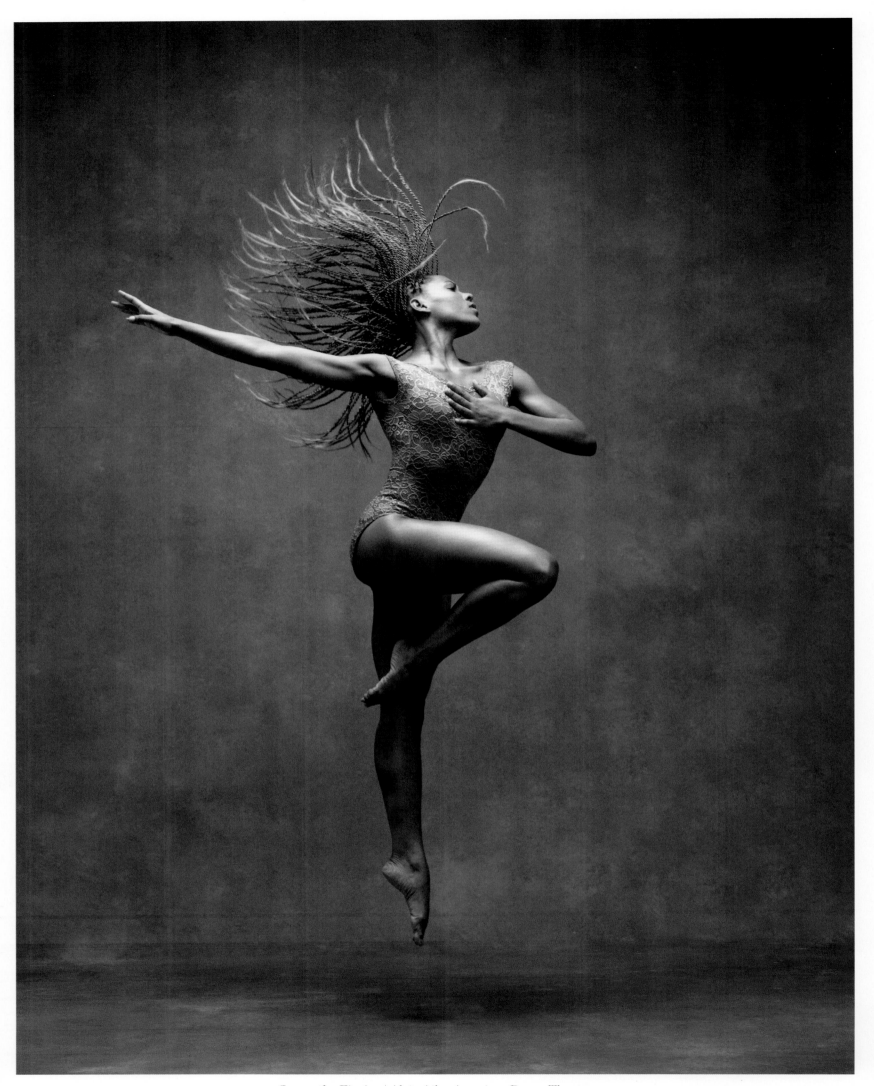

Samantha Figgins | Alvin Ailey American Dance Theater

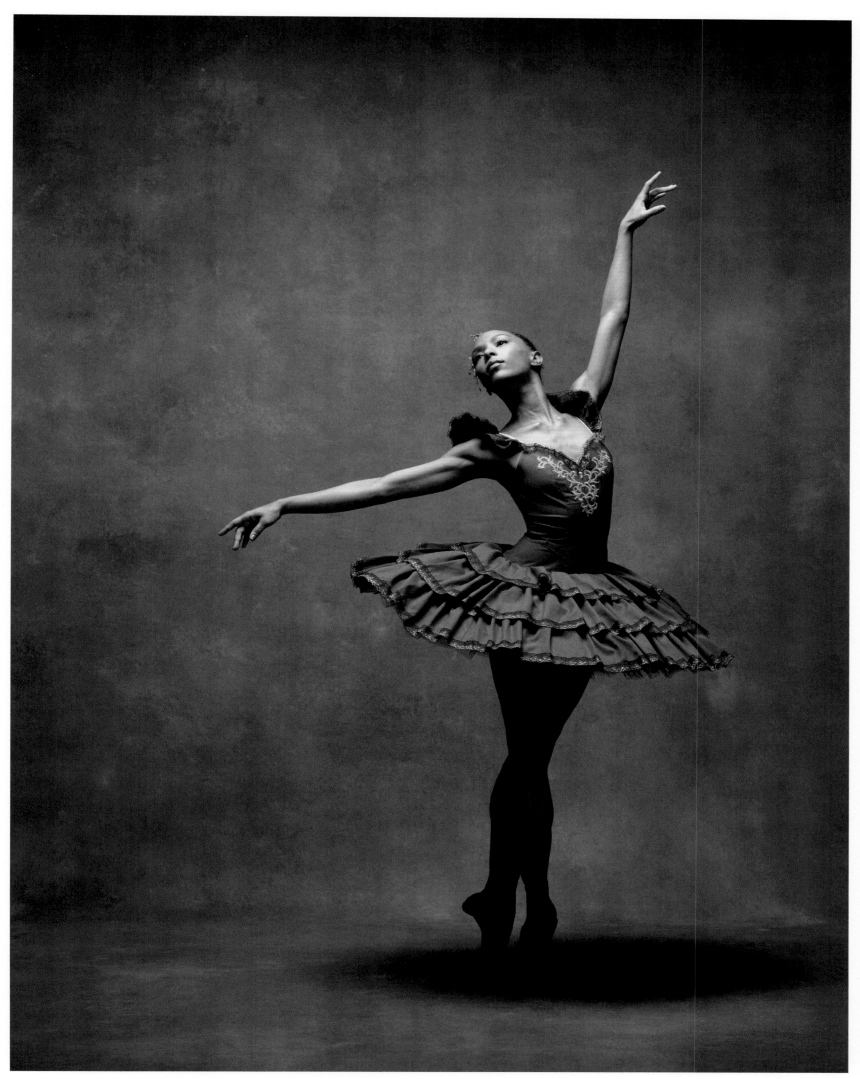

Jenelle Figgins │ Dance Theatre of Harlem

"For my family dance was completely uncharted territory.
We had no idea what to expect.
I don't think, at the time, my parents ever expected it
to shape my life in such a dramatic way."

–Lonnie Weeks

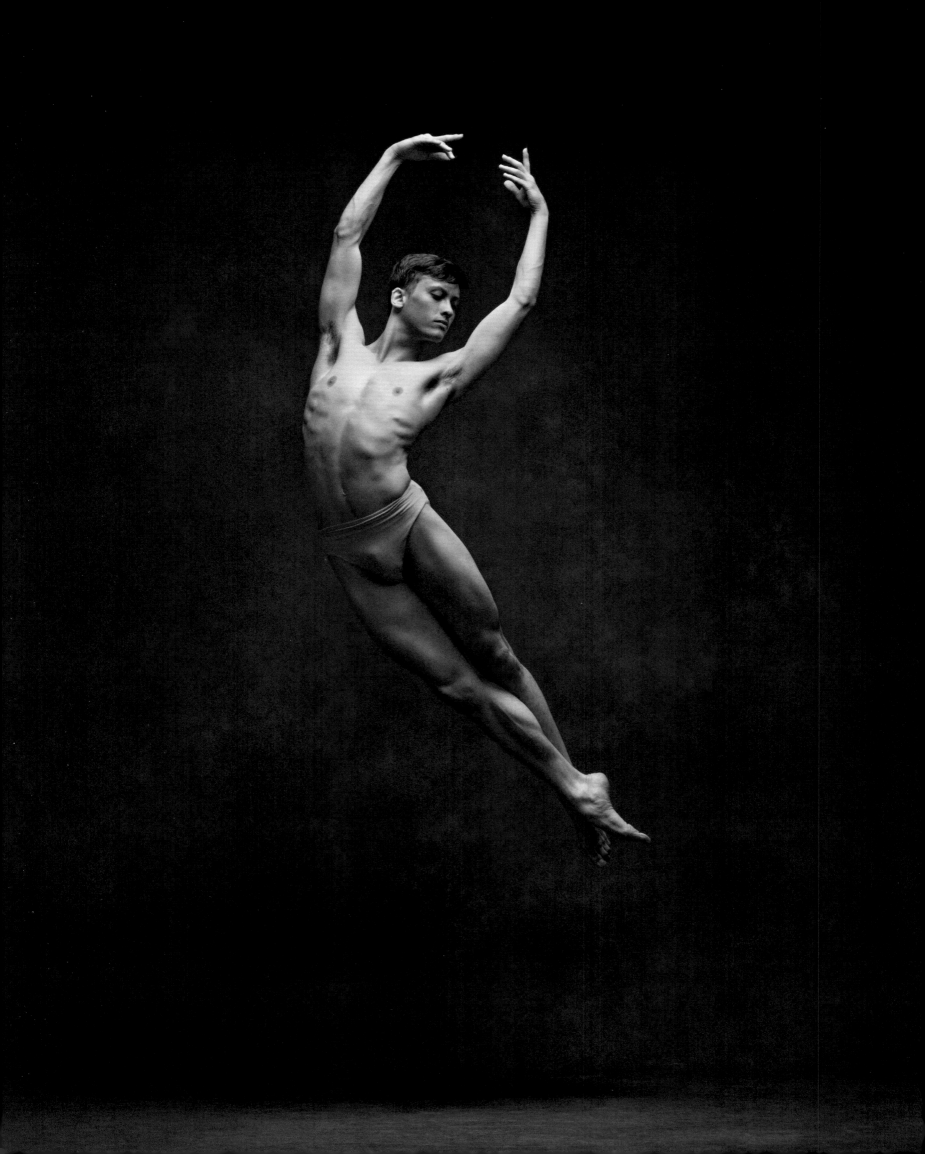

"I don't get nervous as much anymore. I feel like the day
Peter Martins (the Artistic Director) promoted me to soloist
was the day I found what I needed.
It was someone telling me, I am validating you as you are
for who you are as an artist—and that's enough.
It gave me a lot of confidence because it made me feel like
I could be myself, and I don't have to look like anybody else.
I can just be Lauren, and that's enough."

–Lauren Lovette

Lauren Lovette and *Chase Finlay* | Principals, New York City Ballet

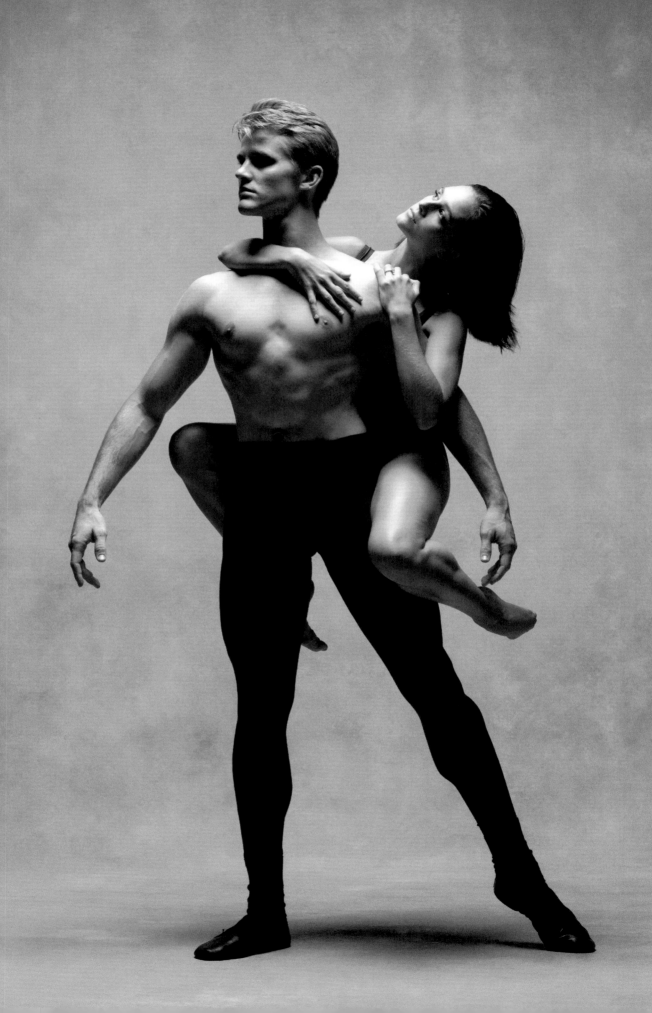

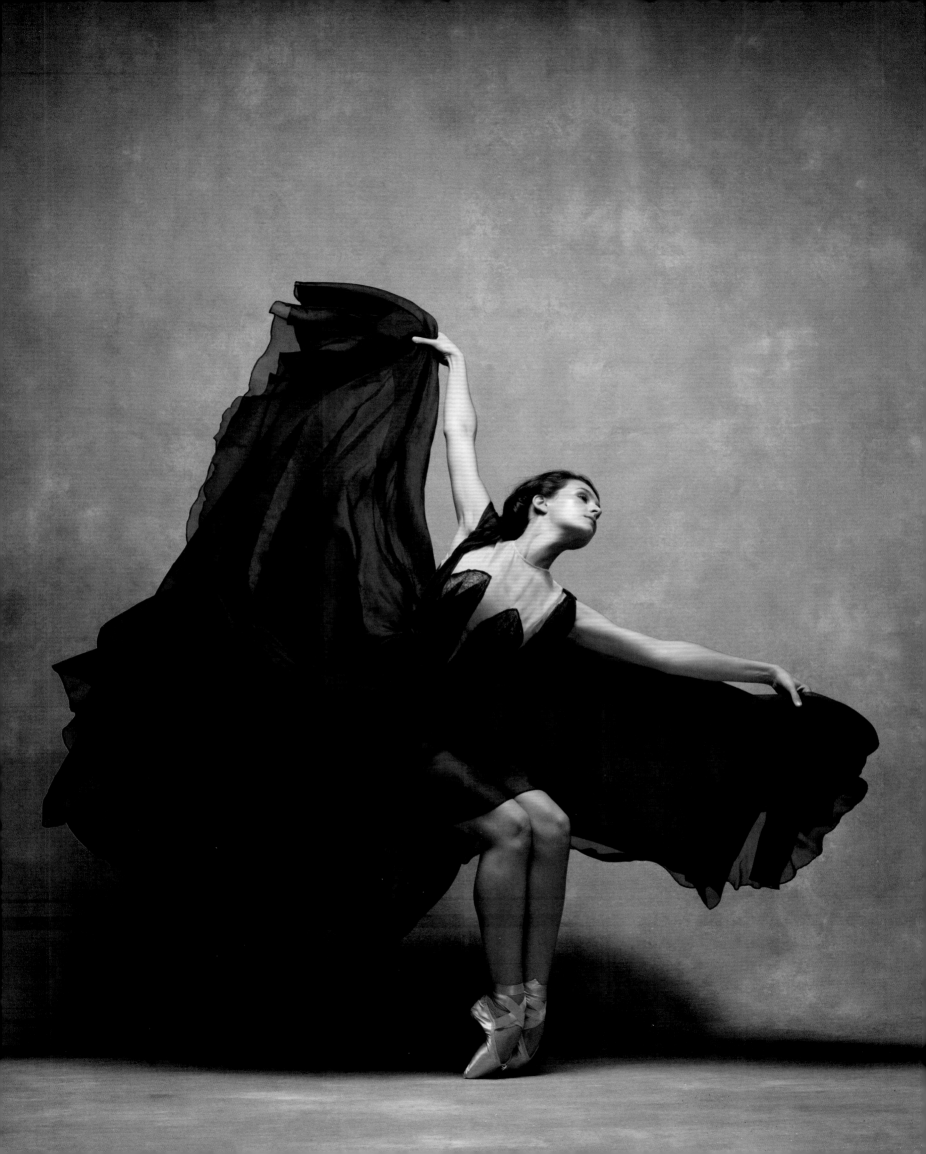

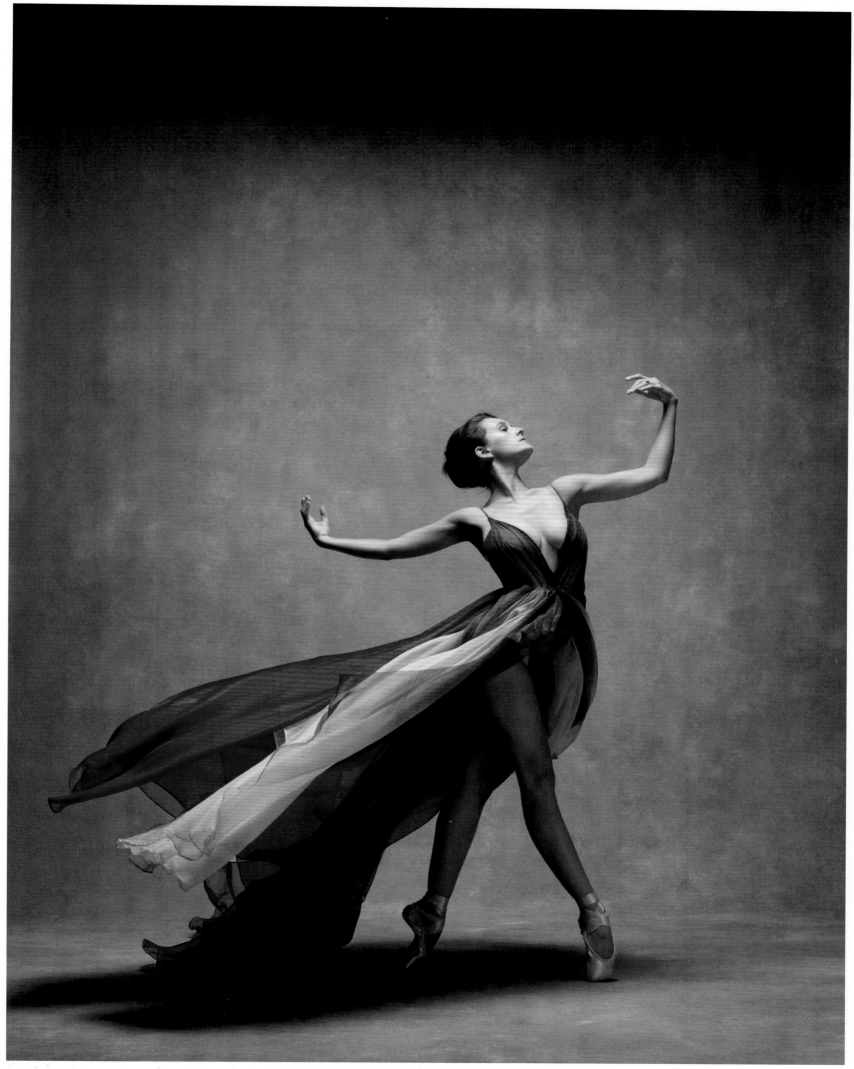

Lauren Lovette | Principal, New York City Ballet

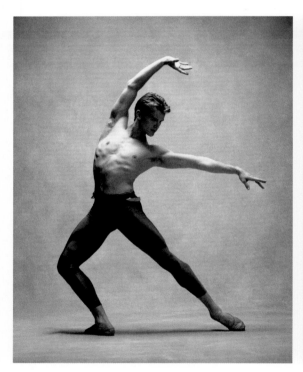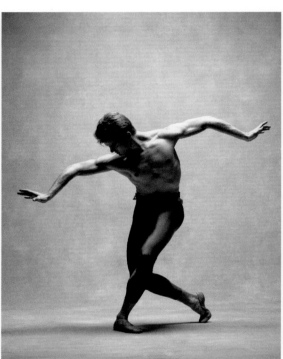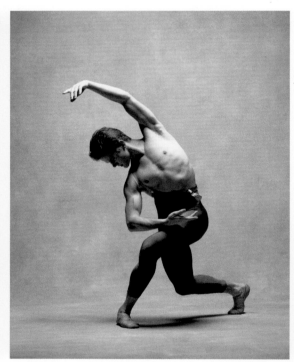

Chase Finlay | Principal, New York City Ballet

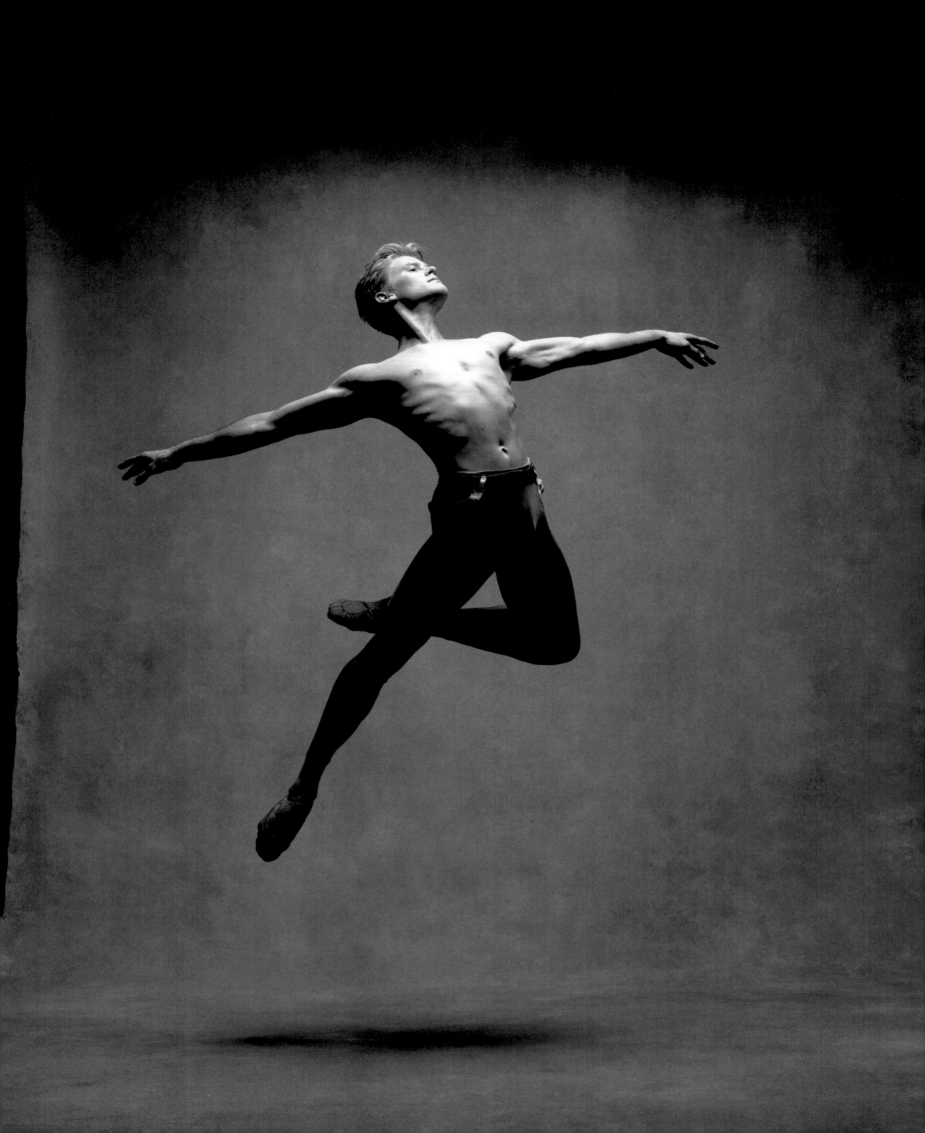

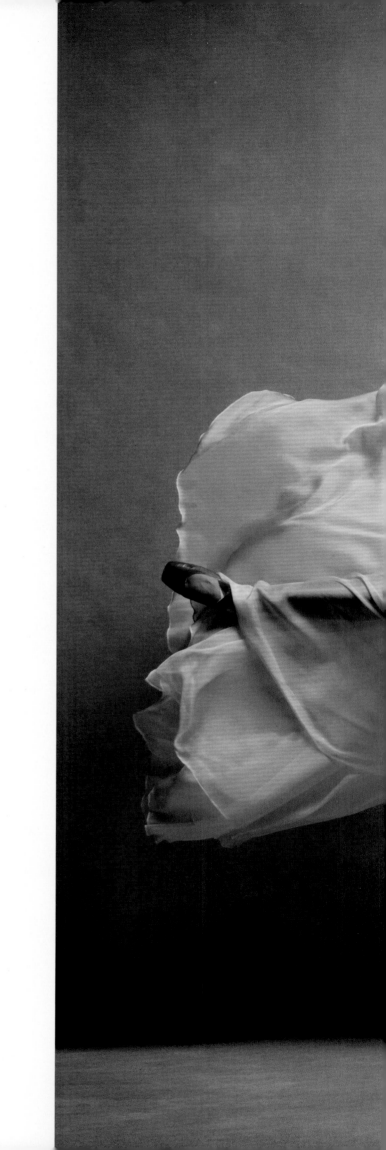

Lauren Lovette and Chase Finlay | Principals, New York City Ballet

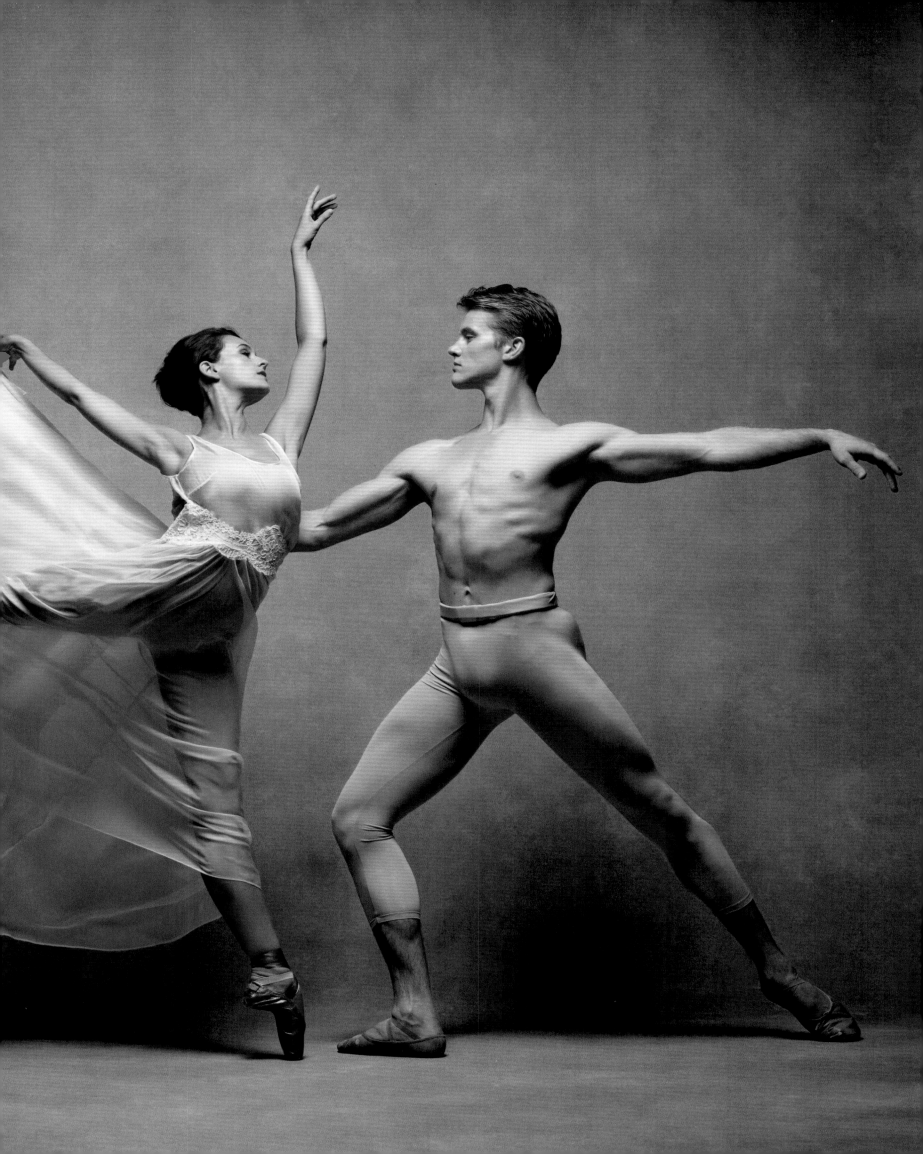

"Everyone has a way of expressing and communicating with their bodies. Classical ballet is an organized way to express feelings between human beings.
People shouldn't be afraid that they don't understand ballet. It is not meant to be understood, it is meant to be enjoyed."

–Angel Corella

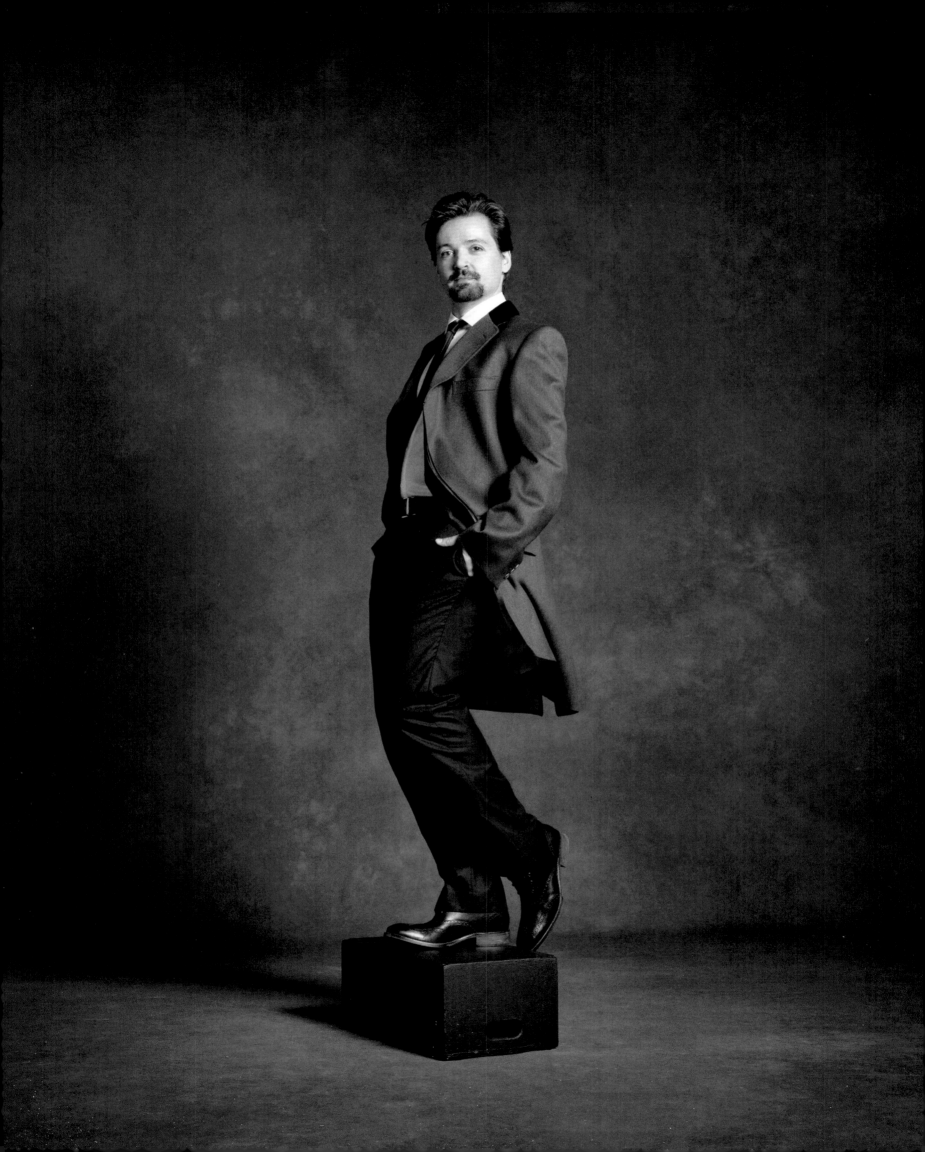

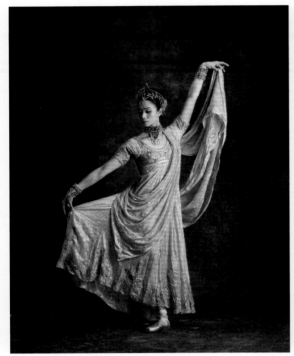 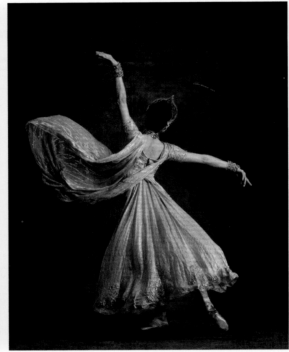 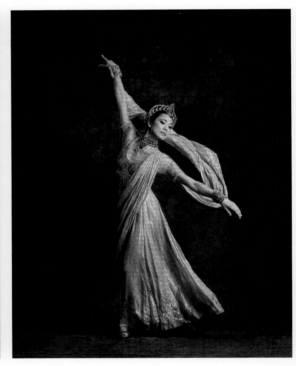

Stella Abrera | Principal, American Ballet Theatre

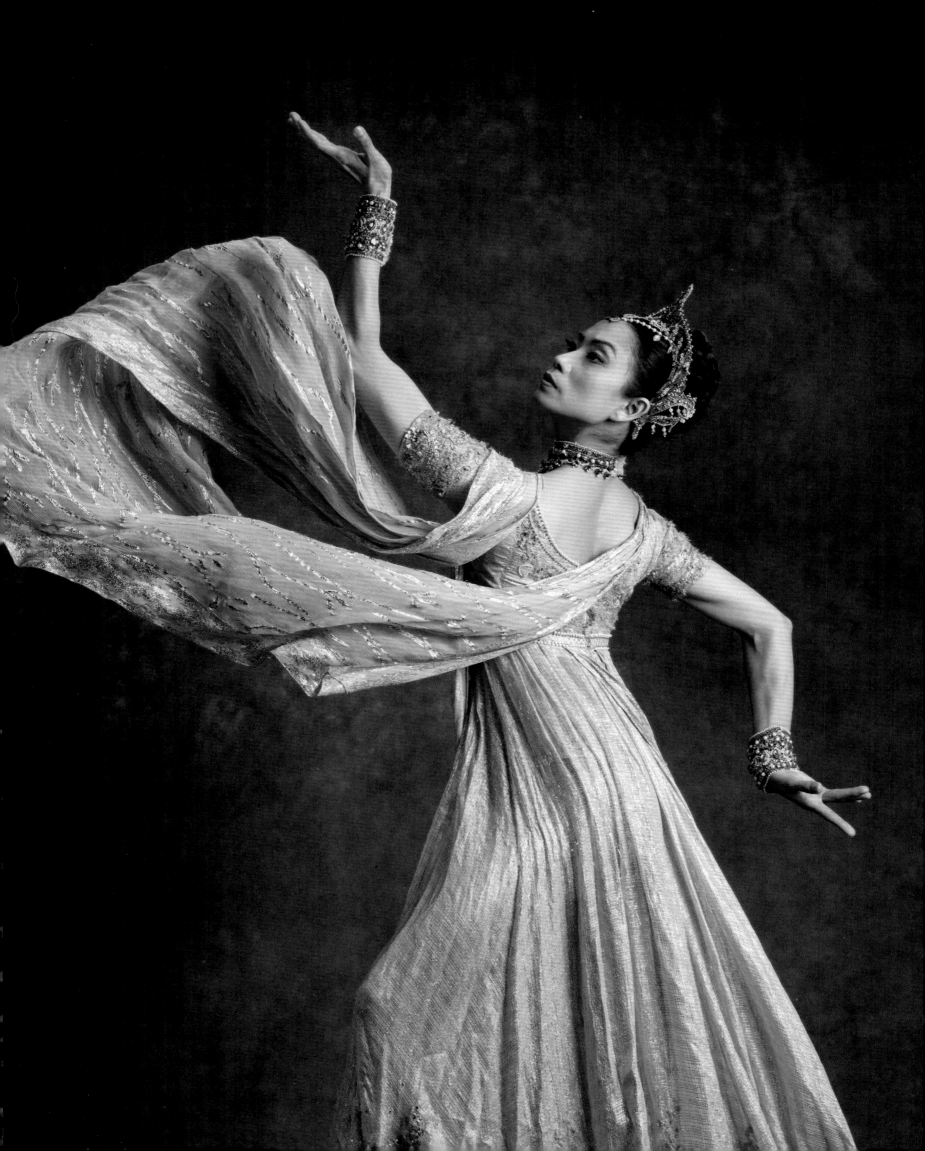

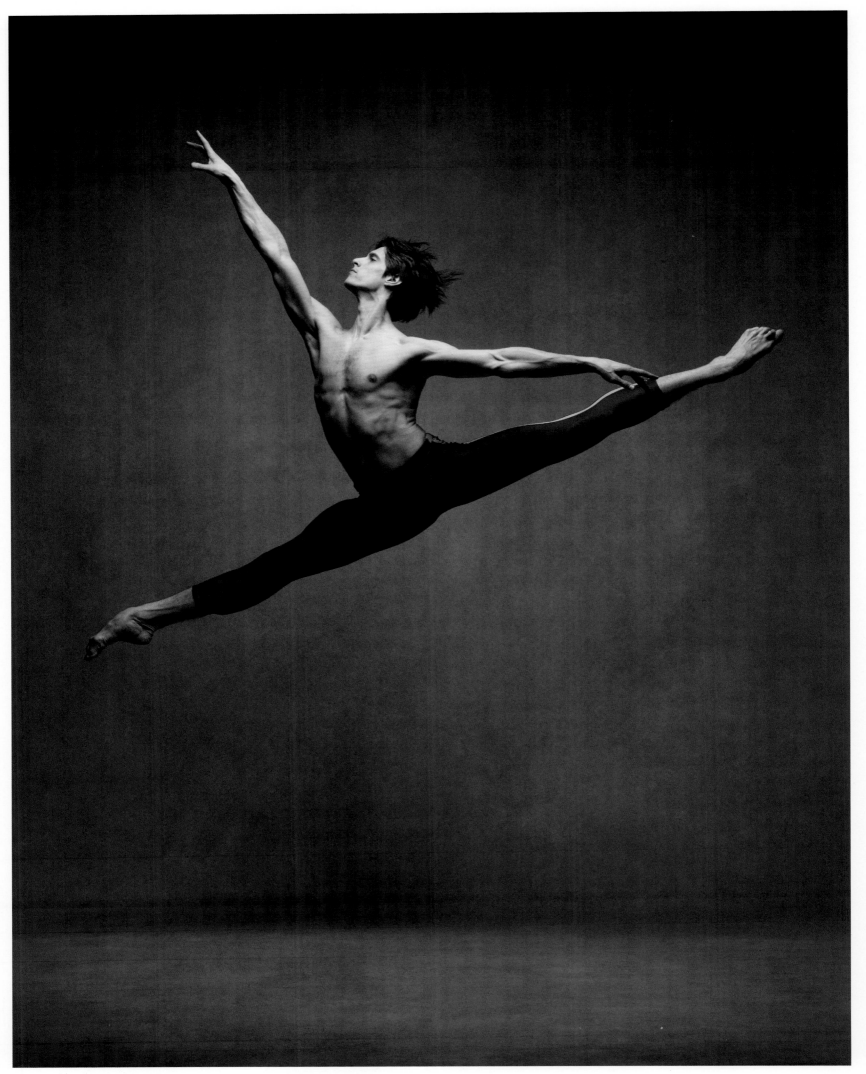

Xander Parish | First Soloist, Mariinsky Ballet

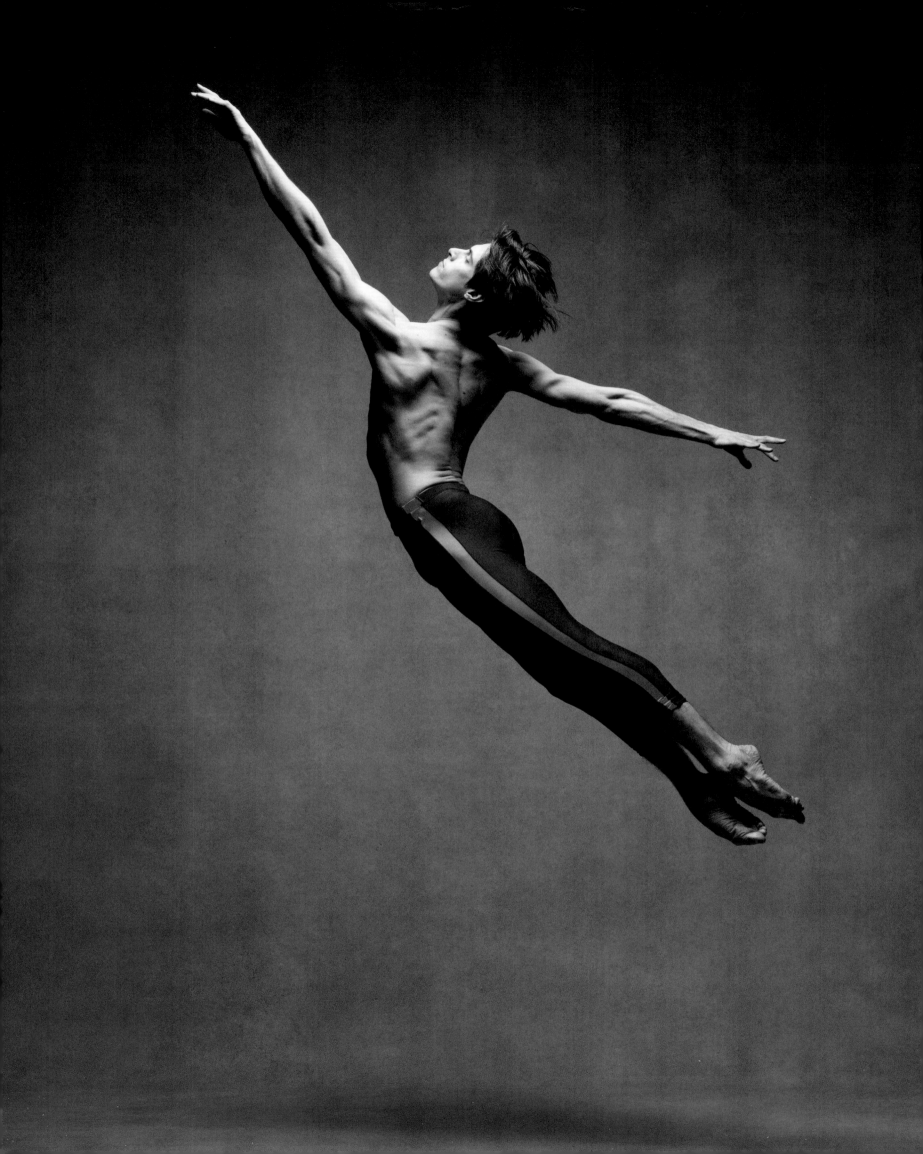

"It seems to me that it must be even more difficult for
 dancers with astounding physicality to bring humanity
to their performance—to reveal their human vulnerability,
their personal hopes, fears, and dreams,
while performing astonishing super-human feats.
But this is the reason you can't take your eyes off of PeiJu.
Every move she makes draws us into her emotional journey.
With the same rigor she has used to become an unmatched
dance athlete, PeiJu has honed the opening of her heart."

–Janet Eilber, Artistic Director, Martha Graham Dance Company

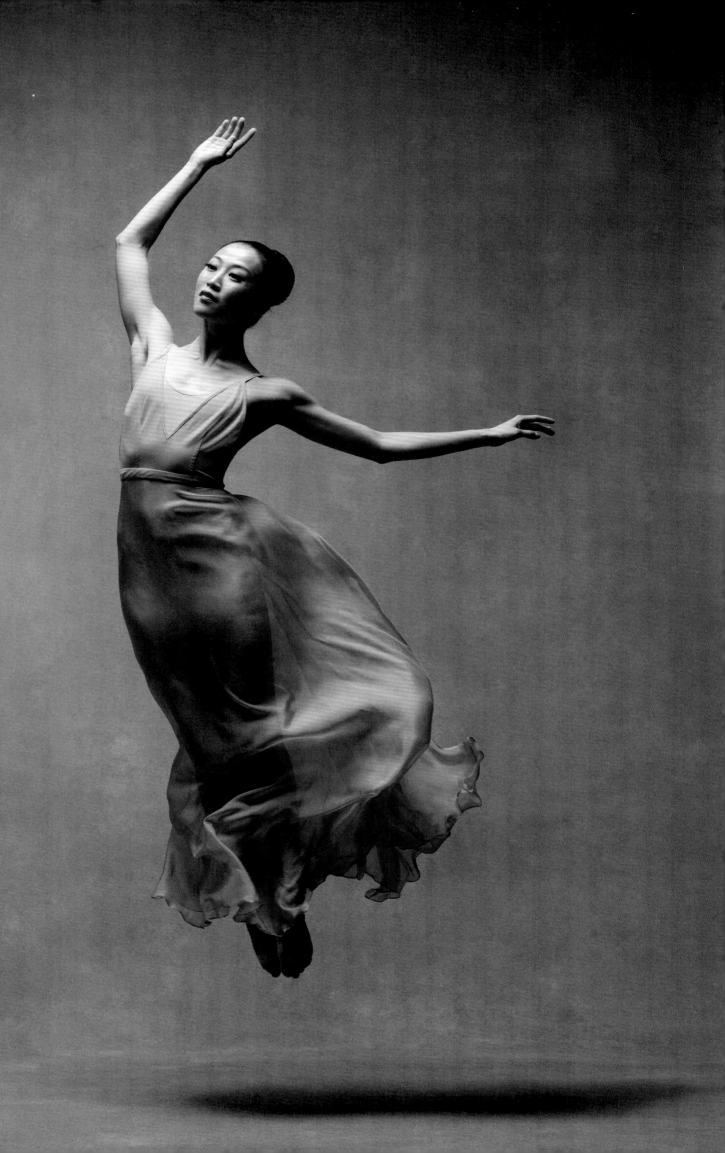

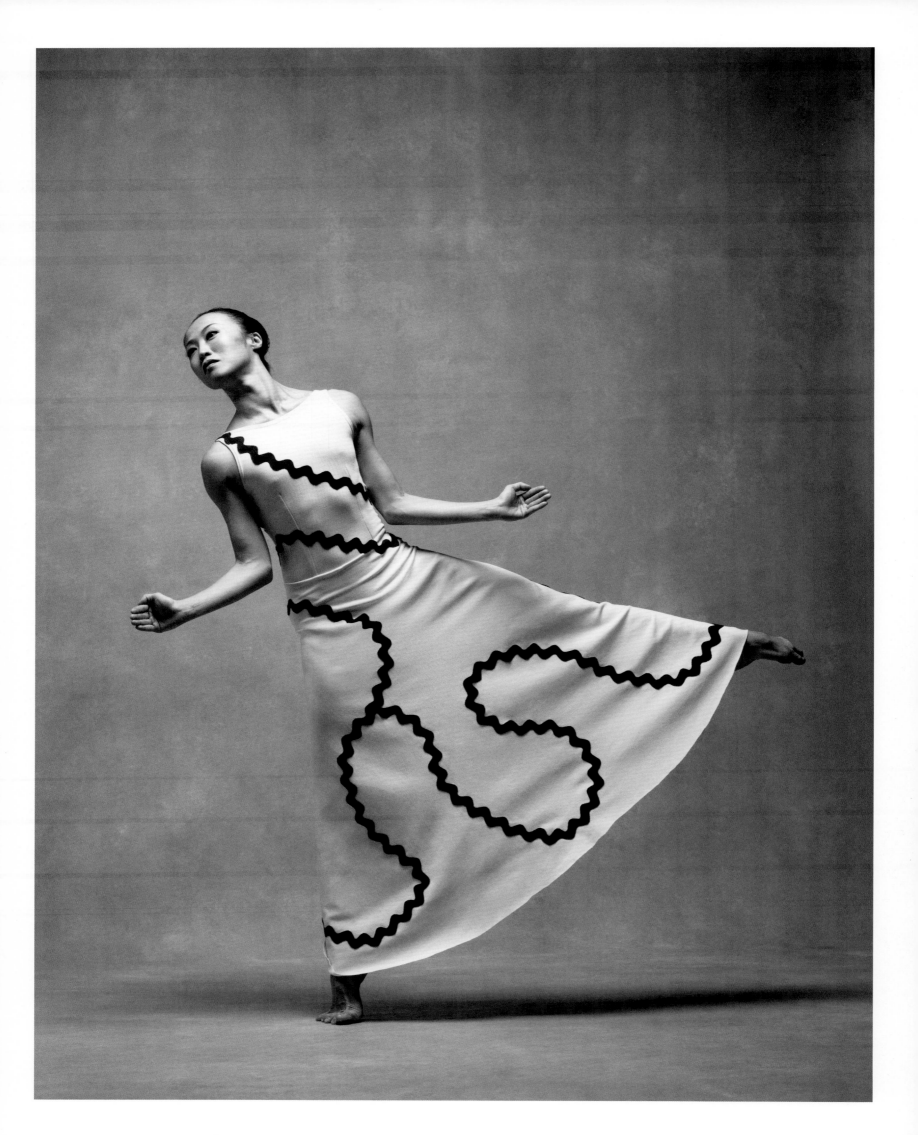

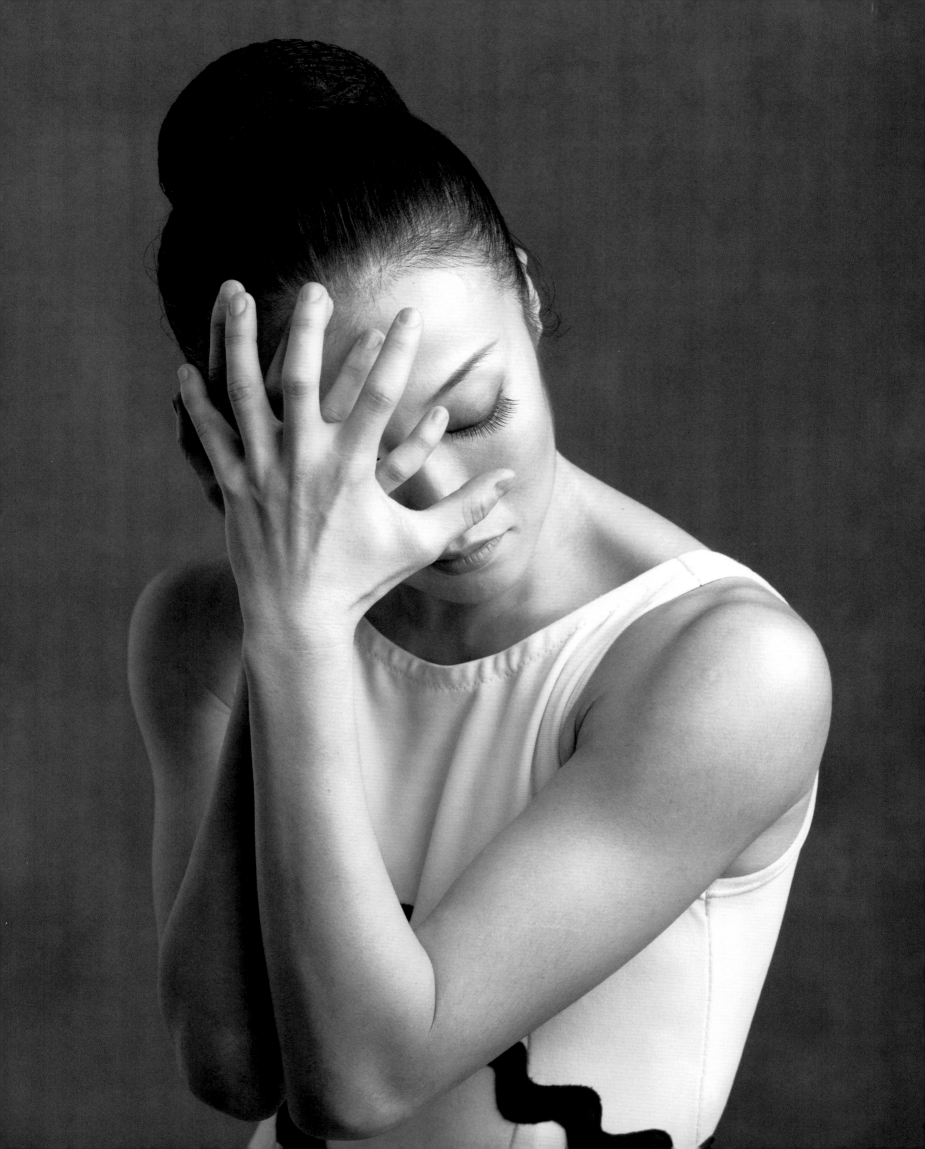

"Being on stage again feels right for me.
I believe that ballet is not just about the number of
pirouettes you can do or how high you can kick your leg.
Ballet is an art and there is no age limit to express yourself.
Just accept who you are and who you have become.
Your age and your limits. Use your life experiences
to bring something new to your art."

–Isabelle Guerin-Frohlich

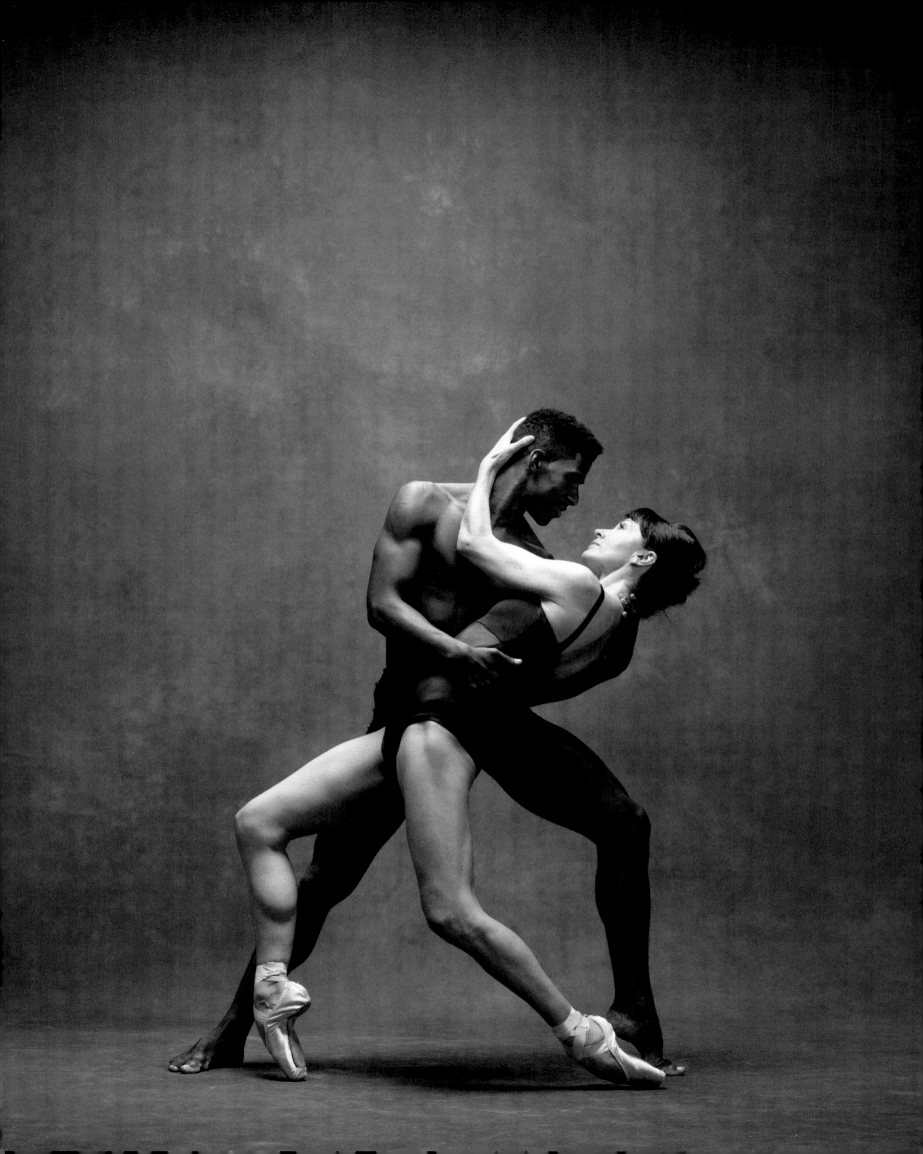

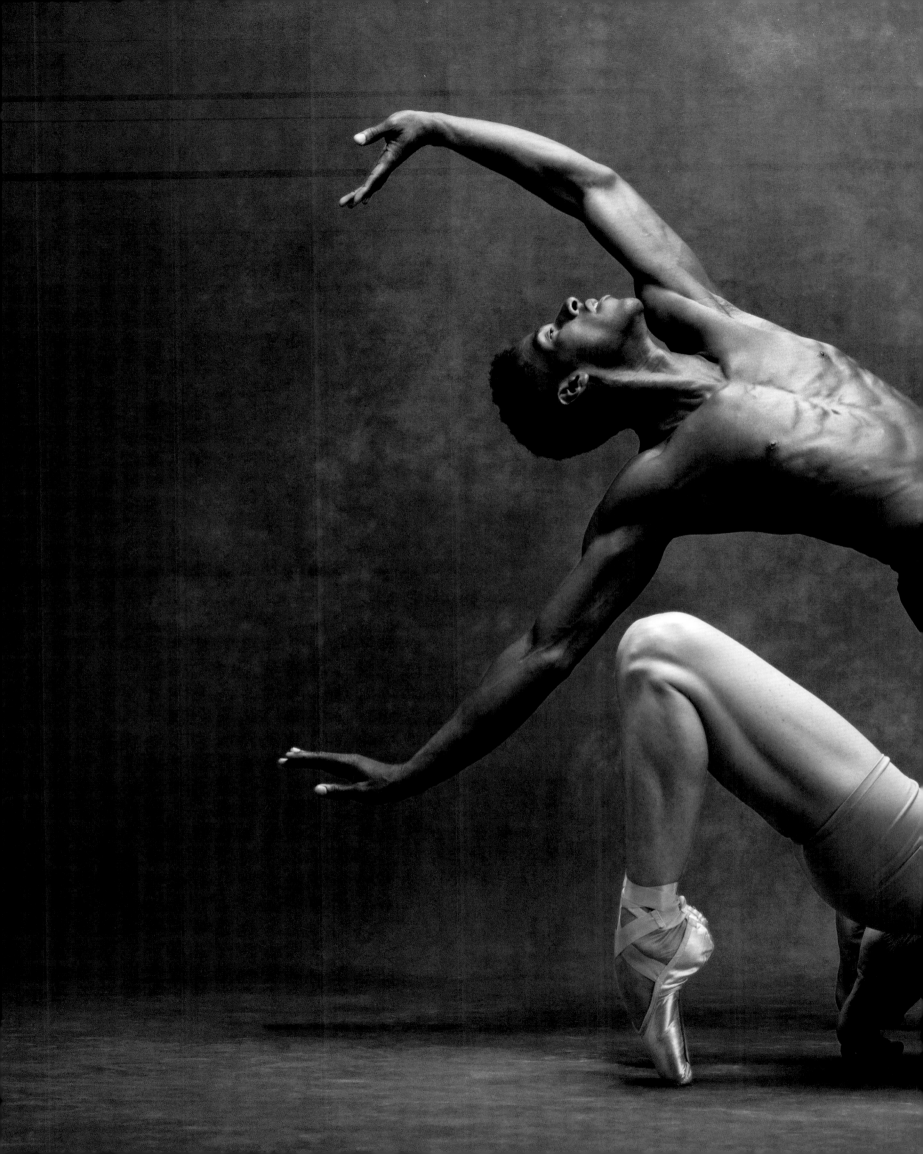

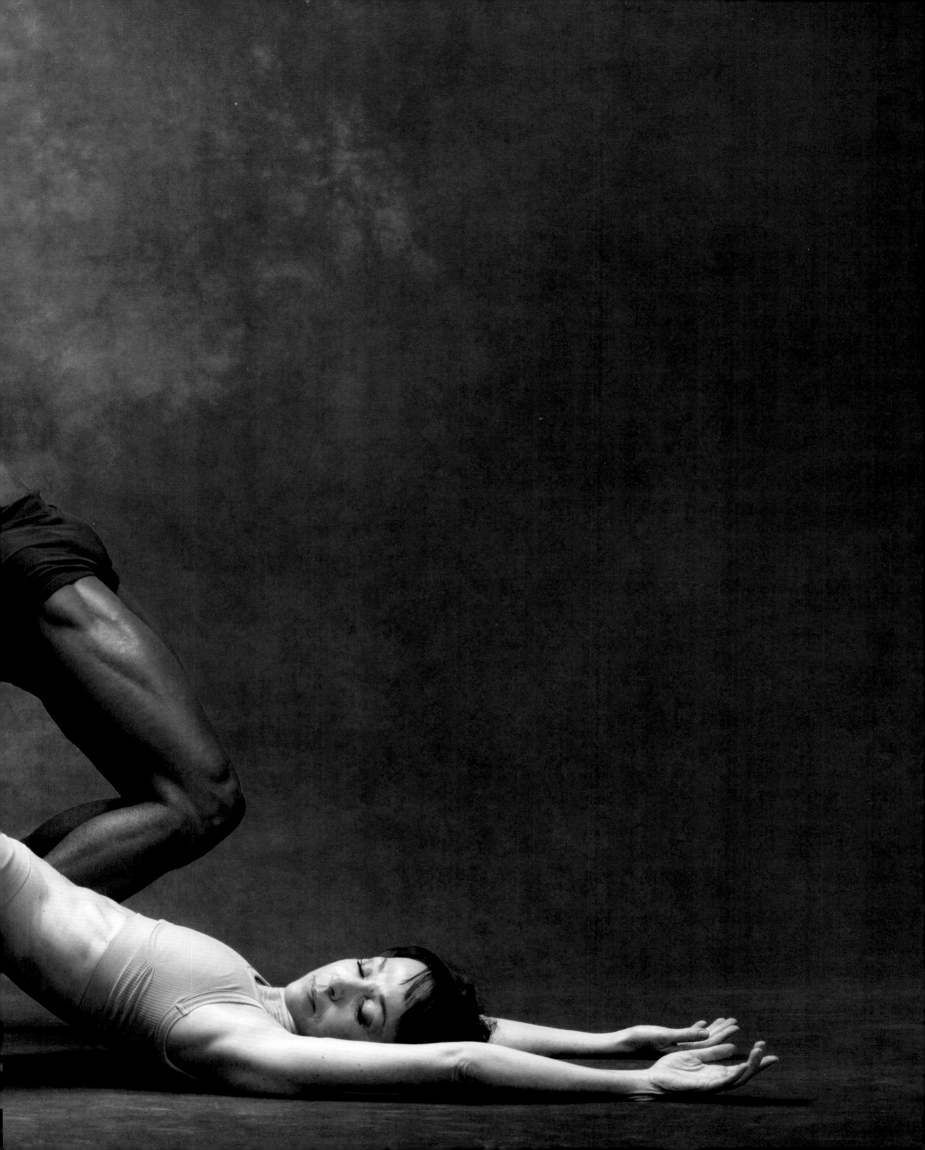

"In order to communicate truth and the universality
of human experience, a ballerina must gain perspective and
dimension from both her own life experience and her intense
respect and dedication to the craft of ballet.
She must go beyond the steps and strive to bring her
humanity and humility purely and truly to every moment
of expression. That, to me, is artistry that is meaningful
both on and off the stage."

–Gillian Murphy

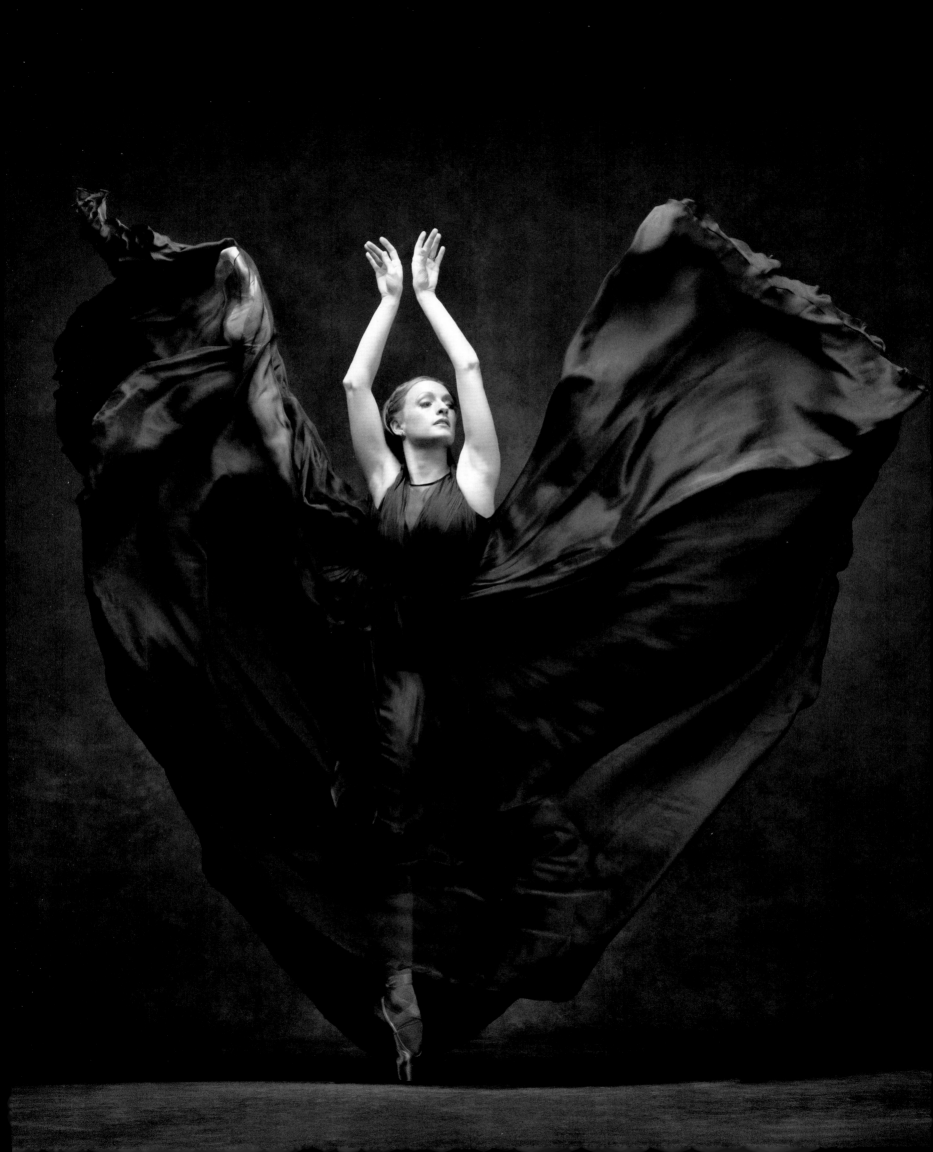

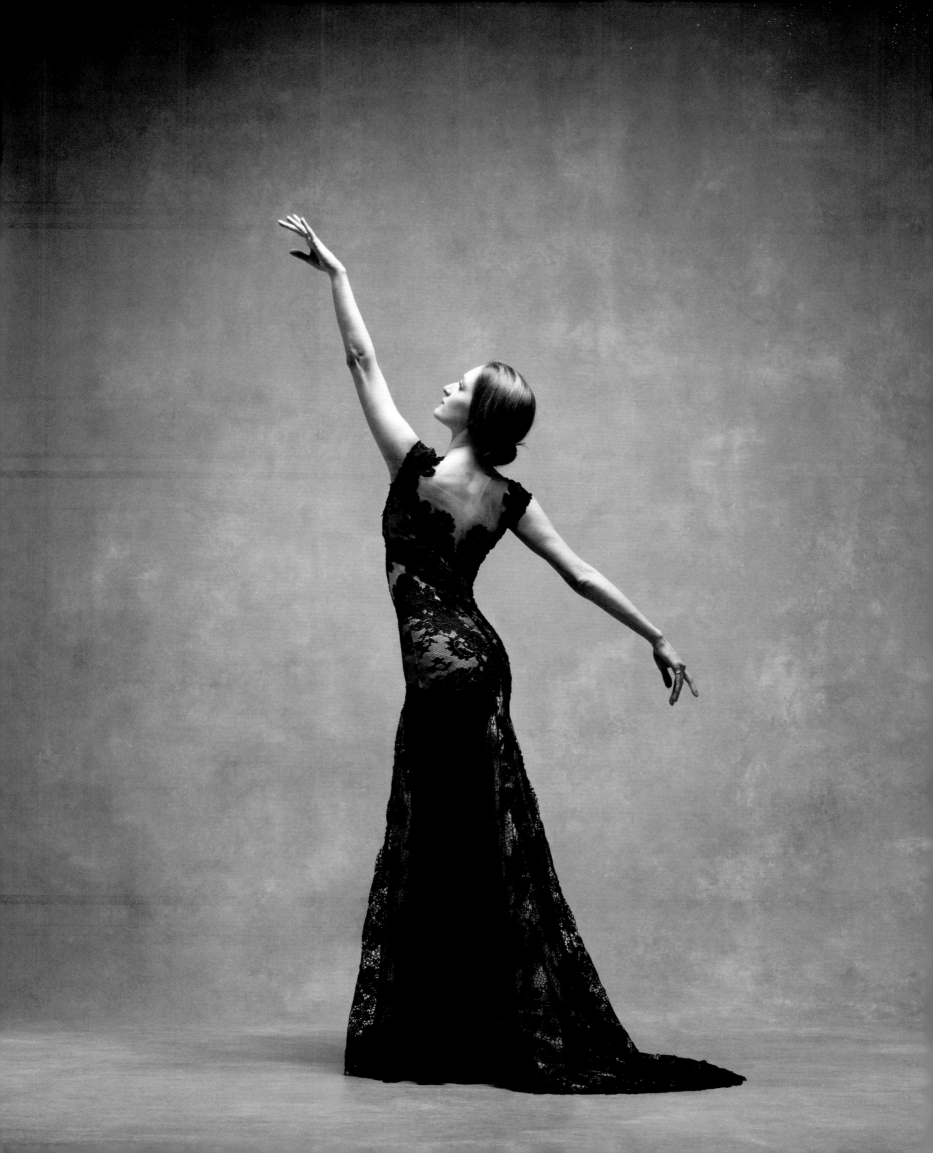

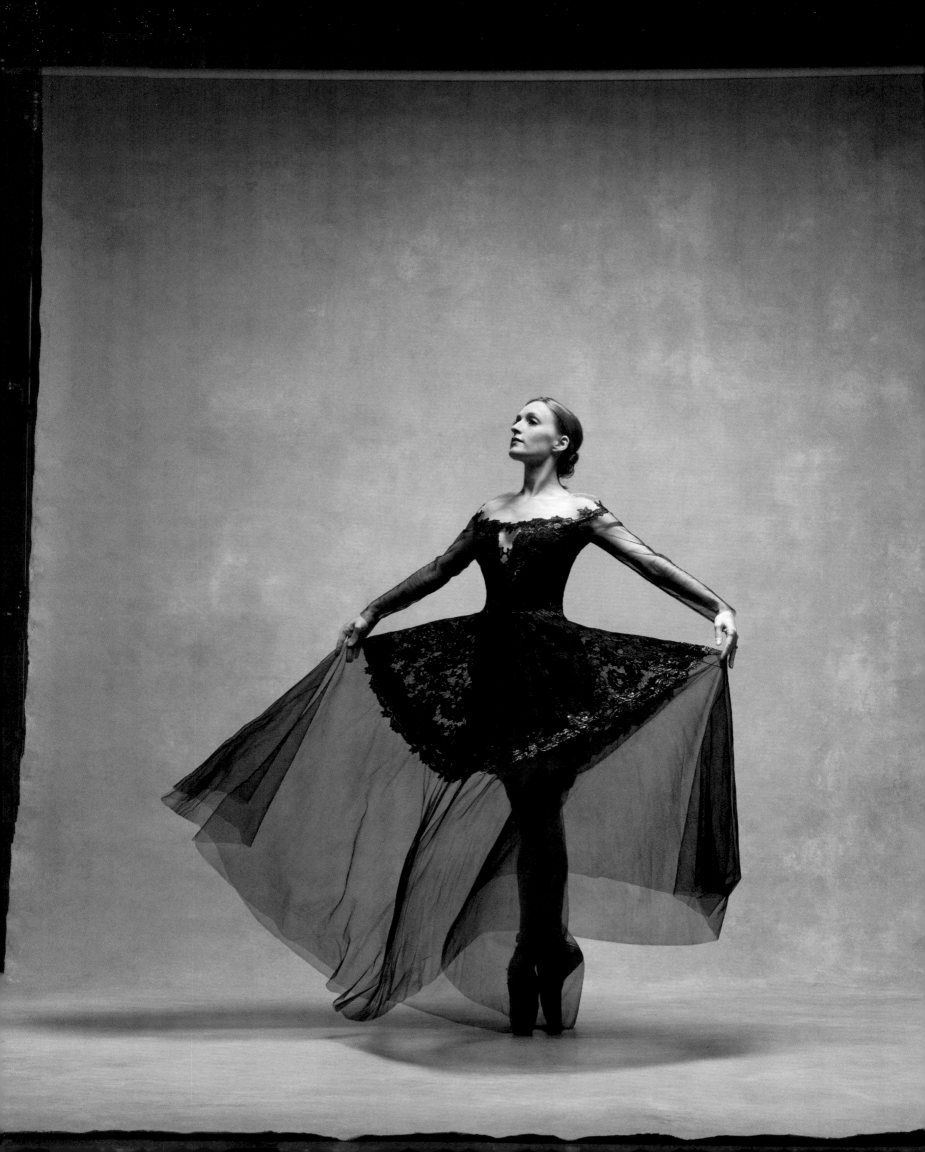

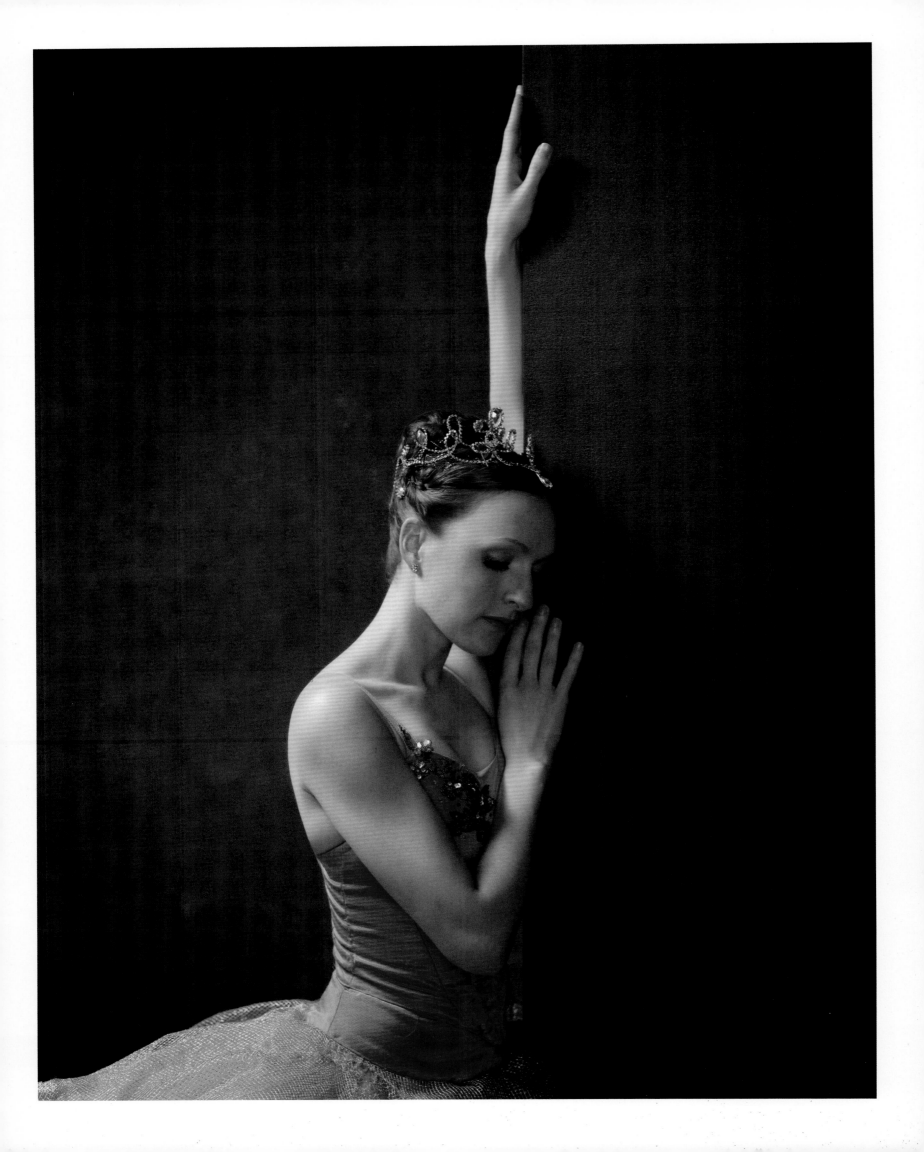

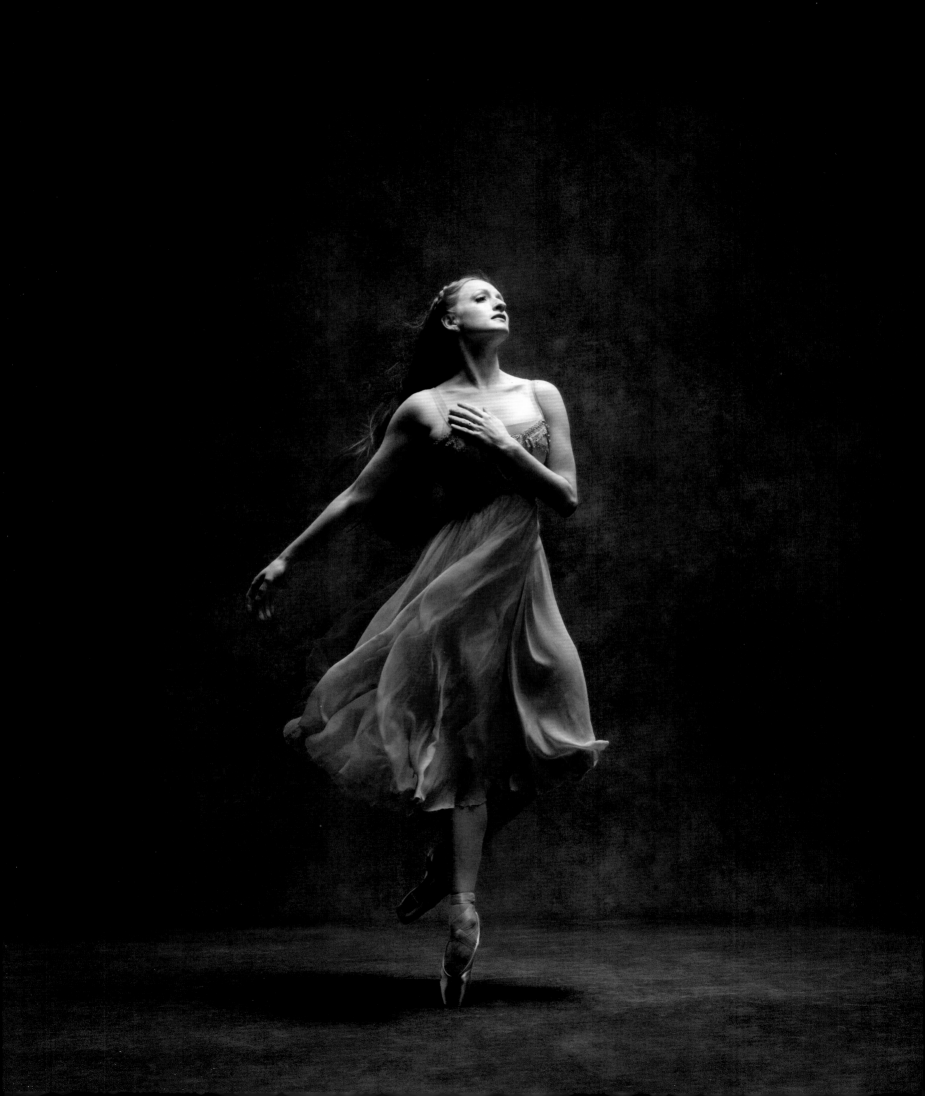

"Dance was simply a natural part of my life.
I will never forget the joyful discovery in my first performance
of expressing myself without words.
For a shy child, with a full imagination, this was a gift.
The lights, the silence, except for the music and the applause,
left an impression on me that lasts to this day."

–Julie Kent

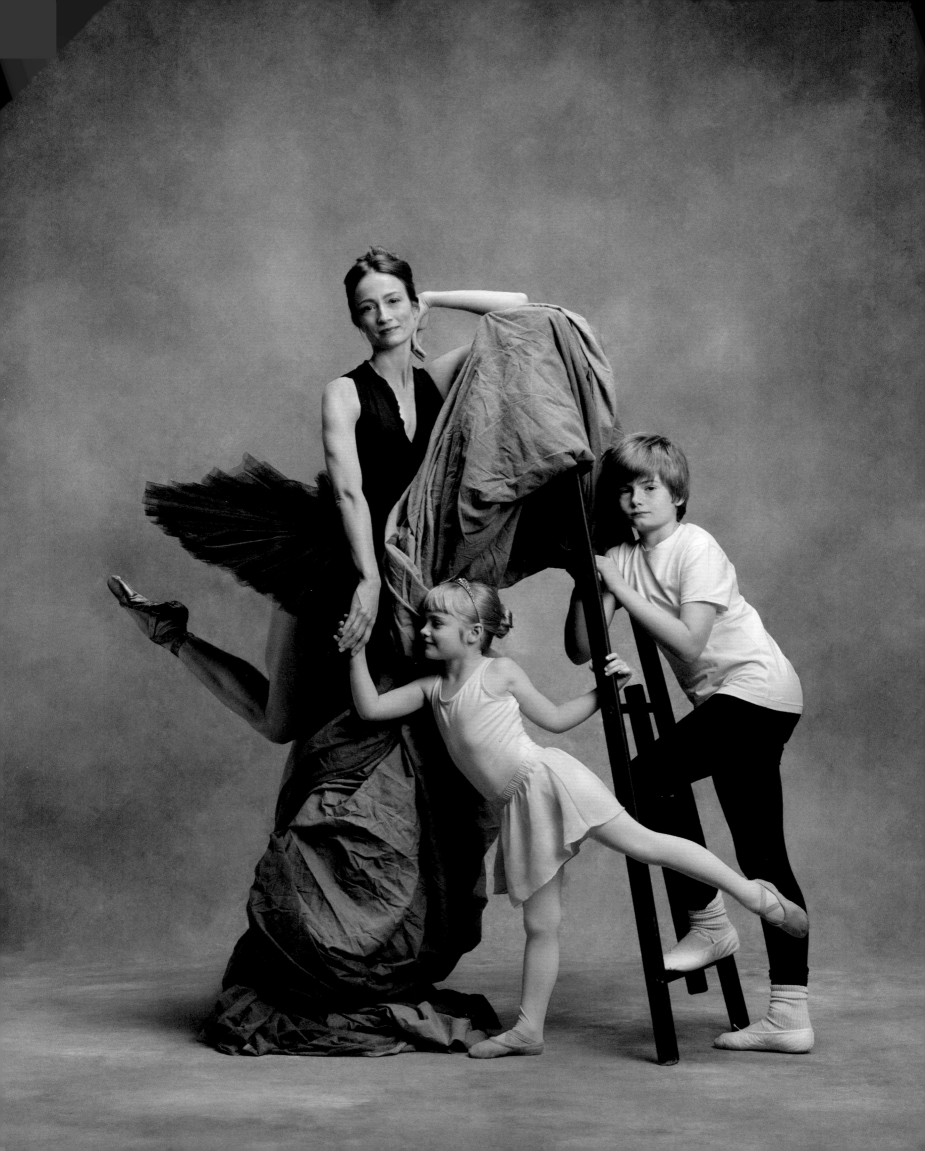

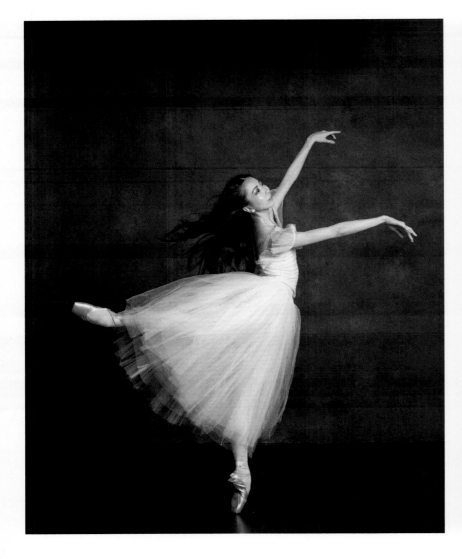
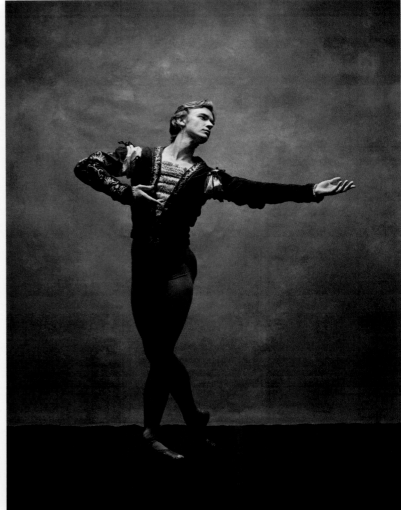

Yuriko Kajiya and **Jared Matthews** | Principals, Houston Ballet

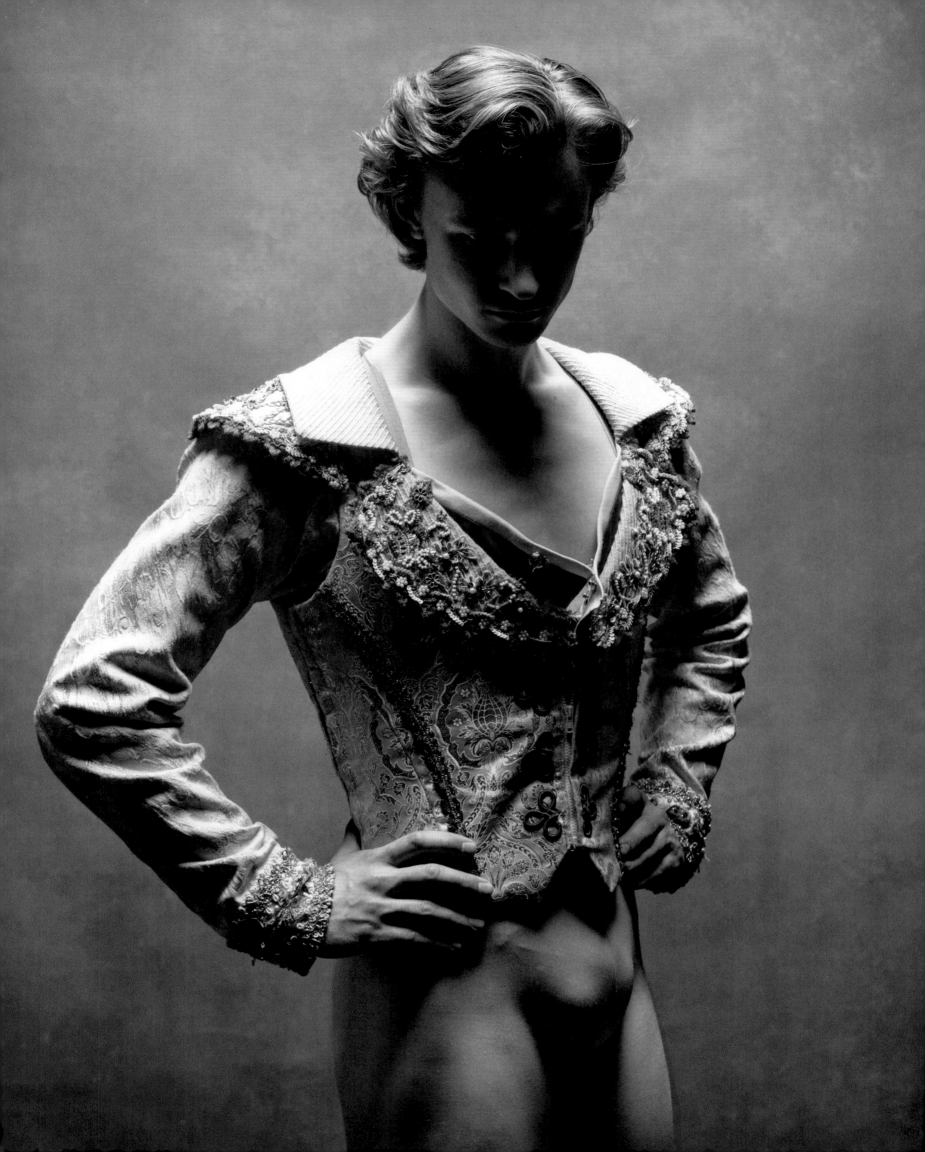

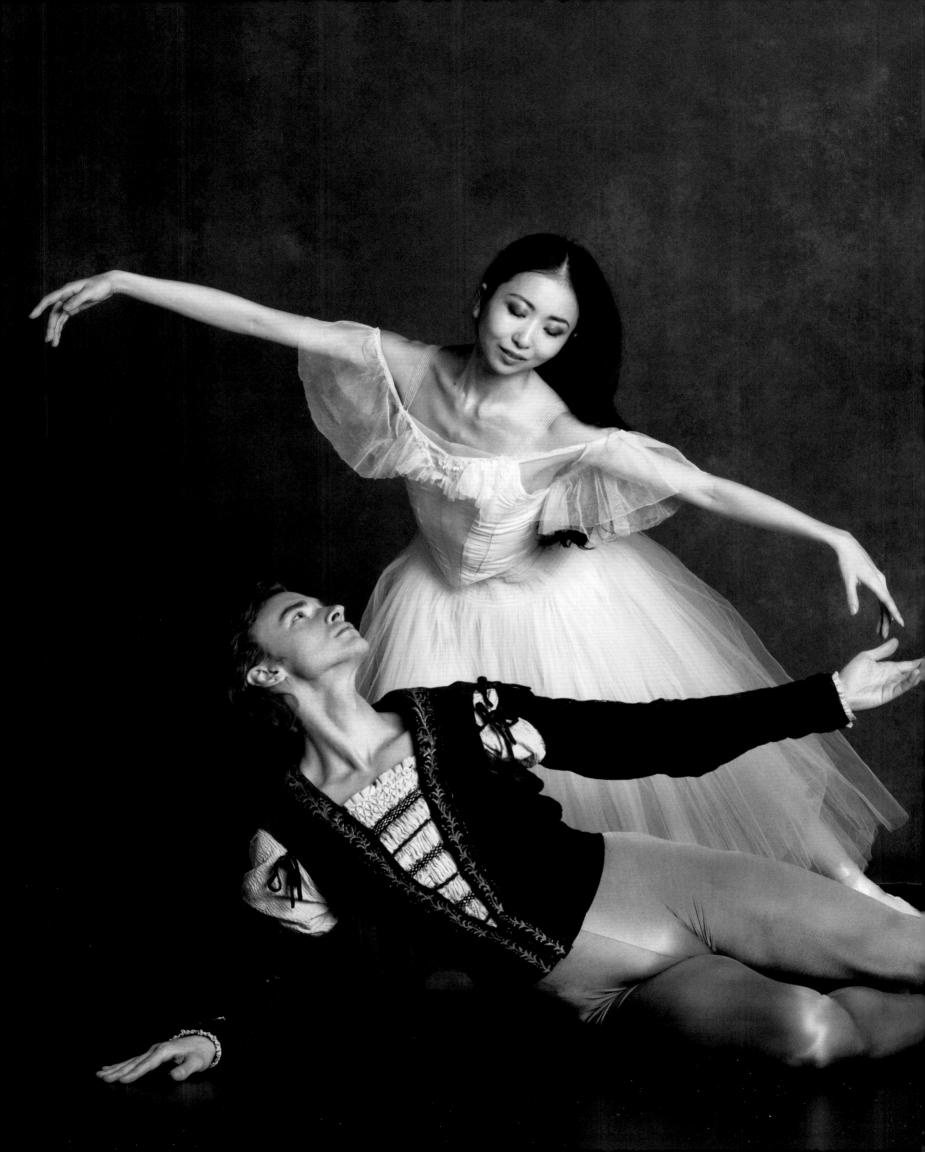

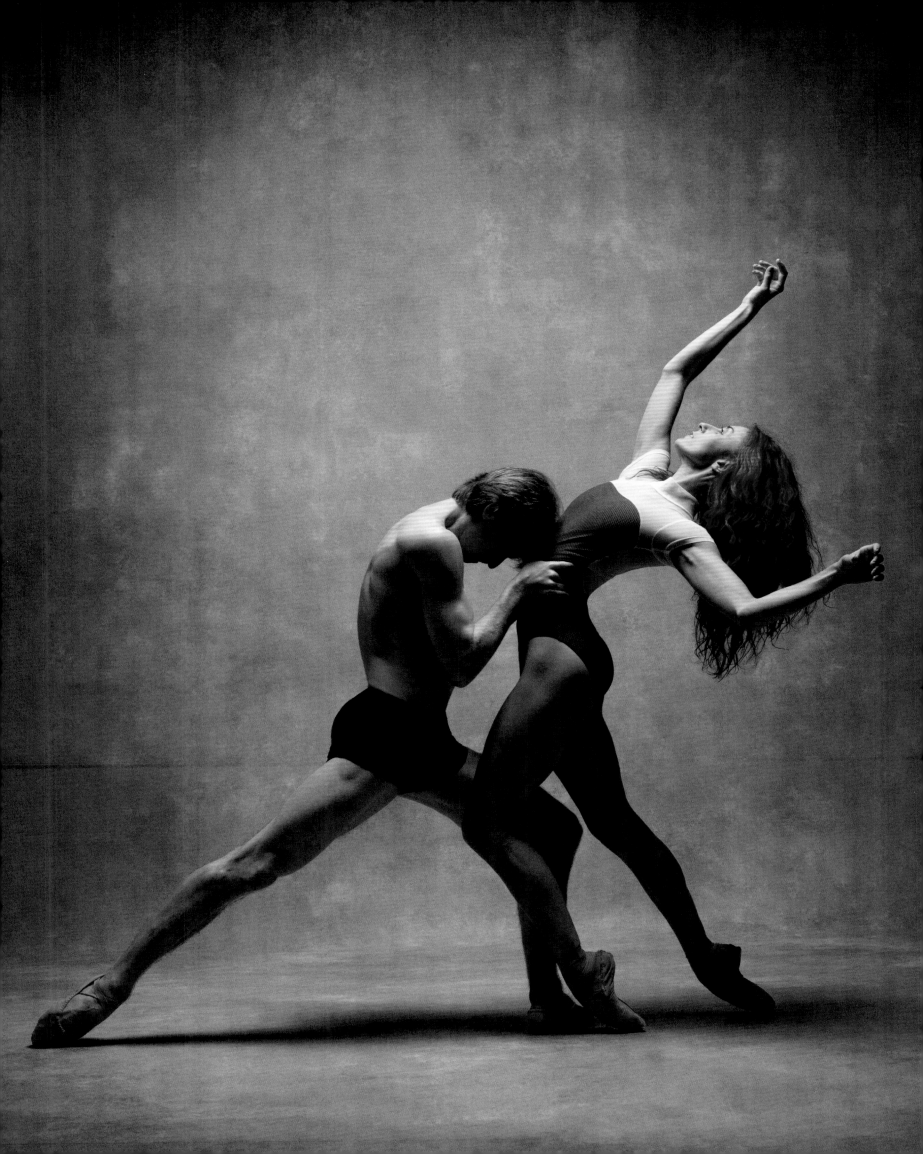

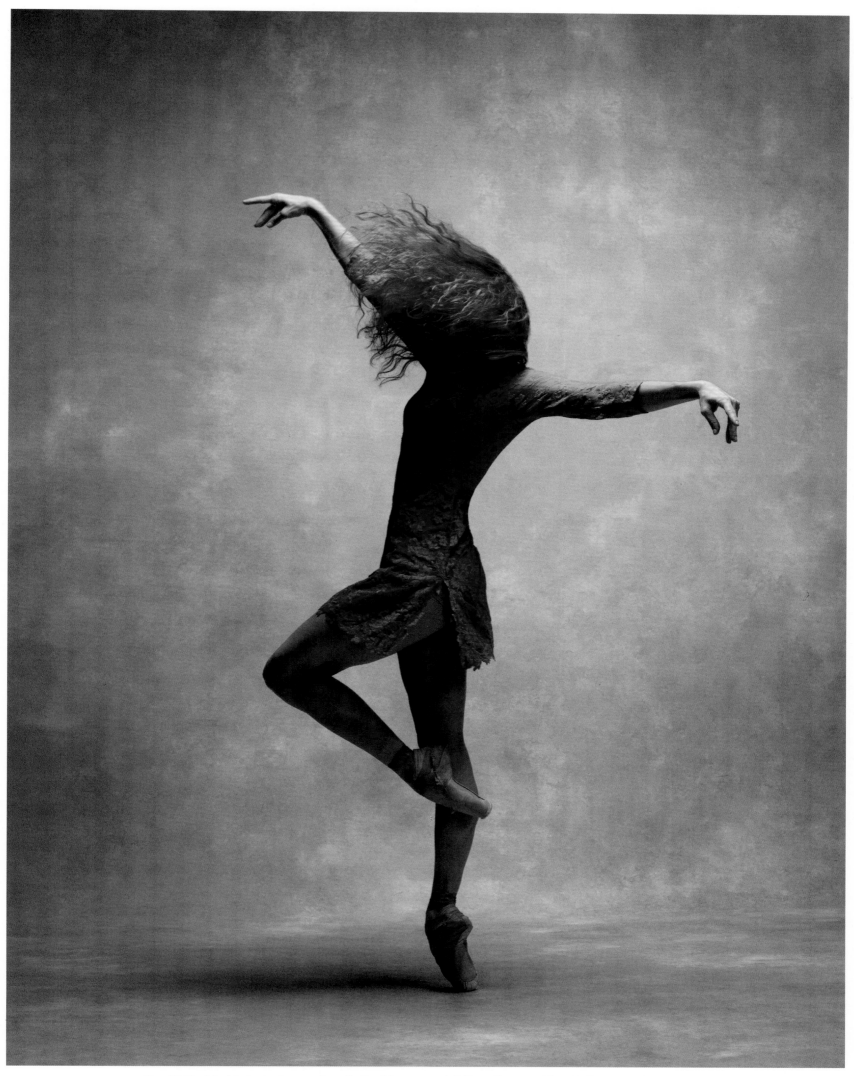

Daniil Simkin | Principal, American Ballet Theatre and **Céline Cassone** | Les Ballets Jazz de Montréal

"I grew up in a log cabin in Pine Creek, Montana—
a town so small it was recently up for sale.
I grew up without a TV, surrounded by nature.
One summer huge herds of buffalo escaped from the park and
decided to graze in our playground. We had to wait to go out
for recess until the American Indians arrived to round them up!

My first exposure to dance was from a beautiful lady
named Judith Younger Hertsens, who had danced with
the San Francisco Ballet. She taught us movement classes
in the back of a restaurant."

–Maria Sascha Khan

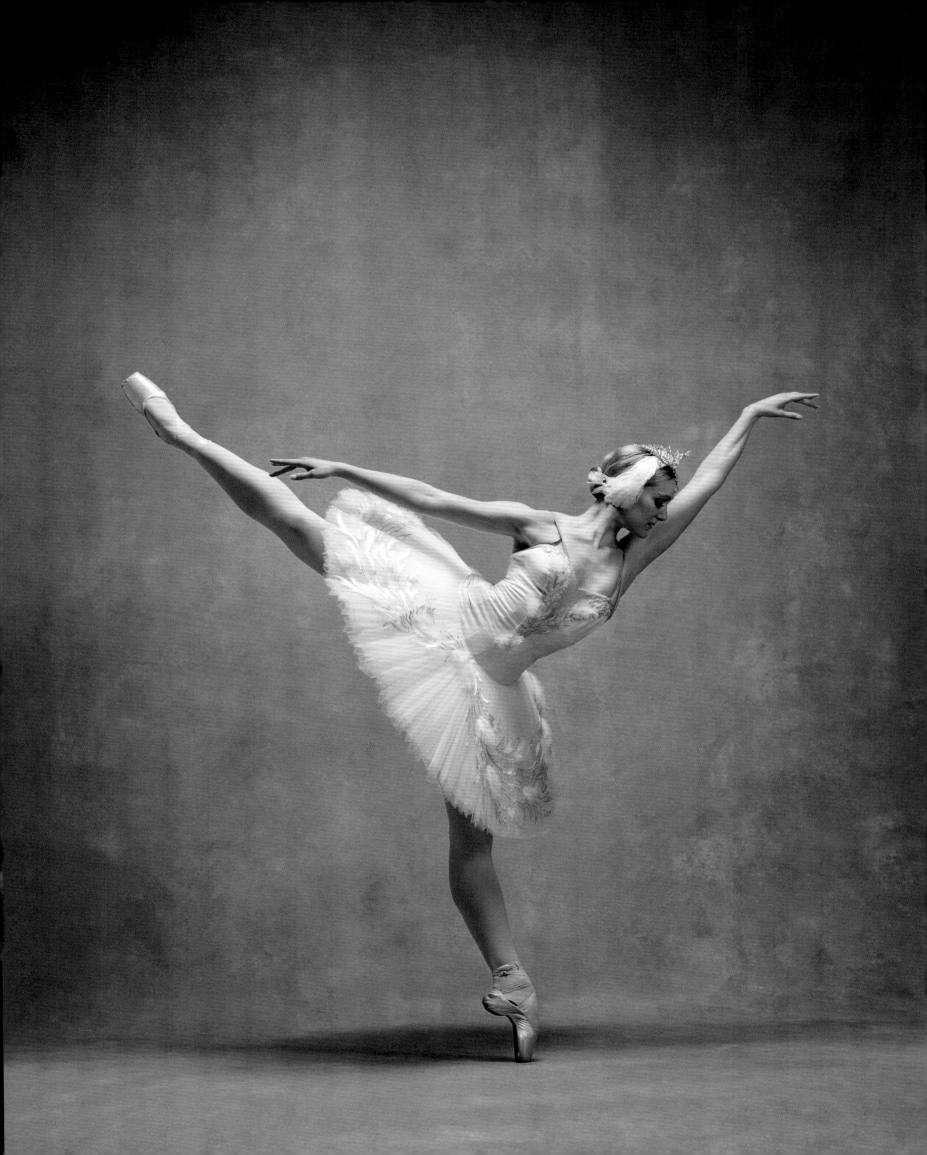

"I wish I could have been more aware that
my ballet career will not last forever.
I am now more cautious of trying to really enjoy each
production whether I have a large role or small."

–Charlie Andersen

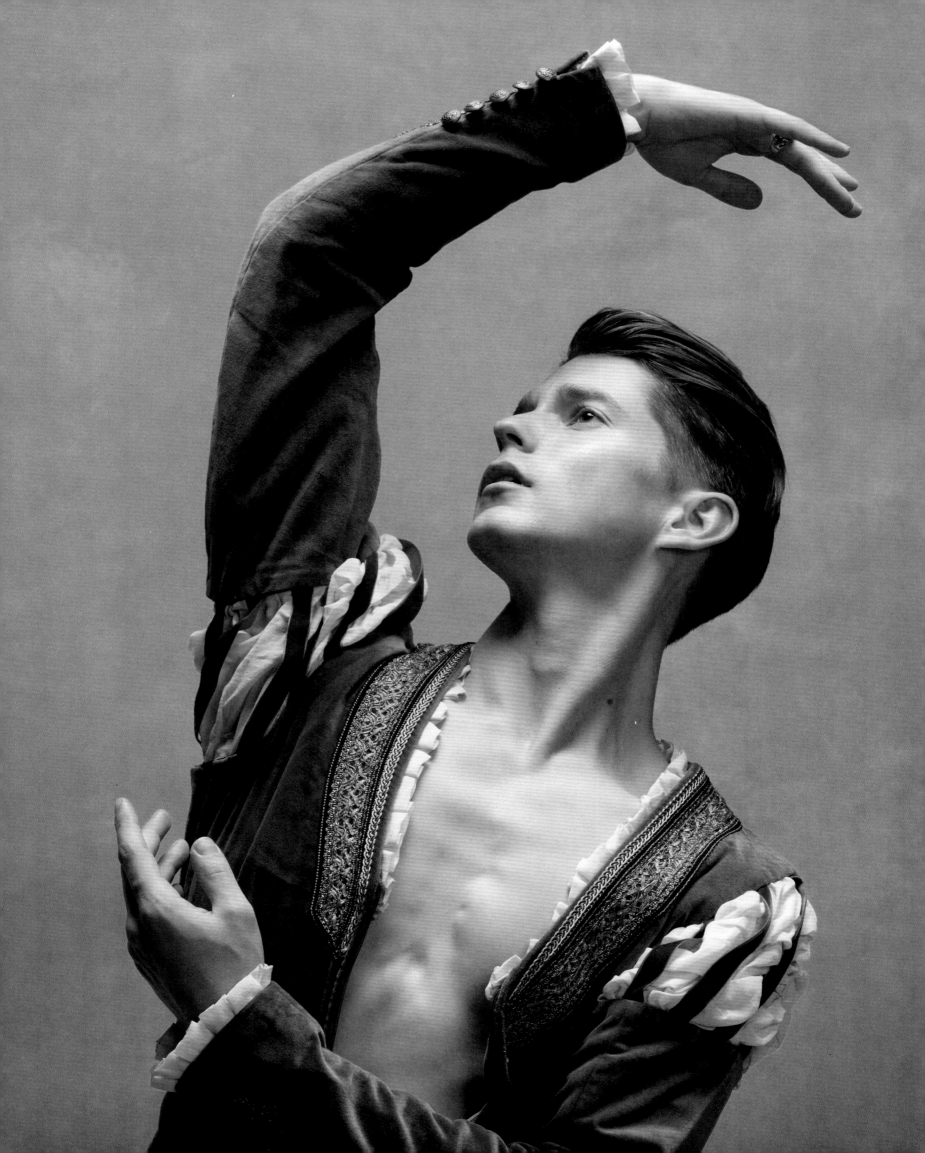

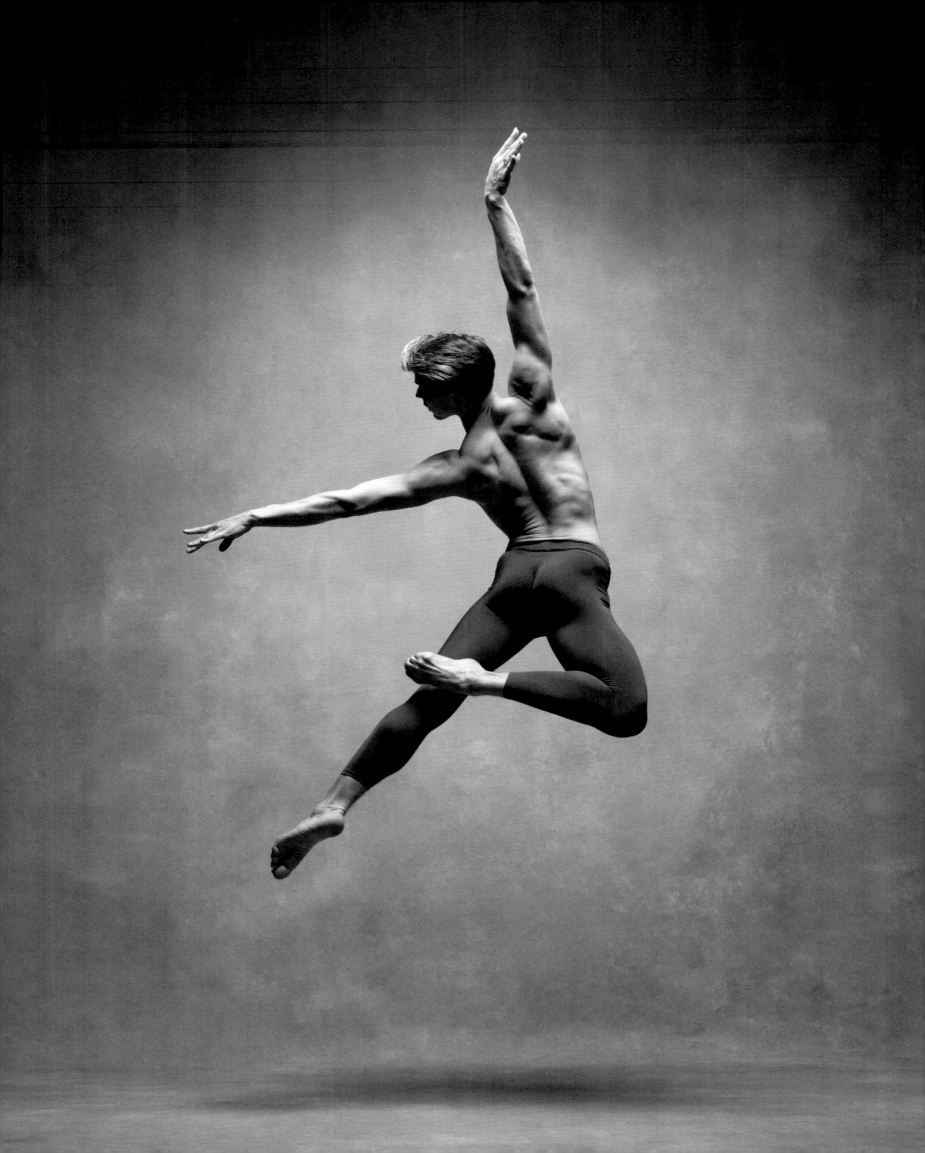

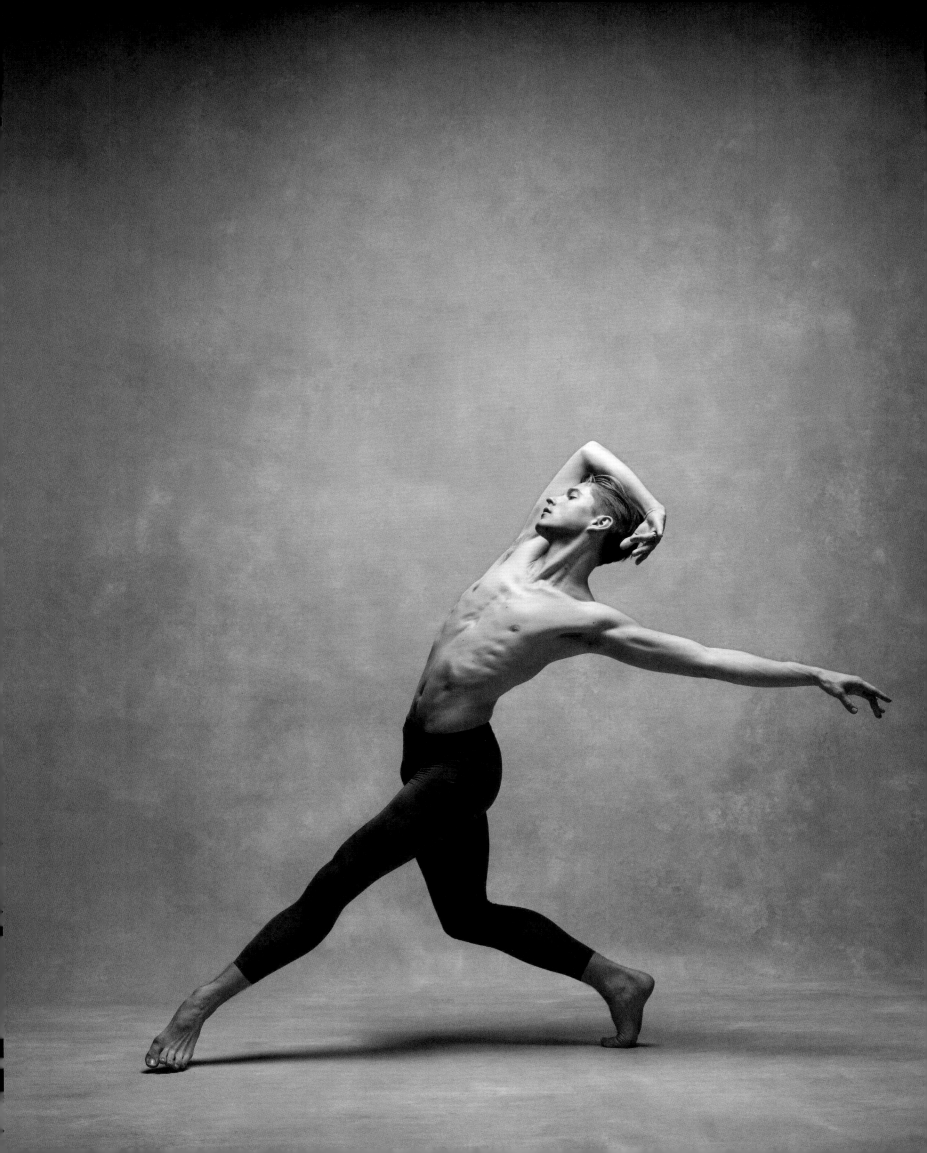

"If a child told me they wanted to be a dancer,
I would say being a professional dancer is a ton of hard work,
but it's the best job in the world.
If dancing makes your inner light shine bright, and you love
being challenged and constantly learning, then go for it!
Get in as many dance classes as possible, make your own dances,
and have dance parties in the rain whenever possible.
Find professionals that inspire you, and simply, fly!"

–Rachael McLaren

Rachael McLaren | Alvin Ailey American Dance Theater

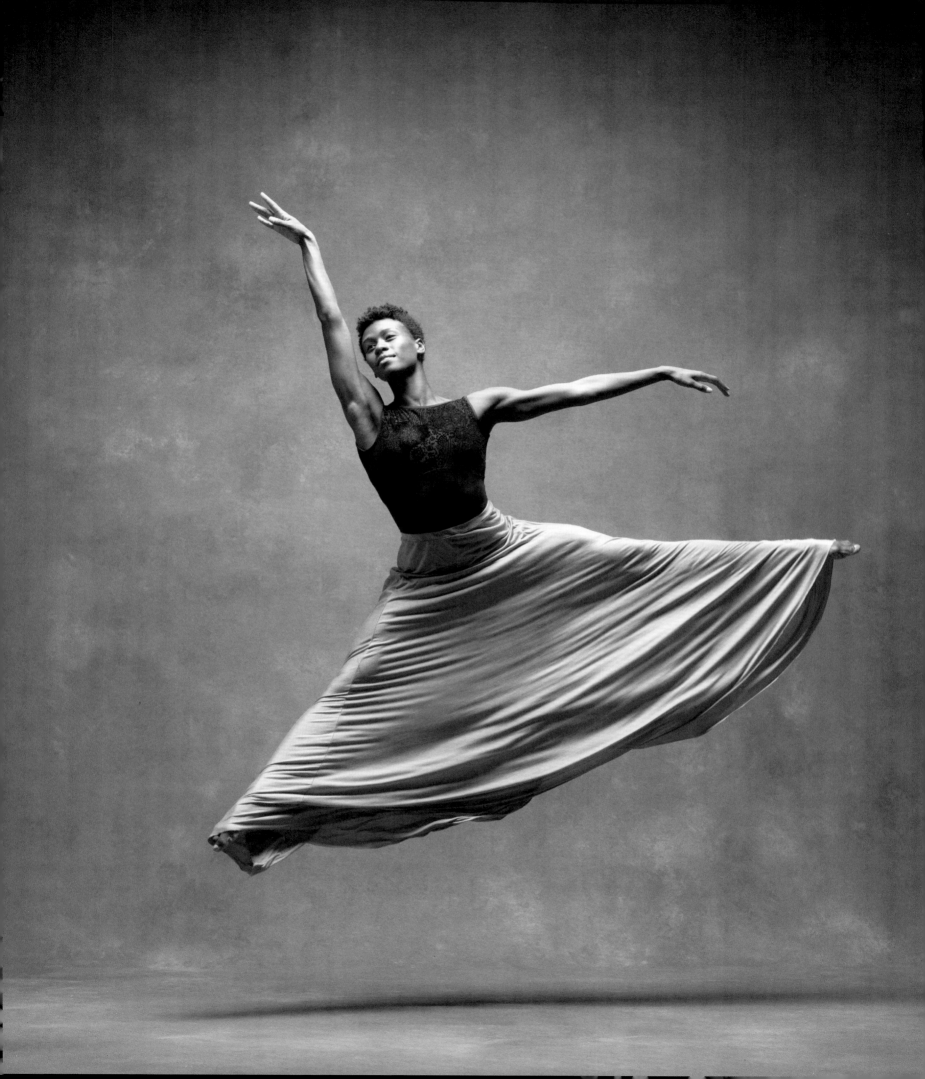

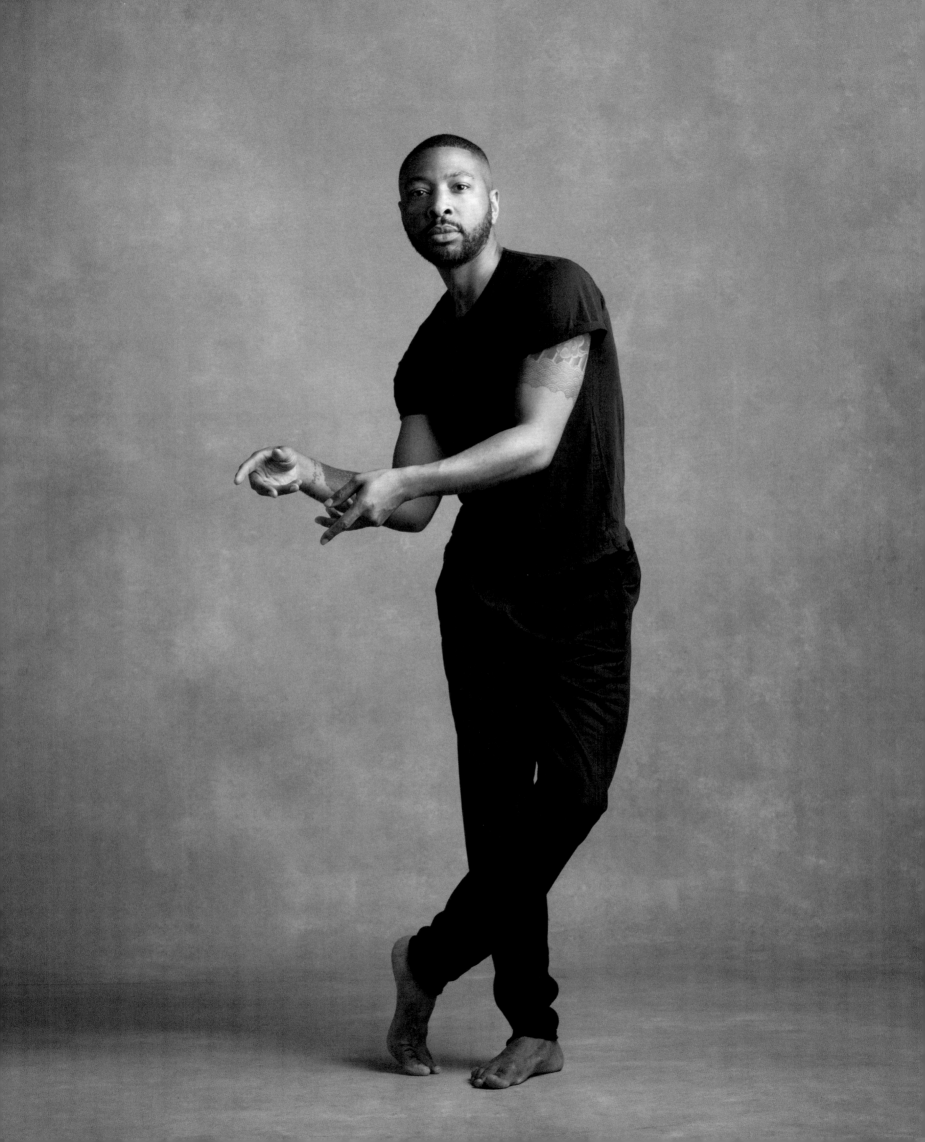

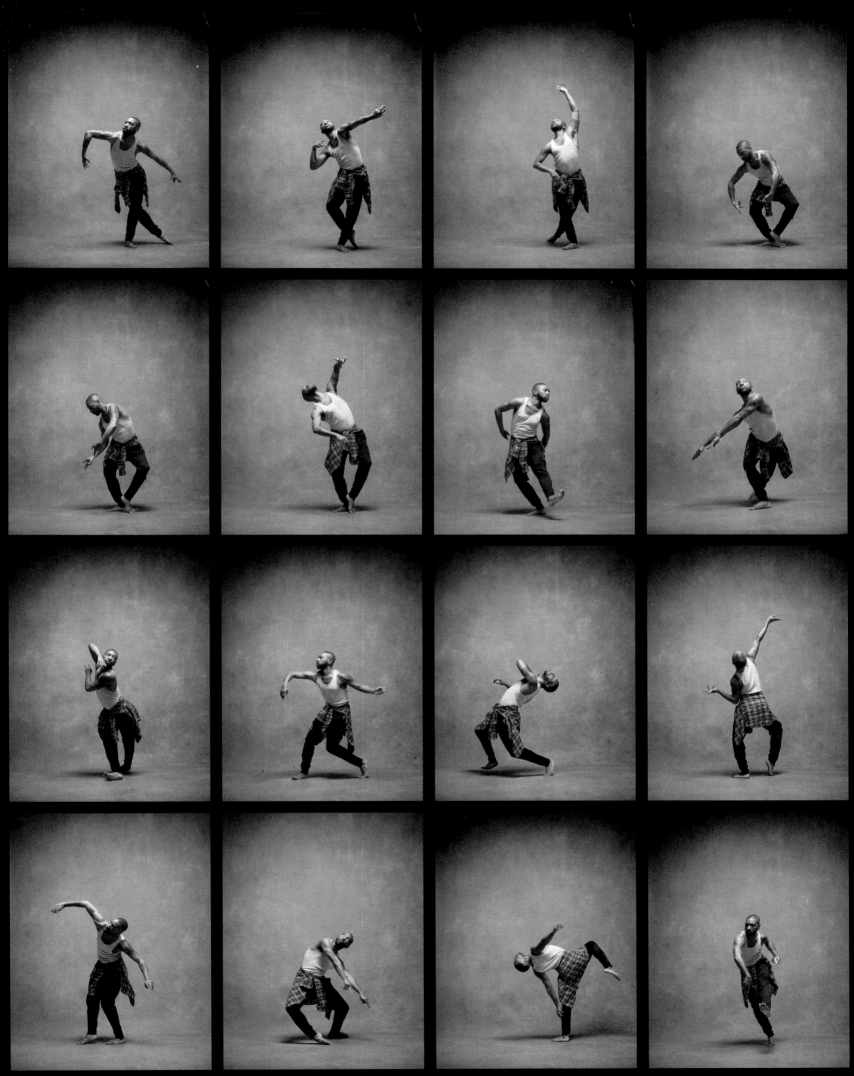

Kyle Abraham | Artistic Director, Abraham.In.Motion

"Other people's words are very powerful . . .
you can't let them define you.
Take what you think is going to help you and
don't let it beat you down."

–Misty Copeland

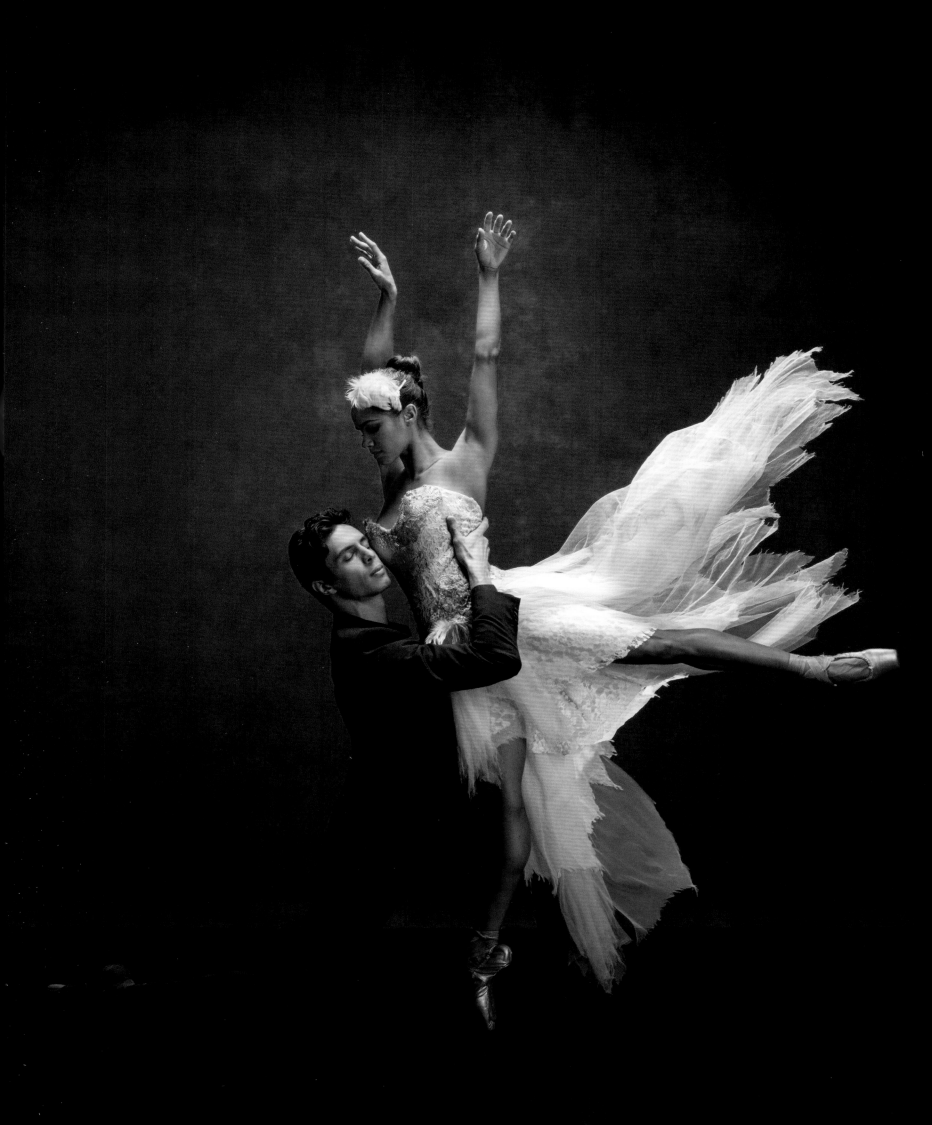

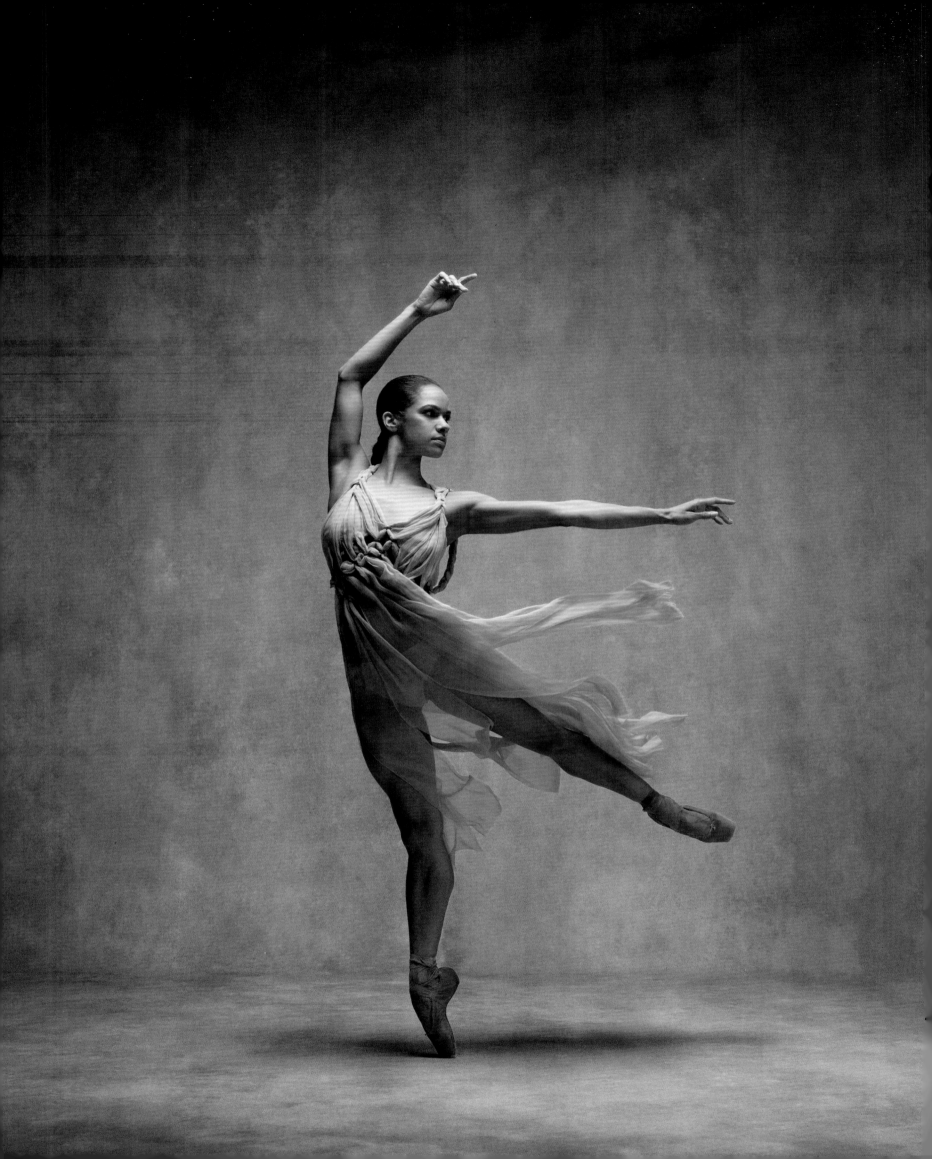

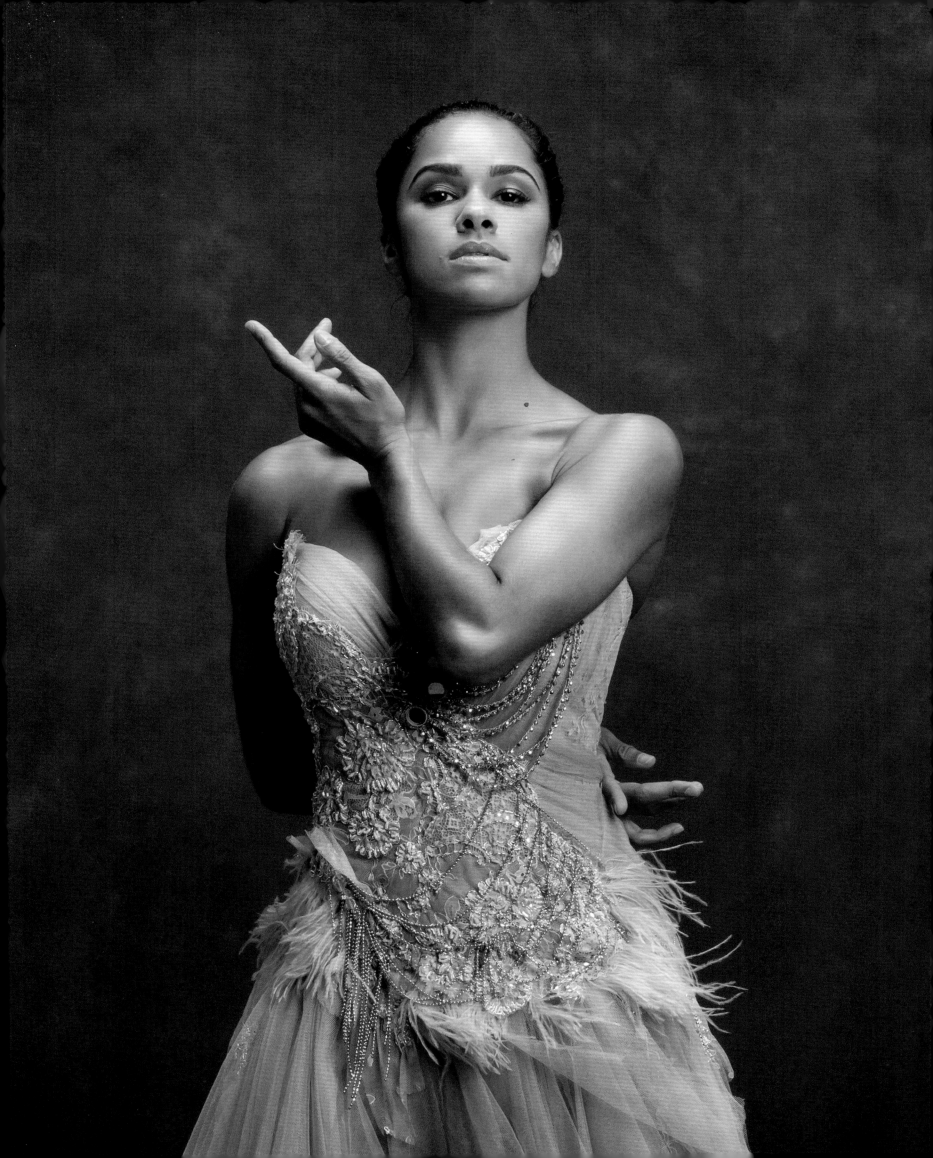

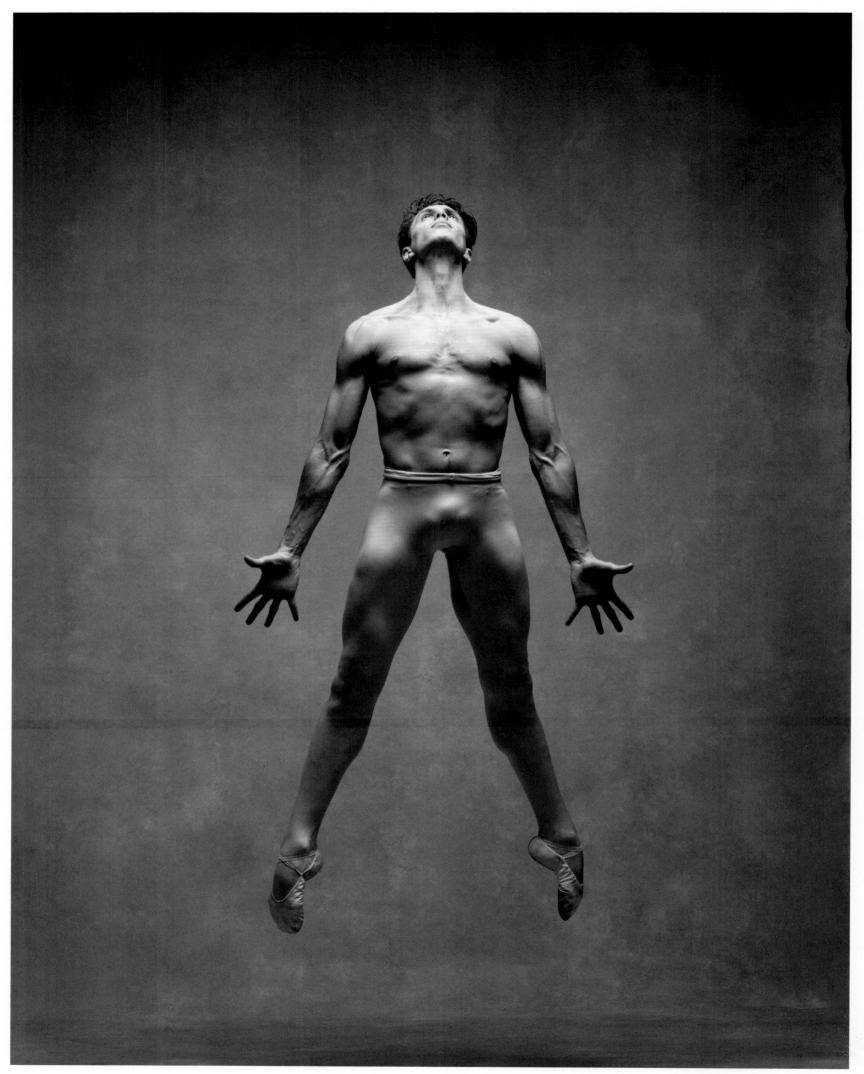

Alexandre Hammoudi | Soloist, American Ballet Theatre

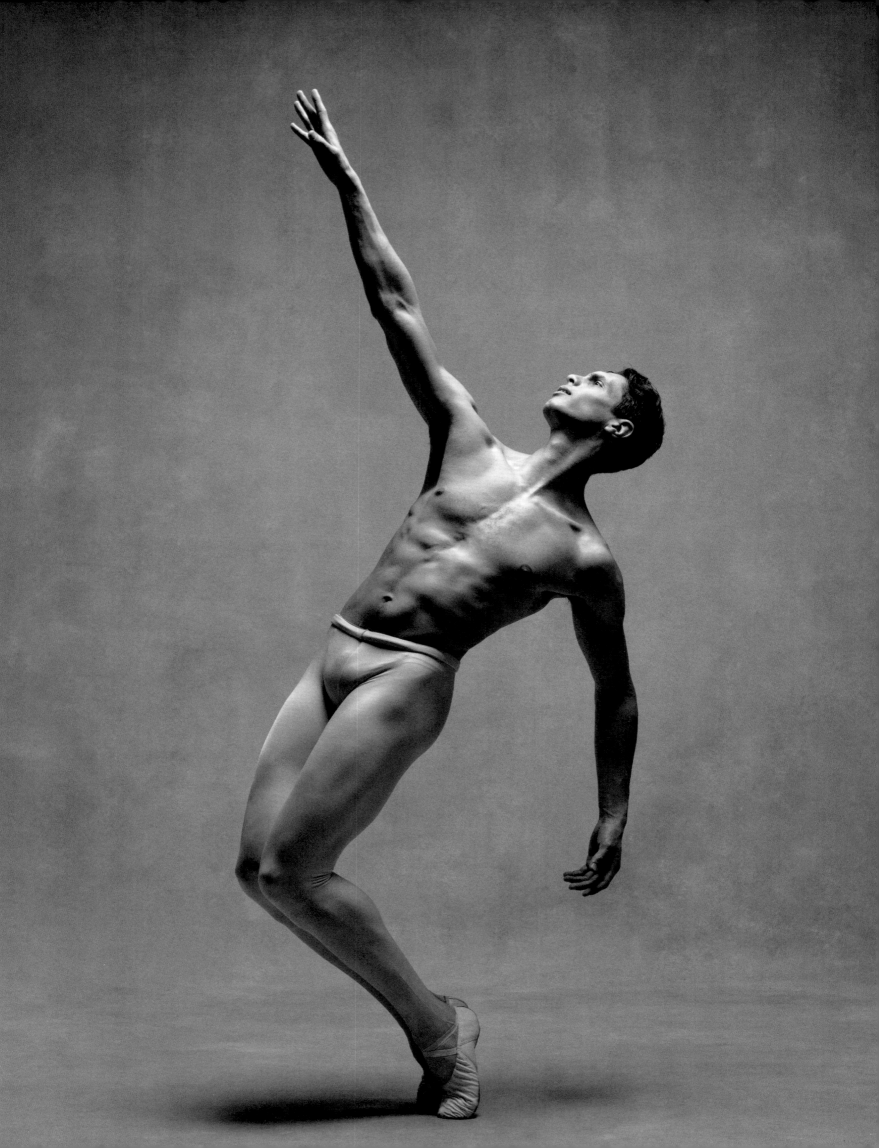

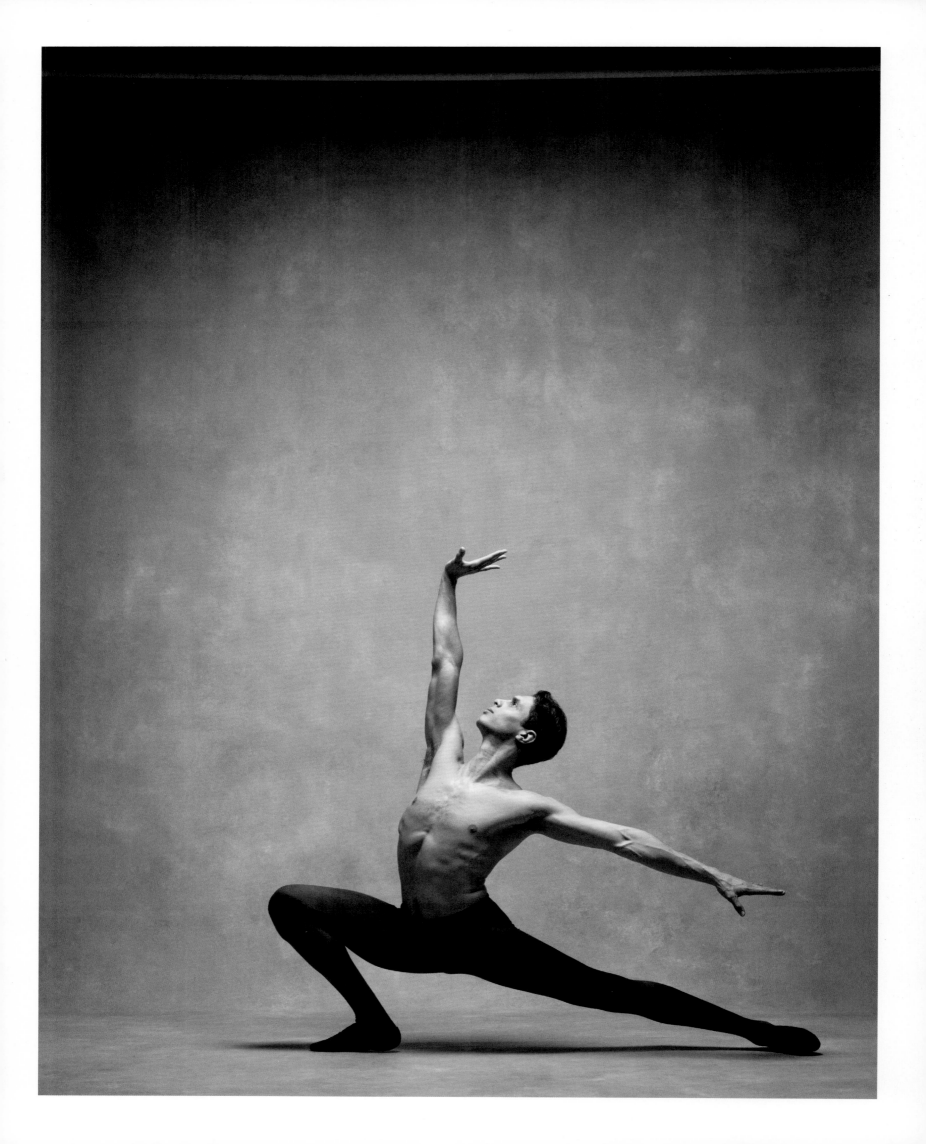

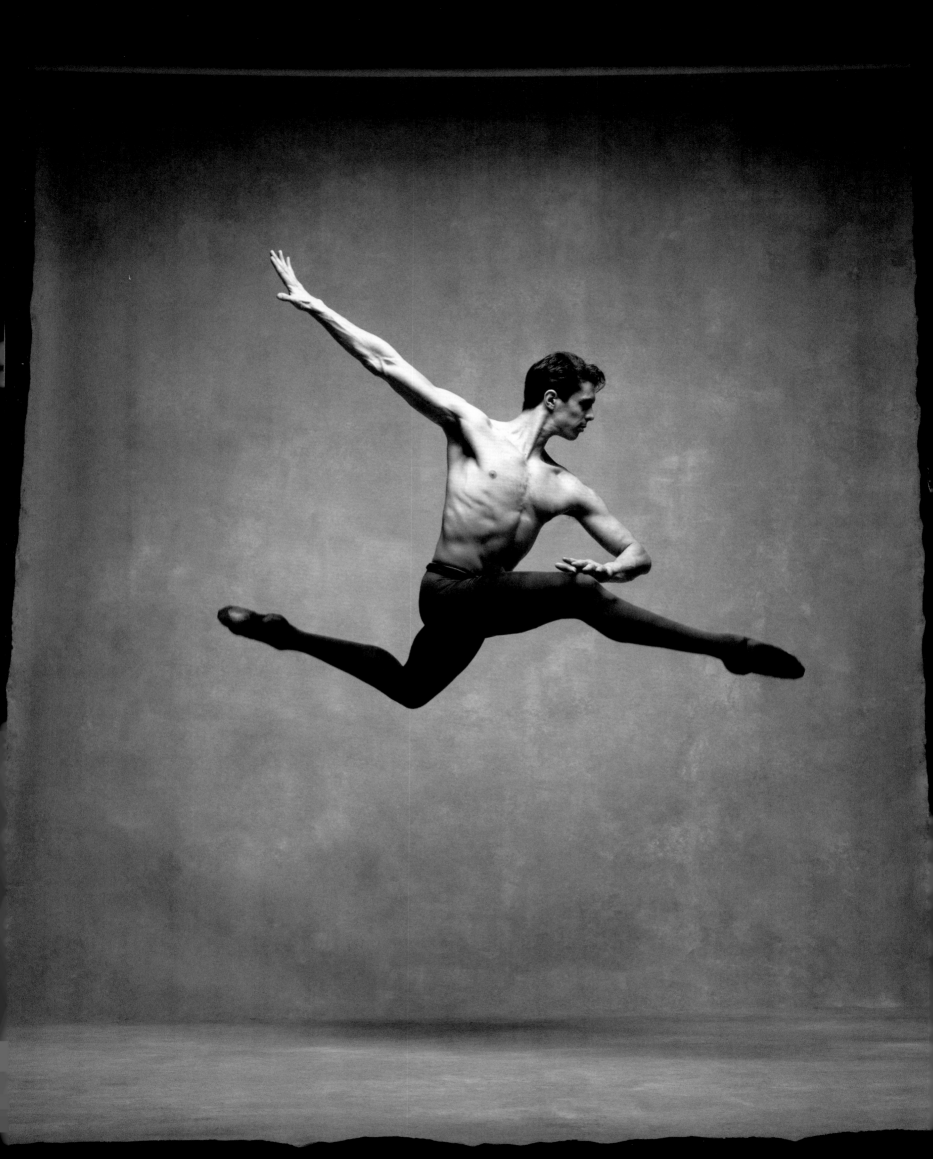

"The path that you think you might have or want,
 isn't the one you'll have.
 There is absolutely no way of knowing how one's career will go.
 There will be unexpected twists and turns."

–Holly Dorger

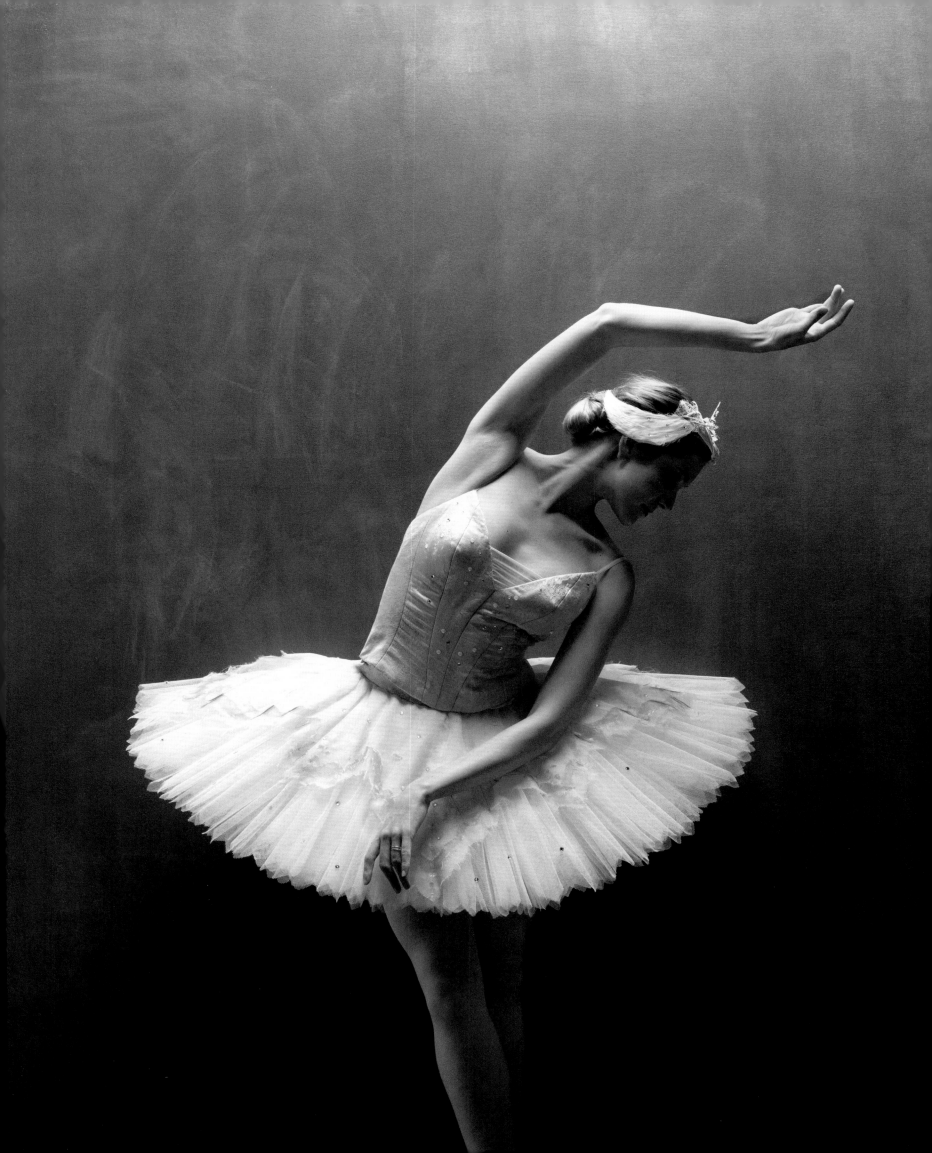

"Dance is, as I see it, a form of poetry for which physical prowess
is merely a means, but surely not an end.
Dancers who get stuck emphasizing only the athletic aspect
of dance seem to have only one note they strike repeatedly.
They appear to be shouting all of the time.
It's the difference between yelling and singing. Barton sings."

–Lar Lubovitch, Artistic Director, Lar Lubovitch Dance Company about dancer Barton Cowperthwaite

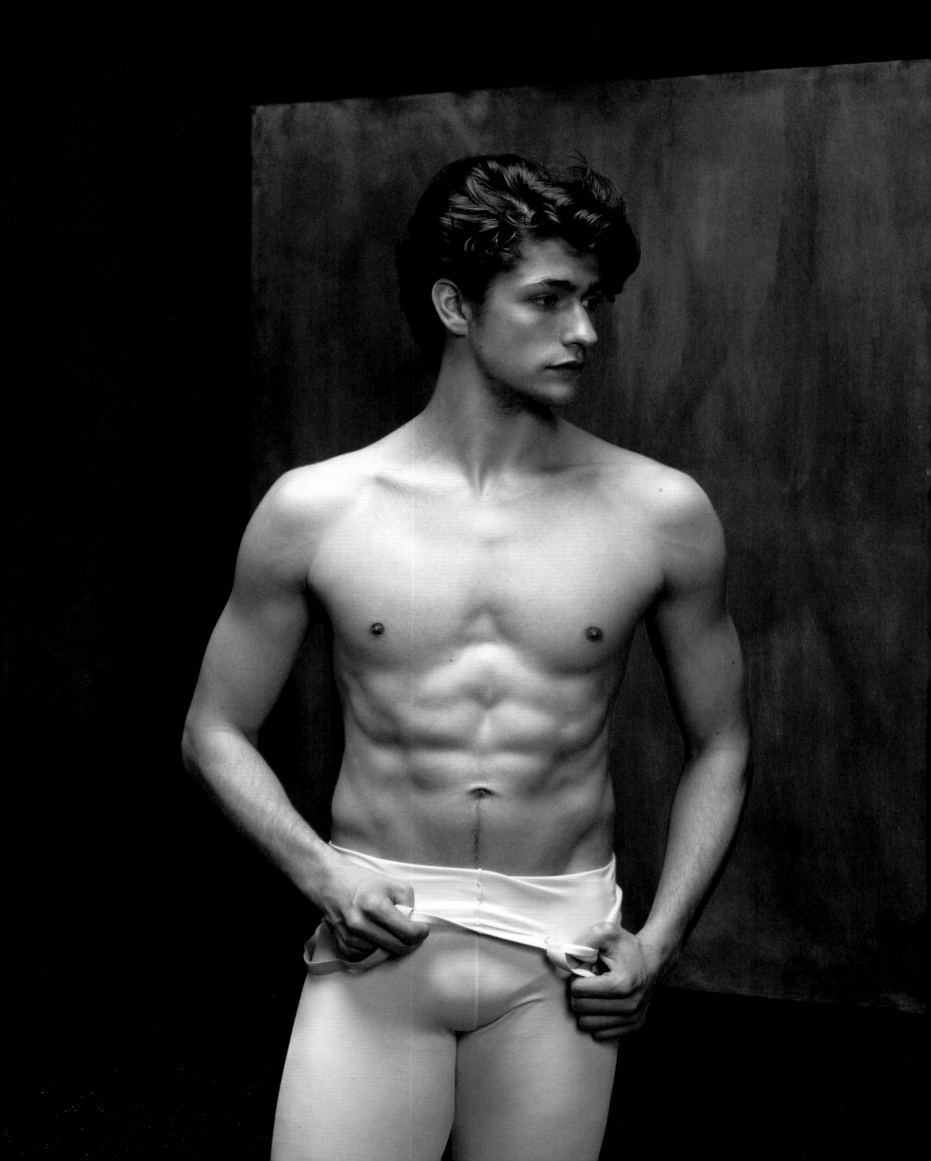

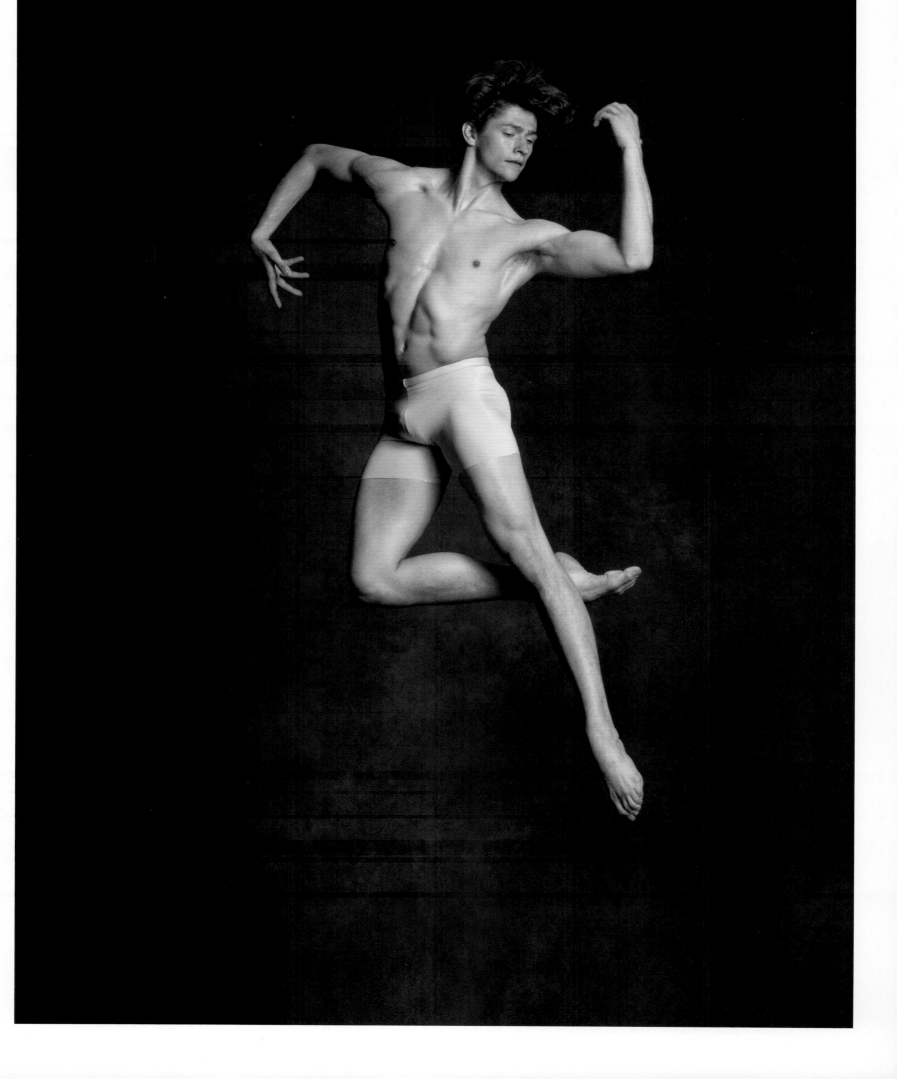

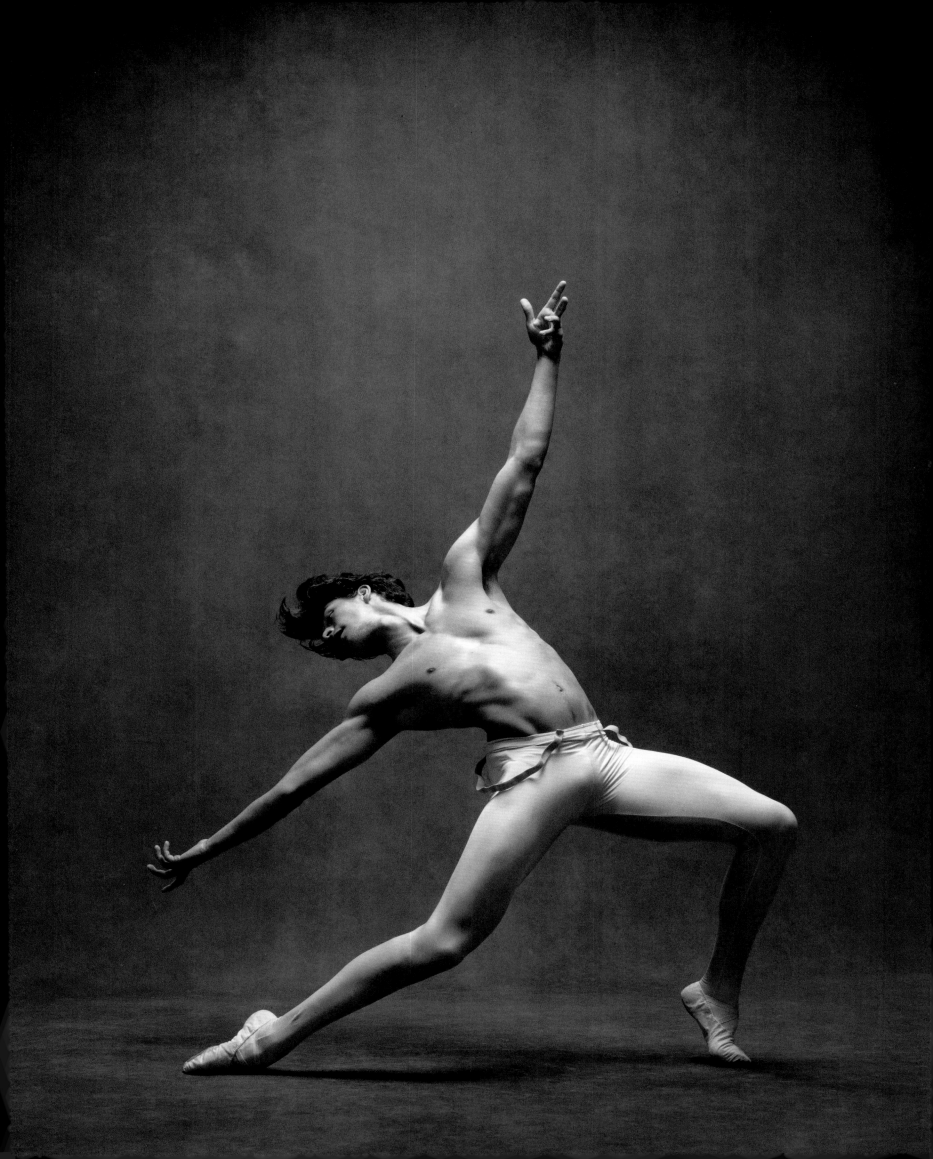

"Dance isn't just movement, it is expression."

–Ashley Ellis

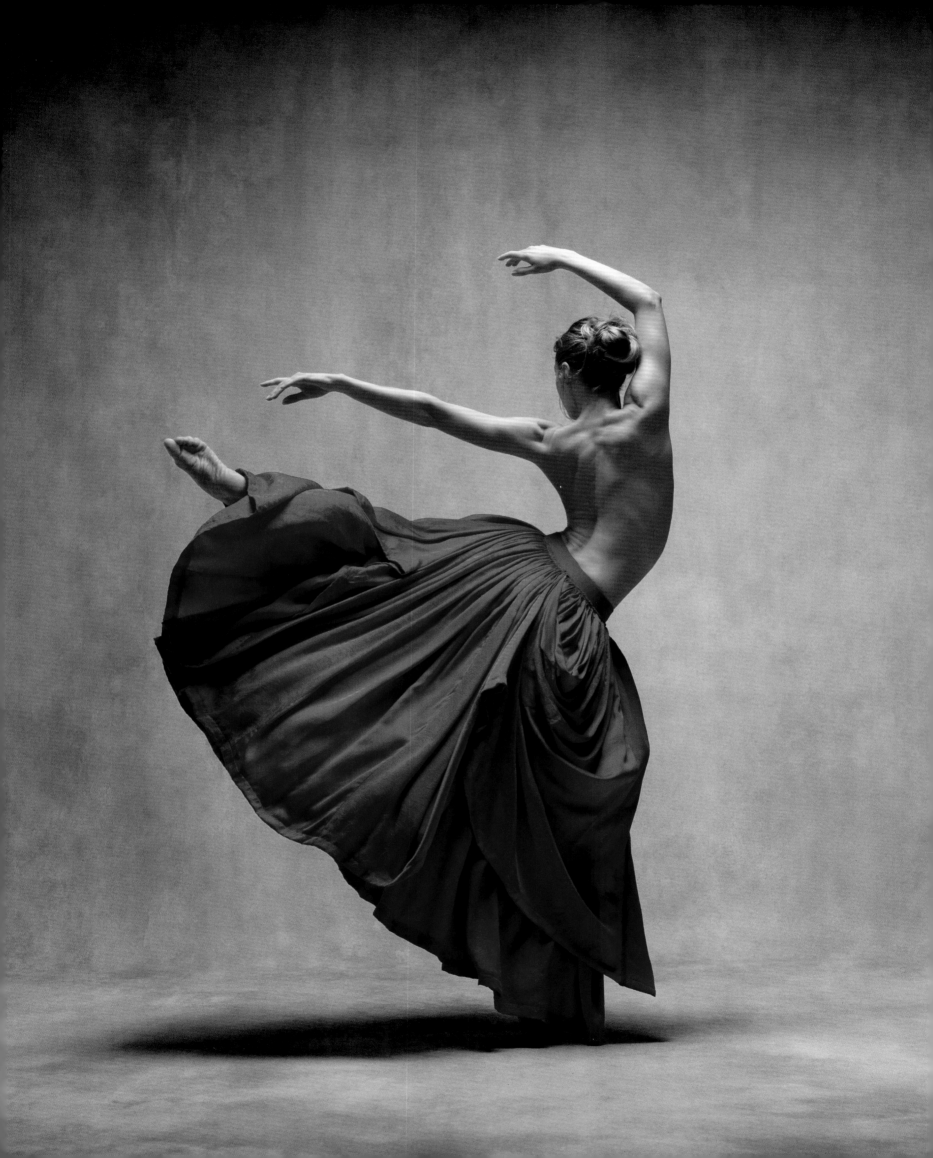

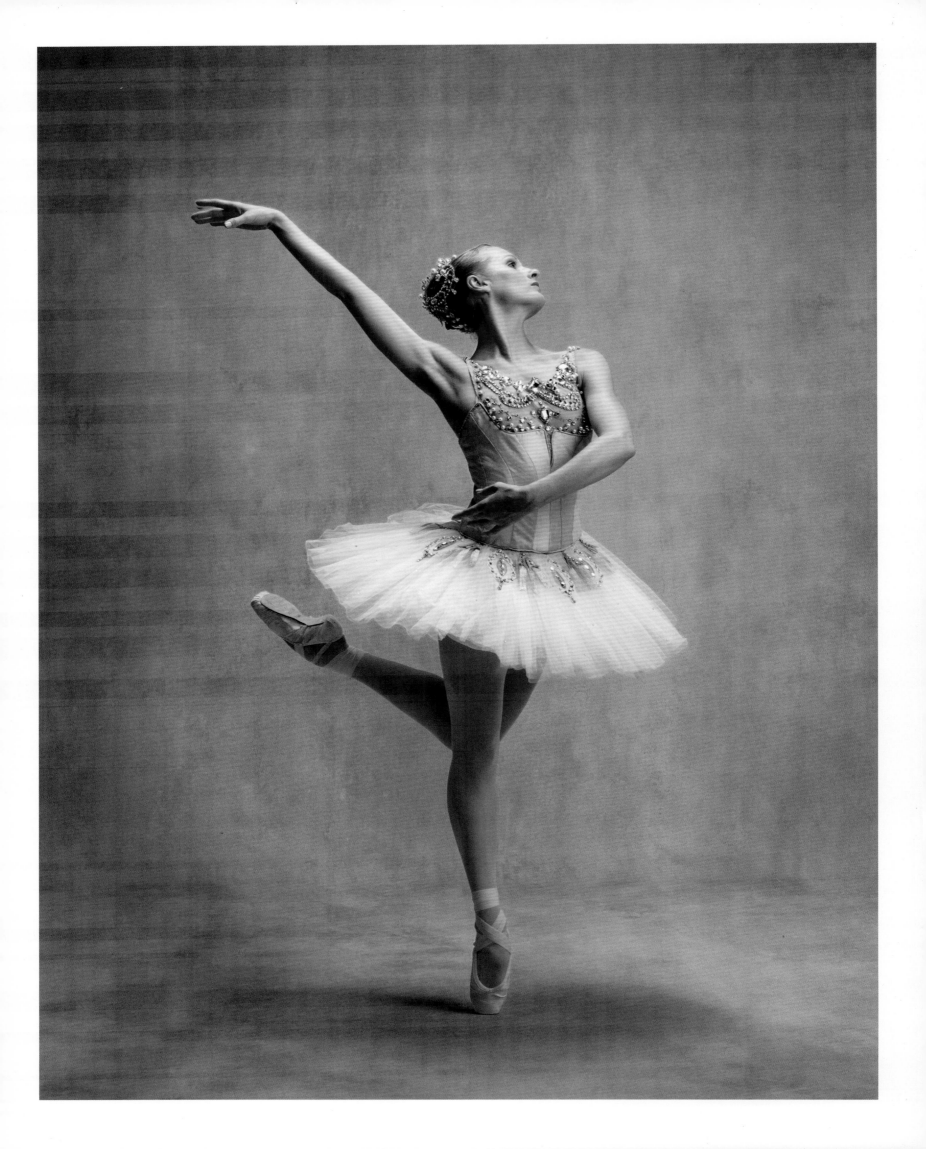

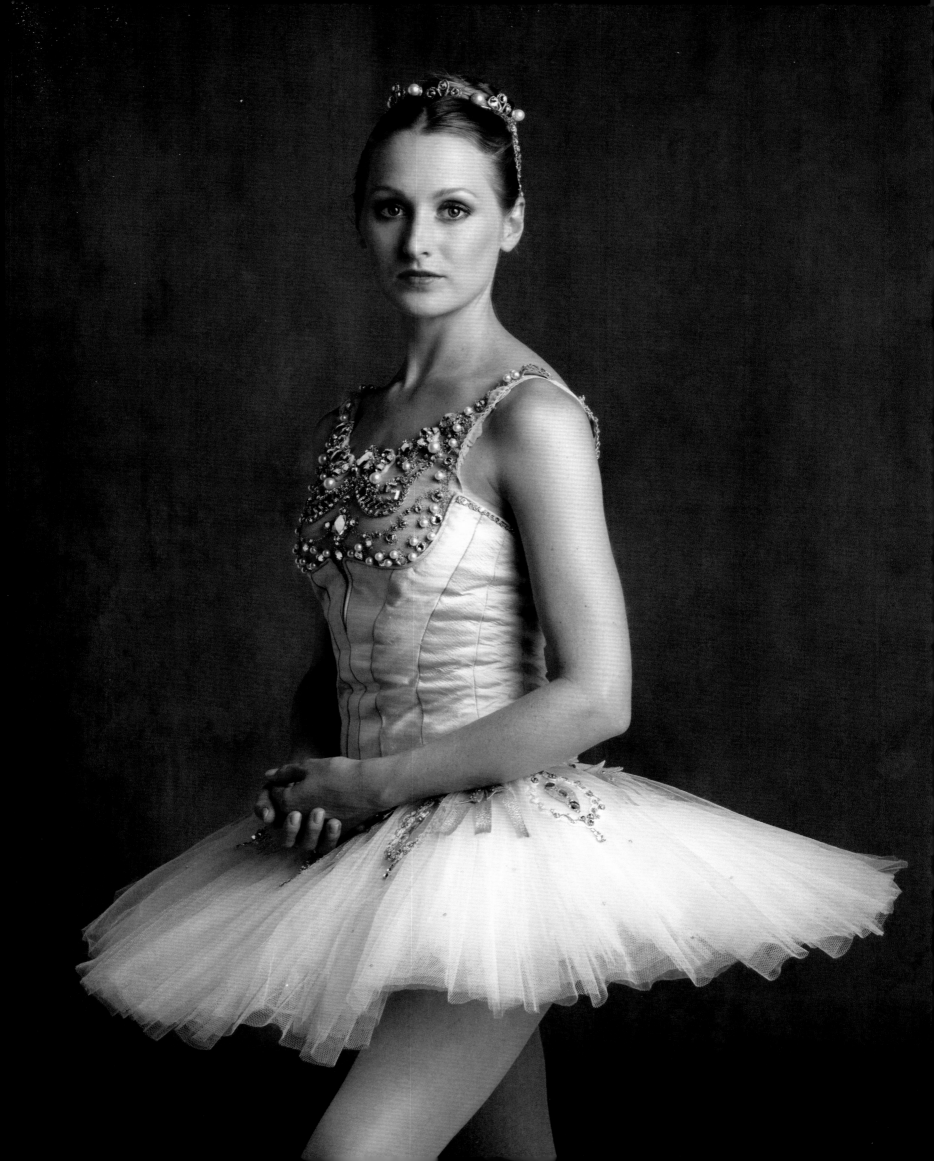

"The first time I performed Mr. Ailey's *Revelations*
and the curtain went up in Oslo, Norway, to reveal us
standing in the famous opening stance . . .
I knew I was exactly where I was supposed to be.
I cried my way through that performance—
tears of happiness and the utmost gratitude."

–Sean Aaron Carmon

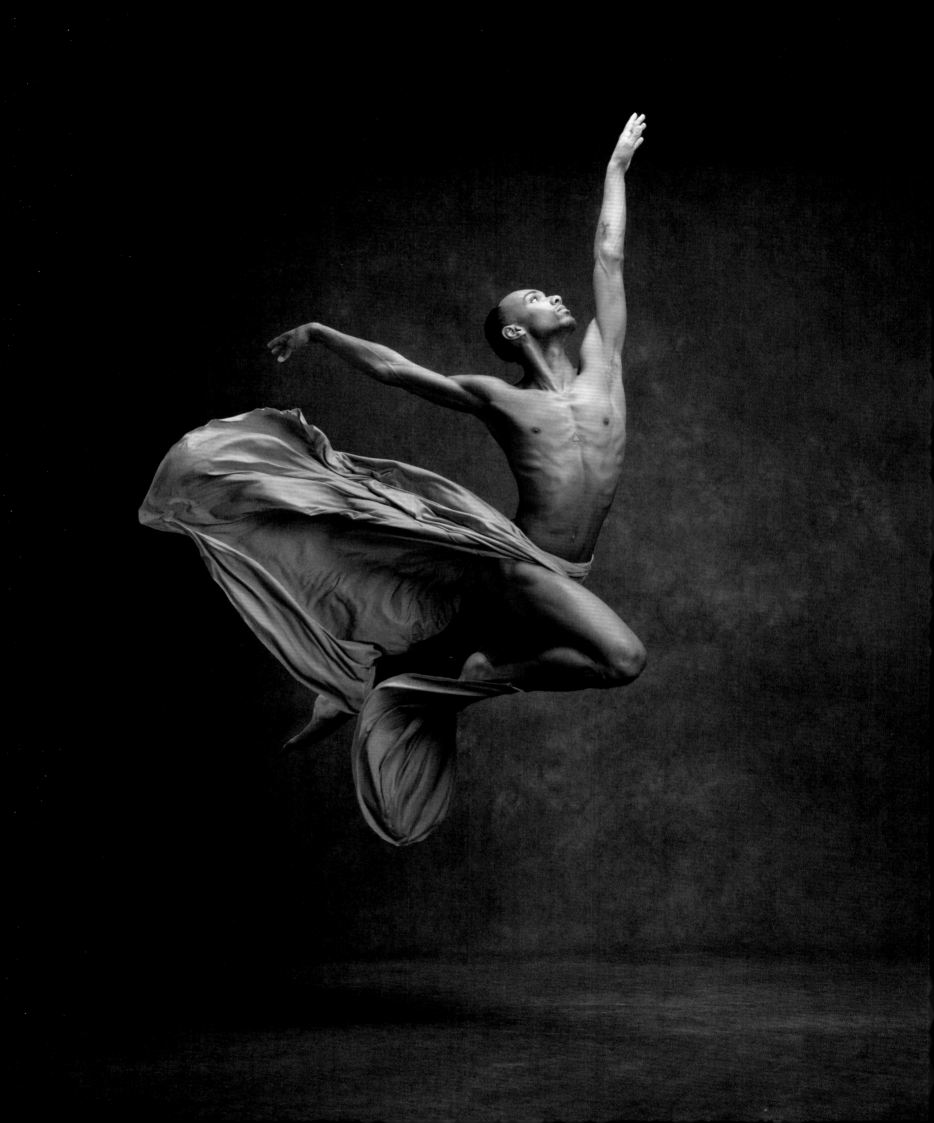

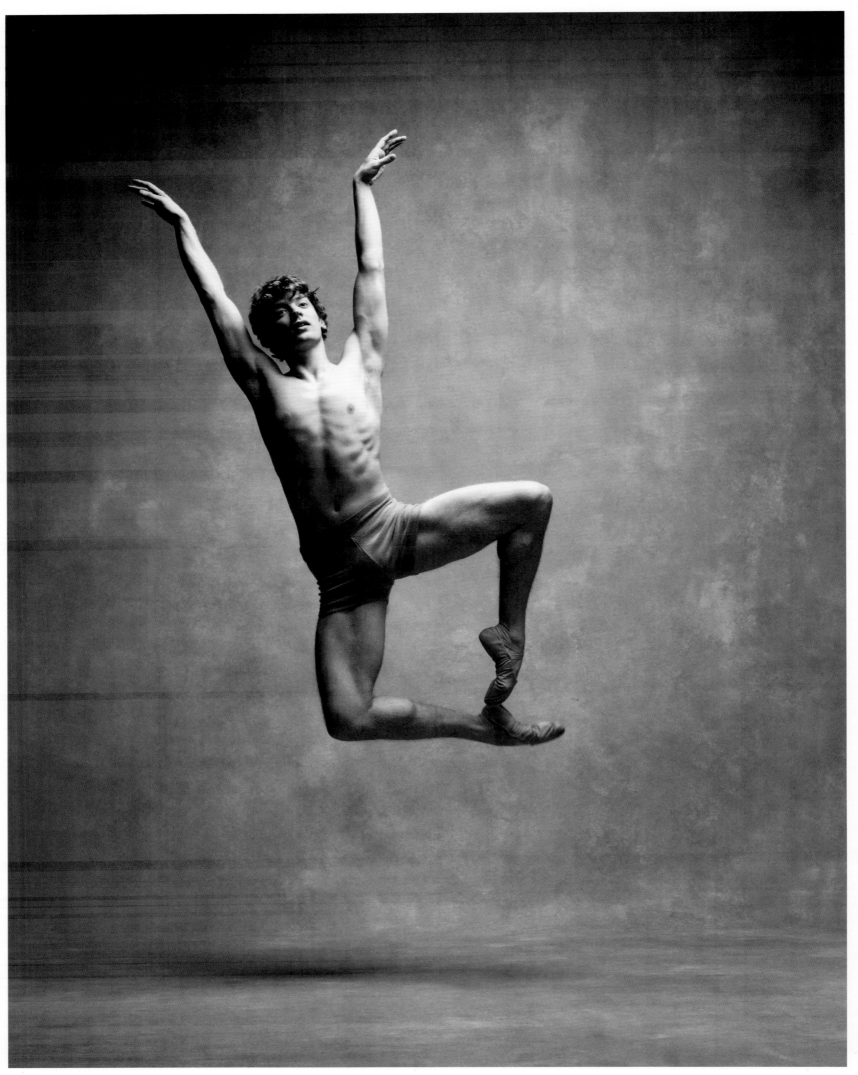

Russell Ducker | Pennsylvania Ballet

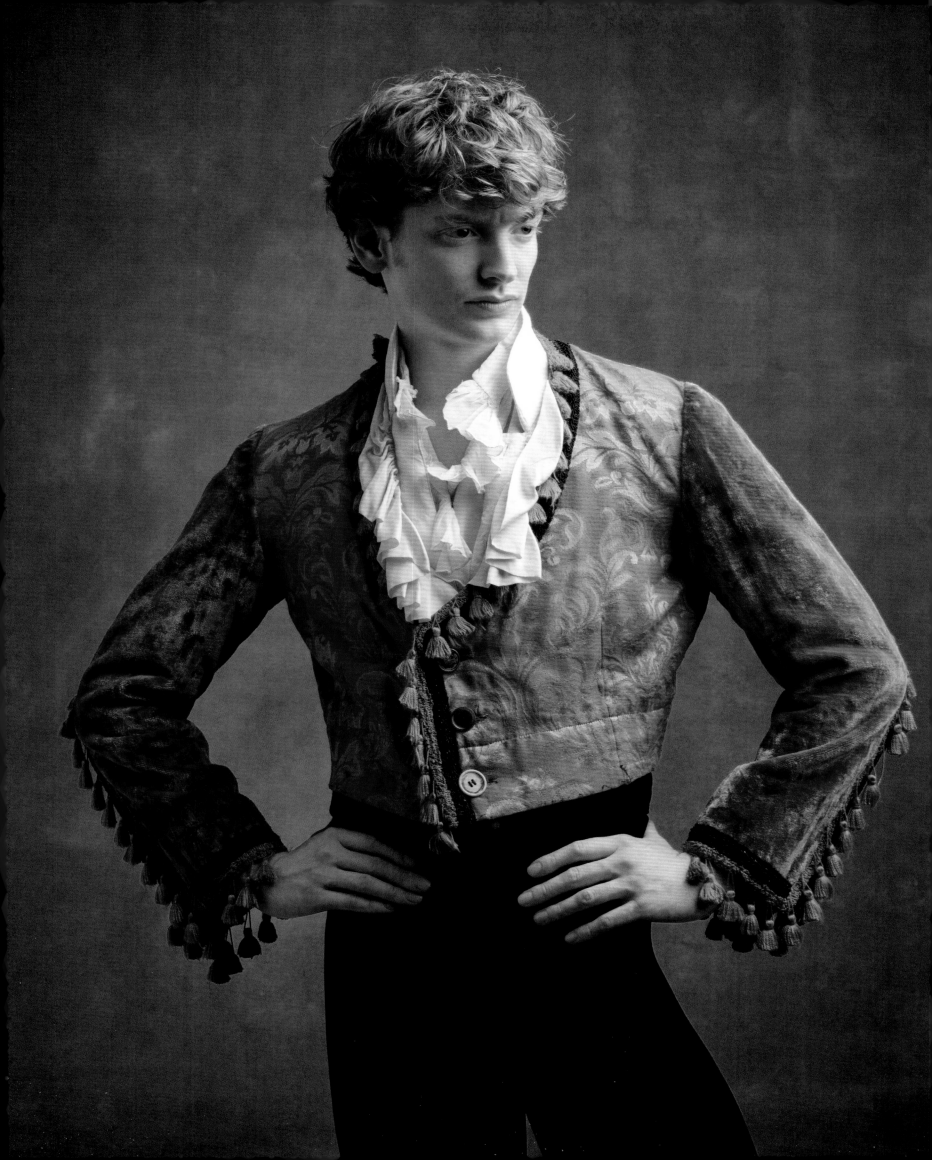

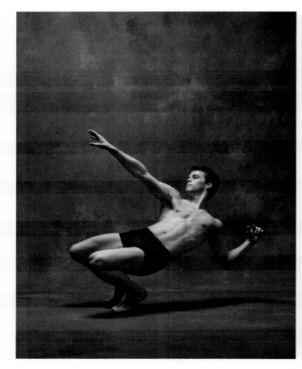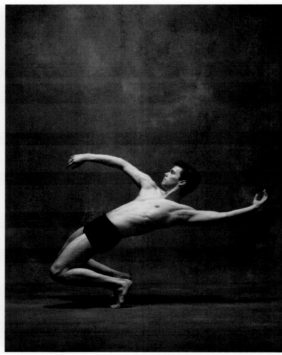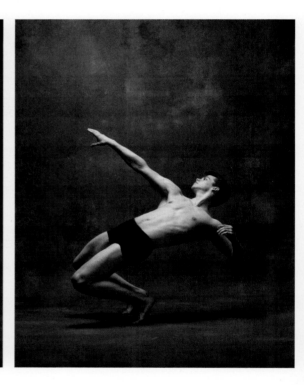

Lloyd Mayor | Soloist, Martha Graham Dance Company

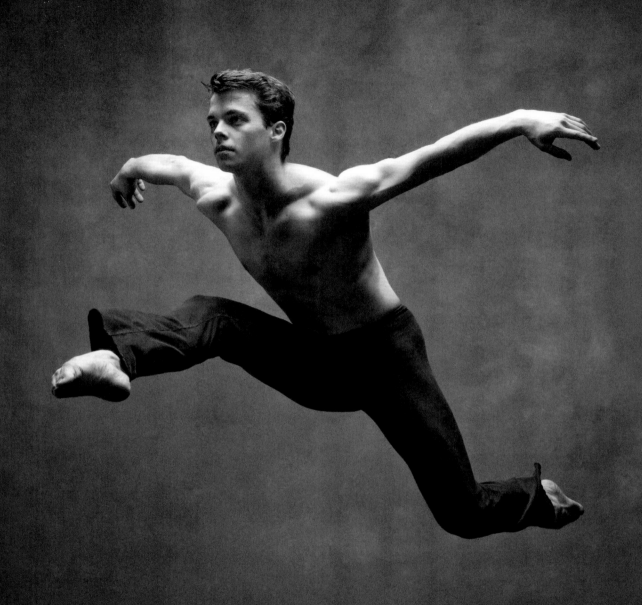

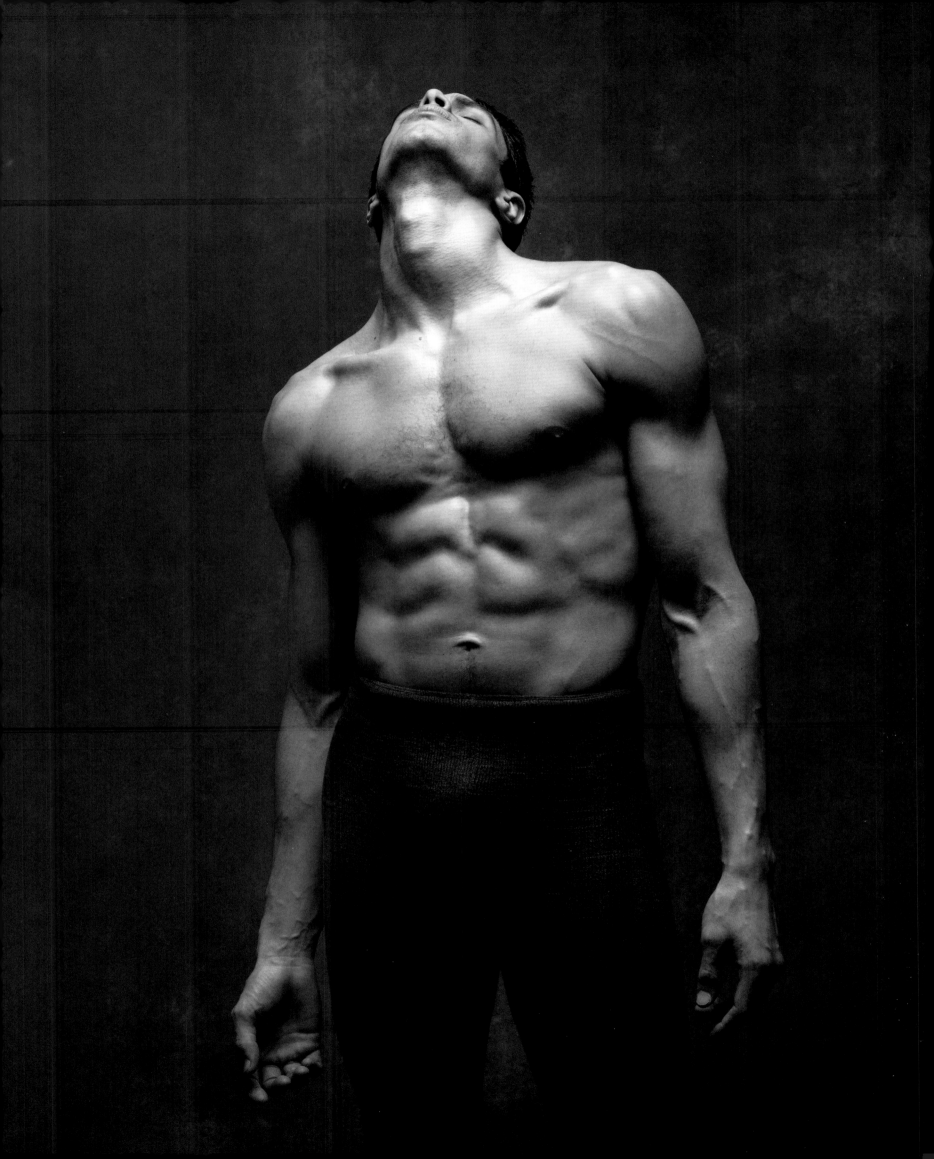

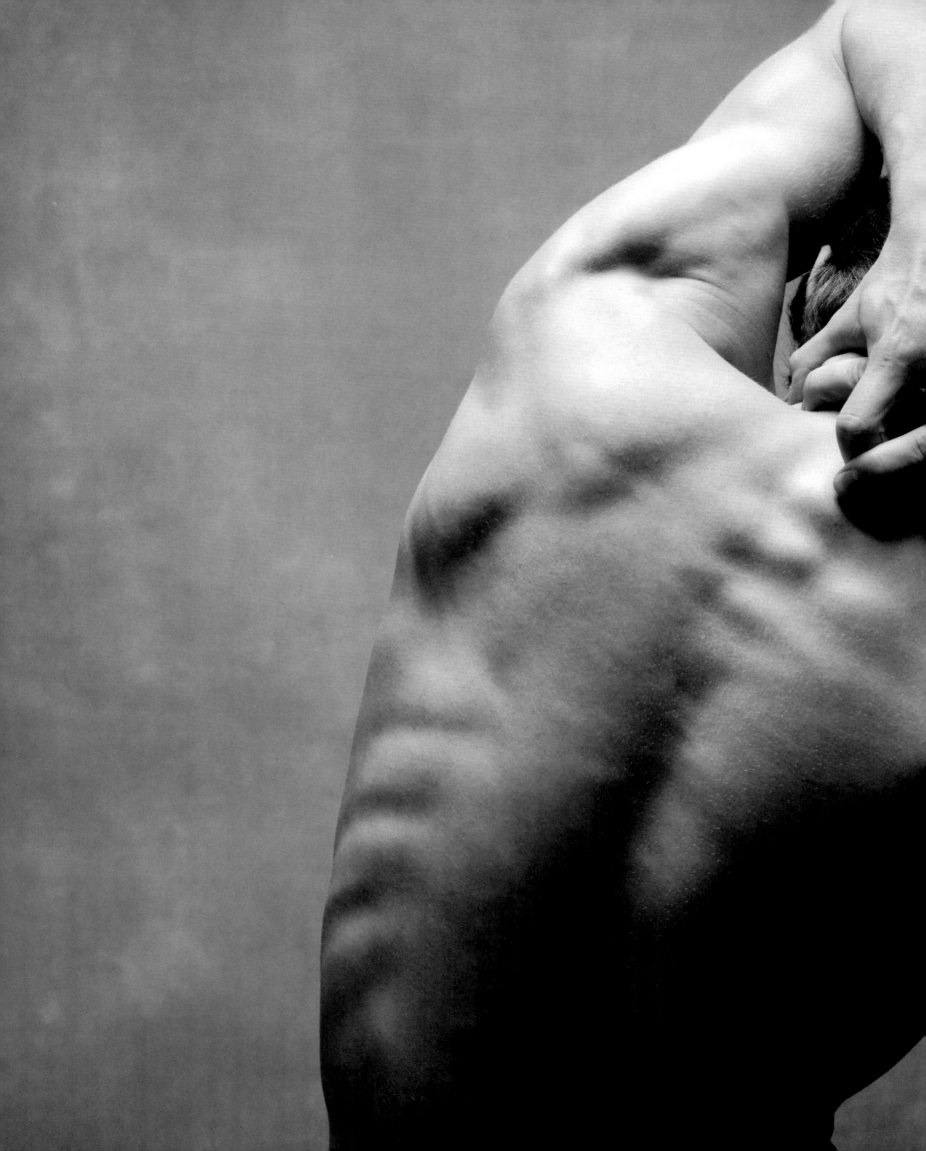

"My family didn't have a background in dance
but somehow they supported and trusted
the 12 yr. old me 100 percent of the way when
I decided to put dance first in my life."

–Cassandra Trenary

Cassandra Trenary | Soloist, American Ballet Theatre

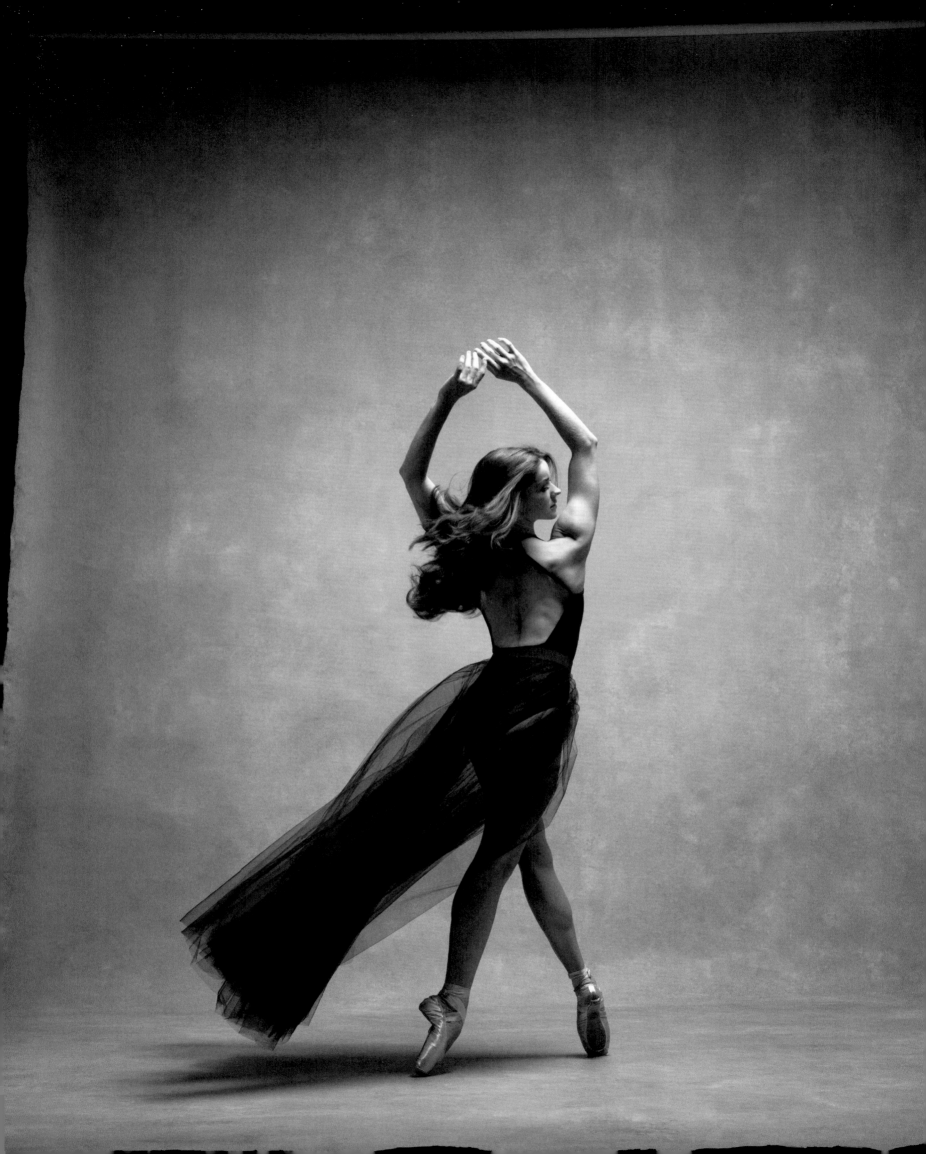

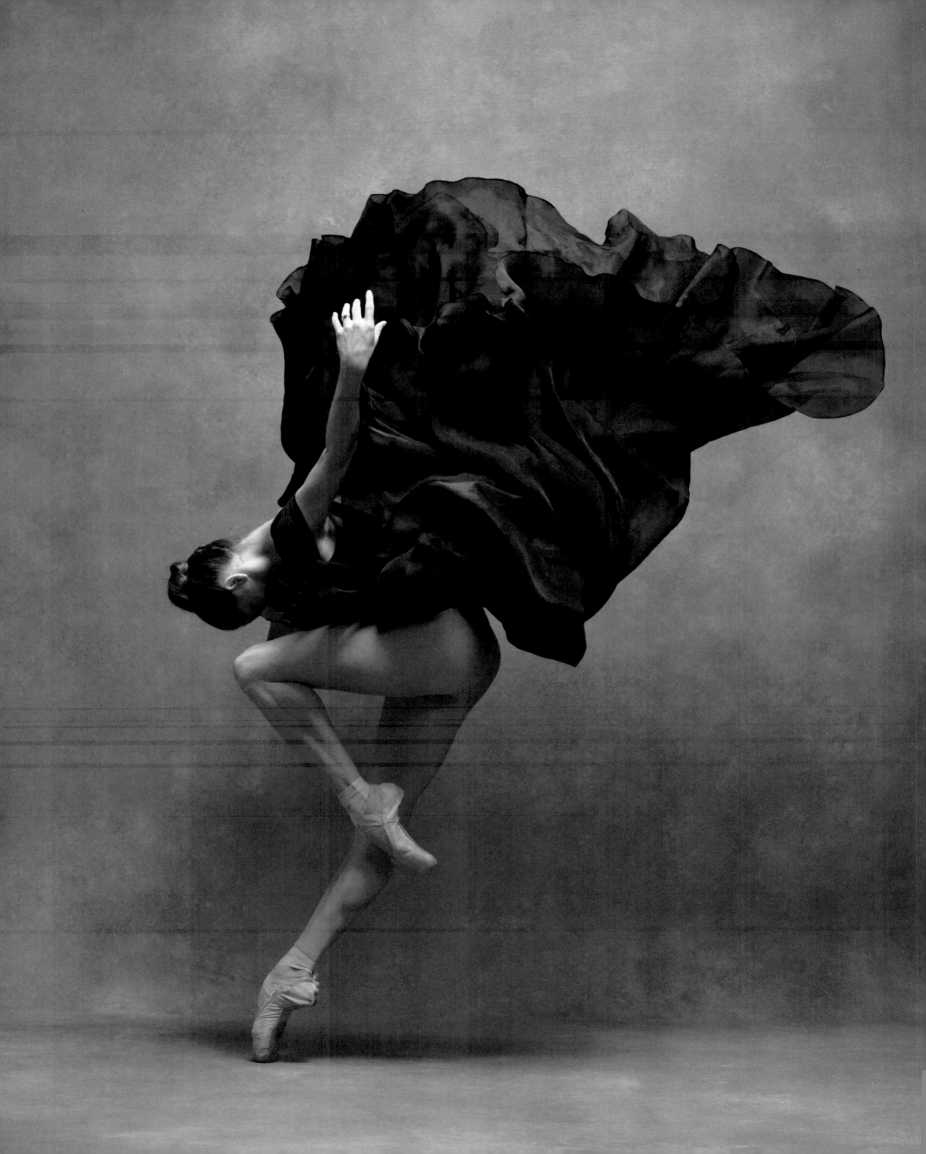

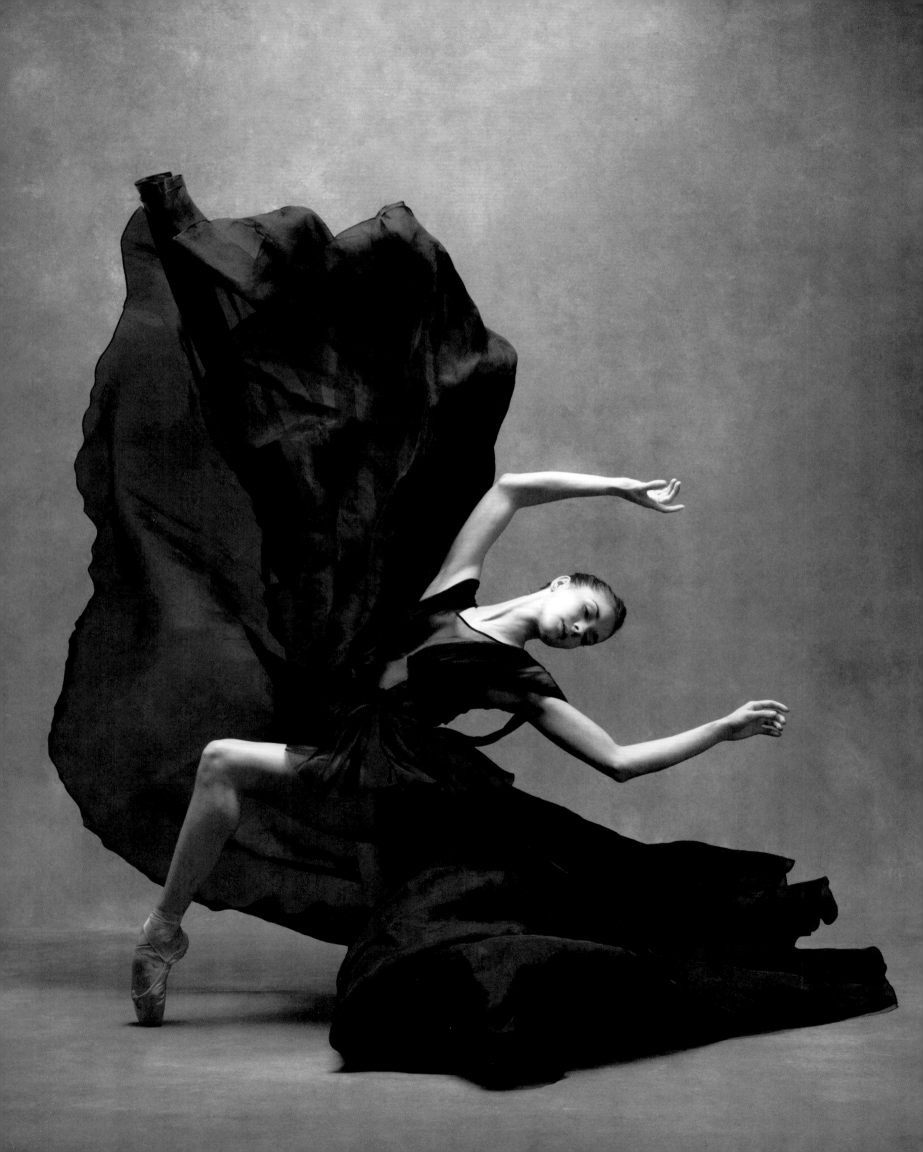

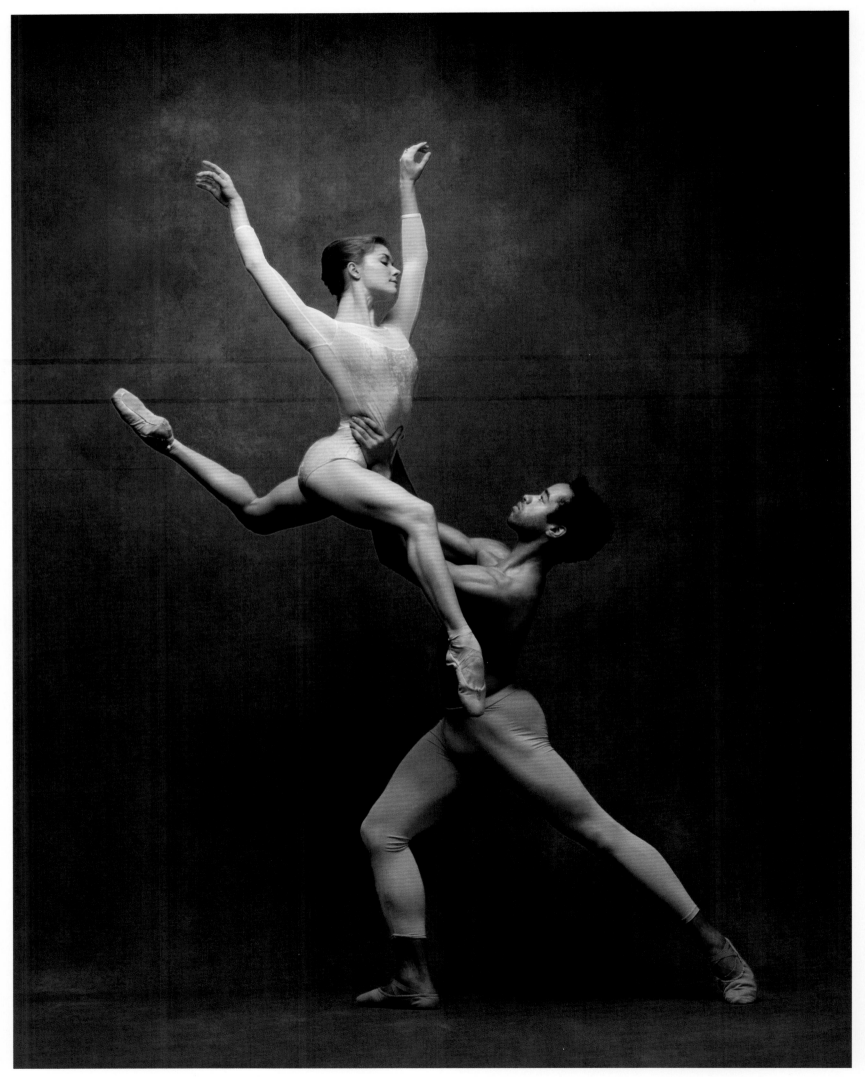

Cassandra Trenary | Soloist, American Ballet Theatre and **Gabe Stone Shayer** | American Ballet Theatre

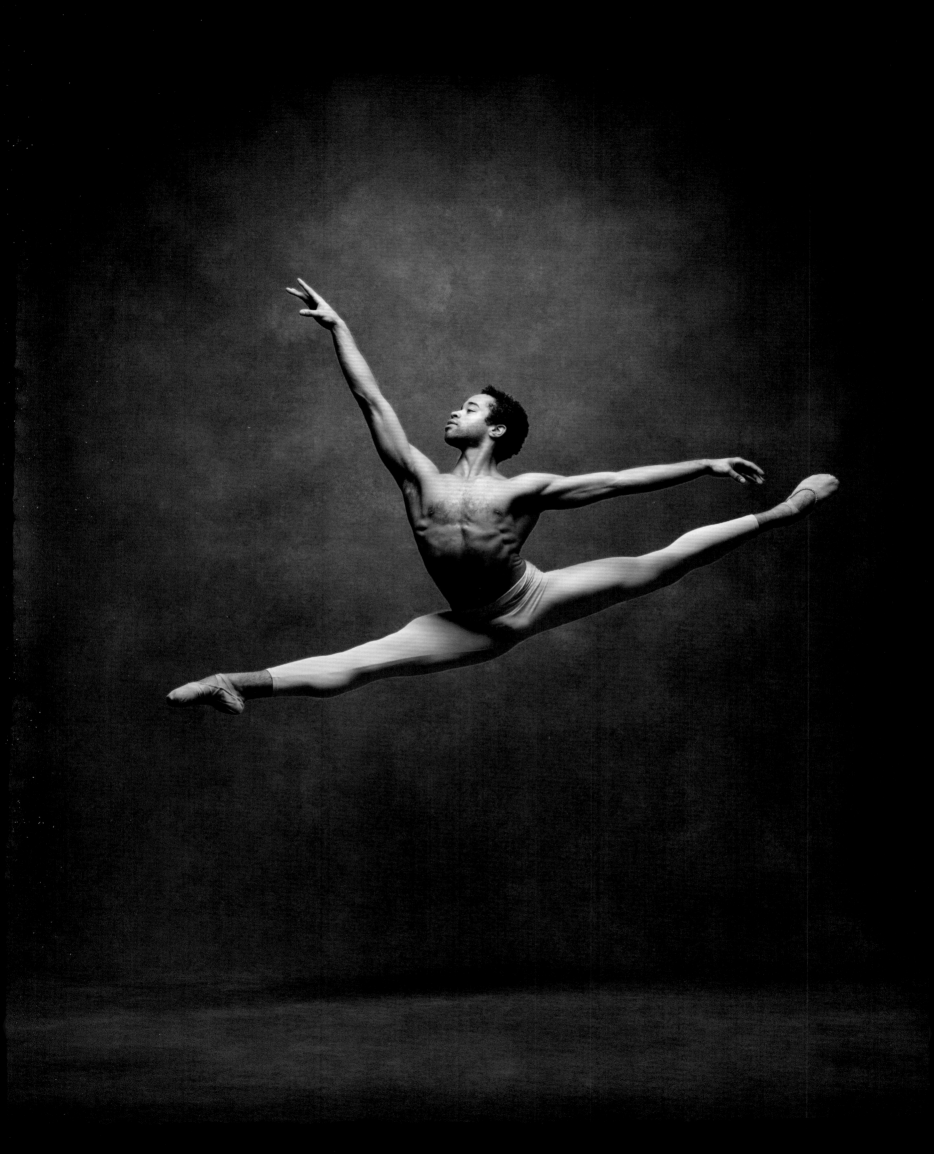

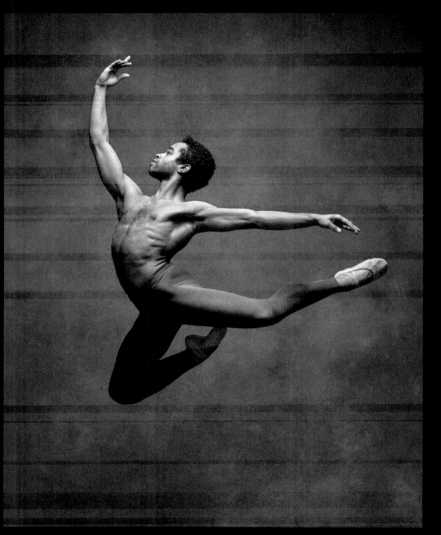
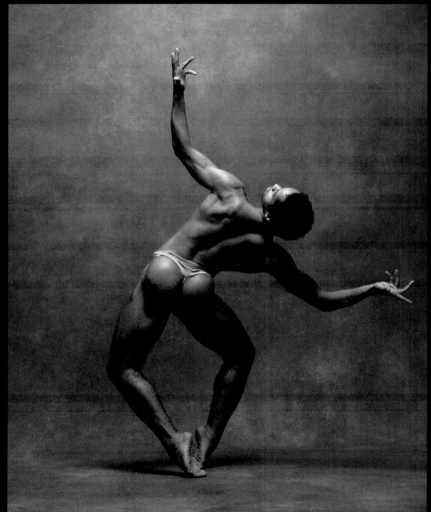

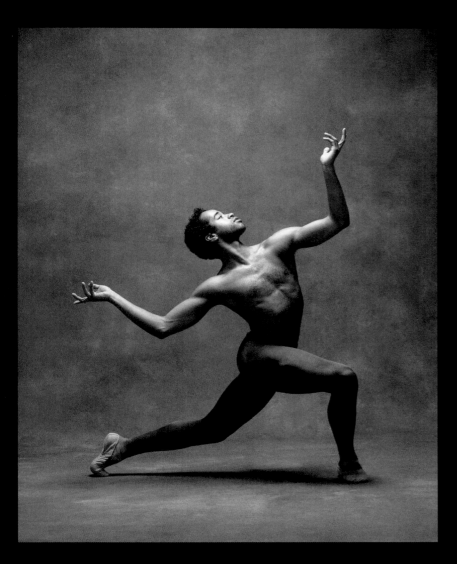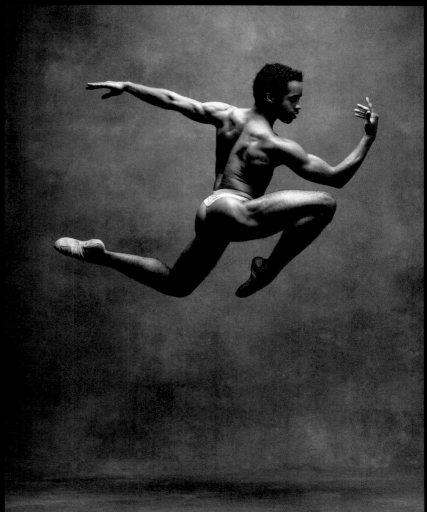

"When I am looking for a dancer, it isn't even the person that gets the material fastest. It's the one that I can't stop looking at. The person who feels hungry for the movement, they want to devour it and they show me something I didn't see in the dance. That's a very precious person."

–Bill T. Jones

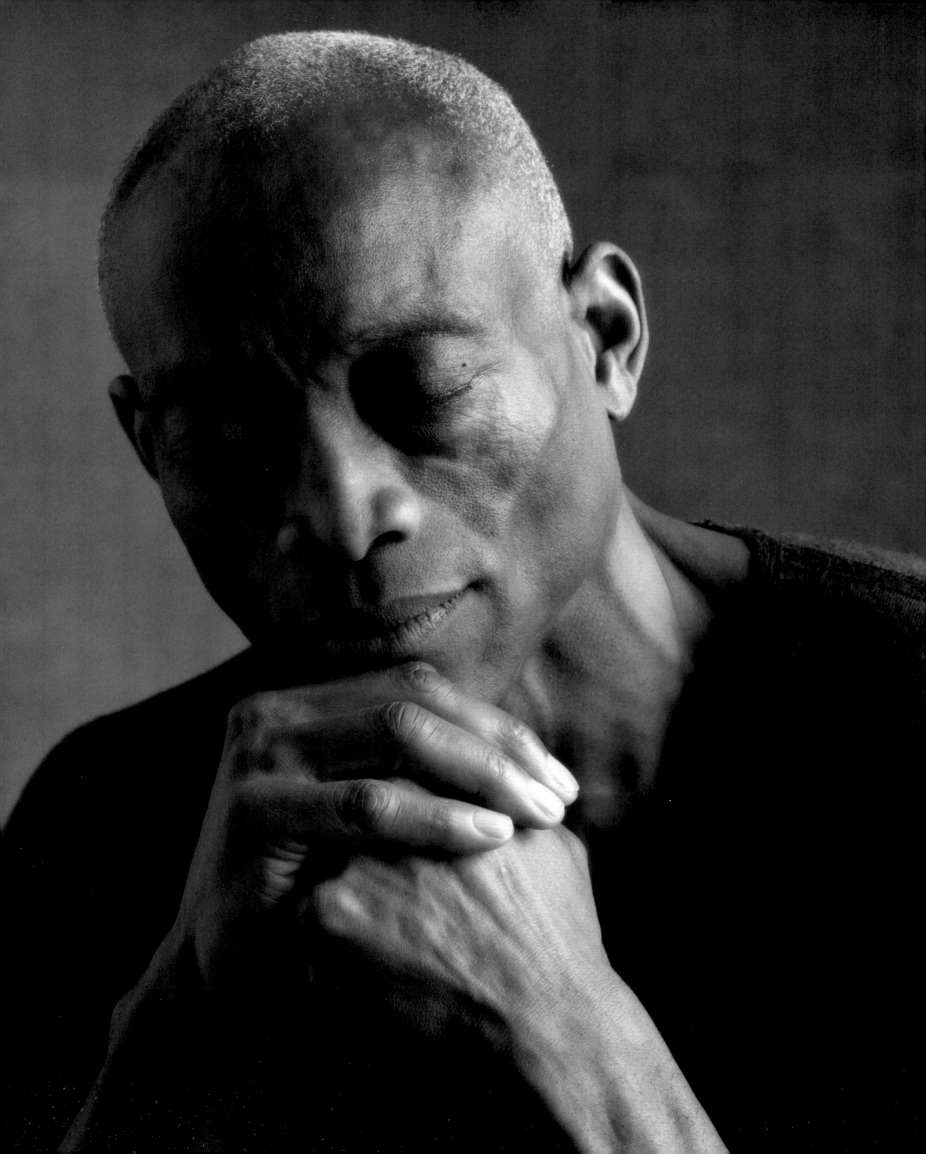

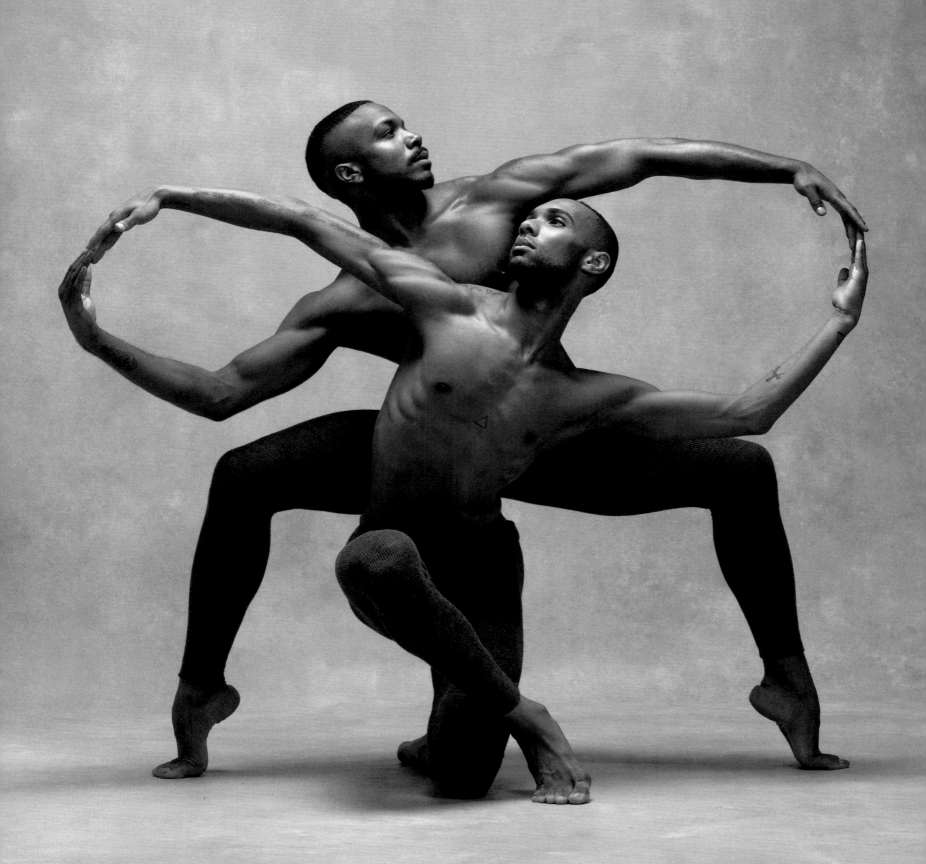

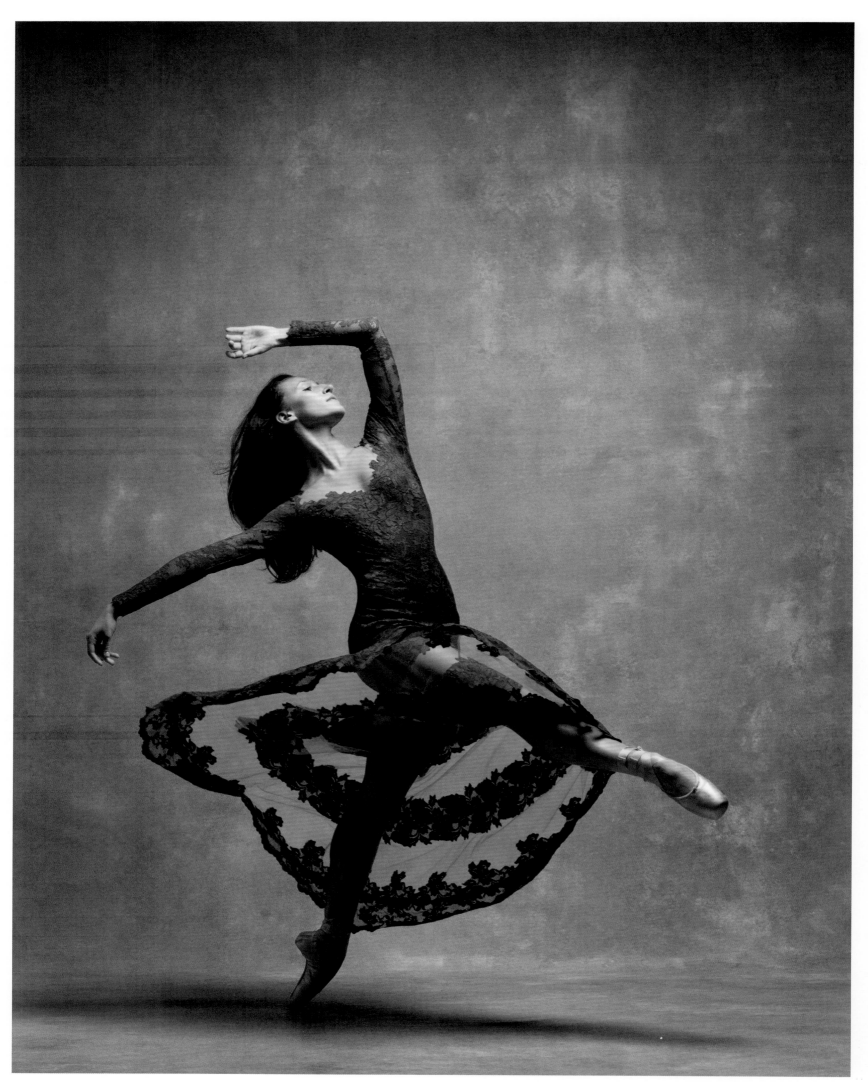

Devon Teuscher | Soloist, American Ballet Theatre

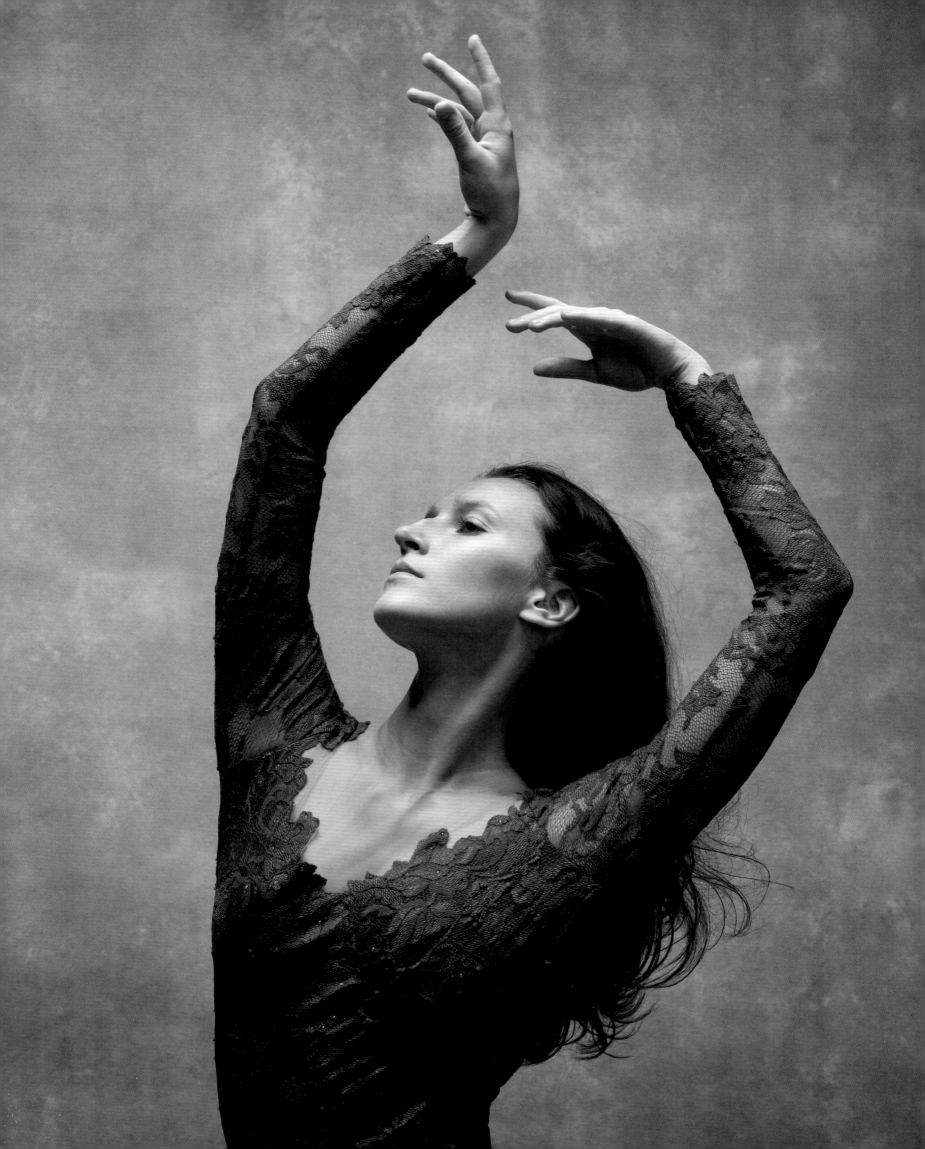

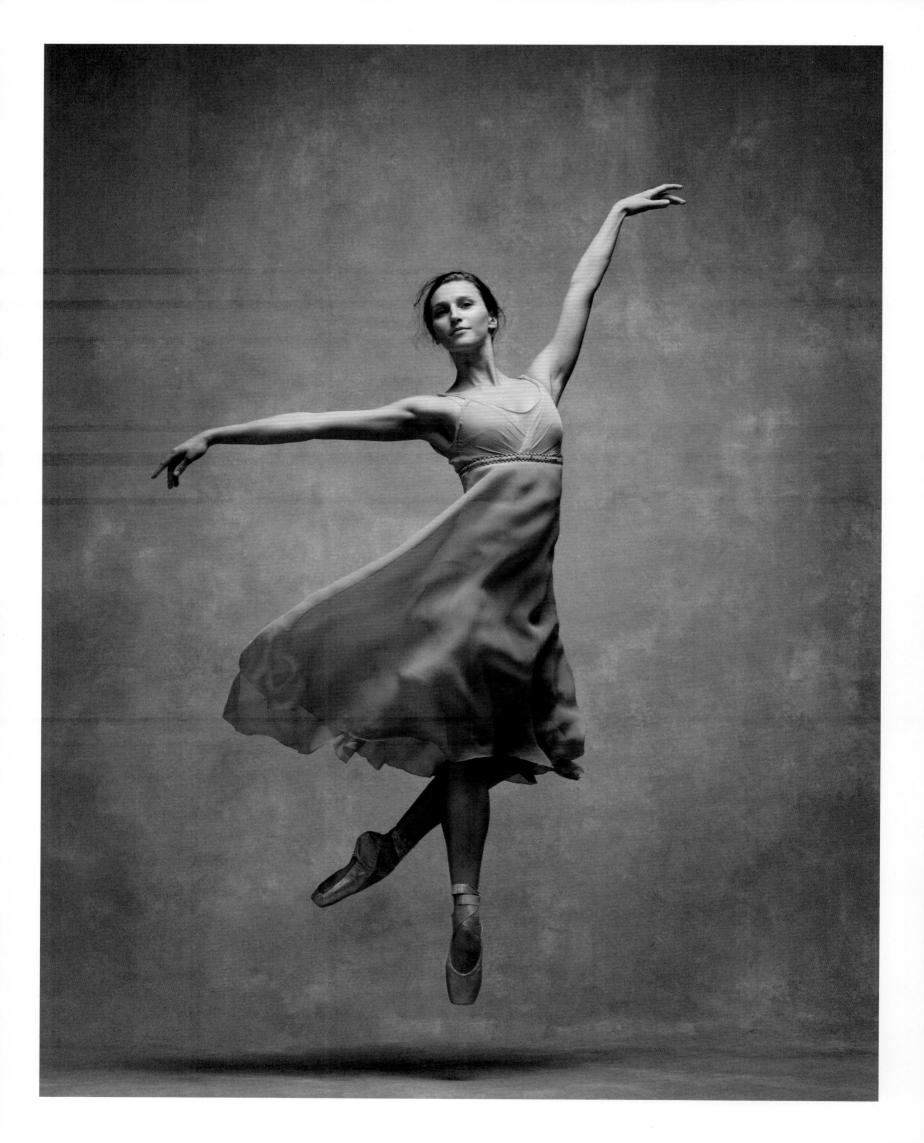

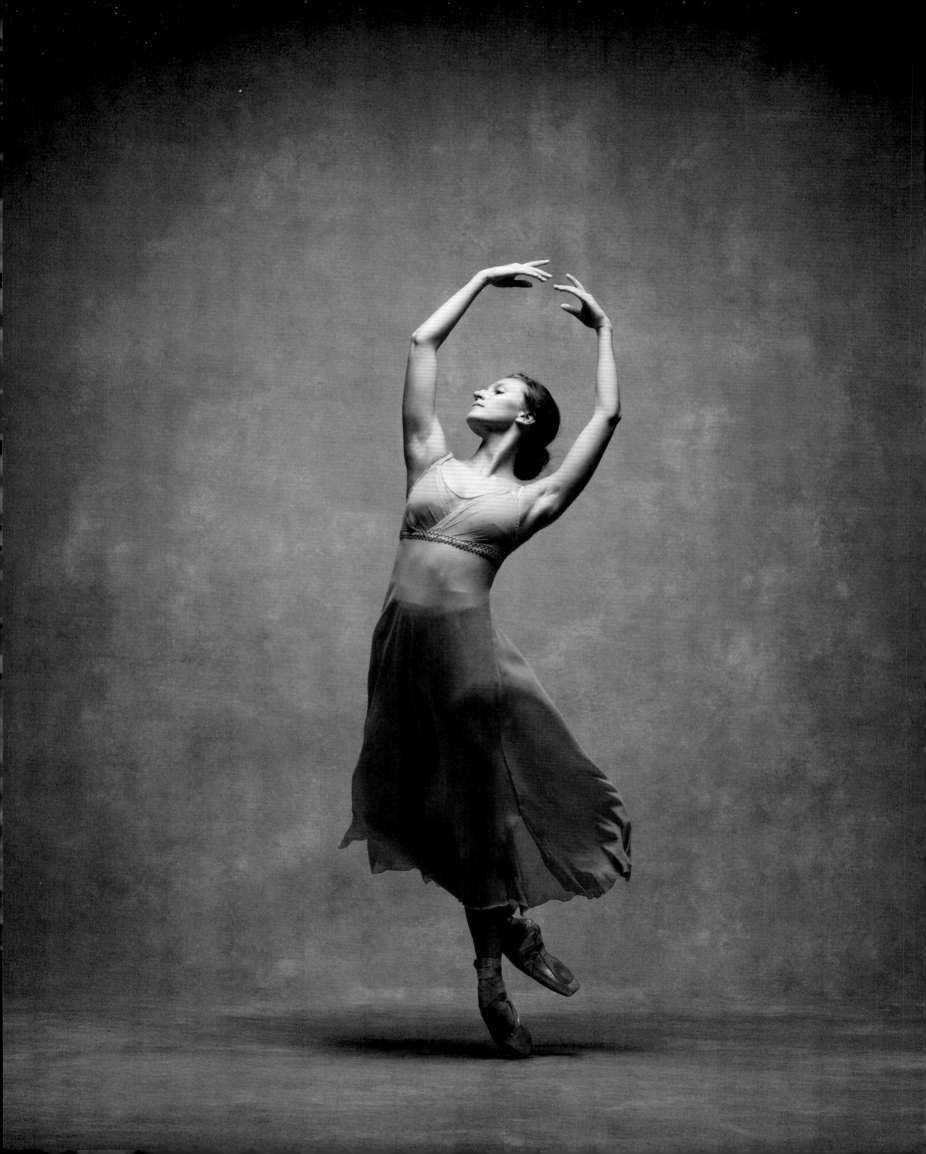

"One of the questions I'm so often asked after a performance is, 'What did that dance mean?' What I wish people knew, and what I always answer, is that there isn't a right or wrong, or a black and white, especially when it comes to the dances of Paul Taylor. What there is, is a beauty in dance's capacity to speak differently to each and every viewer. Watching is a very personal experience. It's an opportunity to allow ourselves to be challenged and delighted, without the pressure of needing to define exactly what we're seeing."

–Michael Trusnovec

Michael Trusnovec | Paul Taylor Dance Company

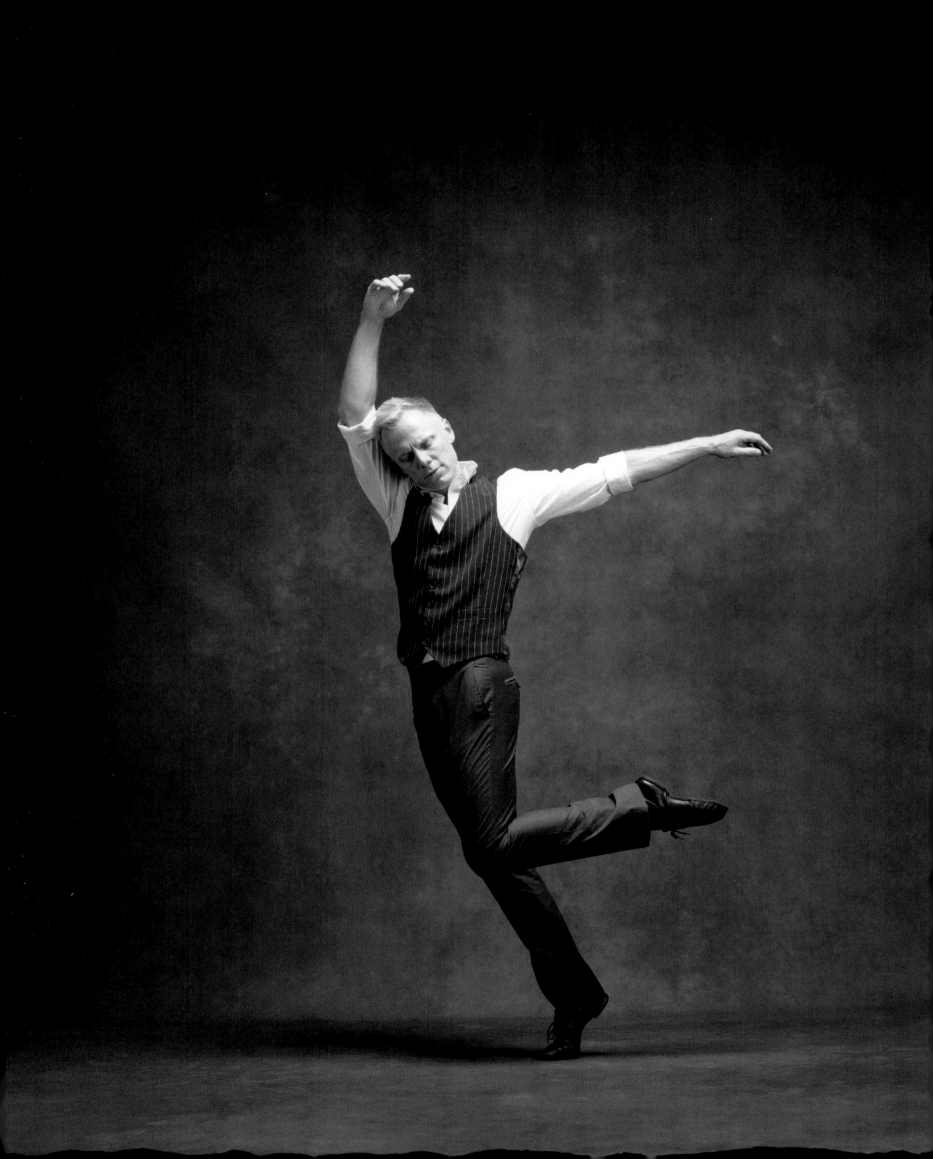

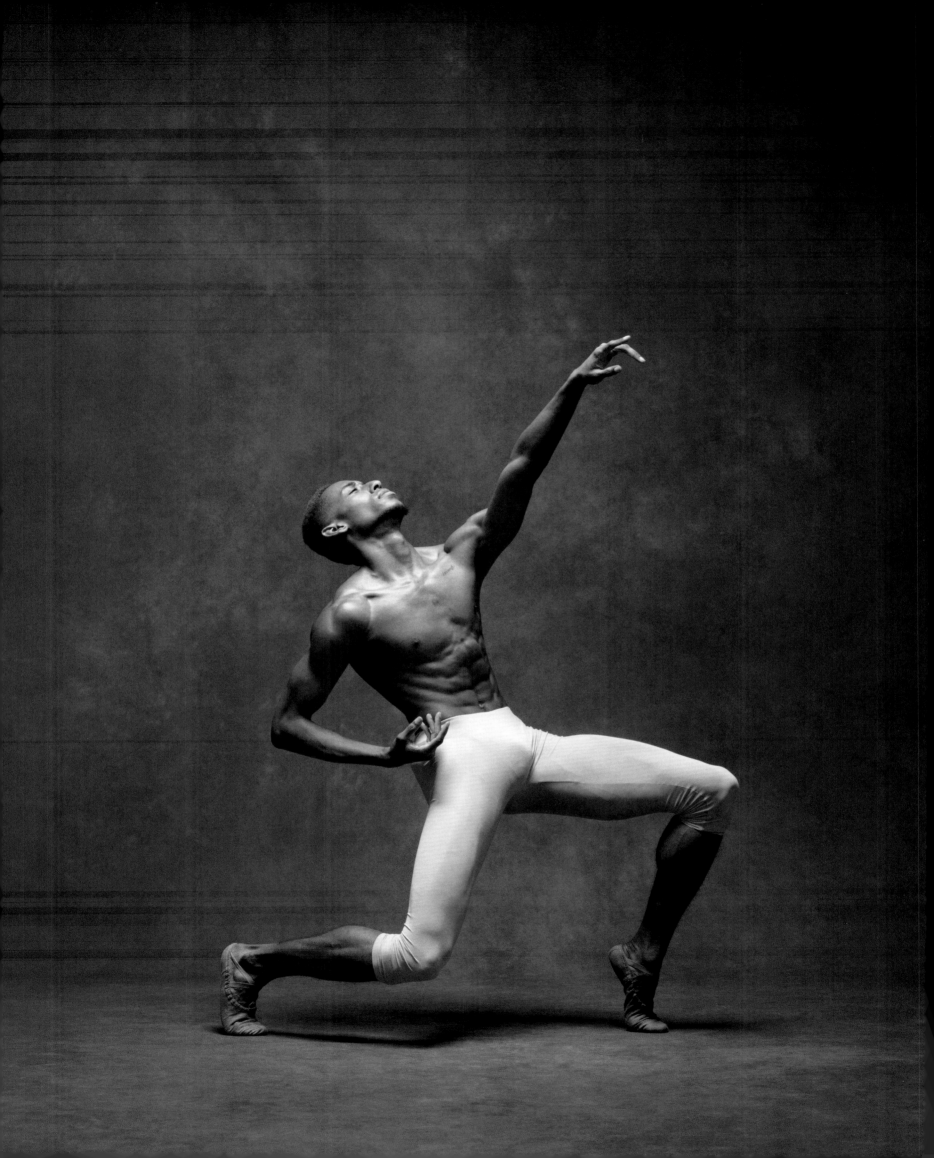

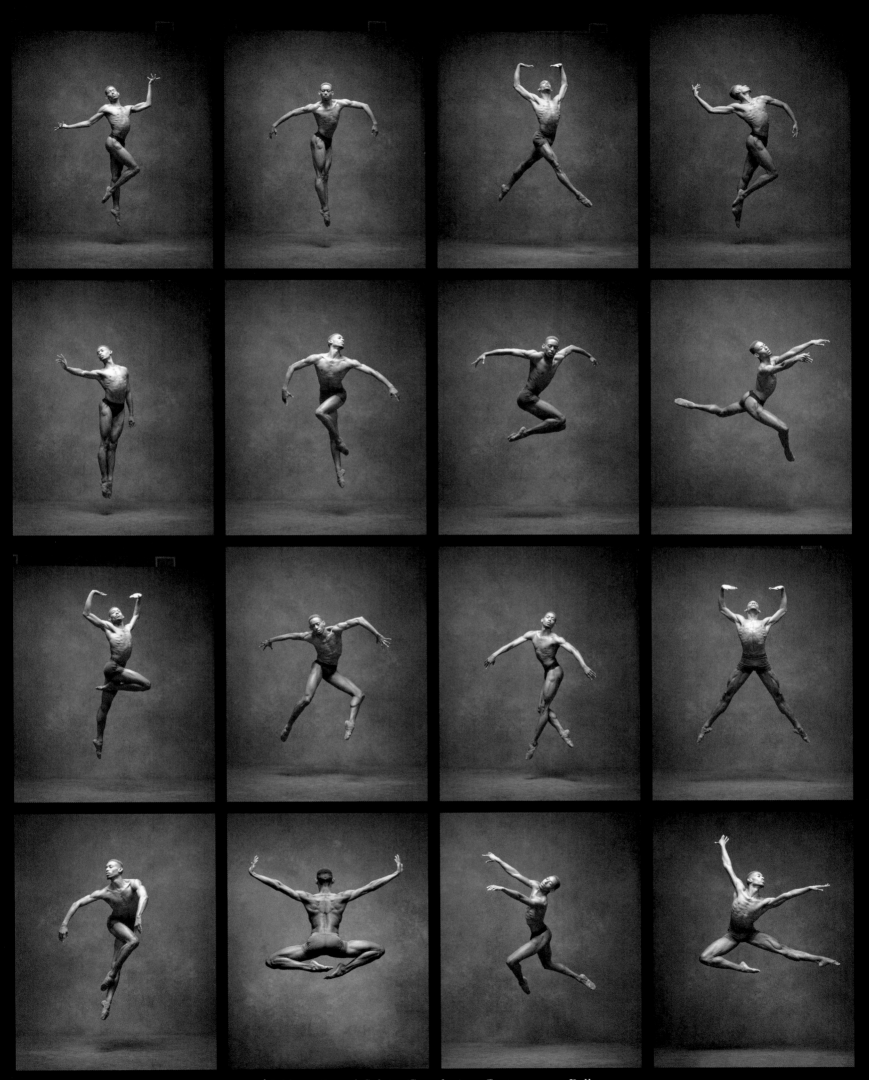

Addison Ector | Soloist, Complexions Contemporary Ballet

"It's not about being small, it's not about being Asian, or not about having an unfortunate body for ballet. It's about how willing you are to dedicate your entire life to this art form."

–Misa Kuranaga

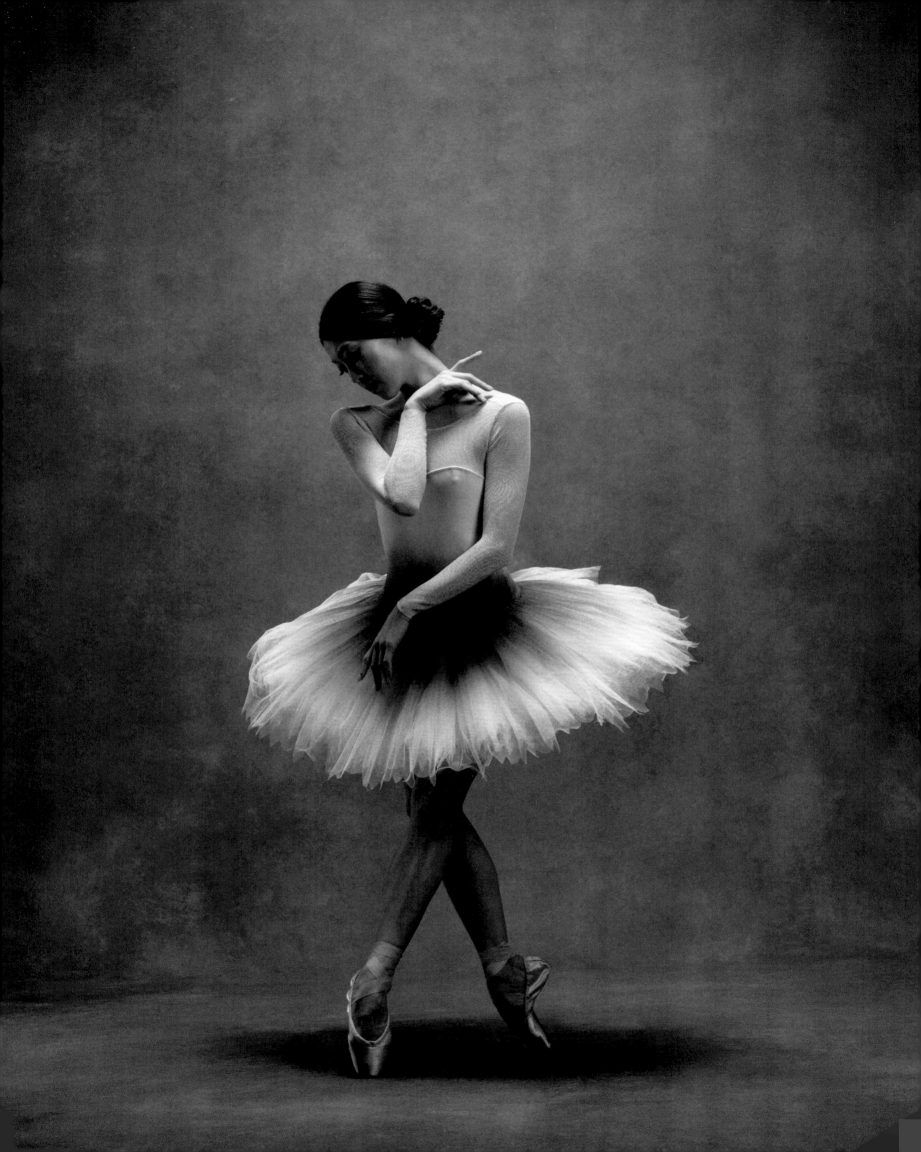

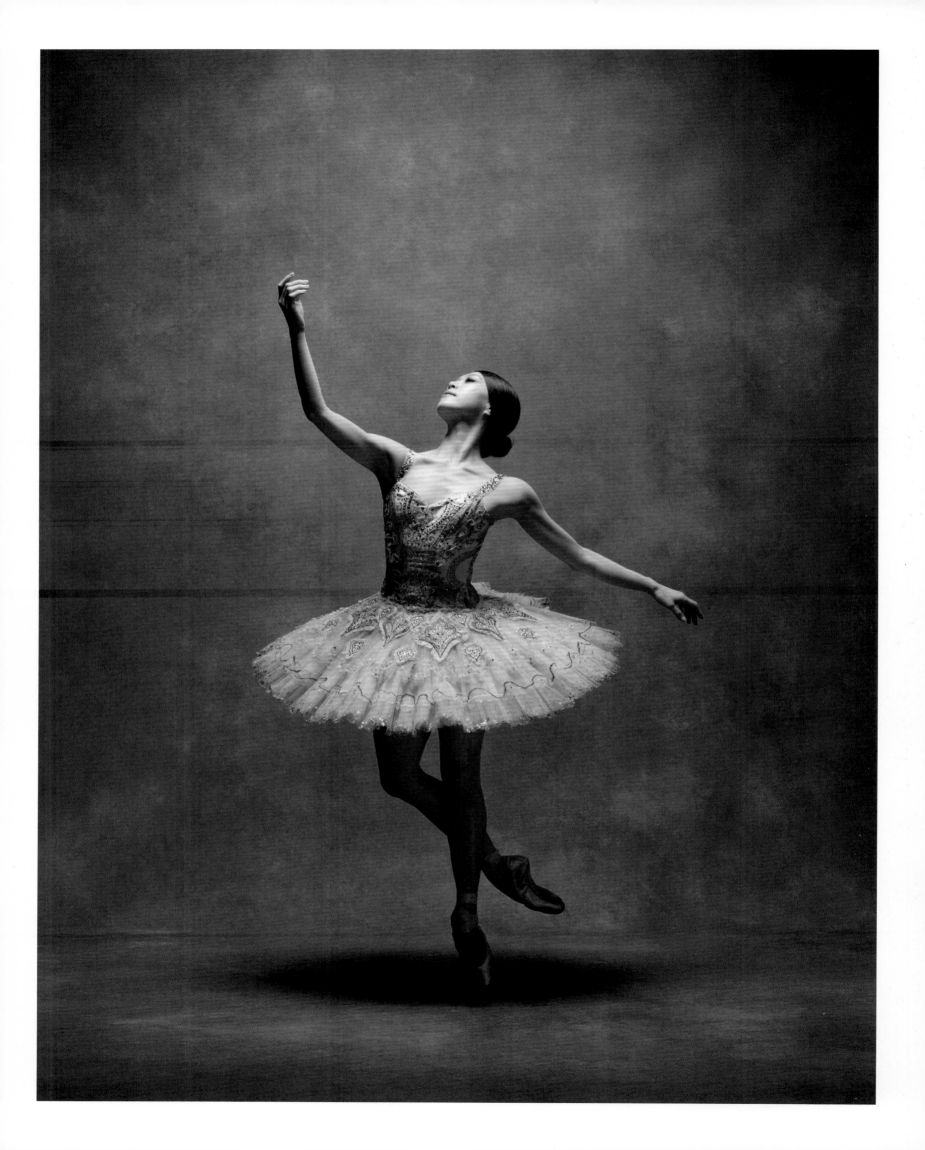

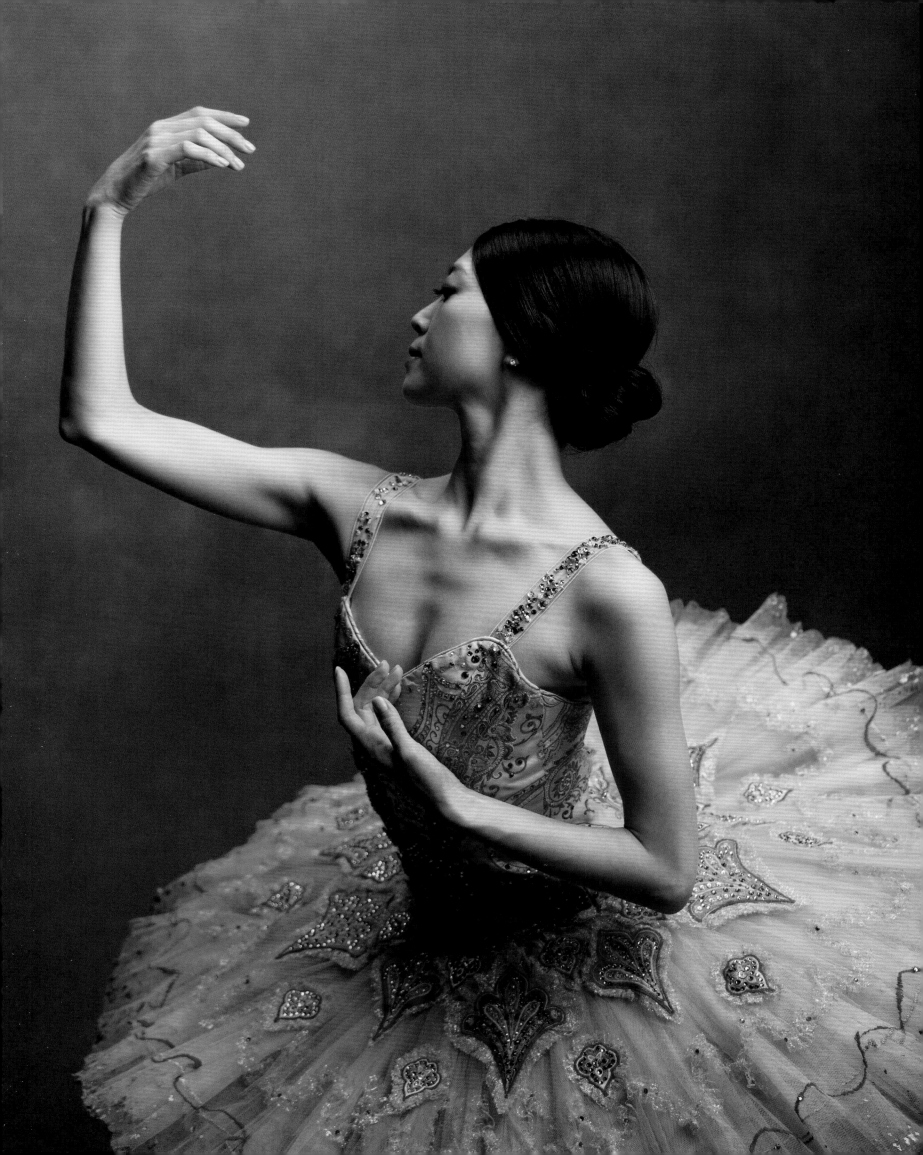

"Martha Graham never met Lloyd Knight,
but when she coined the phrase 'athletes of God,'
she must have had Lloyd in mind."

-Janet Eilber, Artistic Director, Martha Graham Dance Company

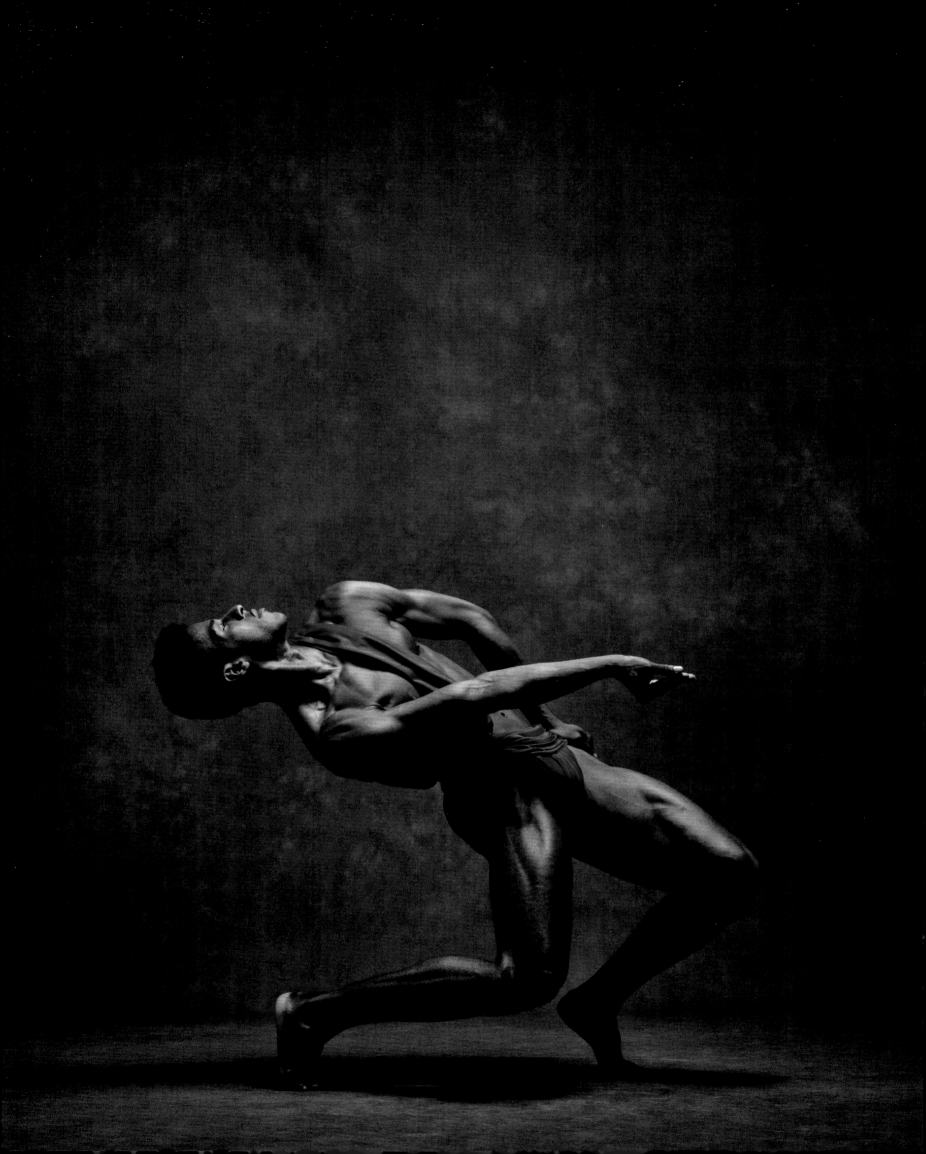

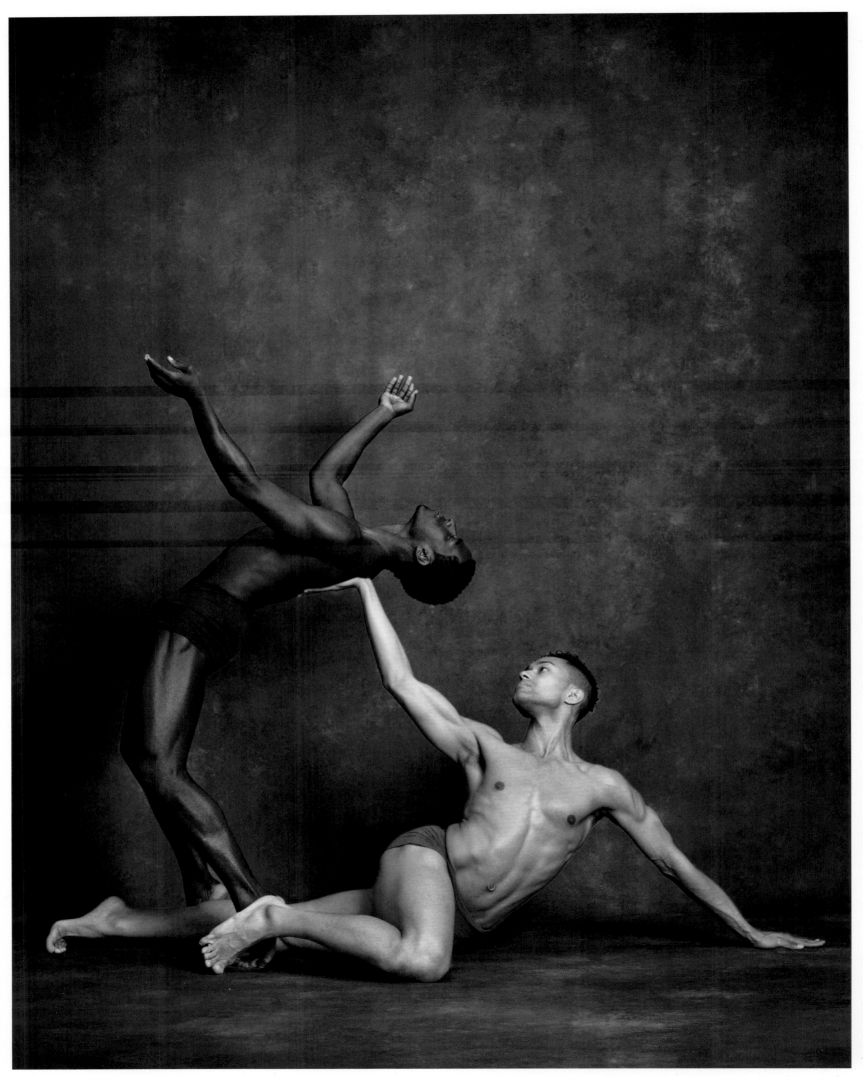

Lloyd Knight | Principal, Martha Graham Dance Company and **Abdiel Cedric Jacobsen** | Soloist, Martha Graham Dance Company

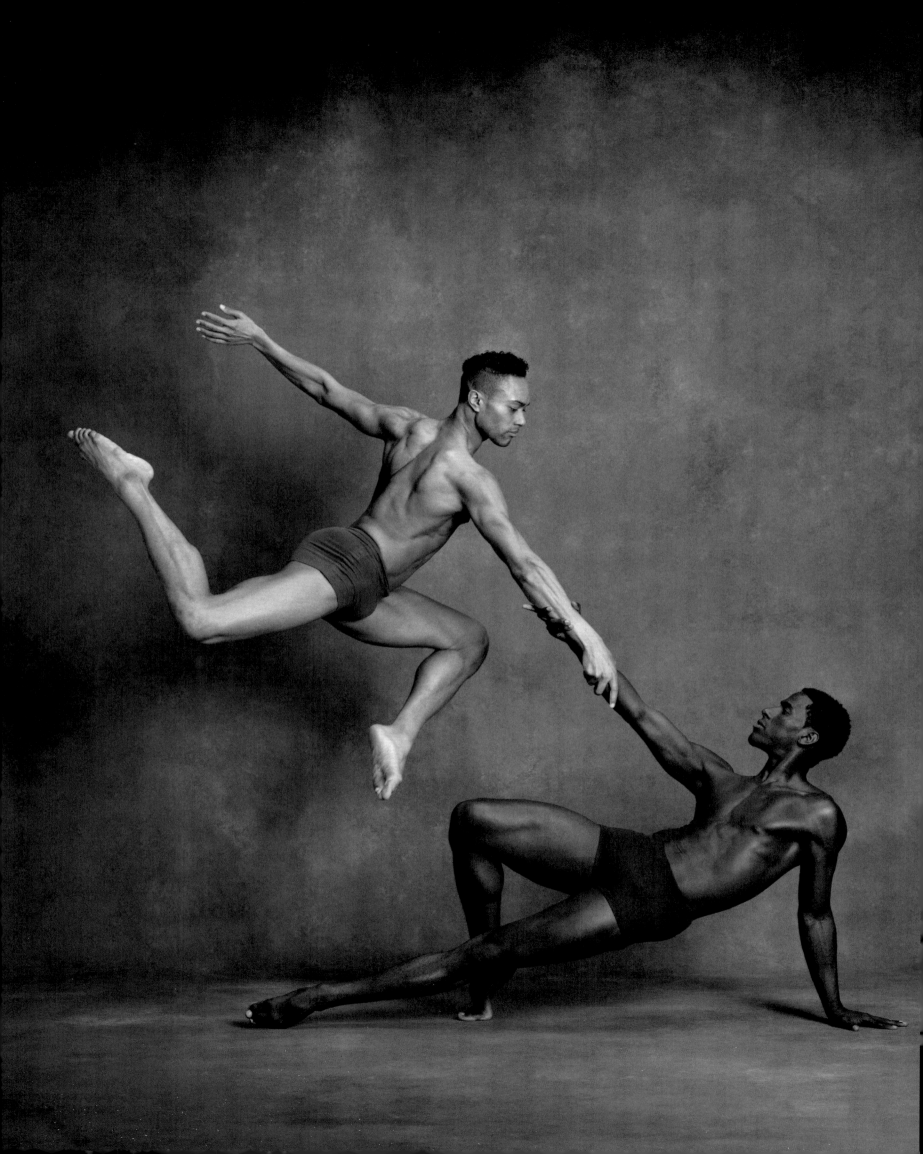

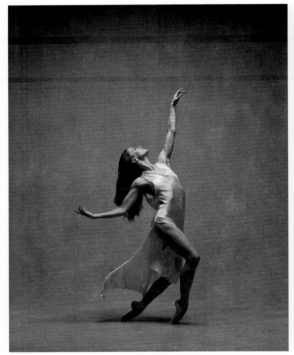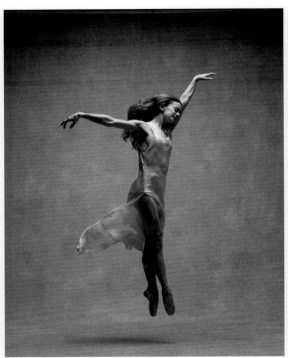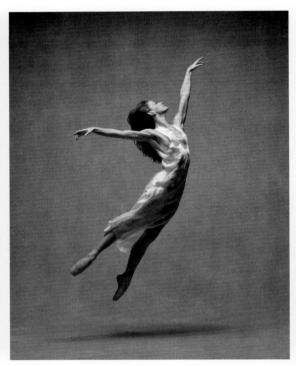

Emily Bromberg | Soloist, Miami City Ballet

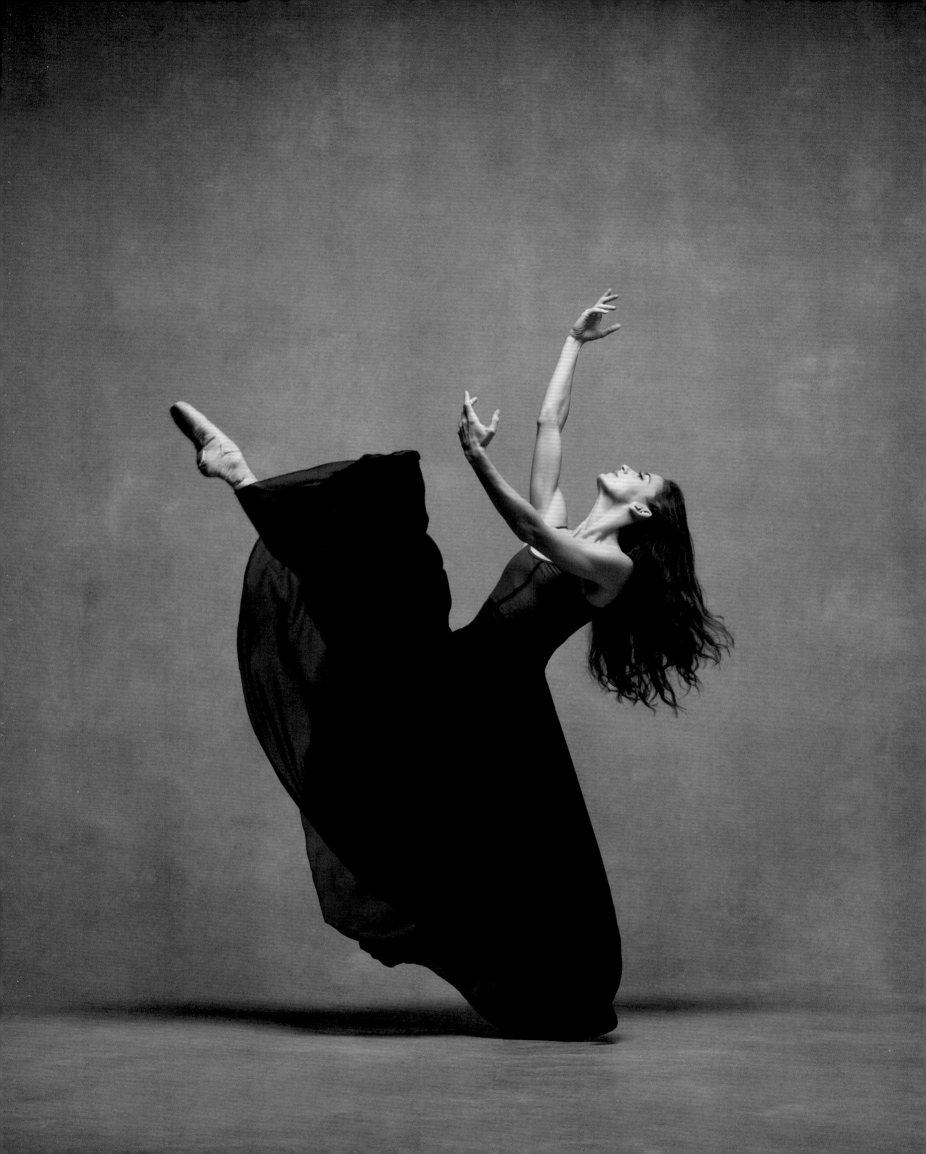

"I always like to say that Michael and Janet Jackson were my first dance teachers because I would study their videos for hours and learn every step until I felt I had it perfected."

–Daniel Harder

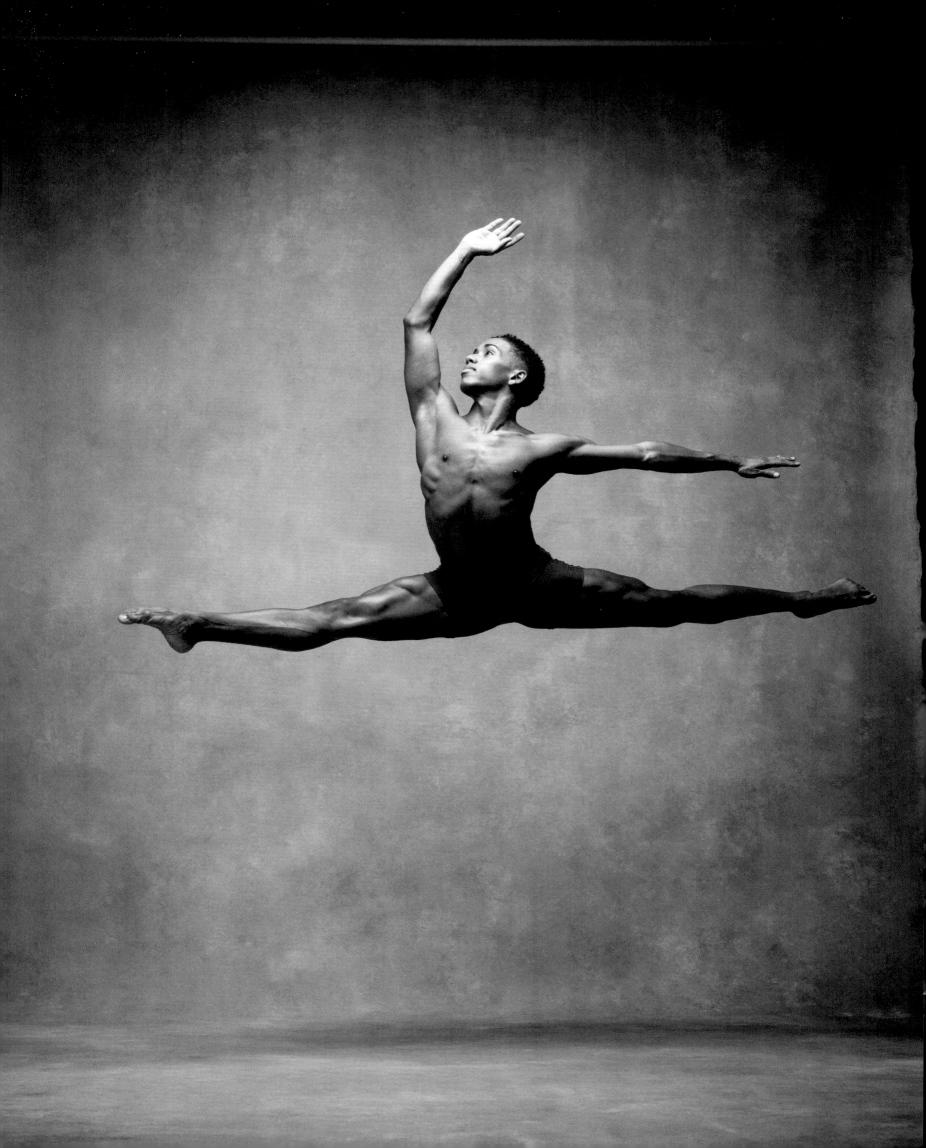

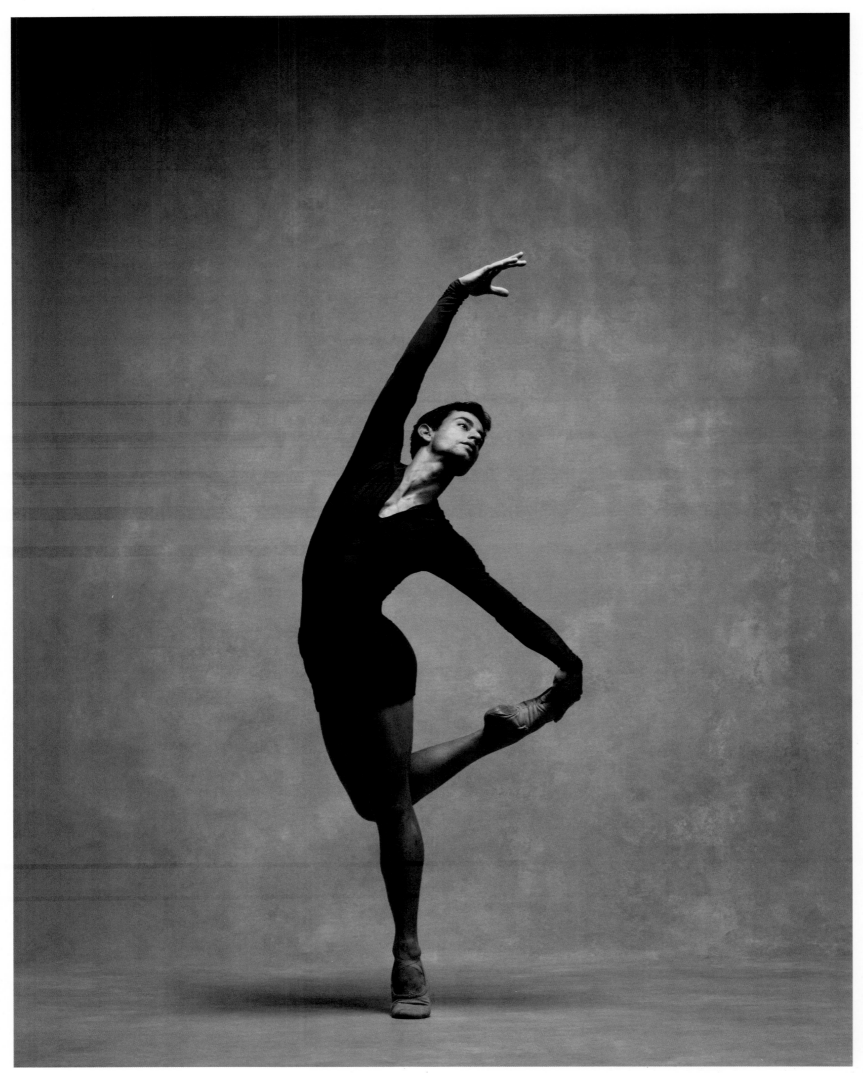

Kleber Rebello | Principal, Miami City Ballet

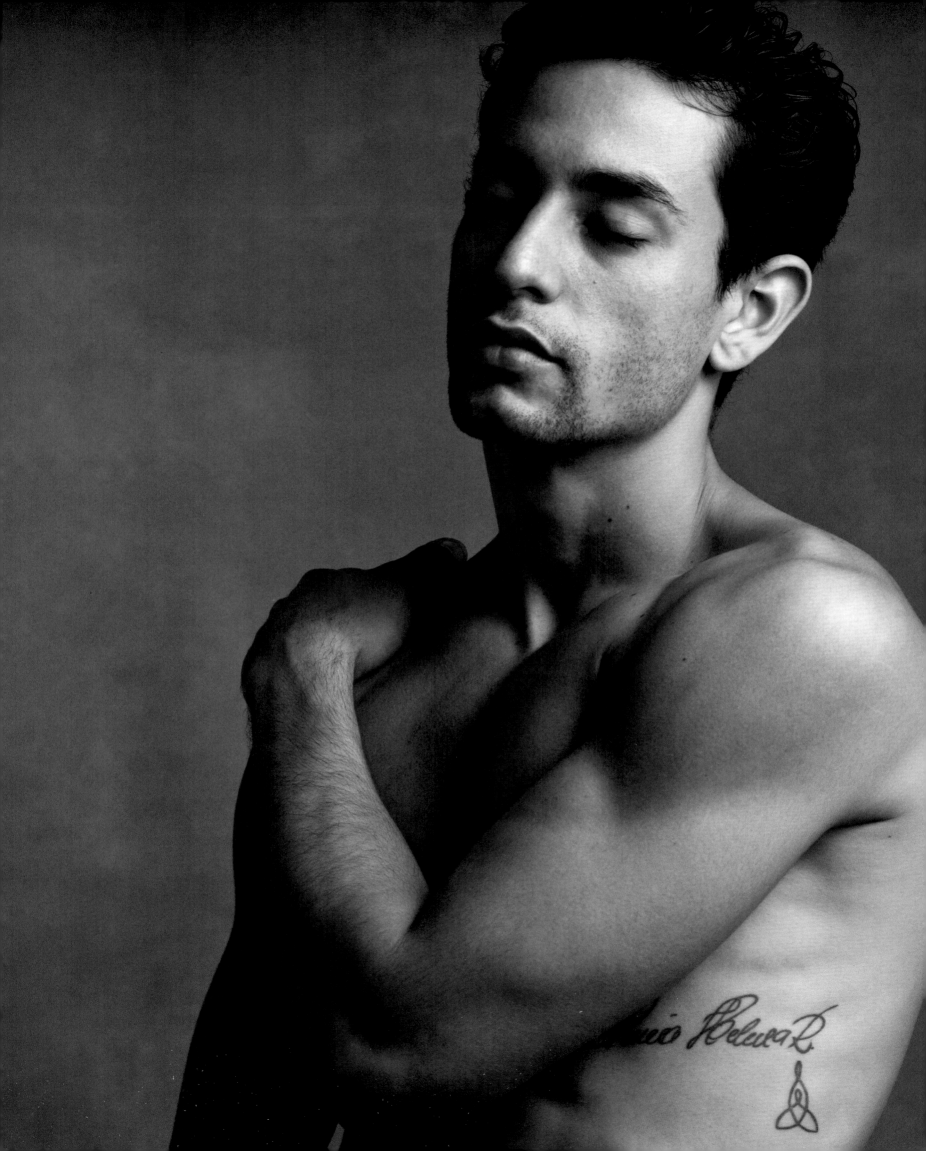

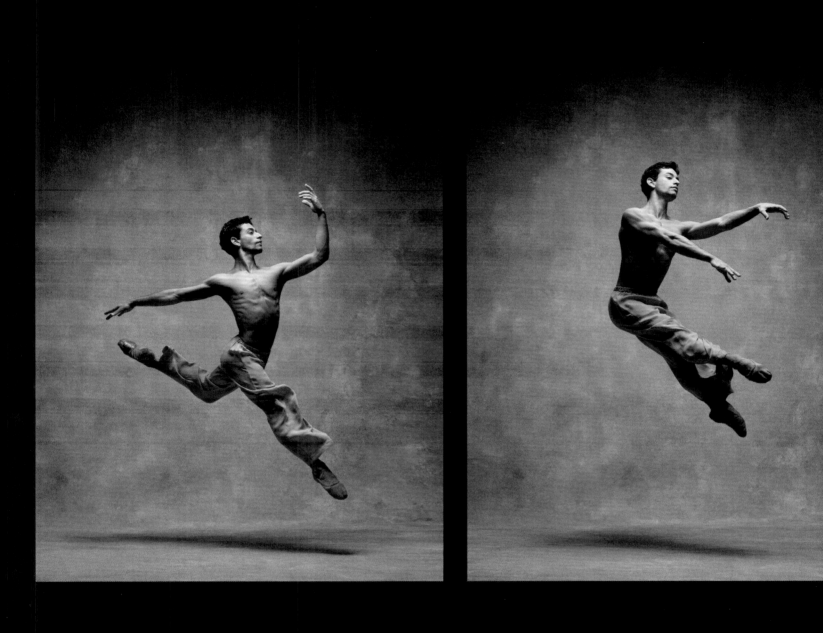

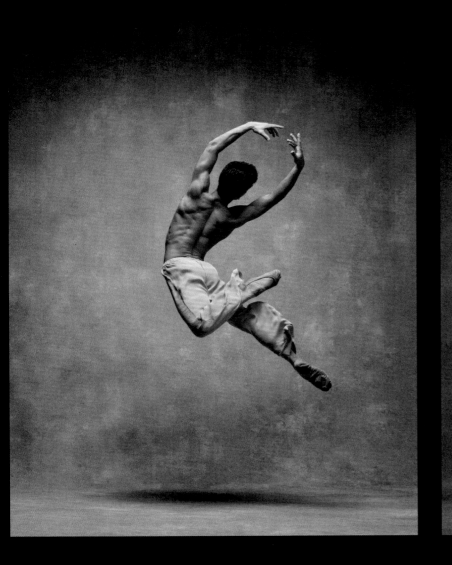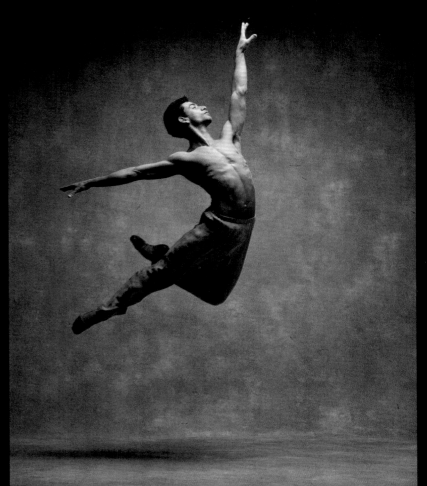

"Growing up in America, I wanted to immerse myself in ballet, but rarely had the funds to do this.
I had to earn scholarships to attend ballet schools and summer intensives. Ballet is not easily accessible.
That's the one thing I would love to change."

–Adrian Blake Mitchell

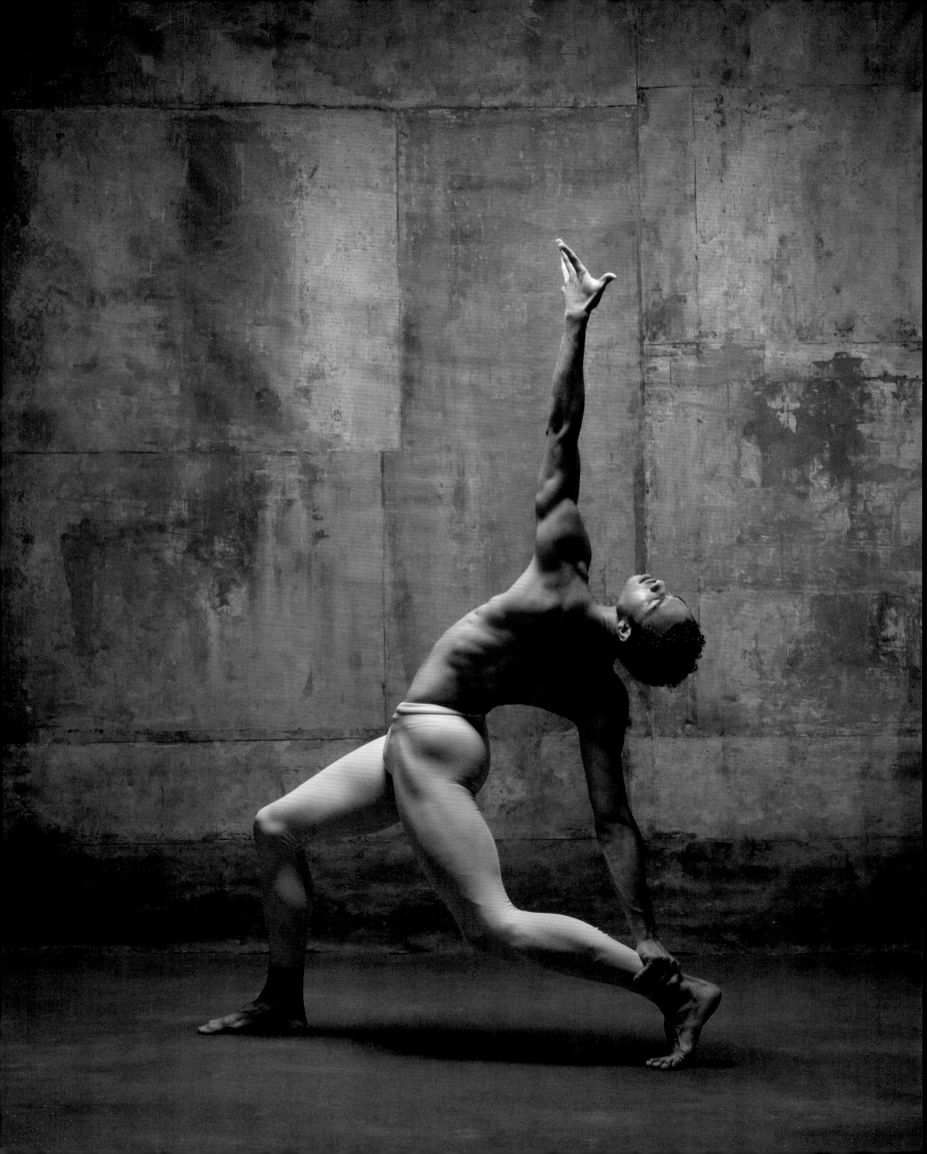

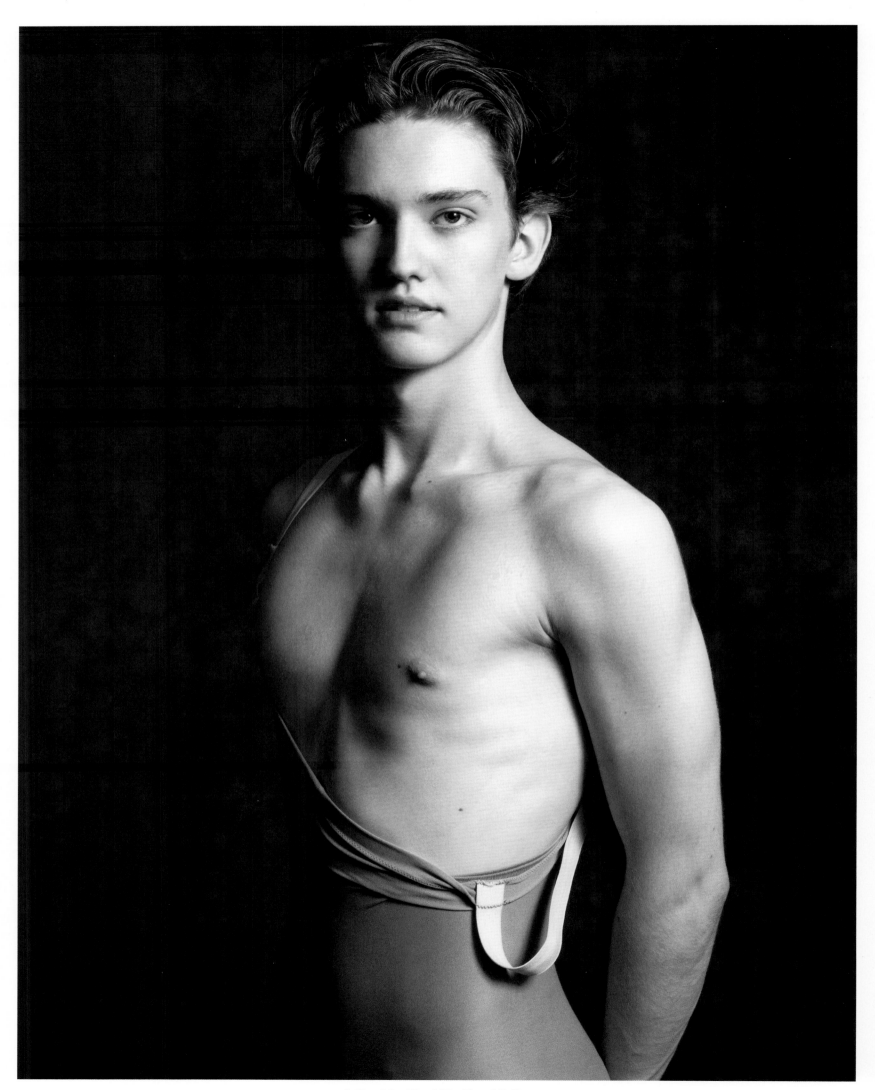

Julian MacKay | The Royal Ballet

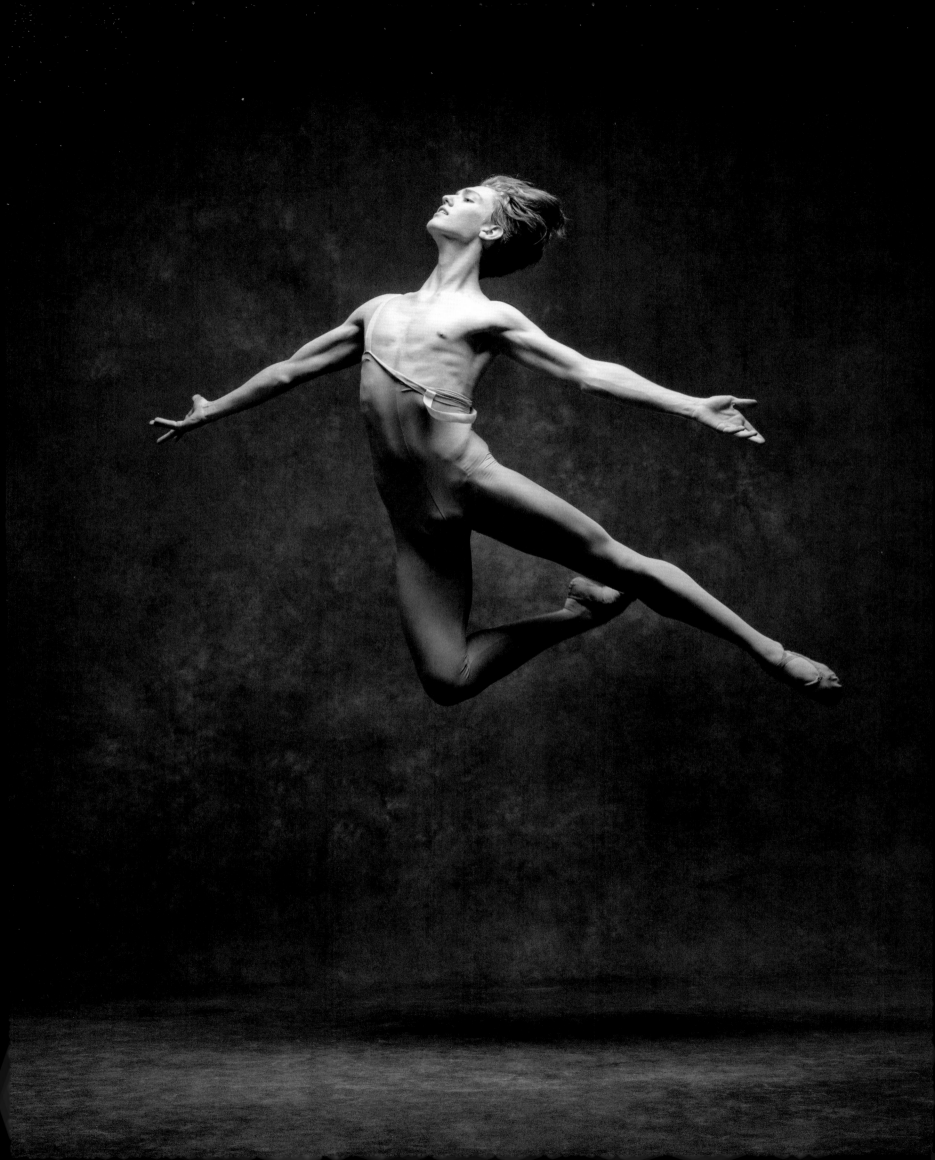

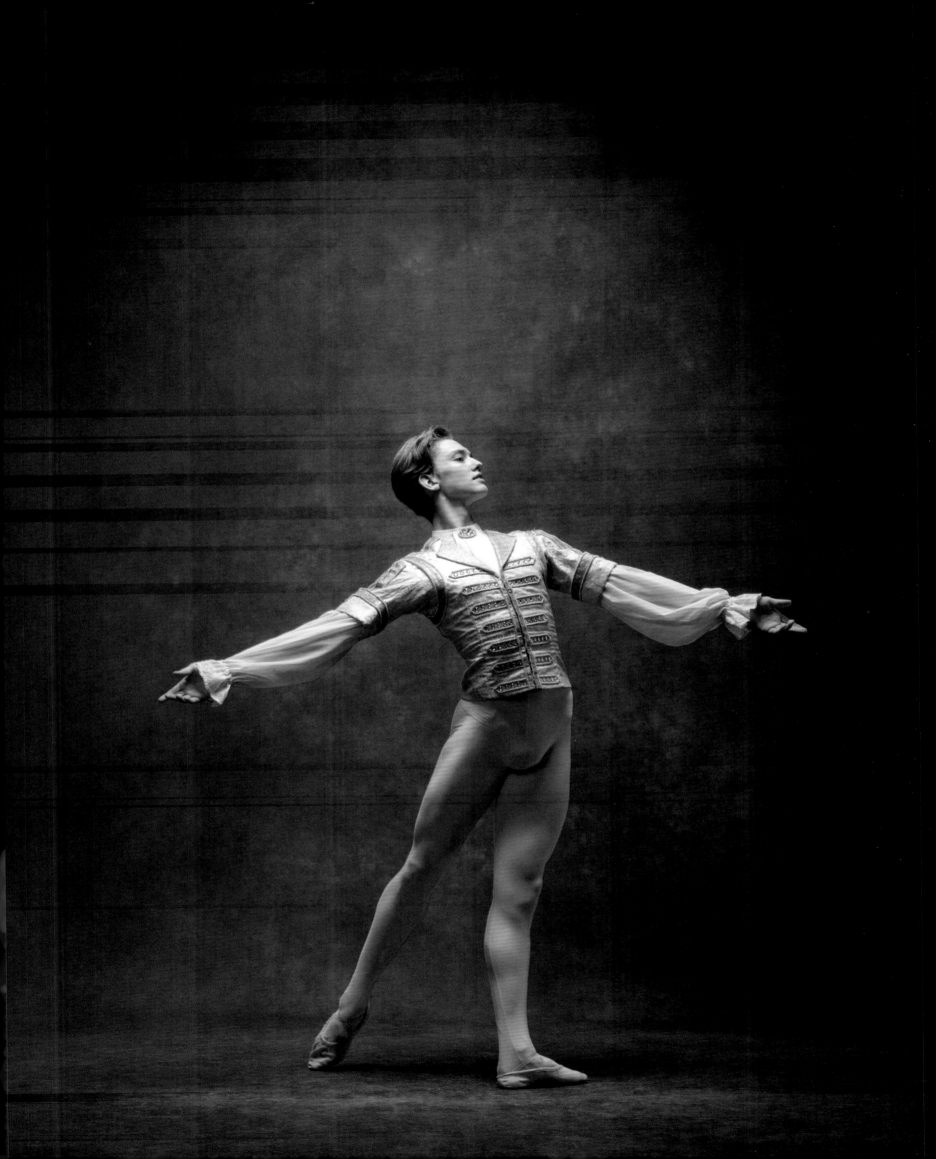

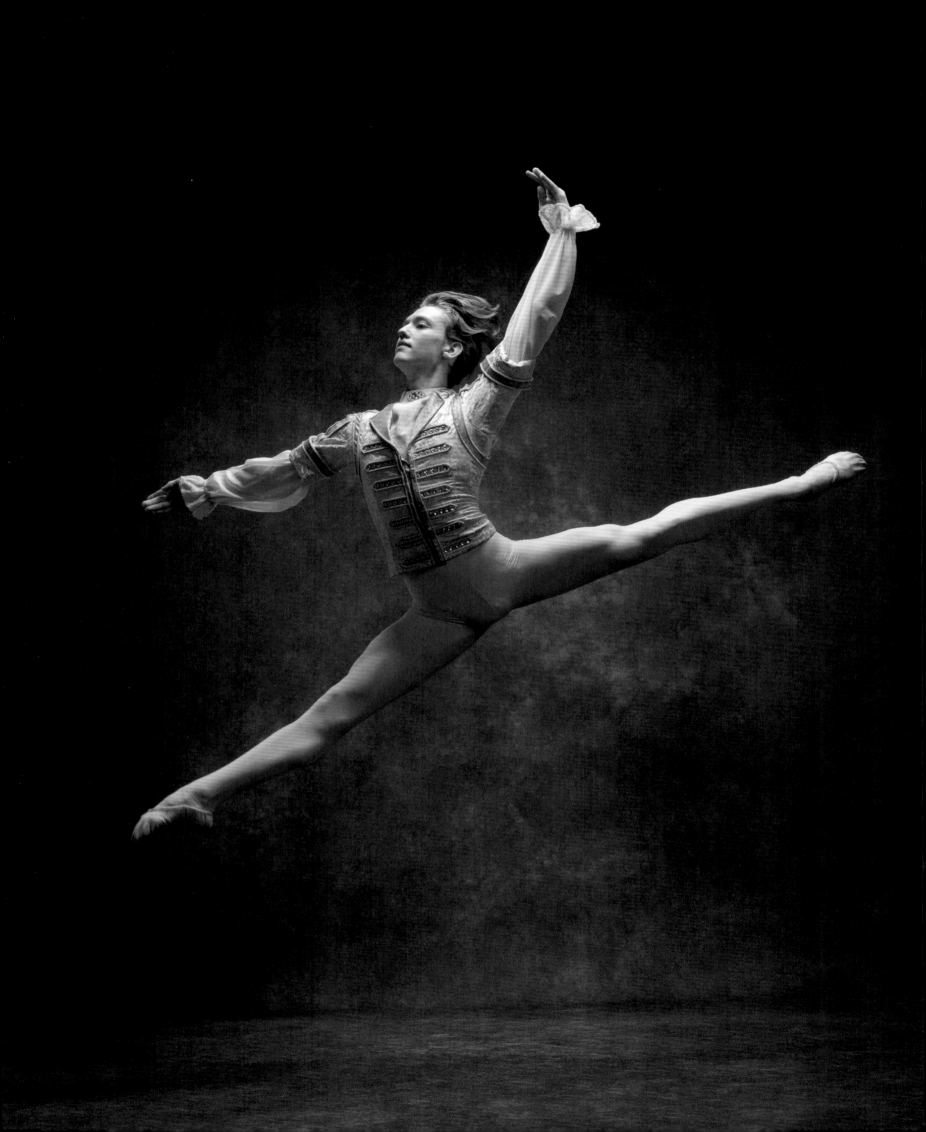

"Time and experience have also taught me that this art form is ephemeral. Rather than focus on my fears for the future, I have realized it is best to be in the present and treasure each fleeting moment."

–Laura Halzack

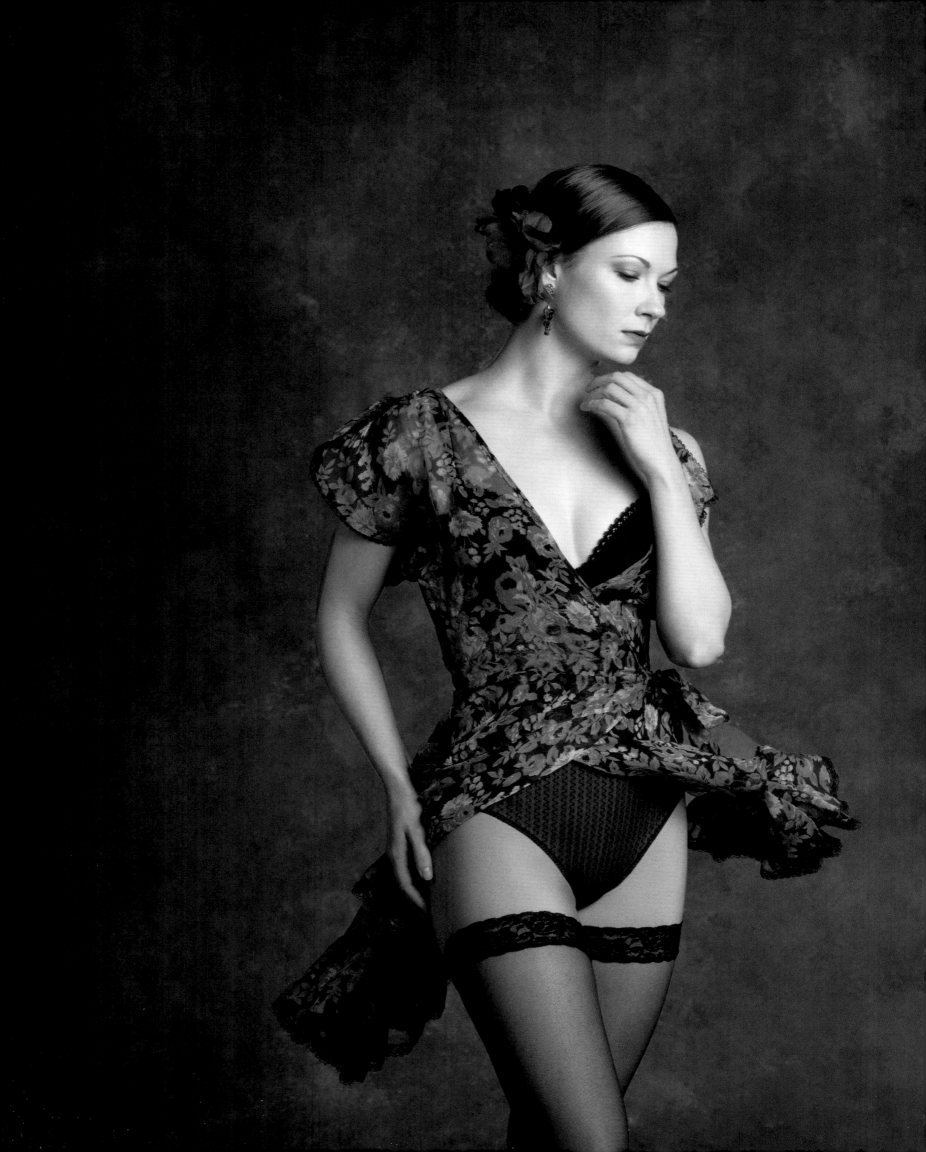

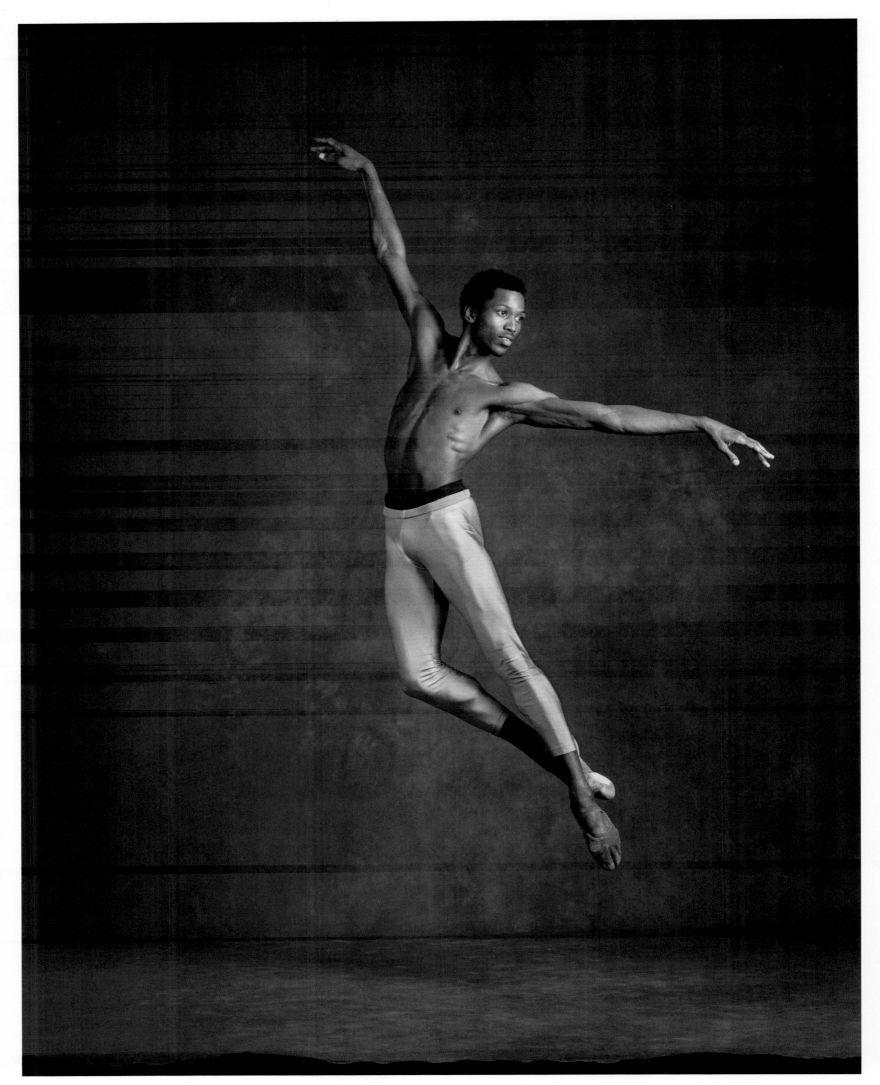

Calvin Royal III | American Ballet Theatre

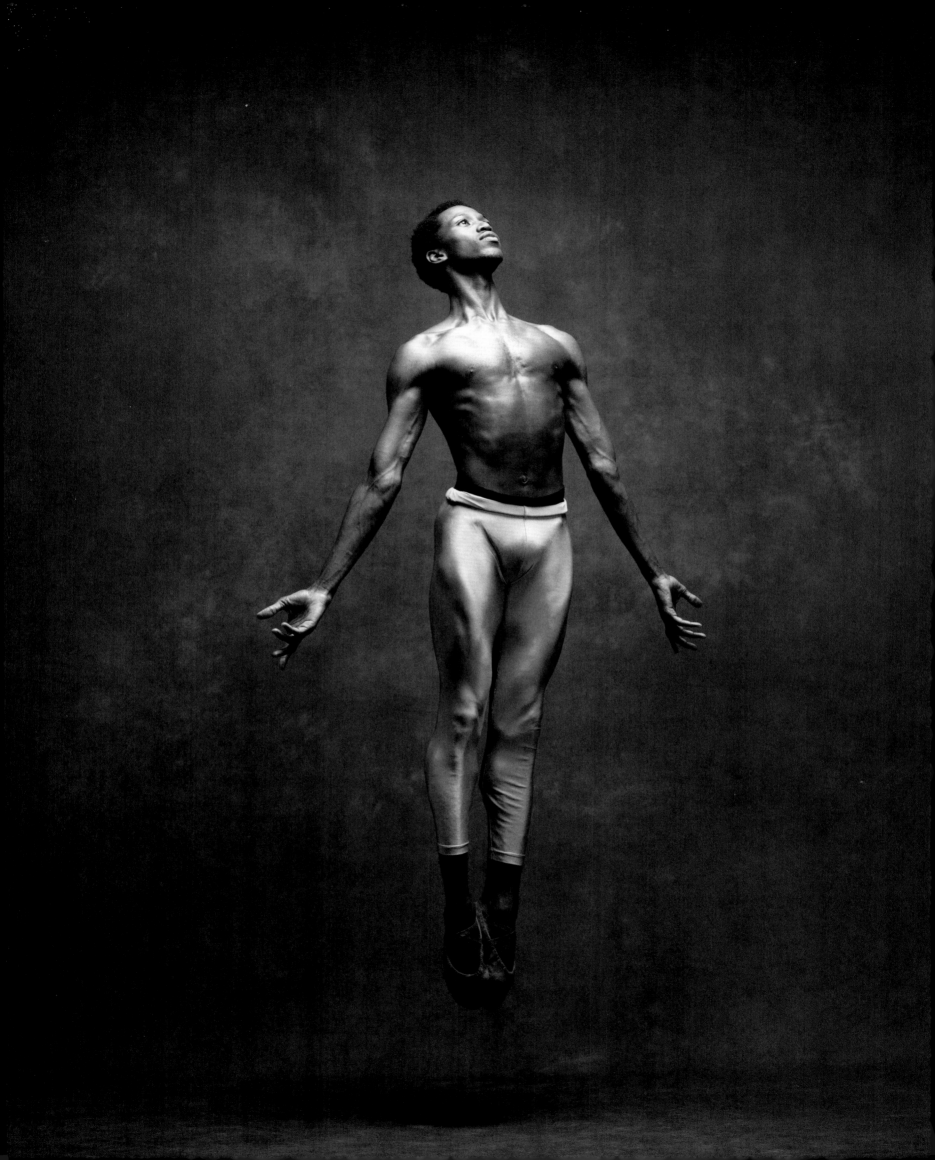

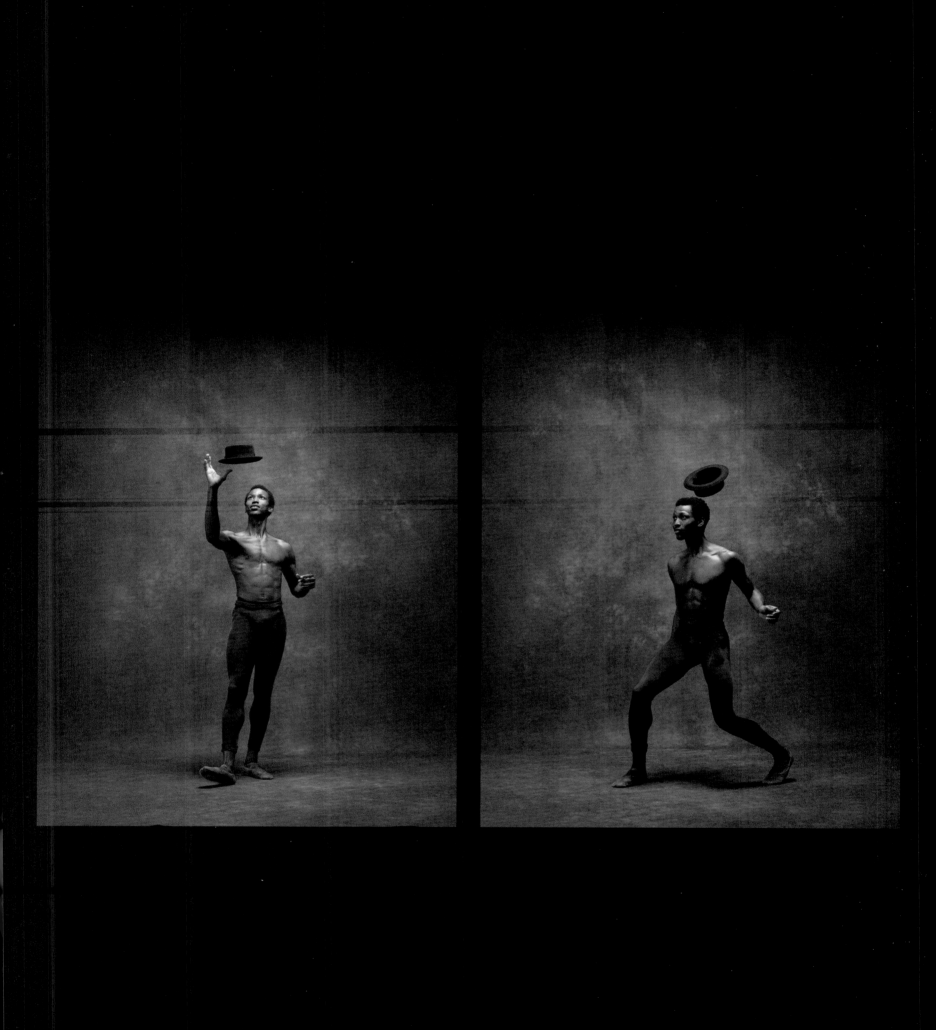

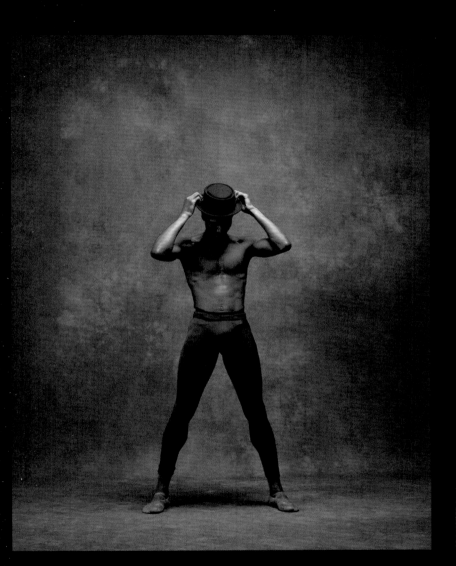
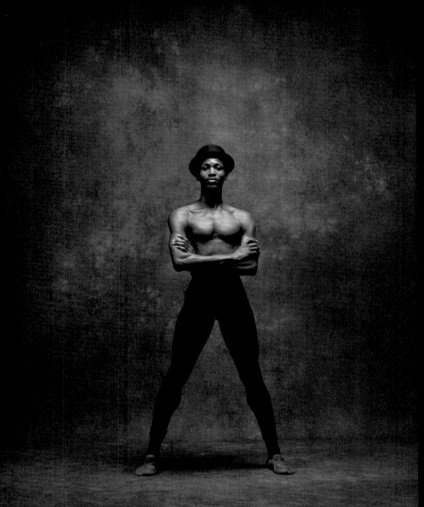

"The one thing I wish I would have known as a young ballerina was that it was okay to not be perfect. I spent most of my early years as a young dancer being really hard on myself and focusing on the mistakes instead of the victories. This career is very short and you have to appreciate all the moments in it."

–Maria Kowroski

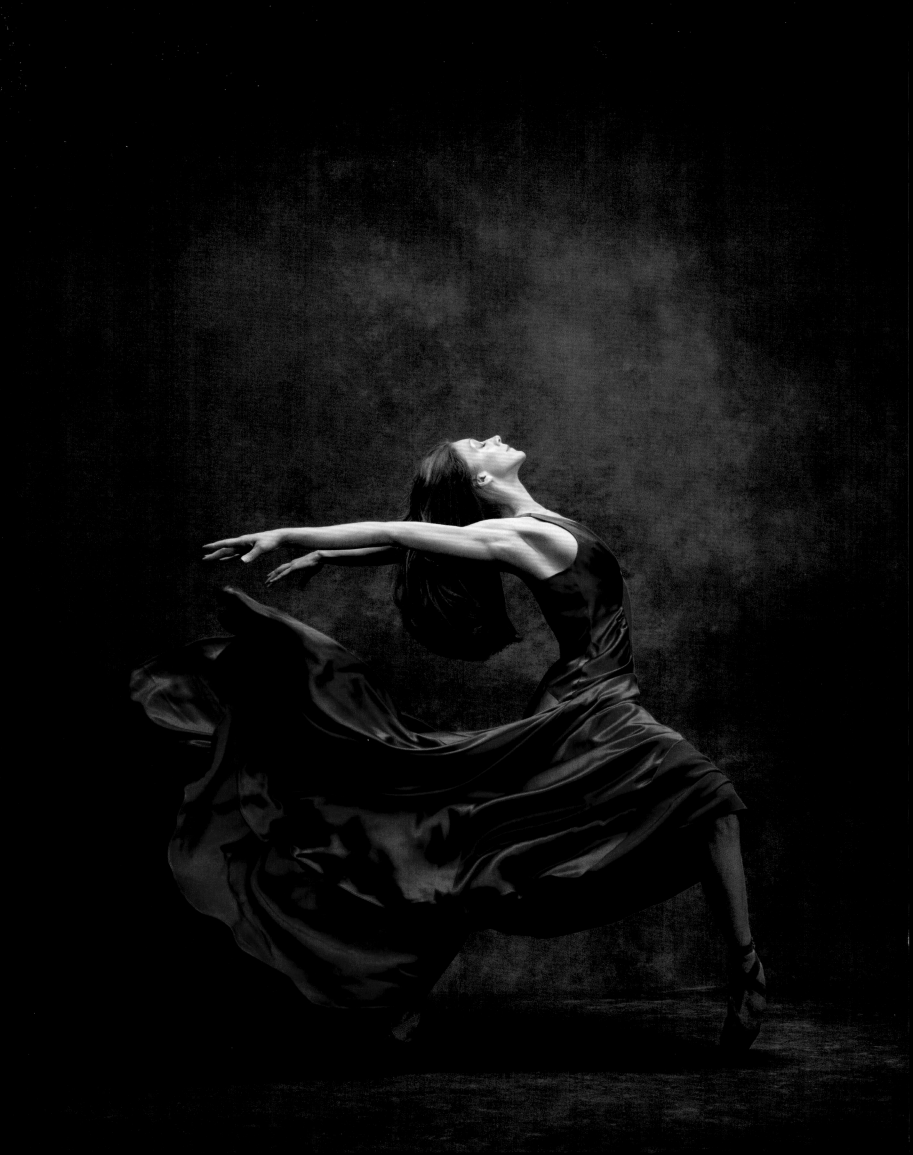

"If I could be any animal, I would be an eagle.
I have always had long arms, which often made me embarrassed
and self conscious. Dance taught me to embrace and use them
to speak the words I could not say."

–Michael Jackson Jr.

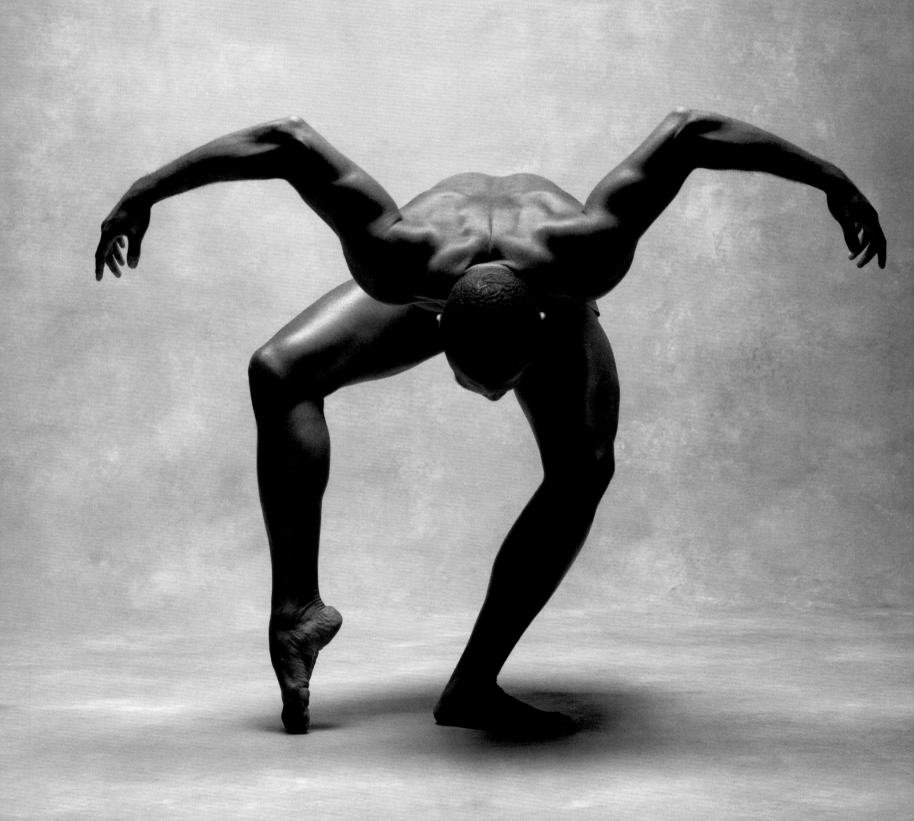

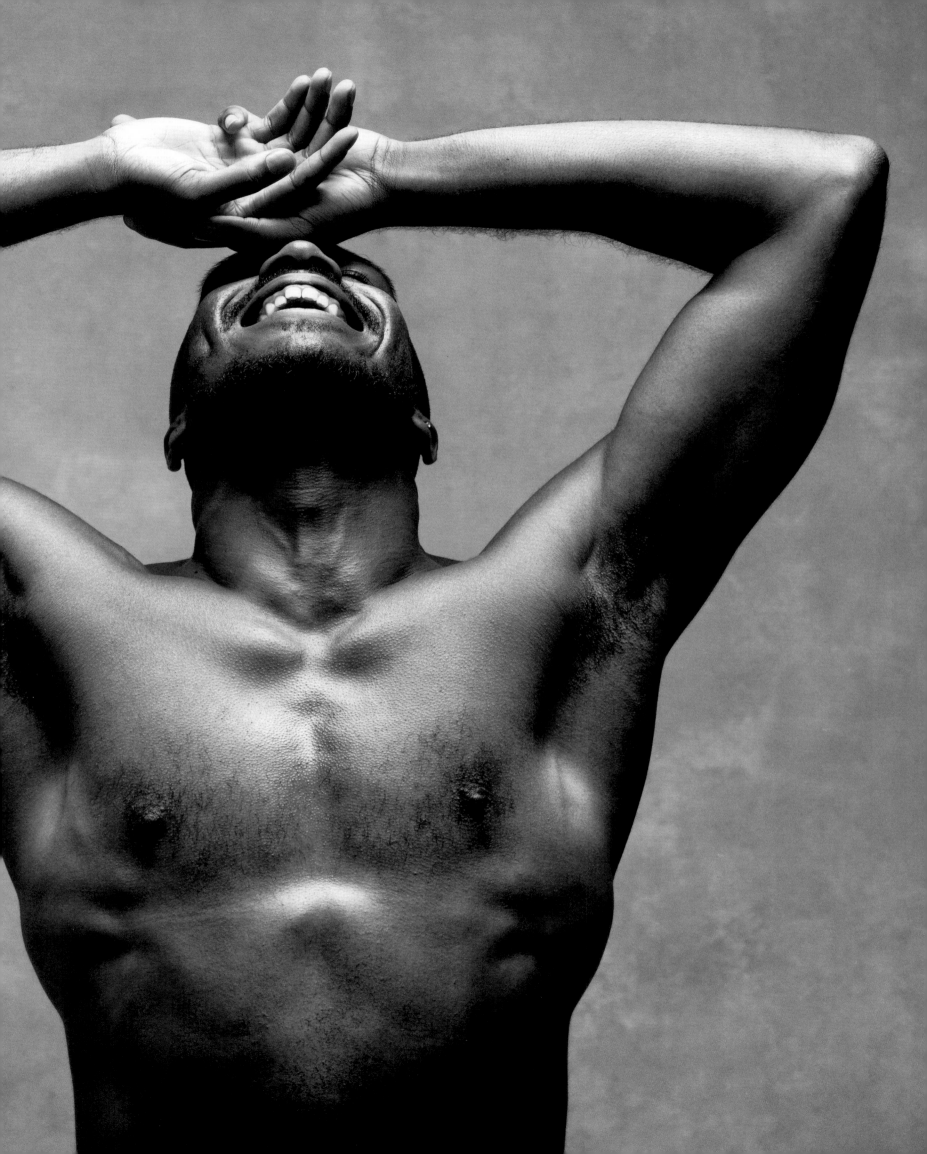

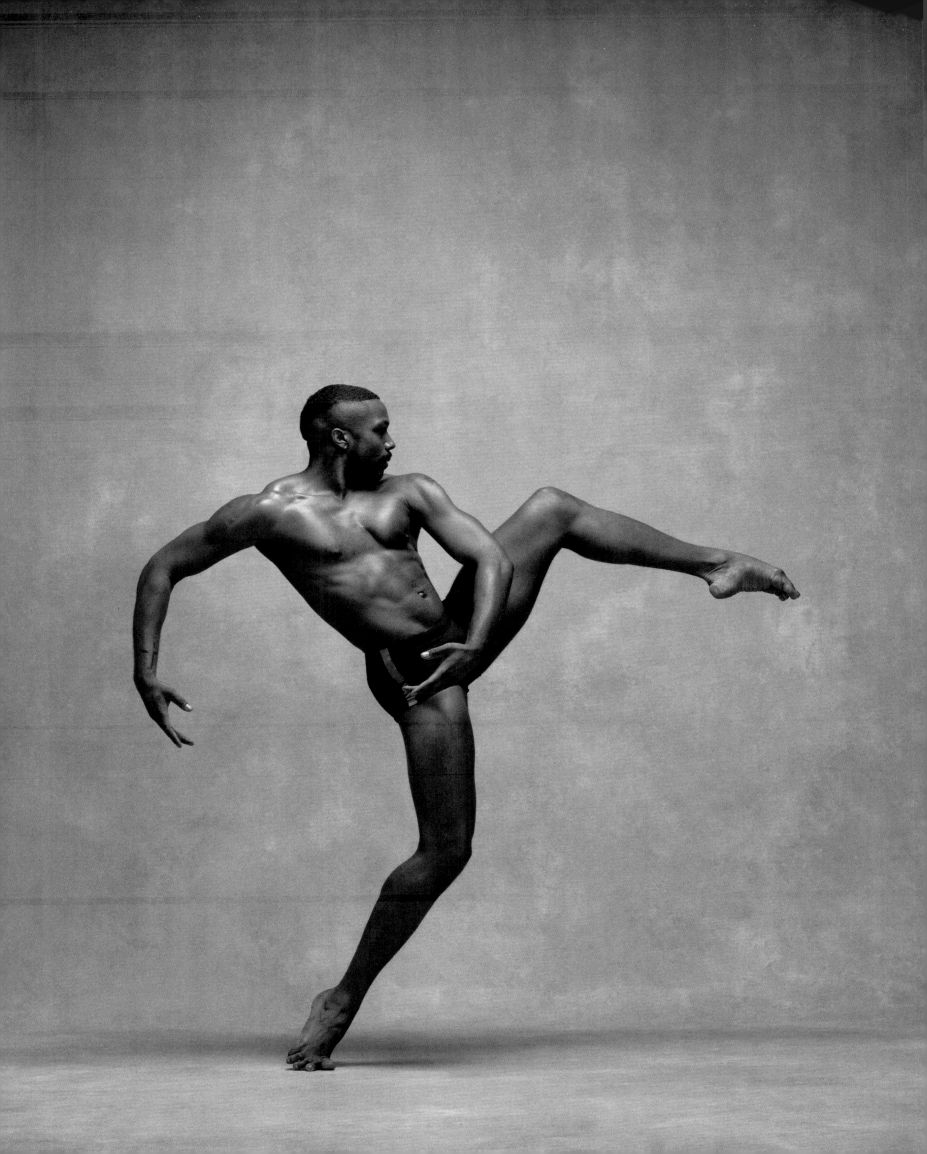

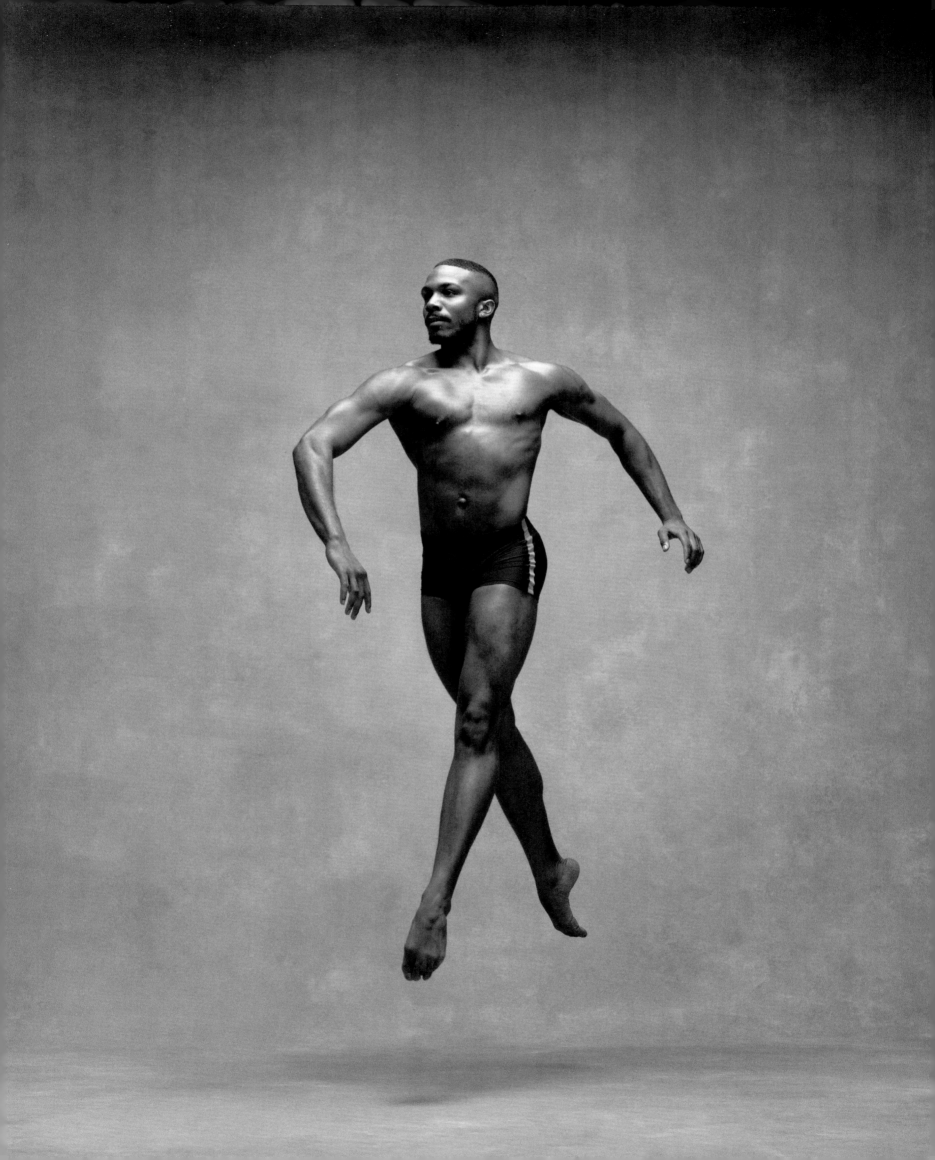

"The one thing I look for in a dancer is
the ability to express themselves and to bring
their own unique personality and power
to any role that they're given."

–Janet Eilber, Artistic Director, Martha Graham Dance Company

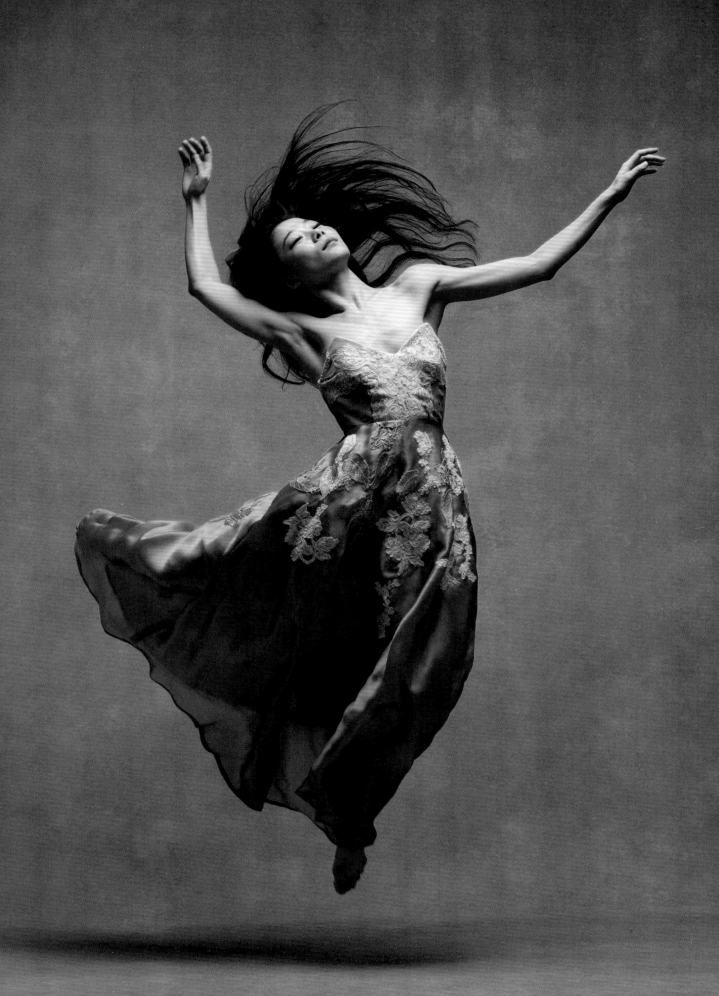

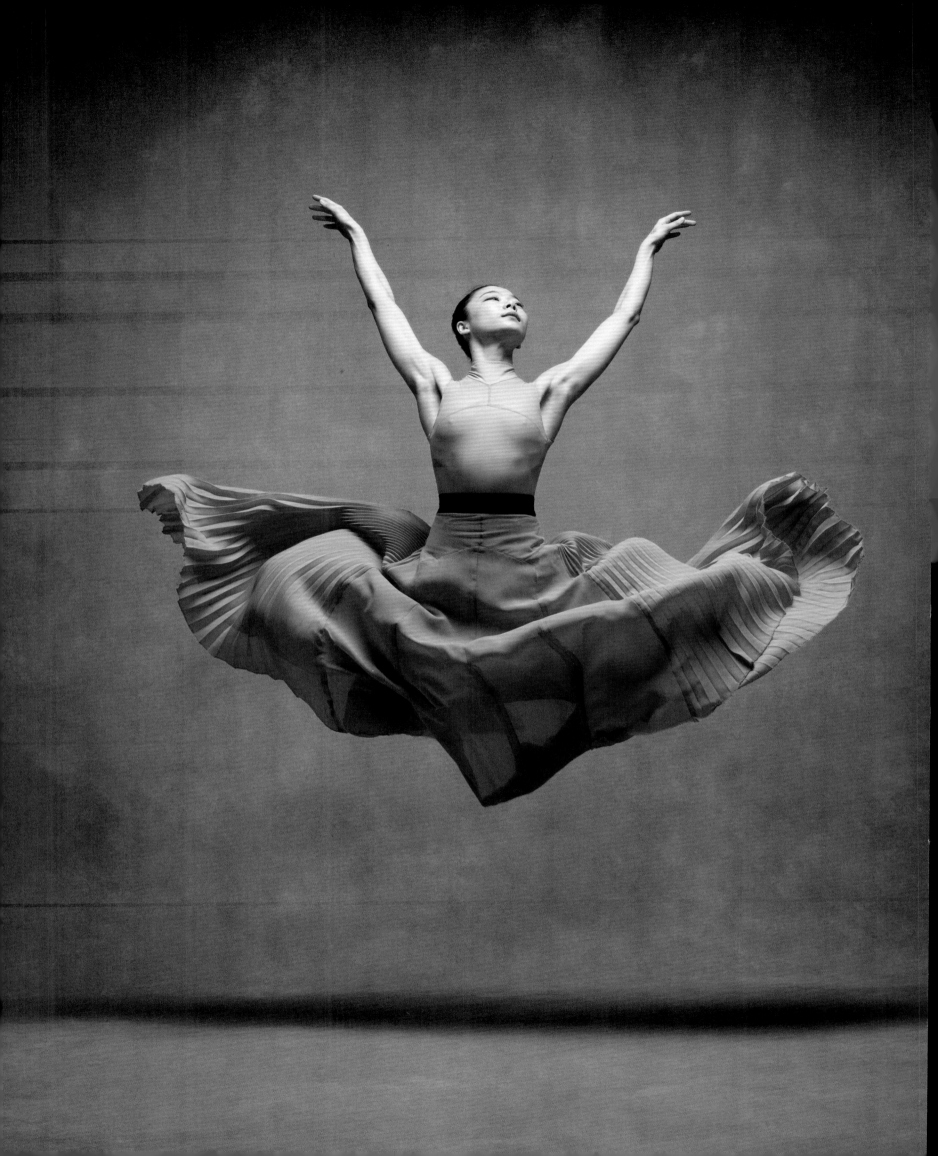

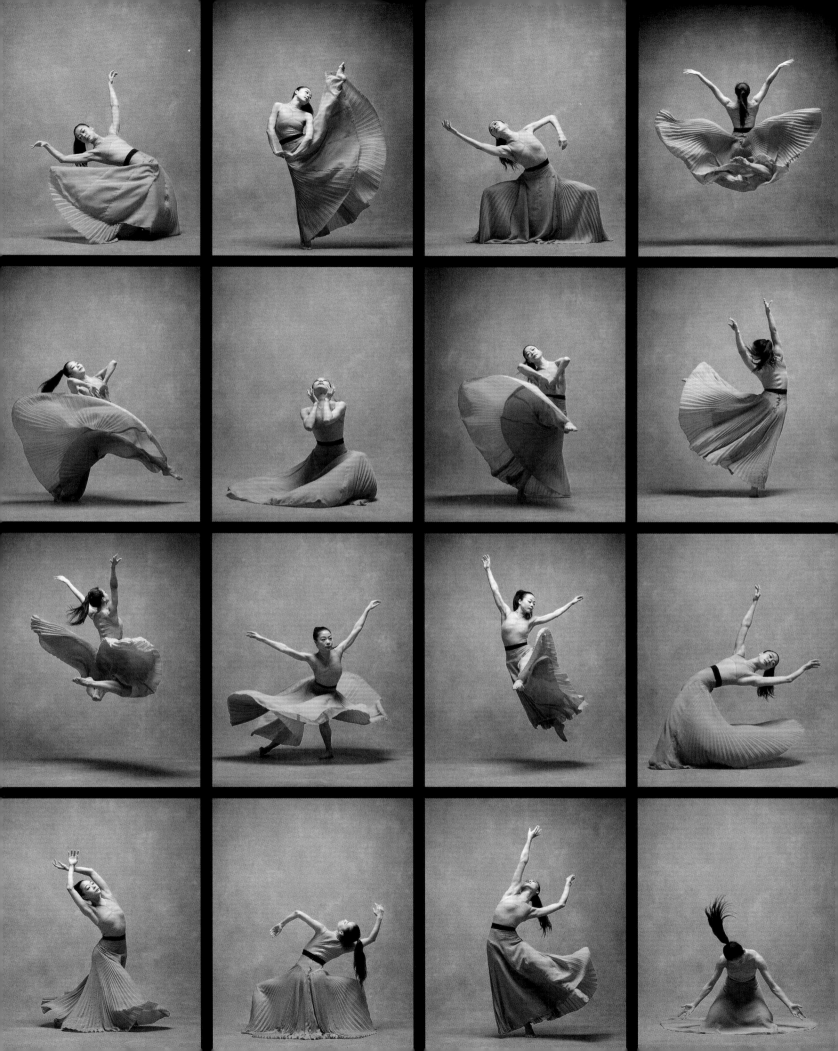

"Dance is very much in the flow, in the moment.
Each performance on stage is unique and it will not repeat itself.
That's why I love photography so much, because you can
remember the moment. Photography freezes a moment in time,
especially as it's very different than the fleeting work
that dancers do, that's very ephemeral."

–Daniil Simkin

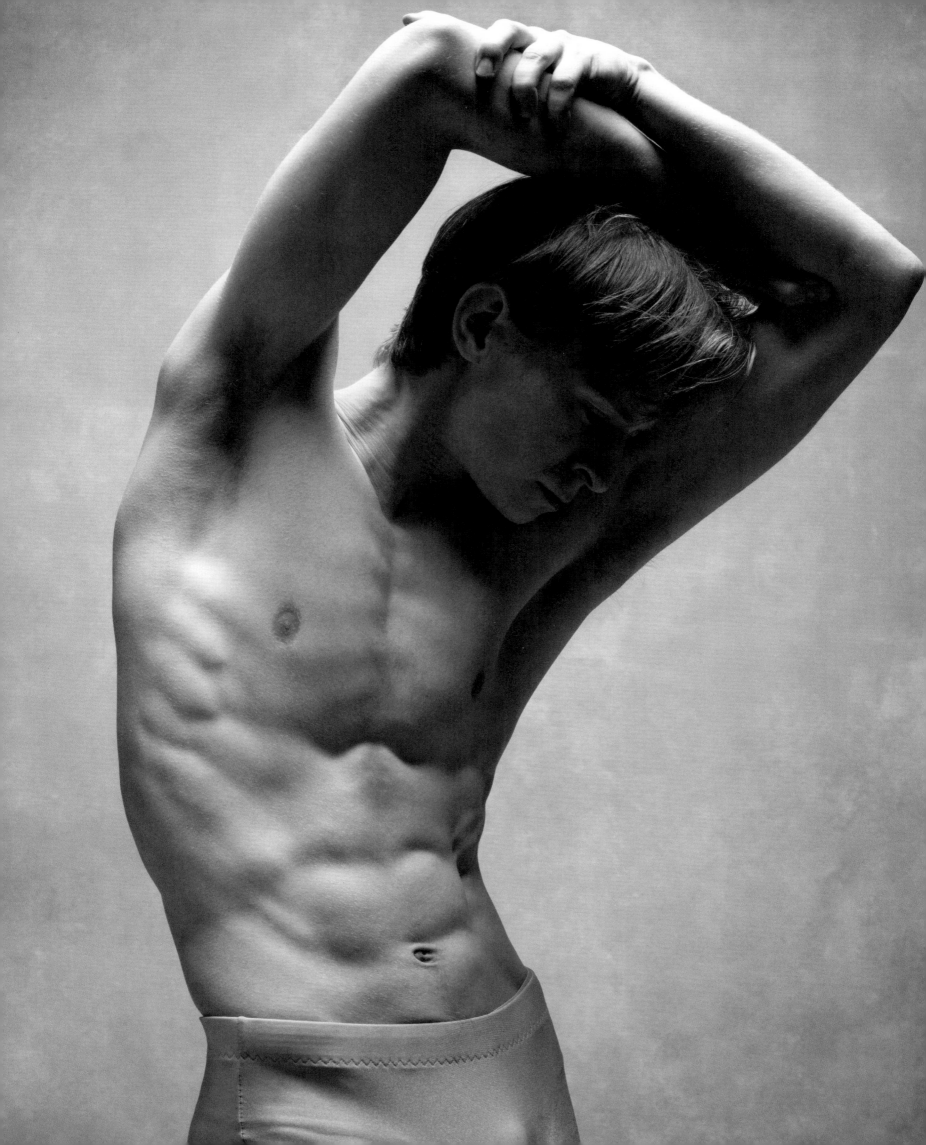

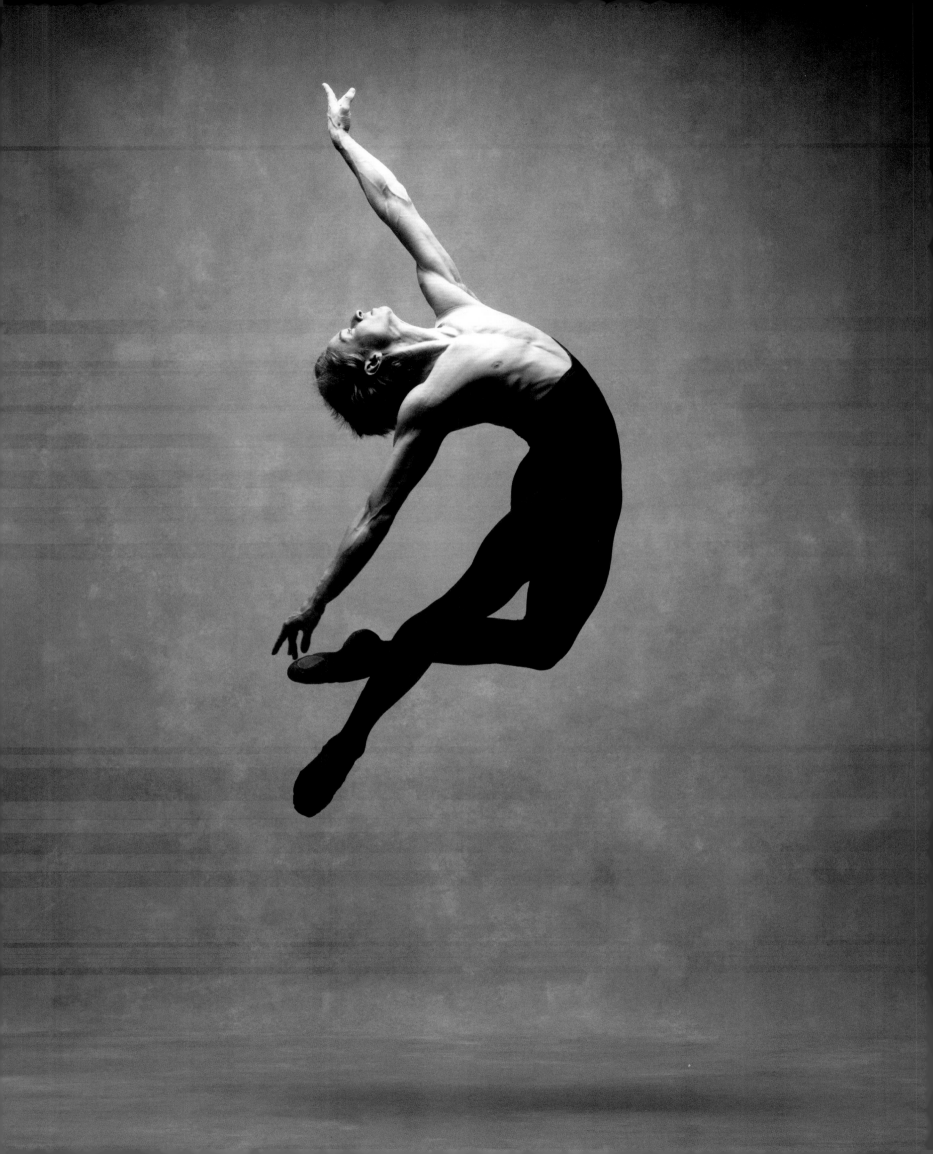

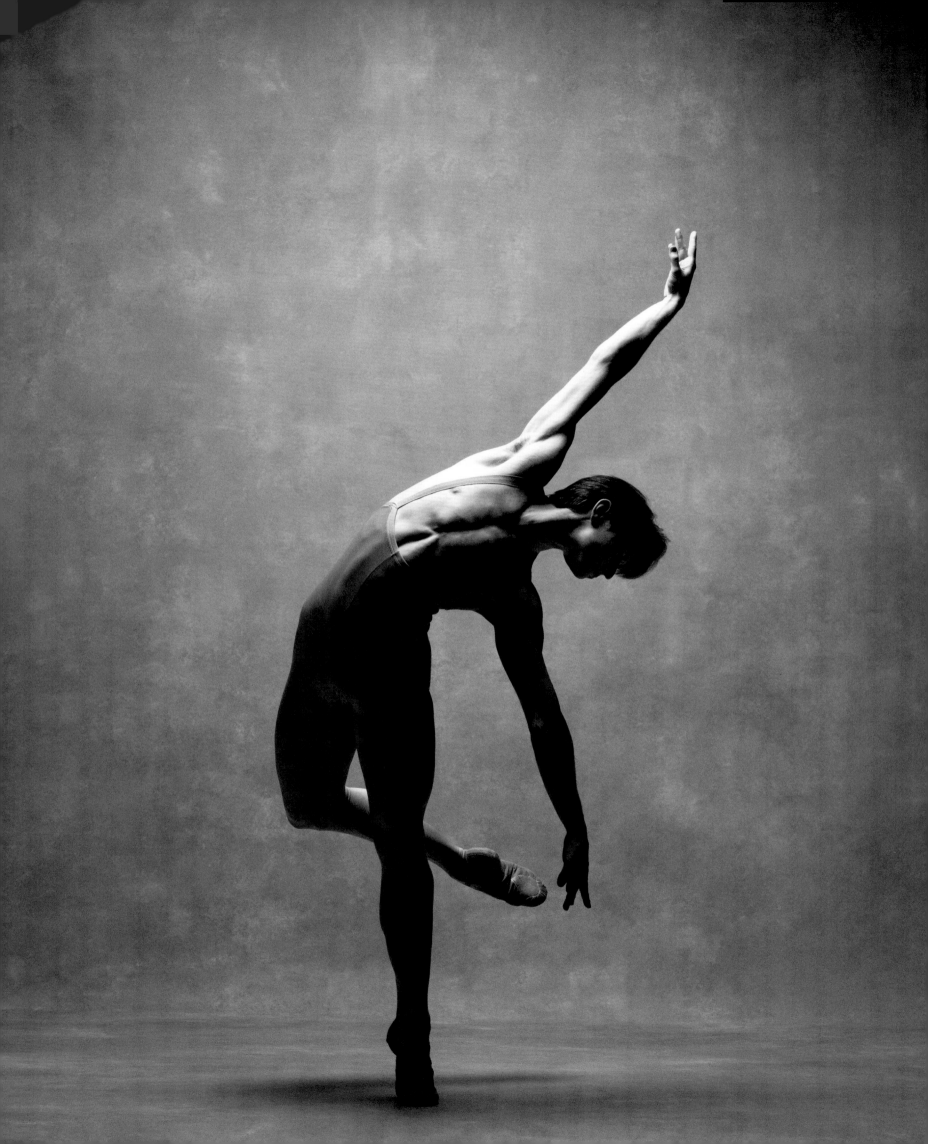

"It's important to keep an eye on innovation, but you can't recognize that something new is innovative unless you know what came before and, let's face it, *Swan Lake* is still beautiful."

–Peter Boal

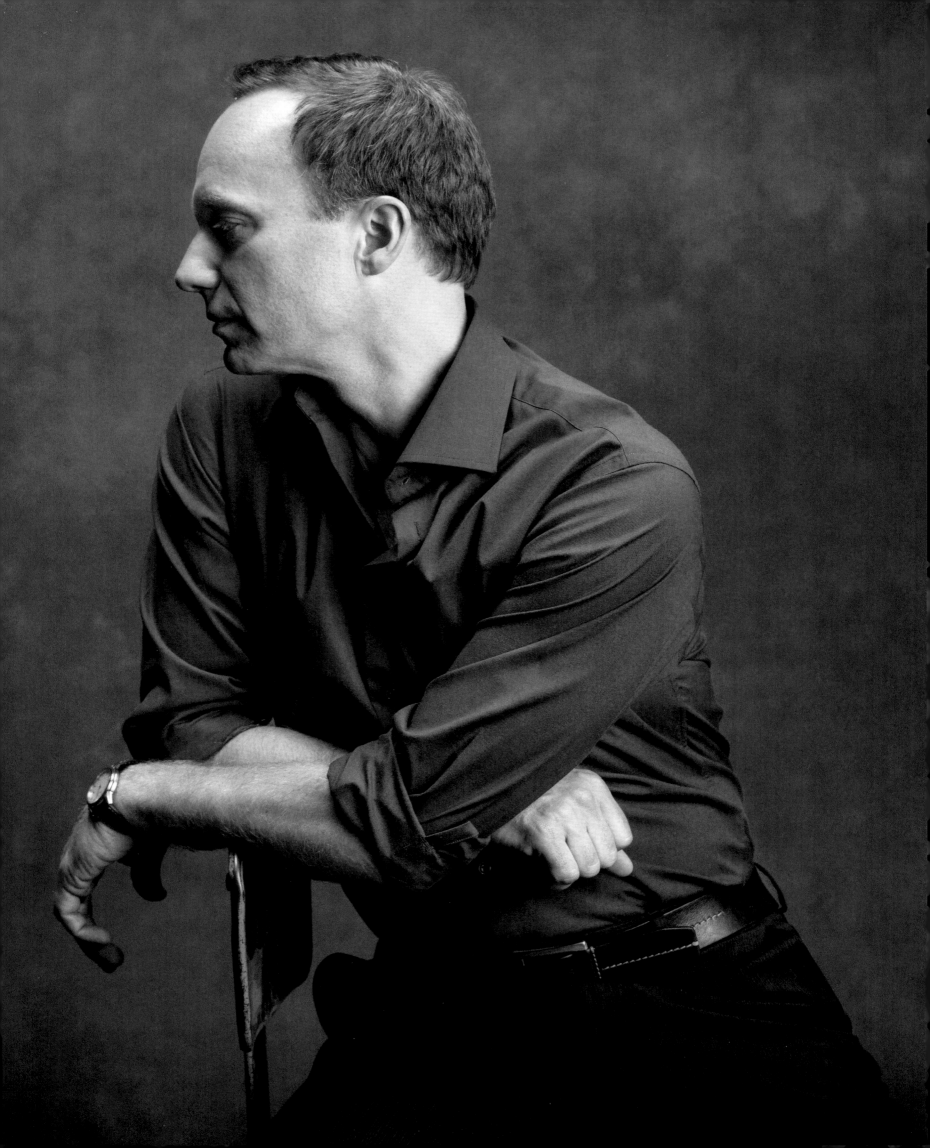

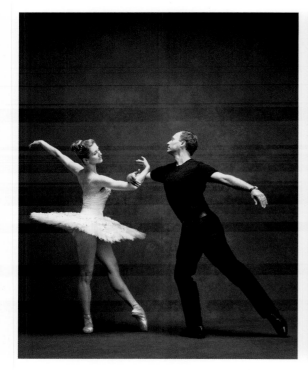
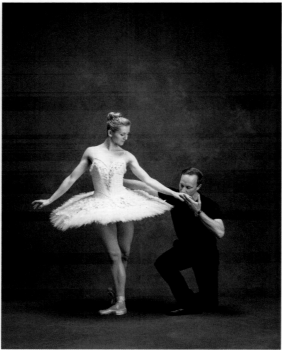
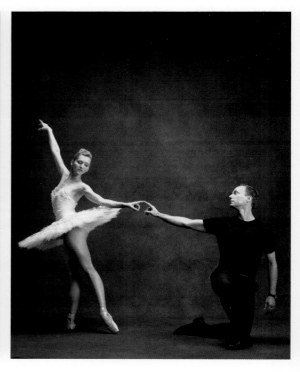

Peter Boal | Artistic Director and **Carla Körbes** | former Principal, Pacific Northwest Ballet

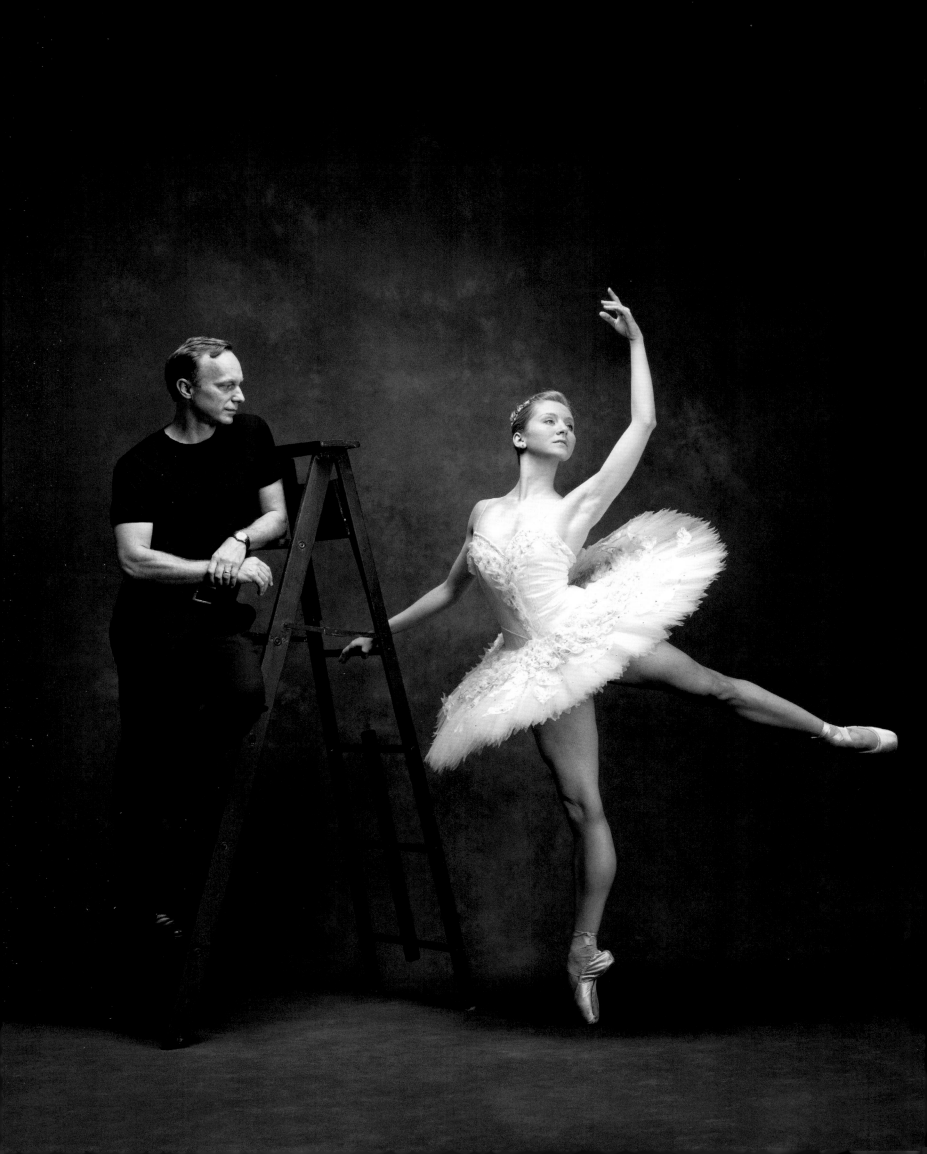

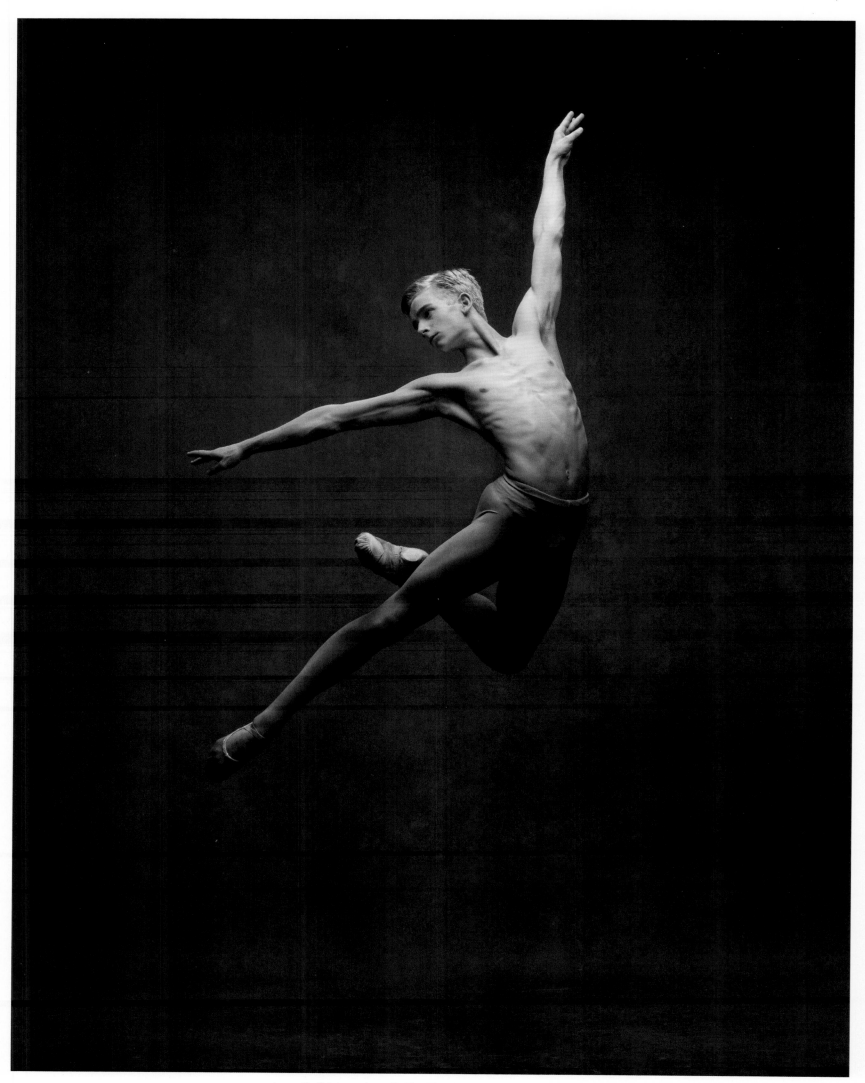

Aran Bell | American Ballet Theatre Studio Company

"I think there are a lot of good dancers out there
 who have good technique and presence, but the ones
 who inspire me are the assured dancers.
 You can see they dance for themselves and the audience.
 They don't dance out of fear, they dance to share . . ."

–Daniel Ulbricht

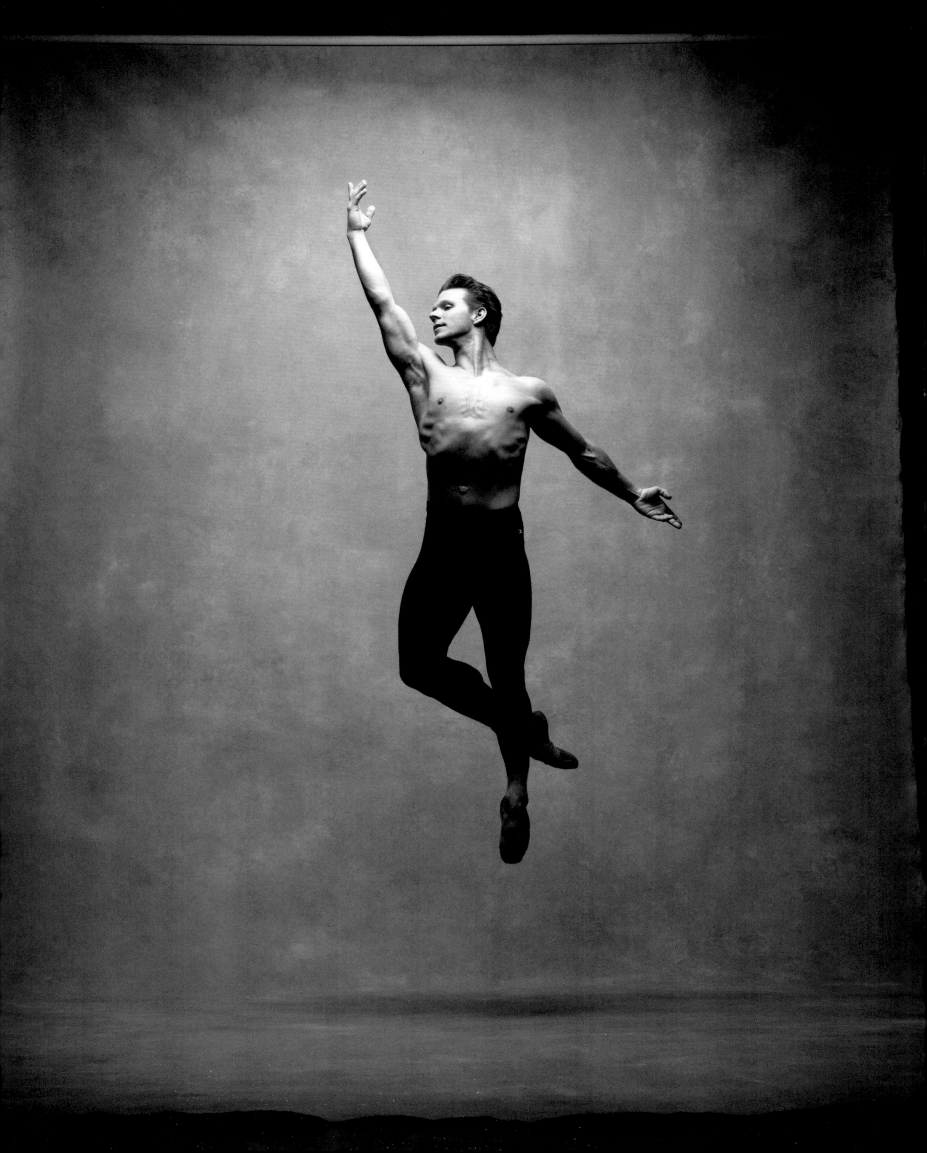

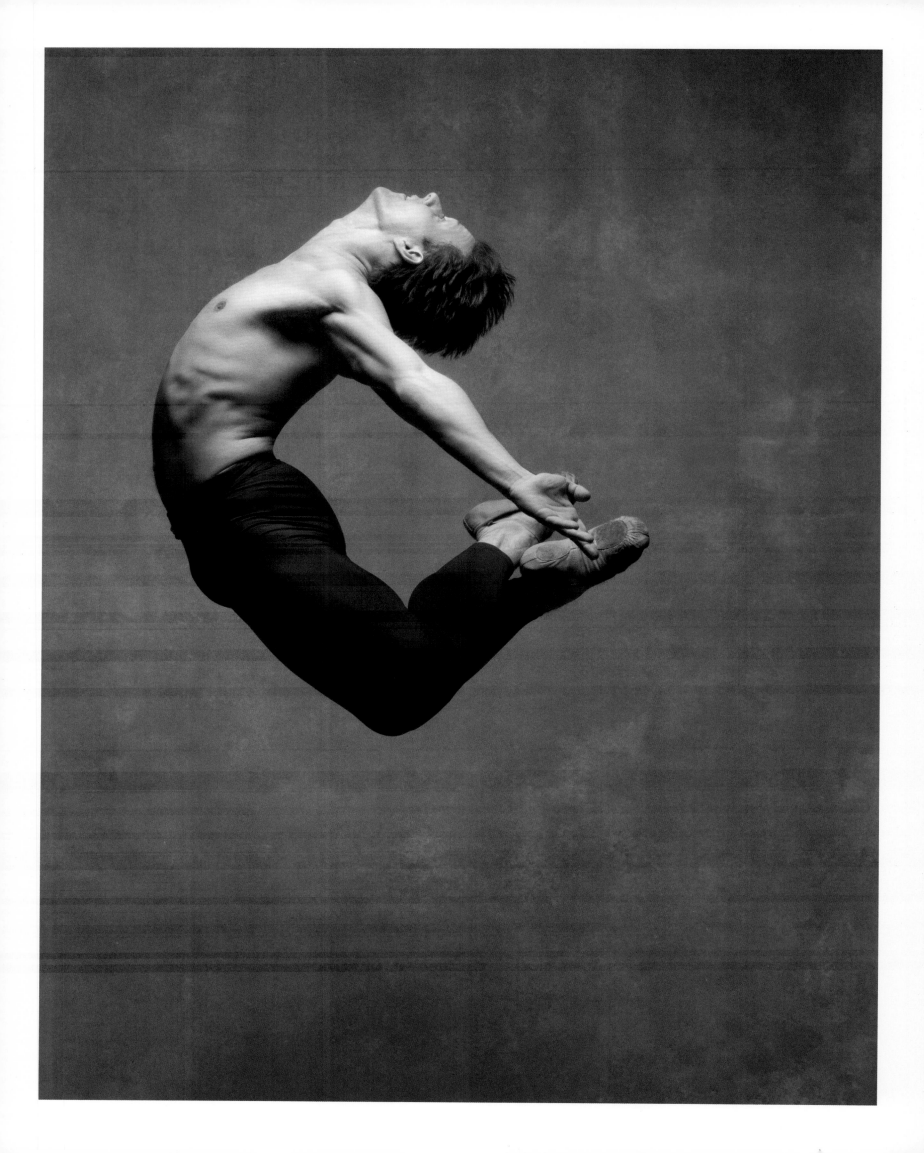

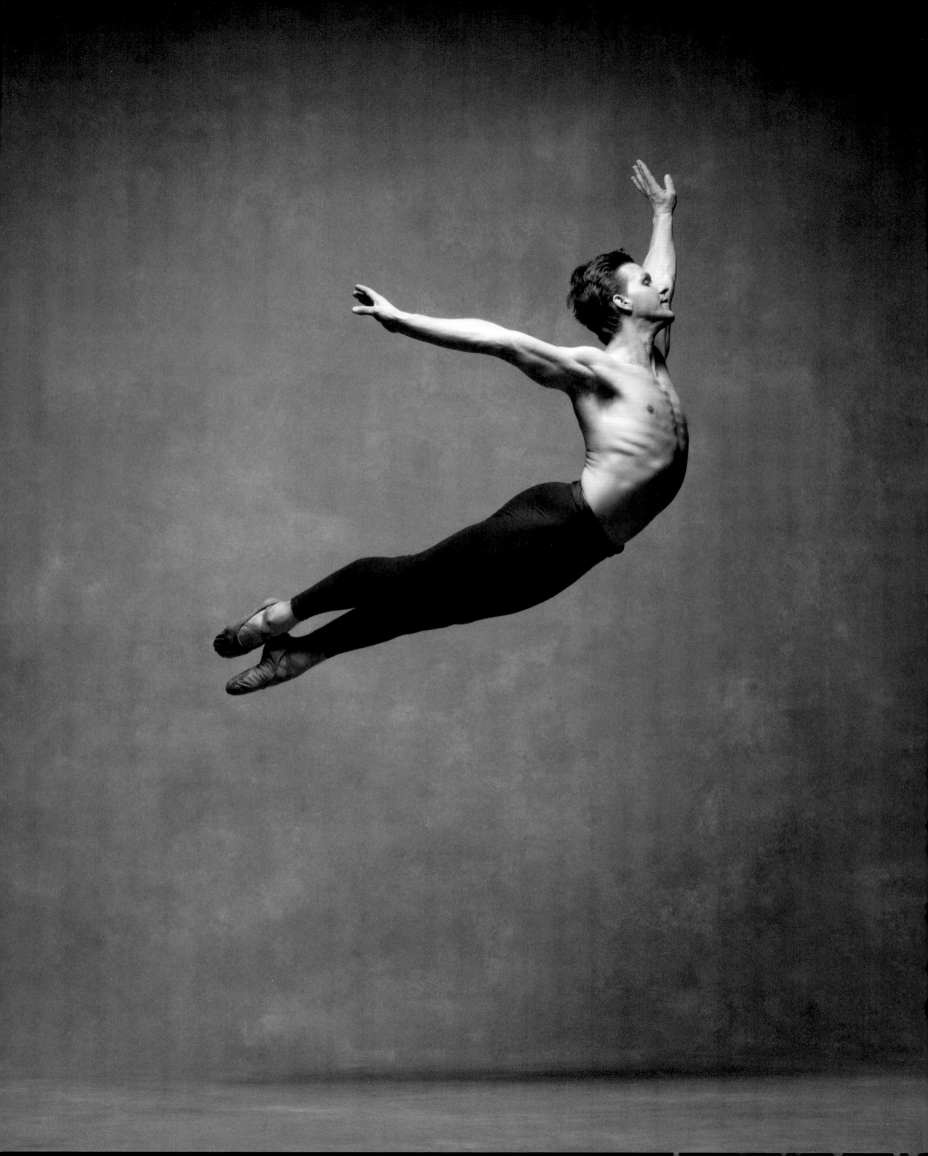

"Remember that there is something unique about you
that brought you to dance in the first place.
It is more than worth your time to explore why."

–Masha Dashkina Maddux

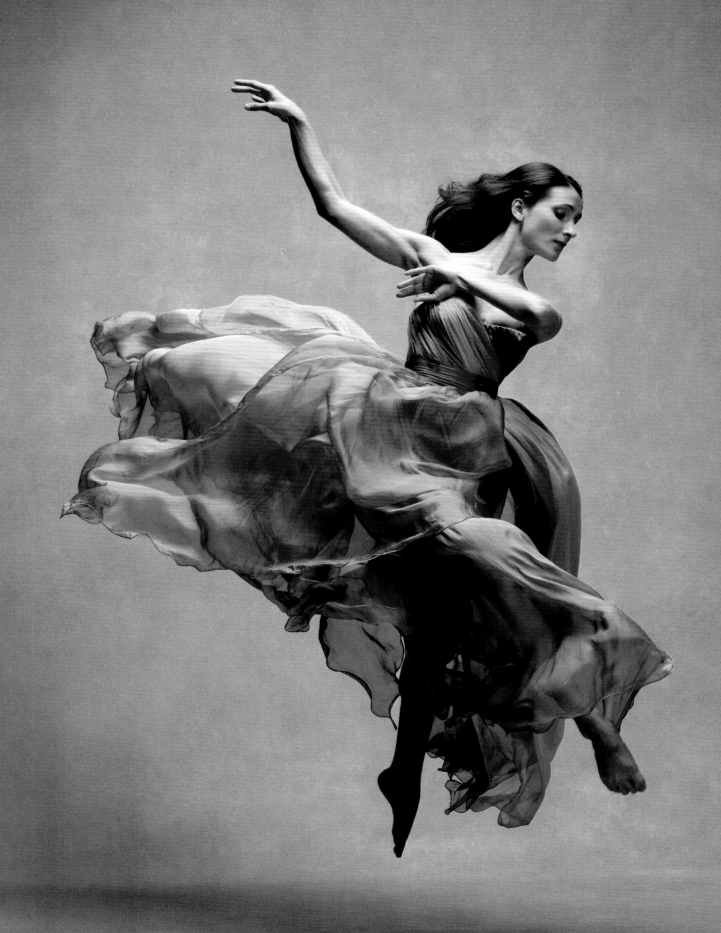

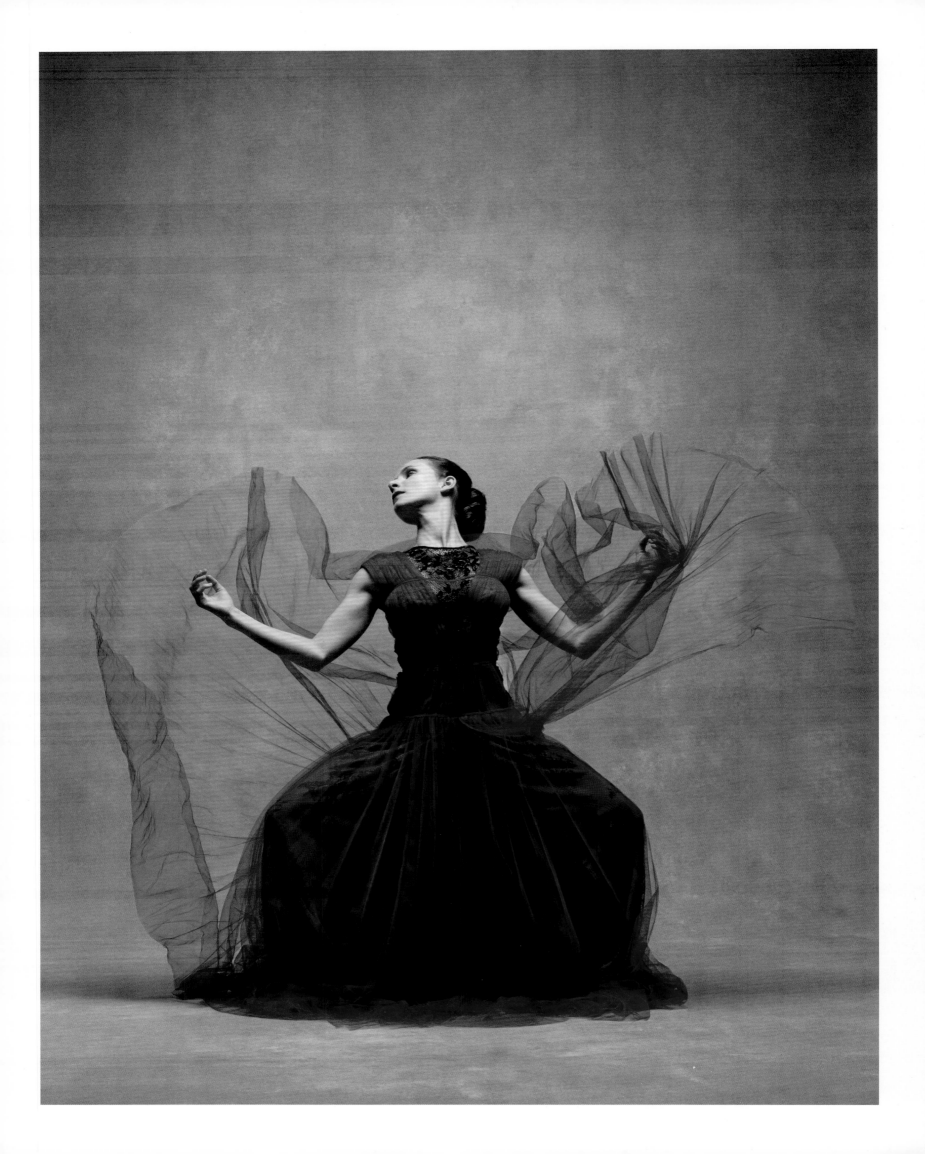

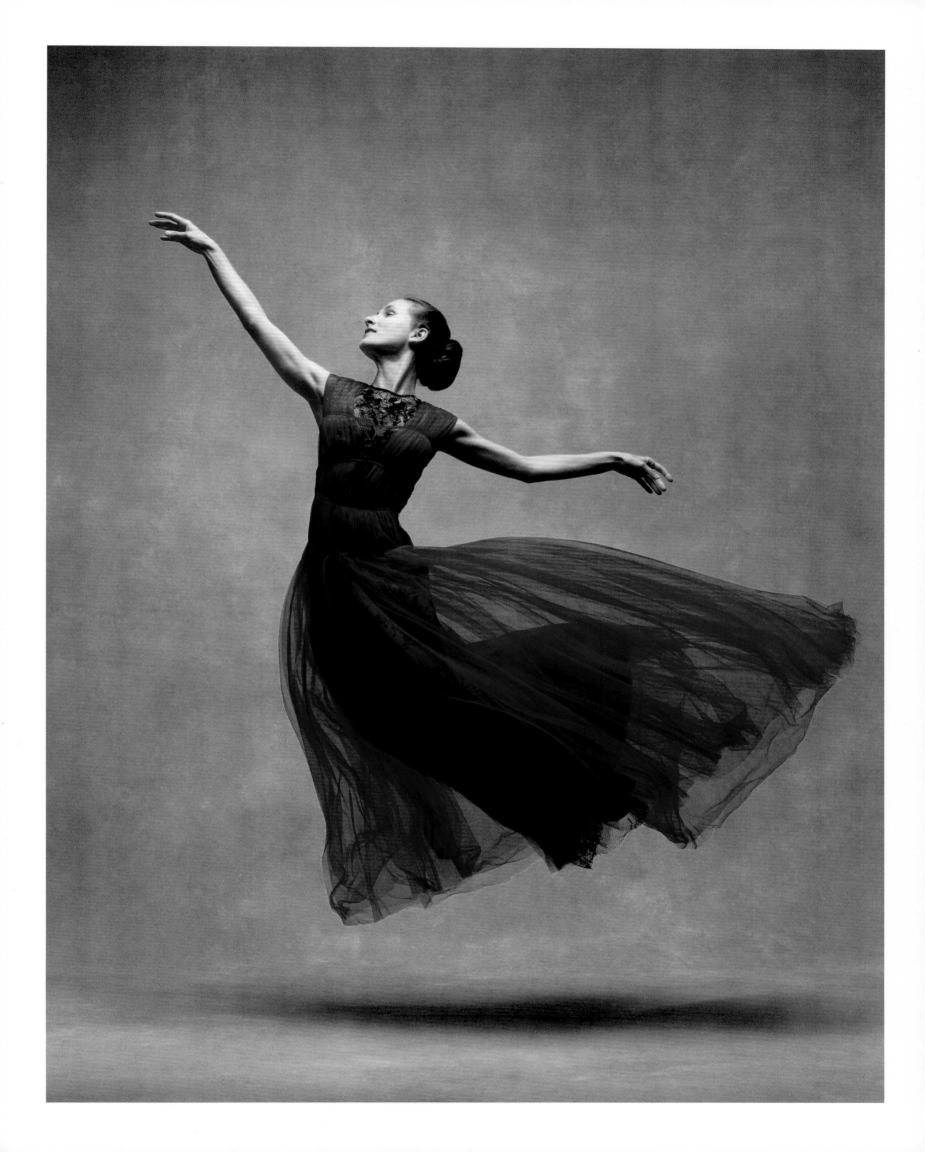

"I wish that people did not think they had to know
anything about dance, when watching dance.
There is some kind of intimidation factor;
people feel they have to have some history of dance
or it all should have some kind of meaning.
It's really about what it means to you."

–Kyle Abraham, Artistic Director, Abraham.In.Motion

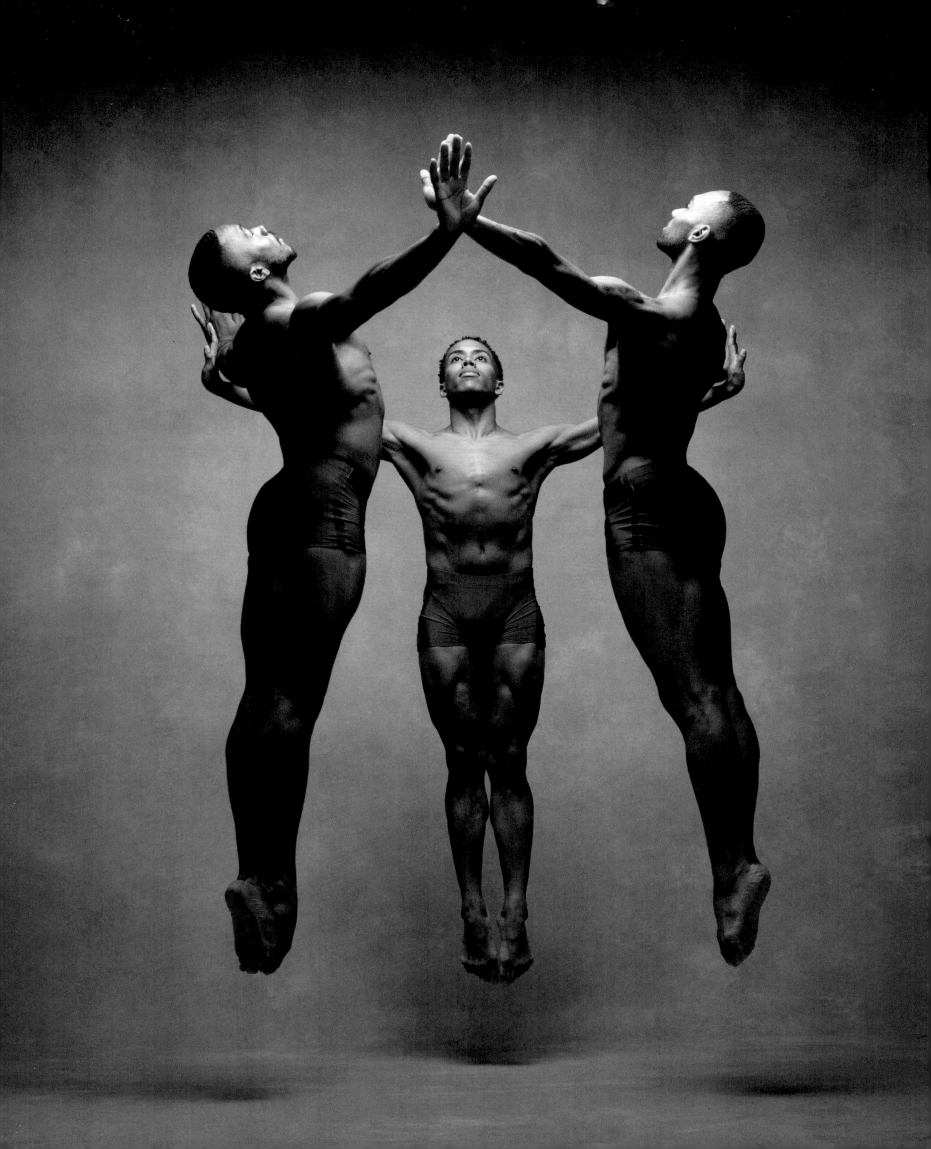

"After dancing *Swan Lake,* you feel like you can conquer the world."

–Misty Copeland

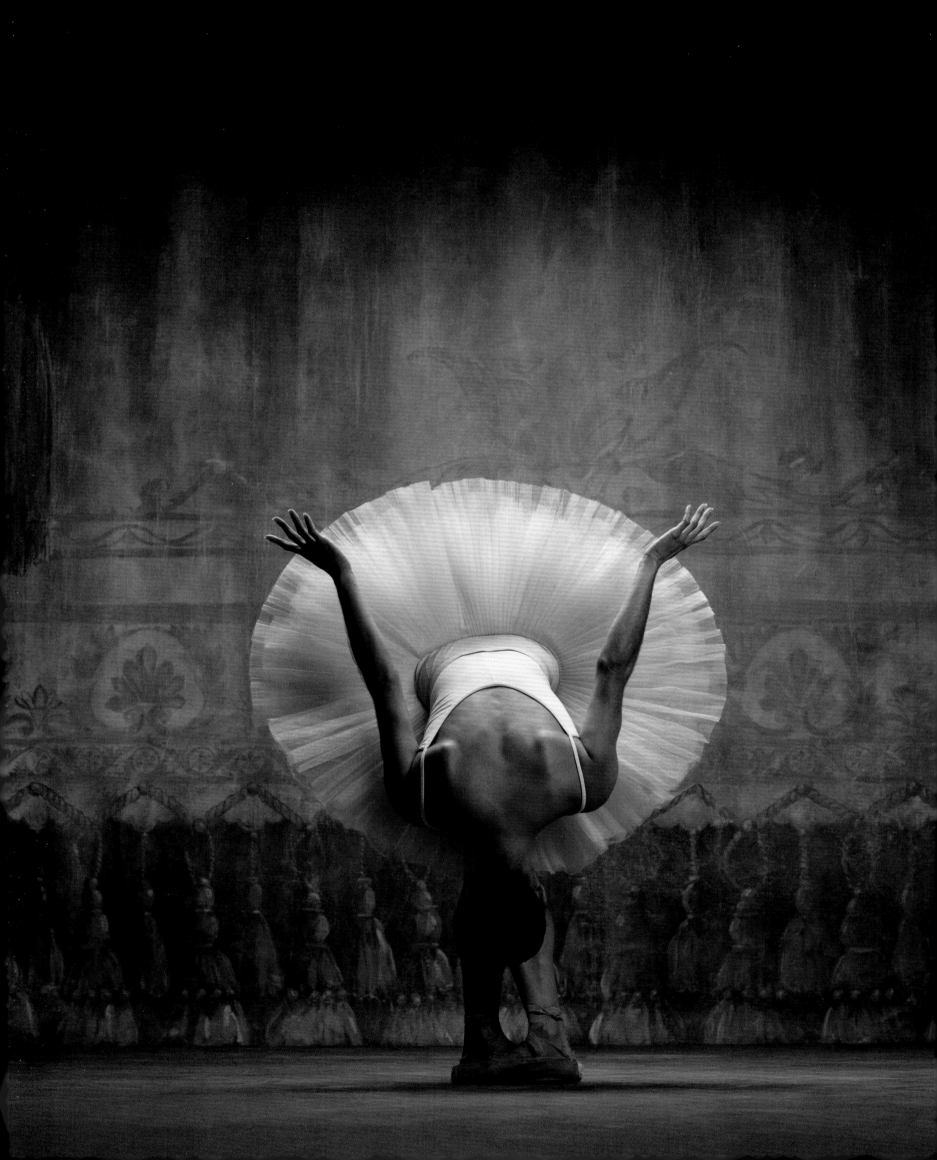

To Sarah,
Move + think!
think + move!
Bill T. Jones
1/20/16

If I said I wasn't
just a little jealous, I'd
be lying! Thanks for letting
me in your awesome space!
Your parents ROCK!
♡ Sean Carmon

To Jenna
with love!
От Артема Овчаренко
Артема Овчаренко
Bolshoi

Dear Jenna,
♡ Dance!
Peija Churchill

To Jenna,
Laugh always,
Love always,
Dance always w/ joy
in your heart!
XO
Laura Jacke

To Sarah,
Follow your dreams
and you will go far!
never stop believing
in yourself!
much Tiler Peck

For Dear Jenna!
Dream BIG—
XO,
John Kent

To JENNA,
MY LONG-LEGGED
PRINCESS, DANCE ON!
I'M NOW ONE OF YOUR
LOYAL SUBJECTS!
♡ Gaven

Let your
light shine!
Jenna
Murphy

Sarah,
You're Gorgeous!
Keep Dancing!
Love,

For Jenna
Toi Toi Toi!
XOXO

Photographers' Note

The inspiration for NYC Dance Project, and subsequently this book, actually came from our daughter Sarah, when she was twelve years old. She was (and is) an aspiring dancer, and wanted her bedroom filled with photographs of her favorite dancers. Simple enough, we thought. We searched bookstores, the internet, and galleries; we purchased books, calendars, and other photos and to our disappointment we were not able to find good images of the current dancers that Sarah most admired. Of course there are beautiful images of famous dancers from past generations—such as Baryshnikov or Markova, taken more than 40 years ago—but nothing of the current stars.

Ken suggested that we photograph these dancers ourselves. We were already great fans of Daniil Simkin, a Principal dancer with American Ballet Theatre, so we contacted him and asked him to be our first subject. Daniil loves photography and agreed to be photographed. Ken, in his twenty-five-year career as a professional photographer had photographed many celebrities (Meryl Streep, Natalie Portman, André Previn, and others). After a successful photo shoot Daniil arranged for other Principal dancers to work with us. Before long, we officially launched NYC Dance Project. After the images were posted on social media, the word spread in the dance community and dancers from all over the world approached us to collaborate.

My background as a photographer began when I was at the University of Michigan as a dance major. Just before a semester was about to begin, I developed a stress fracture and was no longer able to dance. My father had recently purchased a new camera and it was still in the box on our kitchen table. I was depressed about my injury and felt a little lost about what I would be doing that semester, so I impulsively borrowed the camera, feeling that I might enjoy photography. I enrolled in a photography class and focused on photographing the dance rehearsals that I could not participate in. Photographing dancers felt very natural to me, as dance was something that I understood and had a passion for. I later worked as a photography editor for various magazines, such as *Mirabella* and *House & Garden*. I would hire the photographers, come up with concepts, direct the shoots, and even do some styling. Later, I worked as a freelance photographer, shooting everything from portraits, to still life, to fashion and food.

I remember talking about photographing dance with Ken the first time I met him. During his time in Paris as a professional photographer, one of his most memorable assignments had been for *Madame Figaro* photographing the famous Étoile from Paris Opera Ballet, Isabelle Guérin. They had become friends during the shoot, and Ken ended up spending many hours watching ballet at the Paris Opera and also attending many performances, both of ballet and modern companies such as that of Pina Bausch. We both agreed that working with dancers—the movement, the artistry, and the passion—was something we would like to explore more as photographers.

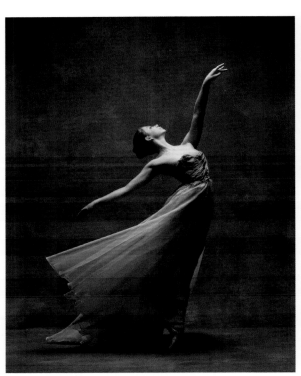
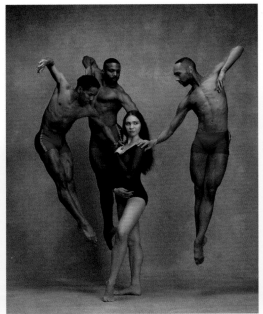
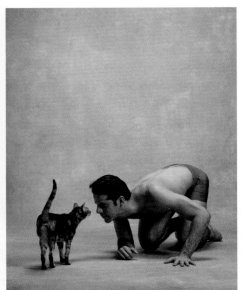
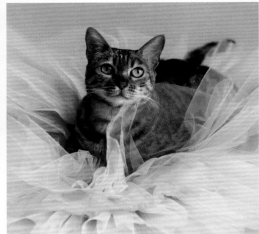
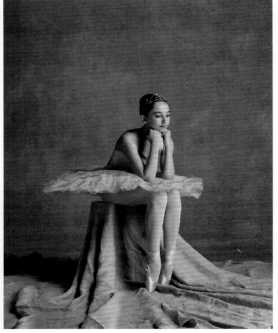
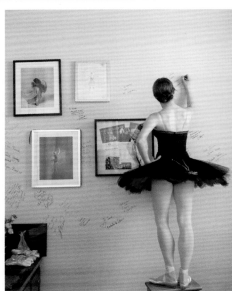
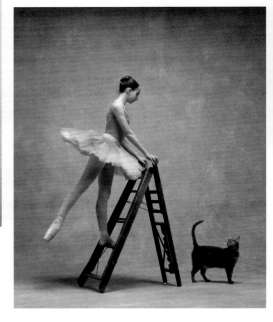

After we married, I moved into Ken's home in Brooklyn. It is a large old factory/loft space that is now our home and studio. Having the dancers come into our home creates a different environment for our shoots. During the photo sessions, our cats walk across the set and nap in the tutus. My daughters arrive home from school and chat with the dancers. It becomes a very warm and friendly place and completely differs from shooting in a rented studio or on location. After the shoots, dancers will often spend time getting to know us and many of them have become close friends. And even better than the photos of dancers that Sarah originally wanted for her bedroom—each dancer has actually signed the bedroom walls of both of my daughters Sarah and Jenna.

We feel that the project is a true collaboration between Ken and myself, but also a collaboration with the dancers. Every photo is carefully planned, almost like a choreographer would plan a performance, with thought going into our backdrops, the lighting, and clothing. Many of our shoots feature costumes or couture clothing, and these details are all coordinated beforehand with the dancers. Photographing the dancers in the studio keeps the emphasis on the dancer, the movement, the lighting, composition, and emotion of the image. Having most of our images against a similar background gives us a style and signature to our images. We work with a Hasselblad, a medium format camera, which is quite slow and not the way that many photographers would think to photograph dance. For Ken and I, though, it forces us to slow things down, really think about each image and allows us the time to collaborate on the process. We take turns shooting, adjusting lights, styling clothing, and dealing with the many other details that crop up on a photo shoot. We both are working at all times on the image, regardless of who is actually taking a particular photo.

The images focus on capturing emotion through movement, which at the core is what I feel dance is about: it's a language that is spoken through movement. We never wanted to focus on the "tricks" in dance, it was always about capturing a feeling. This could happen through simple moments such as the breath the dancer takes preparing to do a movement or it could happen in the freedom one experiences in a beautiful jump. It's important for both of us to feel the sense of movement in the photos, even in a still image. The images are also a celebration of bodies; dancers must simultaneously be artists and athletes and we feel both qualities are highlighted in our photographs.

Early on in the project, we started a blog where we posted interviews with the dancers. We thought our audience, would want to know more about these amazing performers, what dance means to them, and why they want to dance. Having come from editorial backgrounds, it seemed natural to both of us to include some text with the images. We've included some of our favorite quotes from the dancers in this book.

Turning NYC Dance Project—the photographs and the concept—into a book was something that Ken and I had always thought about. As photographers, it's a joy to be able to see a project in a book format, where there is a flow to the work and each image becomes a part of a larger piece We wanted to include all of the world's most famous dancers, but realized that this would be impossible both to define and to achieve, so we've assembled a collection of our images here with the hope that anyone looking at them will experience some of the pleasure we had in creating them.

Deborah Ory, Brooklyn, New York, 2016

Acknowledgments

An extra special thank-you to these people without whom the project would not be possible:
George Greenfield
Daniil Simkin
J.P. Leventhal, Becky Koh, Ankur Ghosh, and the staff at Black Dog & Leventhal
John and Jeri Heiden, Smog Design, Inc.
Elise Weisbach

Designers:
Ainsliewear
Alberta Ferretti
Backdrops from Oliphant Studio
Bullet Pointe
Caryn Wells Designs
Chacott by Freed of London
Eleve
Epperson
Gaynor Minden
Grishko
Karen Young
KD New York
Keiko Voltaire
KeithLink
Leanne Marshall
Liz White Couture
Maurizio Nardi
Melinda Keth Lane
Mirella
Naeem Khan
Norma Kamali
Olvi's
Paul Smith
Reid and Harriet
Tadeshi Shoji
Trash Couture
Valentina Kova
Yumiko
Zachary Alexander

Costumes courtesy of:
Alvin Ailey American Dance Theater
American Ballet Theatre
An American in Paris, Broadway
Bolshoi Ballet
Boston Ballet
Martha Graham Dance Company
New York City Ballet
Paul Taylor Dance Company
Royal Danish Ballet

We would also like to thank:
Ann Wiberg
Angel Corella
Angelica Steudel
Cara Lynn Moccia
Christina Daigneault
Christopher Peregrin
Cory Stieg
Damian Monzillo
Donald Jakubowski
Doug Denoff
Gia Kourlas
Gilda Squire
Giselle Karounis
Glenda Bailey
Hasselblad
Hooman Majd
Hossein Farmani
Isabelle Guerin-Frohlich
Janet Eilber
Jeff Dunas
Jeff Korcheck
Jenna Ory
Juliet Jane
Kara Medoff Barnett
Lar Lubovitch
Leanne Marshall
Leica Cameras
Lori Genkins Marchand
Madeline Hinkis
Mark Bugzester
Matthew Clowney
Meiying Thai
Nathan Johnson
Philippa Serlin
Sarah Oliphant
Sarah Ory
Ticia Baratta

Dress by Norma Kamali
Hair and makeup by Juliet Jane

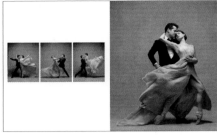

Dress by Leanne Marshall
Hair and makeup by Juliet Jane

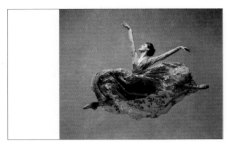

Dress by Naeem Khan
Hair and makeup by Juliet Jane

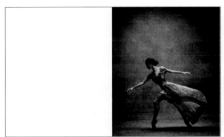

L: Tights by Yumiko
R: Tights by KD Dance

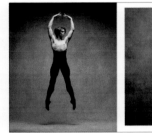

Dress by Leanne Marshall

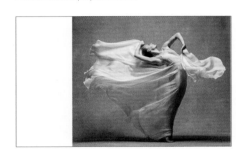

Dress by Leanne Marshall

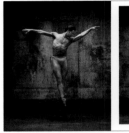

Dress by Liz White Couture

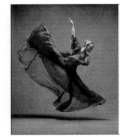

Tights from the Artem Ovcharenko Collection
by Grishko

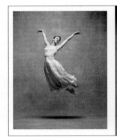

Costume from *Jardin aux Lilas*,
courtesy of American Ballet Theatre.
Hair and makeup by Juliet Jane

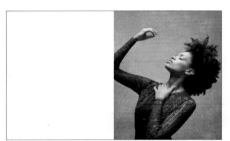

Dress by Naeem Khan

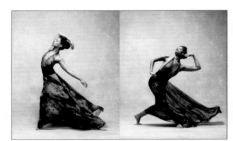

Dress by Keiko Voltaire

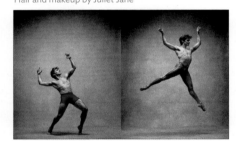

Tights by Yumiko

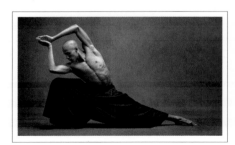

Pants by Alex Rotin

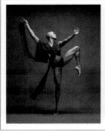

L: Costume by Epperson
R: Leotard by KeithLink

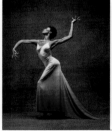

Dress courtesy Alvin Ailey American Dance Theater
Hair and makeup by Juliet Jane

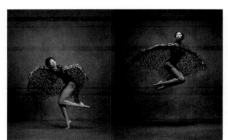

Costume by Epperson
Hair and makeup by Juliet Jane

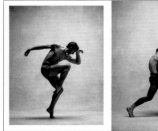

Dress by Olvi's, the Lace Collection

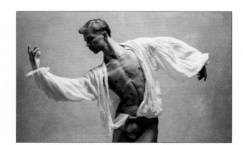

Costume courtesy of the Royal Danish Ballet

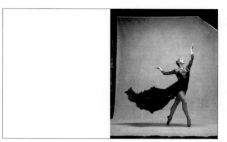
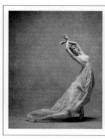
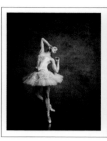

Dresses by Leanne Marshall
Hair and makeup by Juliet Jane

Dresses by Leanne Marshall
Hair and makeup by Juliet Jane

Tutu by Melinda Keth Lane
Hair and makeup by Juliet Jane

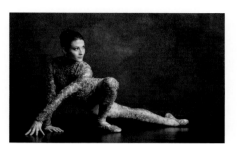
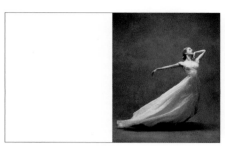
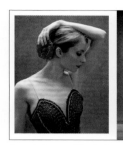

Costume by Chacott by Freed of London

Dress by Leanne Marshall
Hair and makeup by Juliet Jane

Dress by Leanne Marshall
Hair and makeup by Juliet Jane

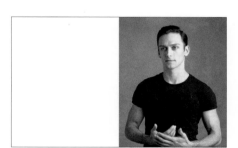
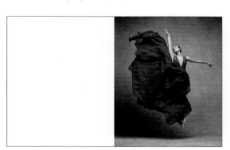
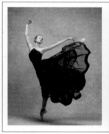

Costume from *An American in Paris*

Dresses by Leanne Marshall
Hair and makeup by Juliet Jane

Dresses by Leanne Marshall
Hair and makeup by Juliet Jane

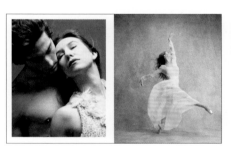
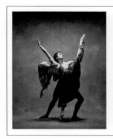
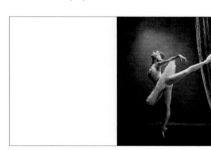

L: Dress by Trash Couture
R: Dress by Valentina Kova

L: Dress by Reid and Harriet
R: Leotard by KeithLink

Tutu by Chacott by Freed of London
Tiara by Caryn Wells Design

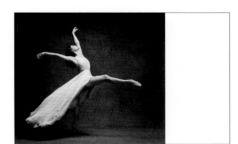
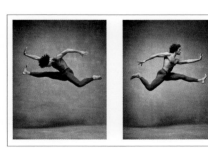
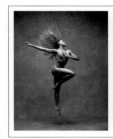

Dress by Leanne Marshall
Hair and makeup by Juliet Jane

Tights by Yumiko

L: Leotard by Lone Reed Design
R: Tutu by Chacott by Freed of London

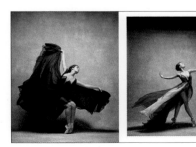
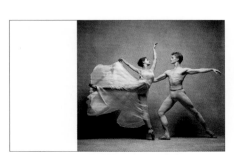
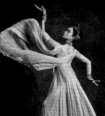
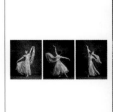

Dresses by Leanne Marshall
Hair and makeup by Gisele Karounis

Dress by Leanne Marshall
Hair and makeup by Gisele Karounis

Costume from *La Bayadere*,
courtesy of American Ballet Theatre
Hair and makeup by Riva Pizhadze

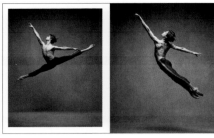

Tights by KeithLink

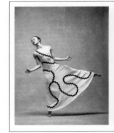

Dress by Leanne Marshall

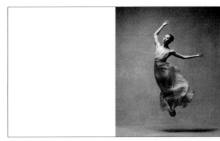

Costume from *Errand into the Maze*,
courtesy of Martha Graham Dance Company

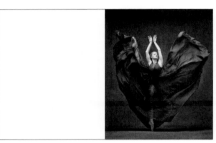

Dress by Leanne Marshall
Hair and makeup by Juliet Jane

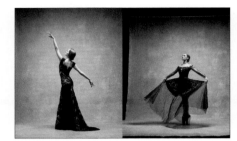

Dress by Olvi's, the Lace Collection

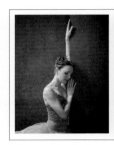

L: Tutu and tiara by Caryn Wells Design
R: Costume from *Romeo and Juliet*,
courtesy of American Ballet Theatre

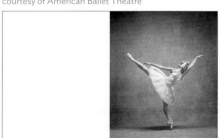

L: Costumes from *Giselle*
R: Costume from *Don Quixote*,
courtesy of American Ballet Theatre

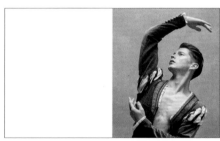

Costumes from *Giselle*,
courtesy of American Ballet Theatre

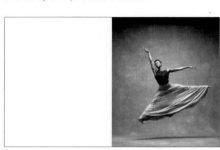

L: Leotard by Eleve Dancewear
R: Dress by Olvi's, the Lace Collection

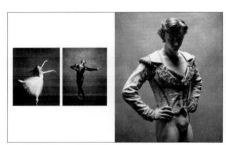

Tutu courtesy of Grishko

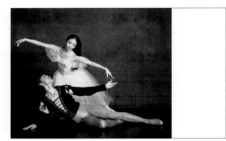

Costume courtesy of the Royal Danish Ballet

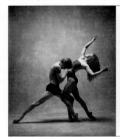

Skirt courtesy Alvin Ailey American Dance Theater
Leotard by Yumiko

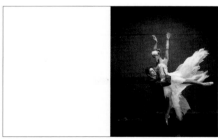

Dress by Trash Couture
Hair and makeup by Juliet Jane

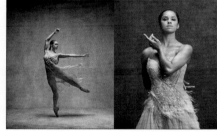

L: Dress by Alberta Ferretti, from *Harper's Bazaar*, 5/16
R: Dress by Trash Couture
Hair and makeup by Juliet Jane

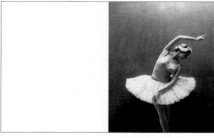

Costume from *Swan Lake*,
courtesy of the Royal Danish Ballet
Hair and makeup by Juliet Jane

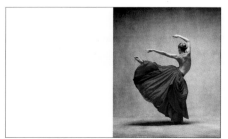

Costume from *Bella Figura*,
courtesy of Boston Ballet

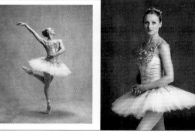

Costume from *Diamonds*, designed by Barbara Karinska
Courtesy of Boston Ballet

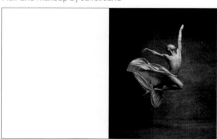

Costume courtesy of
Alvin Ailey American Dance Theater

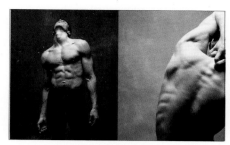

L: Alexandre Hammoudi, Soloist,
American Ballet Theatre
R: Daniil Simkin, Principal, American Ballet Theatre

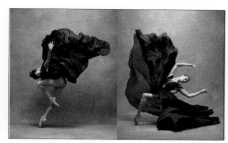

Dress by Leanne Marshall

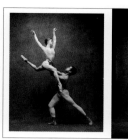

Leotard by Yumiko

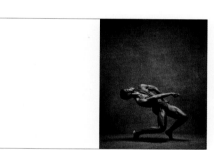

Dress by Olvi's, the Lace Collection

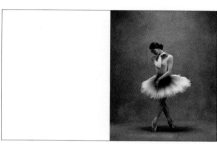

Tutu from Viktor Plotnikov's *Swan*,
courtesy of Boston Ballet

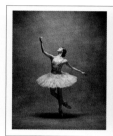

Tutu from *Nutcracker*, courtesy of Boston Ballet

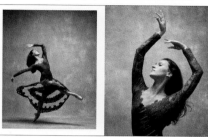

Costume from *Acts of Light*,
courtesy of Martha Graham Dance Company

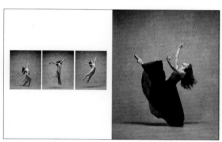

L: Dress by Karen Young

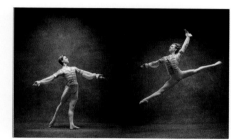

Costume from *Sleeping Beauty*,
courtesy of the Bolshoi Theatre, Russia

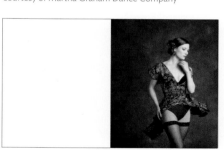

Costume from *Piazzolla Caldera*,
courtesy of Paul Taylor Dance Company
Hair and makeup by Juliet Jane

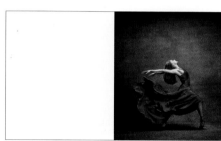

Dress by Valentina Kova
Hair and makeup by Juliet Jane

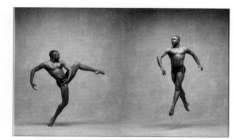

Shorts by Yumiko

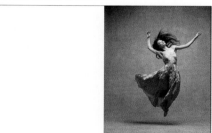

Dress by Zachary Alexander

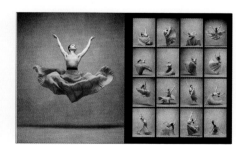

Costume from *Echo* by Adonis Fondiadakis
Costume by Anastasio Tassos Sofronious
Courtesy of Martha Graham Dance Company

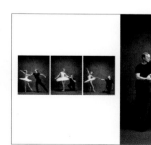

Tutu by Chacott by Freed of London

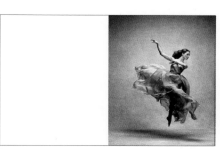

Dress by Maurizio Nardi
Hair and makeup by Juliet Jane

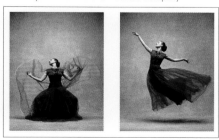

Dress by Tadeshi Shoji
Hair and makeup by Juliet Jane

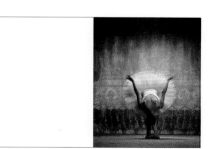

Leotard by Mirella Tutu from tutu.com
From *Harper's Bazaar*, 5/16

Black Dog & Leventhal Publishers
Hachette Book Group
1290 Avenue of the Americas
New York, NY 10104

www.hachettebookgroup.com
www.blackdogandleventhal.com

First Edition: October 2016

Black Dog & Leventhal Publishers is an imprint of Hachette Books, a division of Hachette Book Group.
The Black Dog & Leventhal Publishers name and logo are trademarks of Hachette Book Group, Inc.

The publisher is not responsible for websites (or their content) that are not owned by the publisher.

The Hachette Speakers Bureau provides a wide range of authors for speaking events.
To find out more, go to www.HachetteSpeakersBureau.com or call (866) 376-6591.

Print book interior design by John Heiden, Smog Design, Inc.
Title page photograph: Marcelo Gomes, Principal, American Ballet Theatre
The quotes from the following dancers were taken from interviews by Cory Stieg:
Michele Wiles, Ashley Bouder, Isabella Boylston, Lauren Lovette, Misty Copeland, Adrian Blake Mitchell and Daniil Simkin.

Library of Congress Control Number: 2016939031

ISBN: 978-0-316-31858-7

Printed in China

IM

10 9 8 7 6 5 4 3 2 1